ALBERTO

This exhibition has been made possible by the joint sponsorship of Credit Suisse and the Xerox Foundation.

Supplemental assistance has been provided by Balair and Pro Helvetia Foundation.

The exhibition has been supported by an indemnity provided by the Federal Council on the Arts and the Humanities.

GIACOMETTI

1901–1966

Valerie J. Fletcher

with essays by Silvio Berthoud and Reinhold Hohl

Published for the Hirshhorn Museum and Sculpture Garden by the Smithsonian Institution Press, Washington, D.C.

Published on the occasion of the exhibition *Alberto Giacometti 1901–1966,* organized by the Hirshhorn Museum and Sculpture Garden

Hirshhorn Museum and Sculpture Garden
Smithsonian Institution
September 15–November 13, 1988

San Francisco Museum of Modern Art
December 15, 1988–February 5, 1989

Printed in Hong Kong by South China Printing Company.

Library of Congress Cataloging-in-Publication Data

Fletcher, Valerie J.
Alberto Giacometti, 1901–1966.

"Published on the occasion of the exhibition Alberto Giacometti 1901–1966, organized by the Hirshhorn Museum and Sculpture Garden"—T.p. verso.
Bibliography: p.
1. Giacometti, Alberto, 1901–1966—Exhibitions.
I. Giacometti, Alberto, 1901–1966. II. Berthoud, Silvio. III. Hohl, Reinhold. IV. Hirshhorn Museum and Sculpture Garden. V. Title.
N6853.G5A4 1988 709'.2'4 88-42545
ISBN 0-87474-424-5
ISBN 0-87474-425-3 (pbk.)

Photography Credits

Photographs were supplied by the owners of the works of art. The following photographers are acknowledged (unless stated otherwise, numbers refer to catalog entries).
James Austin: 80; Ben Blackwell: 8, 60; Geoffrey Clements: 81; Walter Drayer: 6, 7, 19, 50, 88, 104; Courtesy Editions Cahiers d'Art: fig. 17; Jacques Faujour, courtesy Musée National d'Art Moderne, Centre National d'Art de Culture Georges Pompidou: fig. 2; Courtesy Galerie Maeght: fig. 18; Lynton Gardiner: 77; Claude Gaspari: 62, 95; Greenberg-May Prod.: 93; Carmelo Guadagno and David Heald: 15, 18; Christine Guest: 82; David Heald: 4; Lasse Koivunen: 31; Don Meyer: 101; Otto Nelson: 32, 75, 90; Courtesy Pierre Matisse Gallery: 79, 99; Pollitzer, Strong, and Meyer: 49; Nathan Rabin: 91; Courtesy Seattle Art Museum: 3; Courtesy Staatsgalerie Stuttgart: 28; Lee Stalsworth: 5, 11, 14, 22, 34, 38, 40, 41, 55, 59, 71, 84, 96, 97; Michael Tropea: 45, 46, 70; Sabine Weiss: 10, 29, 30, 64, 105.

Dimensions are in inches; height precedes width precedes depth. Figures in brackets [] indicate catalog numbers. Works are arranged chronologically, with those from the same year grouped by media and listed with sculptures first, followed by paintings and then drawings. Unless otherwise noted, English citations from French sources were translated by the author.

Frontispiece:

Alberto Giacometti, 1932. Photograph by Man Ray.
© Mrs. Juliet Man Ray.

Contents

Lenders to the Exhibition

Mr. and Mrs. James W. Alsdorf, Chicago
Ernst Beyeler, Basel
Djerassi Art Trust, Stanford, California
Jacques and Natasha Gelman Collection, New York
E. W. Kornfeld, Bern
Richard E. and Jane M. Lang Collection, Medina, Washington
Albert A. List Family Collection, New York
Albert Loeb, Paris
Herbert Lust, Greenwich, Connecticut
Duncan MacGuigan, New York
Mr. and Mrs. Adrien Maeght, Paris
Robert B. Mayer Family Collection, Chicago
Morton G. Neumann Family Collection, Chicago
Private collections
Mr. and Mrs. Harold E. Rayburn Collection, Davenport, Iowa
John Rewald, New York
Mr. and Mrs. David A. Wingate, New York

Alberto Giacometti Foundation, Zurich
Albright-Knox Art Gallery, Buffalo
Art Gallery of Ontario, Toronto
The Art Institute of Chicago
Bündner Kunstmuseum, Chur, Switzerland
Carnegie Museum of Art, Pittsburgh
Des Moines Art Center
Fondation Maeght, Saint Paul-de-Vence, France
Hirshhorn Museum and Sculpture Garden, Smithsonian Institution, Washington, D.C.
Los Angeles County Museum of Art
The Marion Koogler McNay Art Museum, San Antonio
Meadows Museum, Southern Methodist University, Dallas
Musée National d'Art Moderne, Centre National d'Art et de Culture Georges Pompidou, Paris
Museum of Finc Arts, Boston

Foreword

The image of Europe's physical state in 1945 that persists in the memory of those who observed it firsthand or through the stark black-and-white images of the newsreel is that of rubble. The sameness of city block after city block of crumbled and crushed brick and concrete was relieved only occasionally and surprisingly by fragments of walls or the remains of undetermined structures that through some inner strength—or perhaps luck—towered miraculously above the devastated terrain.

Art had also sustained serious damage, spiritually as well as physically, and for artists day-to-day survival had to take precedence over the creation of art. In addition to finding time to paint, searching out the necessary materials (heretofore taken for granted) also became a struggle.

But for a number of painters and sculptors, the war acted as a cultural watershed, and it is difficult to imagine the rise and artistic pre-eminence of the independent figures Francis Bacon, Jean Dubuffet, and Alberto Giacometti without the war to serve as catalyst. Although all three artists were born in the first decade of this century, only Giacometti had enjoyed a reputation of significance in the 1930s. That reputation resided in large part in his works as a Surrealist. The masterpieces of those early years are among the most telling created by any of his colleagues in that movement, but Giacometti was too much his own man to be confined by the restrictive tenets of dogma.

After his break with the Surrealists in the mid-1930s, Giacometti's work seemed tentative and uncertain, particularly the sculpture. The war, which Giacometti had spent in the safety of neutral Switzerland, afforded him the time to reflect upon the chaos and madness surrounding him and to resolve the issues that had been troubling him. The artist who returned to his Paris studio just four months after the war in Europe had ended created solitary images startlingly different from any that had come before. And even though strong intellectual ties to the past remained in his work, visually the sculptures of prewar Giacometti and of postwar Giacometti are the works of two different artists. Relatively few artists of our time have had such strikingly unique signatures.

The Hirshhorn Museum and Sculpture Garden and the San Francisco Museum of Modern Art are truly privileged to be able to present to the public these works by a twentieth-century genius. I would like to thank former director Henry T. Hopkins and his successor John R. Lane at the San Francisco Museum of Modern Art for their close cooperation.

Only through the generosity of numerous lenders in this country and abroad could

the exhibition have been realized. Foremost among these are the Alberto Giacometti Foundation in Zurich and the artist's widow, Annette Giacometti of Paris, to whom we are indeed indebted.

A compatible partnership of Swiss and American corporate and governmental entities has been instrumental in the realization of this exhibition. The ever-mounting costs of major exhibitions have, more and more, necessitated such joint ventures, and we are deeply grateful to Credit Suisse and the Xerox Foundation as joint sponsors of *Alberto Giacometti 1901–1966*. Their generous funding was critical to its success. Supplemental assistance was provided by Balair and Pro Helvetia as well as by an indemnity from the Federal Council on the Arts and the Humanities. To all, we extend our thanks.

In closing, I wish to commend curator Valerie J. Fletcher who organized the exhibition. Her perceptive insights into the artist's work are the results of her long-standing love affair with his oeuvre and her knowledge of it.

James T. Demetrion
Director
Hirshhorn Museum and Sculpture Garden

Acknowledgments

Undertaking an exhibition of Alberto Giacometti's work requires making aesthetic and philosophical choices as well as confronting pragmatic limitations. *Alberto Giacometti 1901– 1966,* the first exhibition of the artist's work organized by a museum in the United States since 1974, was tailored to include only selected examples of high quality and unusual interest that demonstrate the remarkable range of Giacometti's creativity in sculpture, painting, and drawing. Despite the fragility of many of the objects, their rapidly escalating market values, and emotional ties to their works, many private collectors and museums agreed to share them. I wish to express my heartfelt thanks for their generosity, which made this exhibition a reality.

The preparation of the exhibition and its accompanying catalog entailed the collaboration and assistance of many people and institutions over four years. In particular, the Alberto Giacometti Foundation cooperated from the outset. Felix Baumann, director of the Kunsthaus Zurich and member of the foundation's board, was pivotal in obtaining essential loans. Other individuals in Europe and North America made invaluable contributions with loans as well as advice and help in locating works. Members of the artist's family participated with special generosity, sharing both the works in their collections and their time and knowledge. Annette Giacometti, who is compiling the catalogue raisonné of her husband's work in all media, not only endorsed our project but also agreed to lend several works not previously exhibited in an American museum. Her colleague Mary Lisa Palmer handled with aplomb over many months the seemingly endless details. Graciously receiving me into their home, Bruno and Odette Giacometti showed me little-known works, recounted anecdotes, and were most encouraging. The artist's nephew, Silvio Berthoud, also welcomed me warmly and consented to break his long silence about his uncle by writing an informative and affectionate memoir.

Others who knew the artist, including Michel Leiris, Eberhard Kornfeld, and several private collectors, shared their memories and expertise. I am especially grateful to the sculptor Raymond Mason, who contributed a delightful memoir that was my pleasure to read. In addition to writing an essay for the catalog, Reinhold Hohl, whose monograph was an essential source, unhesitatingly responded to questions; my conversations with him were enjoyable, ranging from the factually informative to the philosophical and aesthetic. In a similarly collegial spirit, Giacometti's biographer James Lord received me in his home and provided generous, specific answers to questions. Louise Svendsen, curator emeritus of the Solomon R. Guggenheim Museum, was unfailingly helpful in my research, often at a moment's notice.

Several dealers and auction houses aided me with their knowledge of Giacometti's oeuvre. In particular, Ernst Beyeler, Thomas Gibson, Sidney Janis, Pierre Matisse, and various experts at Sotheby's helped locate owners of works, made overtures for possible loans, and established insurance values for lenders and indemnification.

The efforts of many staff members at other museums were invaluable in shaping and completing this exhibition. Too numerous to cite individually, I would nonetheless like to express my sincere appreciation for their contributions. In Paris Sir Valentine Abdy, the Smithsonian Institution's representative, proved essential in negotiating several international loans. Bonnie Krench successfully pursued the funding necessary to support the show. The exhibition and catalog involved virtually every deparment in the Hirshhorn Museum, from administrators to interns. From the outset Director James T. Demetrion enthusiastically encouraged my efforts. In addition to practical advice on resolving problems, he offered insightful comments on the relative merits of individual works. My thanks also to Deputy Director Stephen Weil for his open-door policy whenever a question arose and to Executive Officer Nancy Kirkpatrick for handling financial and administrative matters.

The efforts involved in producing a scholarly catalog were handled by many at the Hirshhorn Museum. A special note of appreciation is owed to Barbara J. Bradley, who despite an unusually heavy publications schedule thoughtfully edited my manuscript; thanks also to copy editor Kathleen Preciado who did a thorough job in too-little time and to Alan Carter for his handsome catalog design. In the Department of Painting and Sculpture, Deborah Knott de Arechaga, Amy Loveless, and Jennifer Loviglio provided initial assistance, while Dorothy Valakos devoted much effort to the complex preparations that an exhibition and catalog require. Intern Stefania Lucamante helped with a wide range of details. Librarian Anna Brooke and her efficient staff valiantly pursued elusive sources. The museum's photographers Lee Stalsworth and Marianne Gurley labored for months to ensure the quality of the catalog reproductions, no small task with Giacometti's subtly modeled works.

Many individuals contributed to bringing together and installing more than one hundred works. Registrar Doug Robinson and Assistant Registrar for Exhibitions Barbara Freund resolved the complex transportation and insurance requirements, while the entire registrarial department assisted with the works themselves. Sidney Lawrence developed public and press awareness of the exhibition. The handsome design and installation were accomplished by Ed Schiesser and his staff.

Finally, a sincere expression of gratitude to Credit Suisse and the Xerox Foundation, who jointly provided major funding, to Balair for transportation services, and to Pro Helvetia Foundation for its education grant.

Valerie J. Fletcher
Curator
Hirshhorn Museum and Sculpture Garden

ALBERTO GIACOMETTI

1901–1966

Some Personal Memories

Silvio Berthoud

Numerous publications have appeared on Alberto Giacometti, and James Lord's biography presents a faithful image of him. For this catalog, however, I was asked to provide personal recollections. I had the good fortune to know my uncle well, first in Geneva during World War II and later at our family homes at Maloja and Stampa, where I became close to the man and the artist.

When I was between the ages of five and eight, Alberto lived in Geneva in a small hotel near us, and he came to our house almost daily to see his mother, my grandmother. He was still limping, a result of an automobile accident in 1938 in the place des Pyramides in Paris. At that time, he was working with Albert Skira on *Labyrinthe* [the art periodical published in Geneva, October 1944–December 1946] and would often talk to me about Greek mythology or ancient history by evoking the characters as if he had known them personally. Fascinated by this ancient past, no doubt embellished, I never ceased asking for more. From that time on, I learned to see history not as an abstract science but with a human dimension. He immediately inculcated his very strong preferences and judgments upon me. Clearly, he preferred Ulysses, the intelligent and subtle hero, to Achilles; in Crete, it was Ariadne who interested him more than Theseus, and his attitude toward the Minotaur was a mixture of admiration and repulsion.

Alberto also introduced me to Egyptian history, through artworks—the magnificent plates by Nina Davies[1] that we were fortunate enough to have at home. I remember well the effort he made to show me the evolution of the style and the particularities tied to the different dynasties. Always he attempted to go beyond contemplation of the art itself in order to call forth the history of the country and the development of an entire civilization. Our main focus was on ordinary people. The scribes and the fishermen among the reeds, rather than the pharaohs and priests, were our friends. I was probably too young to extract everything that I could have, but his commentaries on Akhenaton's religious and artistic innovations and the retrograde role of the Karnak priests have remained alive in my mind. I was also stunned and scandalized when he described the damage caused by the barbarian invaders of this enticing country and by their scorn toward the Egyptians' work.

During that period I had the privilege, thanks to Alberto, of entering a mythical world, and the hours spent on all fours on the living-room rug in front of those marvelous images are engraved in my memory. In spite of his own interests and of difficulties I learned about later, Alberto knew how to put himself on my level. He spent hours with me, sometimes on walks in the Geneva countryside, frequently on visits to the animal displays at the

Museum of Natural History. I often had the impression that we were accomplices in a universe in which other peoples' concerns were not ours.

With his teasing and ironic turn of mind, my uncle sometimes took pleasure in embarrassing me or making me believe silly things. Did I not believe for a long time that in contrast to Switzerland, in France *pommes de terre* were called just *pommes* and that *pommes* were called *pommes en l'air*?[2] But then, until Alberto was fourteen he had believed that rabbits lay eggs at Easter, so perhaps he was taking his revenge on me.

Other times were less pleasant. Occasionally, Alberto made me pose, forcing me to remain immobile for interminable periods—fifteen, thirty, forty-five minutes, perhaps even an hour. Despite the charm of his conversation, I have very unpleasant recollections of sitting for him, for it was of utmost importance not to move but to fix him right in the eye and listen to him complain, saying as he always did that he was getting nowhere. It was not much fun, particularly at my age. His mother was always present, praising his work and undoubtedly happy to see a portrait or sculpture of her grandson. As a matter of fact, I believe she pressured Alberto to have me pose, for he certainly had less-reluctant models available. Things would deteriorate rather quickly, for Alberto would return to his hotel in the evening with a sculpture eight to twelve inches tall under his arm and come back the next day with a piece no more than three or four inches high. He had worked all night, scraping and reducing this artwork to make it conform to his nascent perception. Such a sculpture was not at all to my grandmother's taste, and I would have to pose again, to my great displeasure. Alberto, probably heeding his mother's remarks, would remodel the sculpture in a "decent" size, which did not last long either. Although those sessions left a rather painful memory, I later realized that I had posed during a crucial period, and the tiny bronzes that resulted (for that size prevailed) continue daily to touch me.

Later on, I used to see Alberto at Maloja or at Stampa during the holidays, and I was free to watch him work, to chat, and to remake the world with him. His immense cultural knowledge, allied to an insatiable curiosity, would drag us into all sorts of subjects. Frequently, of course, he would speak about his work—of his difficulties in reproducing what he saw, of his anguish as he attempted to make palpable the space around objects or persons in his canvases. He could also become furious in front of a certain picture by an unknown artist that hung on the wall at Stampa. Finding it inconceivable that oranges were depicted in their natural size, he would launch into interminable discussions about how to reproduce in painting the real dimensions of objects. Alberto was sincerely anxious and evidently searched relentlessly. Yet whatever may have been said concerning his hesitations and dissatisfaction, I believe he knew, deep down, that he was on the right path. When his mother admired an unfinished canvas, we would have to listen to him say for an hour or longer that he was getting nowhere, that everything was lost, that he was condemned to suffer like Sisyphus or Prometheus—always beginning again. But if by chance his mother, subtle as she was, asserted a day later that his painting was in fact terrible, that it was impossible to paint it that way, all of a sudden he would become conscious of his worth and refuse to tolerate that sort of remark. He would then explain how close he was to the goal and that other artists were on the wrong track, and finally he would appear somewhat satisfied with his work.

While I was studying medicine, Alberto would make me talk about anatomy and physiology. He was fascinated by the movements of the body and, with a diabolical demand for exactness, made me reproduce the skeleton and the muscles in Plasticine. Optics intrigued

him the most, and he was curious about the path of light through the eye and its conversion into neural impulses. Discussions were lively, and we occasionally became alarmed when we decided that the world as we think we see it is ultimately only a convention. In the process of seeing, light travels through the crystalline lens and images in the brain are twice reversed: top is bottom and left is right. Pushing this reasoning to its logical conclusion, we no longer knew what we were actually perceiving. We had fun imagining reality upside-down, and we had to invent a suitable vocabulary in order to understand each other since suddenly we were living with our heads upside-down and with our left hands becoming our right hands. Perception was not the only domain in which, after a few hours of discussion, we ended up with absurdities, which in turn pushed us to search for the fallacy in our reasoning so that we could continue our talks.

Alberto was undoubtedly more attentive to the people around him than anyone I have ever met. He listened to everyone with equal absorption whether in the café at Stampa or among a circle of philosophers. But he would not let a stray remark go unnoticed and would pursue vague and woolly declarations until their unfortunate authors had explained or effaced themselves. He took malicious pleasure in contradicting his interlocutors and generally won his argument. Sometimes he would push the joke too far and end up defending ideas so absurd that the discussion would end in a loud burst of laughter.

To close, I agreed to write these few lines to show that Alberto Giacometti, in addition to being the much-talked-about artist, was above all human. Among the qualities that I remember most vividly are his insatiable interest in people and in the world around him, his rigor, his humor, and his irony—ready to waylay us at every step.

Translated by Michèle Cone

1. Nina Davies was noted for sumptuous illustrations of art from Egyptian tombs. Her most lavish and well-known publication was the enormous folio *Ancient Egyptian Paintings* (Chicago: University of Chicago, 1936), 3 vols.

2. In French the word for *potatoes* literally means "apples of the earth"; Giacometti invented the term "apples in the air (l'air)" for the fruit on the tree, a logical and euphonious counterpart to "apples of the earth (de terre)."

Alberto Giacometti: His Art and Milieu

Valerie J. Fletcher

Long acknowledged as major contributions to the history of modern art, the works of Alberto Giacometti have been appreciated by collectors, scholars, and the general public. His fame and artistic identity are inextricably linked with his postwar bronze sculptures of attenuated, gaunt figures, usually immobile women and striding men. His paintings, portrait busts, and drawings of figures with eyes transfixed in a disturbing stare have become icons of modern art. Yet his adult artistic production, which spans the forty-five years from his departure for Paris in late 1921 until his death in 1966, is far more varied and complicated than the stereotypes suggest and offers substance for appreciation by divergent aesthetic sensibilities.

His image—artist as tragic hero—was shaped largely by Giacometti himself. As his fame burgeoned in his later years, he was often interviewed, and his passionate comments were readily accepted. His eloquent explications certainly contain valuable seeds of truth, notably regarding his quest for an art having an impact equivalent to actual experience (both imaginative and visual). But his desire to clarify the ethos of his late work led him to portray his entire oeuvre as relatively homogeneous, in intention if not in visual form, and to repeat certain ideas as applicable to all his work. Even more detrimental to the full appreciation of his art was the myth that developed around him from the late 1940s until well after his death, casting him as a romantic, Existentialist hero—a lone genius indifferent to physical comforts, dedicated to the pursuit of an unreachable goal. Although Giacometti's commitment to his art was genuine and profound, this image interfered with perceiving the artworks, as they were too often seen through the veil of the mythic persona. Now, more than twenty years after his death, his oeuvre may be appreciated anew for its complexities and contradictions as well as for its threads of continuity.

Primarily recognized as a sculptor, Giacometti also worked extensively in painting, drawing, and printmaking; during the last fifteen years of his life he considered painting as important as sculpture. While he periodically emphasized one medium over another (he executed few sculptures during 1920-24, for example, and nearly abandoned painting during 1925-45), in his youth and again from 1946 through 1965 he moved unceasingly from one medium to another as a means of active cross-fertilization. The full extent of his oeuvre is not generally recognized because many works disintegrated or were destroyed and many others remain unpublished in private collections. Sculptures range from tiny (the smallest figures from 1938 to 1945 measure scarcely two inches high) to monumental (the four large standing female figures of 1960 average more than eight feet tall). While it is tempting to

see a logical progression from the diminutive to the heroic, he actually worked on both small and large figures at the same time during the postwar years and episodically later. His paintings similarly range from small, sketchy still lifes to large formal portraits. Some of his most compelling drawings are the little ballpoint-pen doodles of his last years.

Stylistically, Giacometti's output displays greater variety than the artist cared to admit. Representational modes dominated most of his work, from youth through 1925 and again from 1935 until his death, and he took great pains to emphasize that continuity. Yet from 1925 to 1935 he produced remarkably accomplished sculptures in Cubist, abstract, and constructed styles, including numerous exemplars of Surrealist aesthetics. In the years immediately after World War II his sculptures included multifigure compositions and urban settings. Only later did he settle into his format of single standing women and walking men. During those postwar years he experimented, painting and drawing figures in varied poses and contexts, often with distorted anatomical and spatial effects. Only in the early 1950s did he embrace what would become his standard composition of strictly frontal figures viewed at close range.

Beyond their stylistic range and accomplishment, Giacometti's works offer intellectual rewards. The iconography of his sculptures, both the Surrealist and postwar pieces, is rich in psychological implications and in references to art forms of other cultures. Conceptually, his oeuvre embodies multiple dualities of subject and style: abstract and figurative, male and female, active/mobile and passive/immobile, volume and void, impressionism and expressionism. These opposites often give rise to paradoxes that add an underlying tension to even the simplest works. In many sculptures of 1927–34 and 1946–50, for example, the traditional relation between volume and void is reversed, with far more space than physical form. In both the early works and postwar attenuated figures, the thin linear forms so energize the surrounding space that it plays an active role in the psychological impact of the work.

Some dualistic concepts were not defined until after 1946–50, especially the equation of active/mobile with the male figure and passive/immobile with the female. Earlier works, which tended to make imaginative use of movement versus immobility, did not restrict kinesis to one gender. Tension between abstract and naturalistic forms also pervades much of Giacometti's work. In the Surrealist sculptures the essentially abstract forms are clearly understood as having biological and psychological import. In the postwar sculptures the ultrathin figures read more as lines of force than as articulated individuals, and the urgency of the late busts arises in part from the energy of their abstract silhouettes. In execution, the paintings, sculptures, and drawings after 1946 seem to capture fleeting impressions of purely optical sensations. The bronze surfaces flicker with light and shadow, precluding their description as solids. Lines in the paintings and drawings swirl over and around forms; multiple vibrating outlines seem to trace the transitory act of seeing rather than define a fixed reality. Yet within these shimmering images abide an emotive expressionism and transcendent immutability. Such paradoxical relationships between opposites, ceaselessly active within the artworks, generate a subliminal tension of great expressive power.

The stylistic accomplishments and conceptual depth of Giacometti's works ensure their prominence in art history, but they offer further enticement to modern audiences by expressing the philosophical and psychological concerns of the twentieth century. The passion and conviction of his work undoubtedly arose from the wellsprings of his own personality, but he was by no means an entity unto himself. While he did not belong officially to any

formal movement, apart from his association with the Surrealists in 1930–34, the image of the lone genius dismisses Giacometti's extensive network of friends and acquaintances. A compelling conversationalist, he was friendly with many writers and artists and avidly debated avant-garde ideas of art, literature, and philosophy. His work reflects the intellectual and aesthetic atmosphere of his time. His sculptures of the late 1920s and early 1930s exemplify the most significant aesthetics of the period, and his rejection of Surrealism in late 1934 reflected a feeling expressed by many that the time was ripe for change. His later art shares characteristics with works by other postwar sculptors and painters who had turned to expressionist styles. Since he counted among his friends several noteworthy writers, especially Samuel Beckett and the philosopher Jean-Paul Sartre, it is not surprising to find affinities with their works, especially the angst associated with Existentialism. When the artist attempted to define his mature art, he did so partly in the terms of perceptual phenomenology, influenced by the theories of his contemporary Maurice Merleau-Ponty. Here again, the study of Giacometti and his art presents a paradox. His works are utterly self-absorbed, expressing his personal obsessions, yet they epitomize the spirit of his times.

So extraordinary is the variety, depth, and complexity of Giacometti's work that critics and historians tirelessly explore its contexts, sources, and meanings. Whether factual or formalist or from the more recent theoretical viewpoints (such as structuralism and psychoanalysis), diverse studies have greatly enriched our understanding of the artist and his work. Yet even the most worthy analyses and interpretations may obscure the art itself. What sustains the works and our interest in them is their tremendous expressive power. Giacometti's sculptures, paintings, and drawings have a visual, tangible, and emotional impact that transcends all verbal explications, including his. Confronting his works is an exciting experience, engendering a deeply personal response to their varied and nuanced execution, their textural beauty and symbolic power.

Origins

Raised in an artistic family in Switzerland, Giacometti as a boy encountered no obstacles in turning to art. His father, Giovanni Giacometti, and godfather, Cuno Amiet, were painters who had assimilated French Neo-Impressionist, Symbolist, and Fauvist styles and were becoming recognized as prominent Swiss artists. Giovanni's second cousin Augusto Giacometti, also a painter, had passed beyond Fauvism to create a series of remarkable abstract paintings during the 1910s. When the young Alberto turned to drawing around 1910–12, he found material at hand in his father's studio, especially books from which he copied many artworks.

In his youthful drawings Giacometti sketched the domestic world around him (interiors, family members, self-portraits) in a competent but unremarkable style. He also modeled bust sculptures of his brothers and mother in 1914–16. His artistic abilities flowered during the years 1917-19 at boarding school in Schiers and on visits home. Nurtured by familiarity with his father's and godfather's works, he refined his drawing style, colorism, and sense of composition. He painted Neo-Impressionist canvases and watercolors, including landscapes, and produced a number of assured portraits, often of his schoolmates, in colored pencil and ink. His *Self-Portrait,* 1918 (fig. 1), reveals the emergence of a personal style,

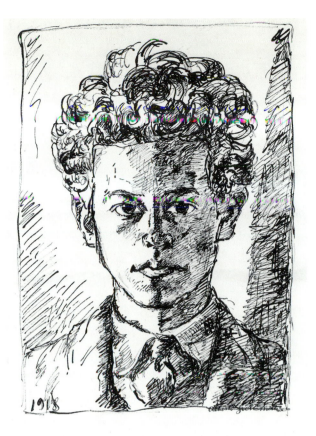

Fig. 1 *Self-Portrait,* 1918, ink on paper, 14⅜ x 10⅛ in. Öffentliche Kunstsammlung Basel, Kupferstichkabinett.

and its frontal pose, direct intense gaze, and rapidly executed lines forecast his later work.

After Giacometti left secondary school his father sent him to Geneva for formal art training. From fall 1919 to early spring 1920 and again in early fall 1920, Alberto studied drawing and painting at the Ecole des Beaux-Arts and sculpture at the Ecole des Arts-et-Métiers. More significant were two visits to Italy, in April 1920 and from November 1920 to summer 1921. There he studied ancient and Renaissance art at firsthand. For the rest of his life he would make copies of artworks in museums and from reproductions, seeking to capture the indefinable essence of their greatness. Extant drawings from the late 1920s through the early 1960s reveal his interest in sources as diverse as African and Oceanic artifacts, ancient Mesopotamian and Cycladic sculpture, and Byzantine, Gothic, and especially Egyptian art. Among European masters, he often copied images by Albrecht Dürer, Jan van Eyck, Rembrandt van Rijn, and Paul Cézanne.

Back in Switzerland during the fall of 1921 Giacometti painted an ambitious *Self-Portrait* [1]. Its size, subject, and execution indicate that this painting was intended as a statement of his purpose and abilities. This image presents the twenty-year-old artist as a painter at work; the geometric structure of the composition, Fauvist color, and brushwork are remarkably accomplished. Having demonstrated his mastery of his father's and godfather's styles, he decided to move on to sculpture and so departed for Paris.

After his arrival in early January 1922 Giacometti followed his father's advice and enrolled in Antoine Bourdelle's sculpture class at the Académie de la Grande Chaumière. The next three years were not particularly productive because he made frequent trips home and struggled to learn French and acclimate himself to the competitive atmosphere of a

major atelier. He made many drawings of the nude models, mostly in a Cubist-influenced style, but few sculptures or paintings survive. In the Fauvist *Self-Portrait,* c. 1923 [2], he again confronts the world with self-assurance. A partial head of his mother modeled around 1923 (Alberto Giacometti Foundation, Zurich) reveals that the young artist had thoroughly absorbed the style of Auguste Rodin (Bourdelle had been Rodin's primary studio assistant from 1893 to 1908). Giacometti had first learned of Rodin's sculpture from his father's art books and in December 1915 had been so interested that he bought a book on the French sculptor's work. Rodin's influence is visible in several of Giacometti's busts of 1916–17 and paramount in the partial head of c. 1923. Like Constantin Brancusi and other sculptors who came to maturity in the wake of Rodin's overwhelming fame, however, Giacometti decided to follow a more avant-garde path.

Around 1925, feeling that working from models and striving for a representational art was insufficient, he decided to work in modes derived from his imagination. Although he later described this as an aesthetic crisis with representation, it probably reflected the harsh realities of artistic fashion. After three years of study in glamorous Paris, the artistic capital of the world, he had to recognize that he was no longer a child prodigy but a foreign provincial working in démodé styles. His decision to develop a more innovative, imaginative style echoed what a number of other aspiring young artists were doing in Paris during the 1920s.

Flirting with the Avant-garde

Giacometti's decision to move away from traditional figurative art to find a more avant-garde style led him to explore a variety of sources currently in vogue. These influences included the reductivist art of Brancusi, primitive art, and particularly the constructivist geometry of Cubism. His liberation from representation occurred with remarkable rapidity, and within a few short years he created dozens of sculptures in radically different styles.

Primitive art played a pivotal role in freeing Giacometti from past traditions. When African art had first been discovered by avant-garde artists in Paris around 1907, it had a tremendous impact on the development of modern art. The most crucial assimilation of African art occurred in the work of Pablo Picasso, particularly directing him and others toward Cubism. By the mid-1920s African art had become fashionable, even influencing the decorative arts. Other forms of ethnographic art, especially Oceanic, were also being discovered, collected, and studied during the 1920s, but it was African art that influenced the young Swiss artist in his first attempts at vanguard sculpture.

Collections of ethnographic art were readily accessible to artists in Paris during the 1920s. The Musée d'Ethnologie du Trocadéro (now the Musée de l'Homme) housed art from ancient cultures and primitive societies, especially artifacts brought back from French colonies. A number of publications were available, including Carl Einstein's *La sculpture africaine* (1922) and Paul Guillaume's *Primitive Negro Sculpture* (1926). Objects were available in galleries, and many artists, including Picasso and Max Ernst, collected a variety of ethnographic objects, as did the art dealer Pierre Loeb. African art taught Giacometti to rethink the human figure entirely—to simplify, abbreviate, and even deform anatomy. Two sculptures of 1926–27 reveal the radical stylization and frontality adapted from African

influences. *Couple (Man and Woman)* [3] presents two abstract vertical shapes, their genders identified by outline (a flattened ovoid for the woman, a tapering column for the man) and by symbolic anatomical attributes. The use of geometric emblems to indicate male and female is one of the more obvious characteristics of much African art. Less decoratively designed than *Couple, Spoon Woman* [4] derived its concept and composition from the large wood spoons of the Dan people of West Africa (see fig. 11). The symbolism of the woman here lies not in the surface emblems of *Couple* but in the basic concept of woman as vessel.[1] In African art Giacometti discovered the power of totemic figures. His sculptures in the next several years would take on narrative or psychological implications, but after World War II Giacometti would return obsessively to this theme of woman as a fetishistic talisman.

Once Giacometti had absorbed from African art the idea of treating the figure as an object independent of resemblance, he was free to develop imaginative compositions. He next examined the autonomous forms and structural compositional methods of Cubism. By the time Giacometti turned his attention to it, Cubist art had been practiced in Paris for nearly twenty years, having developed from the Analytic through the Synthetic phases during 1907–21. After World War I, Cubist art experienced a resurgence of vitality for several years, with works exhibited in the Salons and at commercial galleries, notably the Galerie de l'Effort Moderne. By the mid-1920s many of the original practitioners had evolved other styles, especially the painters Picasso, Georges Braque, and Fernand Léger. Developments in sculpture, however, continued a few years longer. The influence of the originating sculptors, including Alexander Archipenko, Henri Laurens, Jacques Lipchitz, Ossip Zadkine, and others, remained strong in Paris and elsewhere through the late 1920s.

At its simplest Cubism involved the methodical analysis of natural forms into a revolutionary vocabulary of stereometric shapes (geometric planes, polygons, cubes, cylinders, cones). Even Bourdelle, who discouraged Cubist influences in his students' work, recognized the style's compositional strength, and it was in his atelier that Giacometti made figure drawings in a moderately Cubist style. At its most abstract Cubism entailed a constructive method, assembling geometric components into an ordered composition without depending on resemblance to nature. This additive structural method constituted a radical break with traditional sculpture. It redefined sculpture away from traditional solid mass toward an art of dynamic interchange between volumes and active voids. In some cases it also led to pure abstraction, although most Cubist artists retained a tenuous evocation of a recognizable subject. Cubism served as a crucial catalyst by shifting the artist's attention away from focus on the subject to emphasis on aesthetic experimentation with purely visual forms.

Although Giacometti had seen Archipenko's geometric sculpture on his visit to the Venice Biennale in 1920 and again after his arrival in Paris, his own ventures into Cubism were not influenced by it. Rather his first attempt at a sculpture in a geometric idiom, *Torso*, 1925 (Alberto Giacometti Foundation), was analytical and reductivist, derived more from Brancusi's *Torso of a Young Man*, 1917–24 (Hirshhorn Museum and Sculpture Garden, Washington, D.C.), than from constructivist Cubist practice. Only in 1927, after he had absorbed the lessons learned from African sculpture, did Giacometti fully develop a Cubist mode.

The year 1927 marked the start of a productive period of wide-ranging experimentation and stylistic development in Giacometti's sculpture. That spring he and his brother Diego moved into the studio in Montparnasse where Alberto would remain for the rest of his

career. He also composed more than half a dozen Cubist sculptures, influenced by the works of Lipchitz and Laurens, whose studios he visited on several occasions in the mid-1920s. He particularly admired Laurens, but several of Giacometti's sculptures owe more stylistically to Lipchitz's sculptures of c. 1919–26, both the solid cuboid figures and the linear openwork sculpture, which Lipchitz called "transparents." Several of Giacometti's Cubist compositions are heavy-handed in their use of cubes piled vertically, but two of his works from 1927, both called *Composition,* are remarkably accomplished arrangements of geometric forms. One [5] features a solid mass with richly varied surface volumes, the spaces of which do not penetrate through the central core. In contrast, the other *Composition* [6] features abstract forms with planes and volumes alternating rhythmically with narrow open spaces to create a complex, openwork structure. This linear, spatial construction anticipates the sculptures of 1929, such as *Three Figures Outdoors* [12] and *Reclining Woman Who Dreams* [13]. The contrasting uses of solid mass versus openwork structure in the two 1927 Compositions demonstrate Giacometti's command of the Cubist idiom at its most abstract.

Having assimilated the volumetric and spatial style of Cubism with remarkable speed, Giacometti experimented in the winter of 1927–28 with several conceptions of flattened form. In a group of stylized portraits of his parents [7, 8] he compressed the natural roundness of the heads in various ways. Despite his decision in 1925 to explore avant-garde styles, Giacometti continued to make figurative works on visits to Switzerland, although those representational images were informed by his avant-garde Parisian developments. This dichotomy continued episodically throughout his career. For example, in 1930–32 he constructed some of his most revolutionary Surrealist sculptures in Paris, yet on visits home he painted two straightforward portraits of his father (Alberto Giacometti Foundation and private collection, Switzerland).

During the winter of 1927–28 Giacometti continued working with flattened sculptures, producing a group of eight or so plaques that are scarcely more than rectangular tablets mounted upright. Although he later described them as having derived from his memories of a female body or head, they do not literally depict their sources. These plaques are clearly conceptual and imaginative, combining the flat, rectangular format of a painting with minimal sculptural modeling: two gently rounded depressions (one vertical and one horizontal) in *Gazing Head* [9] and an elegantly sinuous silhouette in *Woman* [10]. These plaques exist as objects more than as representations and perpetuate the totemic nature and frontal, planar approach of the earlier *Couple* and *Spoon Woman.* They mark a distinct break with the geometric forms and independent structures of the two 1927 Compositions [5, 6]. Having reduced his sculptures to monolithic slabs with a few surface motifs, Giacometti had come to an impasse, one that was conveniently resolved by the sudden influx of new ideas.

Surrealism

Until mid-1929 Giacometti had remained essentially an outsider to the Parisian art scene, speaking poor French and associating with few artists beyond the students in Bourdelle's atelier and a group of minor Italian painters. At his father's urging to earn some money and public attention, Alberto took two plaques to Galerie Jeanne Bucher. They were exhibited there and led to a meeting that altered the course of his art and career. When André

Masson befriended him in the Café du Dôme in spring 1929, Giacometti was introduced to stimulating new ideas and friends, and his horizons suddenly expanded.[2] Masson had been one of the originators of Surrealism a few years earlier, gathering together a group that included Antonin Artaud, Georges Bataille, Robert Desnos, Ernst, Michel Leiris, Georges Limbour, Joan Miró, Jacques Prévert, Raymond Queneau, and others.

In 1924 Masson's circle had joined forces with the group led by André Breton (including Louis Aragon and Paul Eluard) to form the official Surrealist group. They launched their literary and artistic movement by issuing manifestoes and publishing two periodicals from 1924 through 1933. The movement was further publicized by independent art magazines, including *Documents, Cahiers d'art,* and *Minotaure.* Works were exhibited from 1925–26 on at several galleries, including Galerie Pierre (Loeb), Galerie Pierre Colle, Galerie Simon, Galerie Bernheim, and Galerie Jeanne Bucher. Thus when he met Masson, Giacometti was suddenly welcomed into an exciting and prominent avant-garde movement that had become well known in the Paris art scene and was on the verge of having international impact.

Surrealism had inherited a number of important concepts from Dada: an anarchistic rebelliousness against established values, an antitraditional approach to art expressed by outrageous artworks and actions intended to shock the public, and a fascination with irrationalism. Thus the "Declaration" of January 1925 defined Surrealism as an active attitude, "state of mind," and means of "total liberation of the spirit." Hoping that the overthrow of existing social and artistic orders would liberate people from the bondage of past beliefs, the Surrealists intended to move beyond the nihilism of Dada. In working to expand intellectual and spiritual awareness beyond rational thought and conscious perceptions, the Surrealists hoped to reveal a new, intensified reality on personal and social levels. The prefix *sur* means "above or beyond," thus *sur-réalisme* implies a state of exalted awareness beyond ordinary phenomenological reality.

Intended to be shocking in content and style, Surrealist artworks proffered disquieting and enigmatic images. Heavily influenced by the psychoanalytic theories of Sigmund Freud, the Surrealists regarded the sub- or unconscious as an untapped reservoir of ideas, perceptions, creative impulses, and intuitions far exceeding the scope of the conscious, rational mind. As means of obtaining access to this hidden realm, their art and writing emphasized dream imagery and free-association techniques (including "automatic" drawing). Fantastic forms and subjects inspired by Freudian psychology abound. Themes of sexuality became essential in the search for liberation and self-realization and useful as well for attacking bourgeois values. Perceived as an important key to the subconscious, eroticism was often portrayed imaginatively, at times graphically and violently. In keeping with Freud's ideas, depictions of women generally focused on their biological role.

Surrealist styles ranged from imagist representation to abstraction. Even the most abstract compositions retained some figurative implications and were intended to stimulate free association and other imaginative responses. Stylized organic forms, known as biomorphs, which had originally been formulated by Jean Arp, were frequently used for their abstract beauty and because their allusive shapes suggested familiar biological forms, including human and animal anatomy and plant and cellular life.

By the time Giacometti met Masson the Surrealists had largely defined their seminal ideas. From mid-1929 through mid-1930, Giacometti associated primarily with Masson and his group of dissidents, who were becoming disenchanted with Breton's dogmatic leadership (Masson left the official group in 1929). Already prone to sexual fantasies, Giacometti found

their company stimulating. The predilections of Masson, Bataille, and Leiris (who would remain a lifelong friend) for fantasies of eroticism, brutality, and massacre corresponded with his own and were henceforth reflected in his art.

Giacometti continued to use forms derived from the Cubist vocabulary of geometric shapes and constructed compositions that he had mastered in 1927. These forms became more linear, flattened into the planar space of the plaques, but now they dramatically incorporated areas of empty space, as in three works from 1929, *Man* [11], *Three Figures Outdoors,* and *Reclining Woman Who Dreams.* The open linearity of these sculptures, particularly *Man,* may reflect the influence of Picasso's *Constructions* (*Maquettes for a Monument to Guillaume Apollinaire),* 1928 (Musée Picasso, Paris), but Giacometti had already used the basic elements in his 1927 compositions.

Unlike the earlier sculptures based on African and Cubist sources, the 1929 works express psychological dramas. The vocabulary of abstract forms developed by Giacometti in 1926–28 was animated in subsequent years into imaginary scenes, often expressing personal fantasies. Although *Reclining Woman Who Dreams* derived structurally from the 1927 *Composition* [6], the title and forms indicate a shift toward evocative content. The dominant horizontal planes supported by upright posts and topped with a head (hemisphere) at one end signify a woman reclining in bed. The undulating horizontal bands suggest the rhythmic ebb and flow of dream-filled sleep.

In several sculptures of 1929 Giacometti used abstract geometric forms to express violent sexual narratives. For example, in *Three Figures Outdoors* two pointed spikes grasp or penetrate a zigzag form, which may be understood as two males assaulting a female who twists back and forth. Even without such a literal interpretation, the central linear form appears fragile, threatened by the aggressors at its side. The vertical lines and top and bottom horizontals construct a stage for this symbolic and powerful psychological drama.

Many of Giacometti's sculptures during the next four years would serve as symbolic psychodramas acted out on miniature stages. He used several formats: those enclosed within a framework or cage, those played like a game on a board, and those consisting of a lone figure whose pose implies a narrative. Most are horizontal and thus read better as drama, most—the cages or game boards—are separated from our reality by their presentation as stage sets.

The group of cage-like sculptures, which constitute self-enclosed universes of the imagination, are among Giacometti's most innovative works. *Suspended Ball,* 1930 (fig. 2), consists of two abstract geometric forms within a metal frame: a crescent on a platform and a slitted ball suspended by a filament. With its novel kineticism, *Suspended Ball* might at first suggest a child's toy, but a sexual interpretation readily emerges. The sphere hangs with its slit directly over the crescent, almost touching the upper edge. The filament allows the ball to be swung back and forth, coming only close enough to glide over the crescent without touching it, implying a perpetual state of arousal with no possibility of final gratification. Because the wood ball is heavy, it moves only when an onlooker intervenes to push it, making the viewer not only a voyeur but a participant. Furthermore, the scythe-like crescent suggests a painful aspect of erotic pleasure, a combination irresistible to many Surrealists.[3]

Prominently displayed in the *Miró-Arp-Giacometti* exhibition at Galerie Pierre in 1930, *Suspended Ball* attracted Breton's attention. Impressed by its eroticism, he acquired it and

Masson befriended him in the Café du Dôme in spring 1929, Giacometti was introduced to stimulating new ideas and friends, and his horizons suddenly expanded.[2] Masson had been one of the originators of Surrealism a few years earlier, gathering together a group that included Antonin Artaud, Georges Bataille, Robert Desnos, Ernst, Michel Leiris, Georges Limbour, Joan Miró, Jacques Prévert, Raymond Queneau, and others.

In 1924 Masson's circle had joined forces with the group led by André Breton (including Louis Aragon and Paul Éluard) to form the official Surrealist group. They launched their literary and artistic movement by issuing manifestoes and publishing two periodicals from 1924 through 1933. The movement was further publicized by independent art magazines, including *Documents, Cahiers d'art,* and *Minotaure.* Works were exhibited from 1925–26 on at several galleries, including Galerie Pierre (Loeb), Galerie Pierre Colle, Galerie Simon, Galerie Bernheim, and Galerie Jeanne Bucher. Thus when he met Masson, Giacometti was suddenly welcomed into an exciting and prominent avant-garde movement that had become well known in the Paris art scene and was on the verge of having international impact.

Surrealism had inherited a number of important concepts from Dada: an anarchistic rebelliousness against established values, an antitraditional approach to art expressed by outrageous artworks and actions intended to shock the public, and a fascination with irrationalism. Thus the "Declaration" of January 1925 defined Surrealism as an active attitude, "state of mind," and means of "total liberation of the spirit." Hoping that the overthrow of existing social and artistic orders would liberate people from the bondage of past beliefs, the Surrealists intended to move beyond the nihilism of Dada. In working to expand intellectual and spiritual awareness beyond rational thought and conscious perceptions, the Surrealists hoped to reveal a new, intensified reality on personal and social levels. The prefix *sur* means "above or beyond," thus *sur-réalisme* implies a state of exalted awareness beyond ordinary phenomenological reality.

Intended to be shocking in content and style, Surrealist artworks proffered disquieting and enigmatic images. Heavily influenced by the psychoanalytic theories of Sigmund Freud, the Surrealists regarded the sub- or unconscious as an untapped reservoir of ideas, perceptions, creative impulses, and intuitions far exceeding the scope of the conscious, rational mind. As means of obtaining access to this hidden realm, their art and writing emphasized dream imagery and free-association techniques (including "automatic" drawing). Fantastic forms and subjects inspired by Freudian psychology abound. Themes of sexuality became essential in the search for liberation and self-realization and useful as well for attacking bourgeois values. Perceived as an important key to the subconscious, eroticism was often portrayed imaginatively, at times graphically and violently. In keeping with Freud's ideas, depictions of women generally focused on their biological role.

Surrealist styles ranged from imagist representation to abstraction. Even the most abstract compositions retained some figurative implications and were intended to stimulate free association and other imaginative responses. Stylized organic forms, known as biomorphs, which had originally been formulated by Jean Arp, were frequently used for their abstract beauty and because their allusive shapes suggested familiar biological forms, including human and animal anatomy and plant and cellular life.

By the time Giacometti met Masson the Surrealists had largely defined their seminal ideas. From mid-1929 through mid-1930, Giacometti associated primarily with Masson and his group of dissidents, who were becoming disenchanted with Breton's dogmatic leadership (Masson left the official group in 1929). Already prone to sexual fantasies, Giacometti found

their company stimulating. The predilections of Masson, Bataille, and Leiris (who would remain a lifelong friend) for fantasies of eroticism, brutality, and massacre corresponded with his own and were henceforth reflected in his art.

Giacometti continued to use forms derived from the Cubist vocabulary of geometric shapes and constructed compositions that he had mastered in 1927. These forms became more linear, flattened into the planar space of the plaques, but now they dramatically incorporated areas of empty space, as in three works from 1929, *Man* [11], *Three Figures Outdoors,* and *Reclining Woman Who Dreams.* The open linearity of these sculptures, particularly *Man,* may reflect the influence of Picasso's *Constructions (Maquettes for a Monument to Guillaume Apollinaire),* 1928 (Musée Picasso, Paris), but Giacometti had already used the basic elements in his 1927 compositions.

Unlike the earlier sculptures based on African and Cubist sources, the 1929 works express psychological dramas. The vocabulary of abstract forms developed by Giacometti in 1926–28 was animated in subsequent years into imaginary scenes, often expressing personal fantasies. Although *Reclining Woman Who Dreams* derived structurally from the 1927 *Composition* [6], the title and forms indicate a shift toward evocative content. The dominant horizontal planes supported by upright posts and topped with a head (hemisphere) at one end signify a woman reclining in bed. The undulating horizontal bands suggest the rhythmic ebb and flow of dream-filled sleep.

In several sculptures of 1929 Giacometti used abstract geometric forms to express violent sexual narratives. For example, in *Three Figures Outdoors* two pointed spikes grasp or penetrate a zigzag form, which may be understood as two males assaulting a female who twists back and forth. Even without such a literal interpretation, the central linear form appears fragile, threatened by the aggressors at its side. The vertical lines and top and bottom horizontals construct a stage for this symbolic and powerful psychological drama.

Many of Giacometti's sculptures during the next four years would serve as symbolic psychodramas acted out on miniature stages. He used several formats: those enclosed within a framework or cage, those played like a game on a board, and those consisting of a lone figure whose pose implies a narrative. Most are horizontal and thus read better as drama, most—the cages or game boards—are separated from our reality by their presentation as stage sets.

The group of cage-like sculptures, which constitute self-enclosed universes of the imagination, are among Giacometti's most innovative works. *Suspended Ball,* 1930 (fig. 2), consists of two abstract geometric forms within a metal frame: a crescent on a platform and a slitted ball suspended by a filament. With its novel kineticism, *Suspended Ball* might at first suggest a child's toy, but a sexual interpretation readily emerges. The sphere hangs with its slit directly over the crescent, almost touching the upper edge. The filament allows the ball to be swung back and forth, coming only close enough to glide over the crescent without touching it, implying a perpetual state of arousal with no possibility of final gratification. Because the wood ball is heavy, it moves only when an onlooker intervenes to push it, making the viewer not only a voyeur but a participant. Furthermore, the scythe-like crescent suggests a painful aspect of erotic pleasure, a combination irresistible to many Surrealists.[3]

Prominently displayed in the *Miró-Arp-Giacometti* exhibition at Galerie Pierre in 1930, *Suspended Ball* attracted Breton's attention. Impressed by its eroticism, he acquired it and

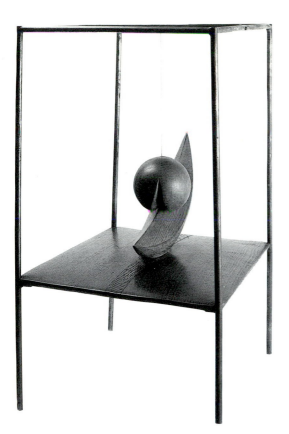

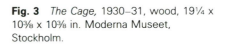

Fig. 3 *The Cage,* 1930–31, wood, 19¼ x 10⅜ x 10⅜ in. Moderna Museet, Stockholm.

Fig. 2 *Suspended Ball,* 1930, wood, iron, and filament, 23⅝ x 14⅛ x 13⅛ in. Private collection, Paris.

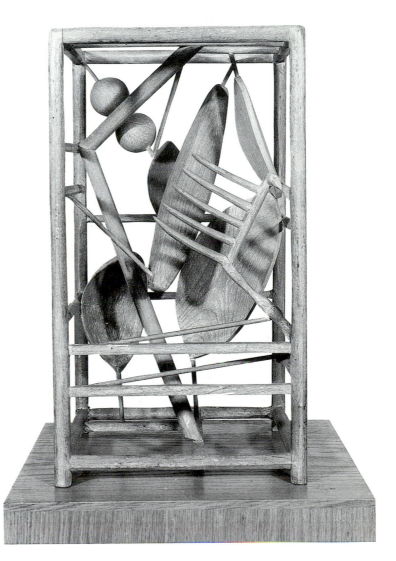

invited the young sculptor to join the official Surrealist group. Most Surrealist artists up to that point had been painters. Ernst and Man Ray had made Dada assemblage objects around 1919–20, but they had abandoned them during the 1920s in favor of paintings, collages, and frottages. Before 1930 Arp had applied his elegant biomorphic style to collages and painted wood reliefs rather than to freestanding sculptures. Giacometti's sculptures of 1930–34 presented new possibilities, and he became an instant star in the Surrealist firmament. His works triggered a rush toward object and assemblage sculptures, particularly with sexual innuendoes. In 1931 Miró made his phallic umbrella stand, and Salvador Dali published his article promoting Surrealist "objects"; the group's 1933 exhibition at Galerie Pierre Colle consisted of many new Surrealist sculptures.

Giacometti's *Cage,* 1930–31 (fig. 3), is infused with abstract violence. Even more than *Suspended Ball, The Cage* emphasizes that the space contained within the constructed frame represents an interior space of reverie and imagination. Within the realm defined and controlled by the framing cage, a dramatic struggle of abstract forms wages fiercely. The forms, especially the long pointed ones, seem to attack or threaten one another, and in the process they energize the intervening spaces with an almost palpable tension. More than any of Giacometti's other constructions, *The Cage* offers an abstract metaphor for the destructive conflicts in life. The symbolic potency of this work was such that Giacometti planned to enlarge it to a scale larger than life-size and place it outdoors, where the viewer would be at eye level with the conflict and drawn into its center.[4]

Giacometti's innovative contributions to modern sculpture include the various compositions that resemble miniature platforms, like children's tabletop games. Unprecedented in the history of art, this format radically redefines the base as the sculpture. Most of the platform pieces suggest imaginary or metaphorical landscapes and are populated by small stylized figures. In *Man, Woman, and Child,* c. 1931 (fig. 4), the concept of the family becomes a game, with the genders identified by stereotype: the male element aggressively points its sharp triangular edge at the center element whose widespread arms imply physical and psychic receptivity—characteristics generally attributed to women. The small sphere suggests a child, possibly in embryonic form or playing ball. The ball rolls down the groove into a hole, alluding to the mechanics of procreation. *No More Play,* 1931–32 (fig. 5), derived from the African pebble game *i,* presents a fantastic necropolis. Its cratered surface suggests a volcanic or lunar landscape, with motifs that affirm the theme of death: a skeletal figure and snake lie in their graves, while another figure stands with arms raised in supplication or resurrection. The barren ground, cemetery setting, and title all denote destruction and death. As in real games, the elements in both sculptures can be moved and rearranged, providing an illusion of control. In these pessimistic metaphors of life and death, the purpose and rules of the games remain a mystery, making the motions seem futile.

Giacometti's most famous Surrealist sculpture, *The Palace at 4 A.M.,* 1932-33 (fig. 6), combines the structural approach of the cage compositions with the game-board format. He fabricated a miniature theatrical stage set for an imaginary psychodrama. Its thematic and visual sources are several, including Arnold Böcklin's *Isle of the Dead,* 1880 (Öffentliche Kunstsammlung Basel, Kunstmuseum)—a favorite image among the Surrealists—and a model stage set by Liubov Popova from 1920 (known only through a photograph).[5] Having created a delicate setting of thin supports and fragile objects, all seemingly on the verge of collapse like a house of cards, Giacometti composed the drama by placing each actor and

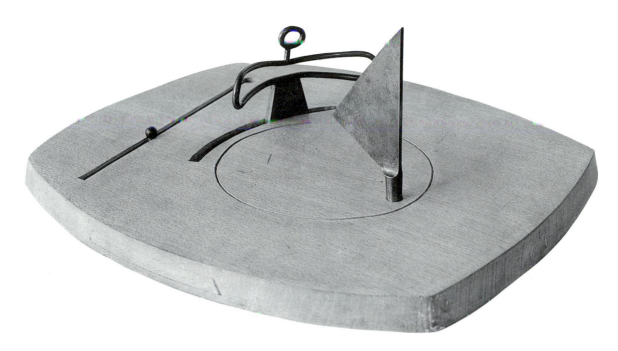

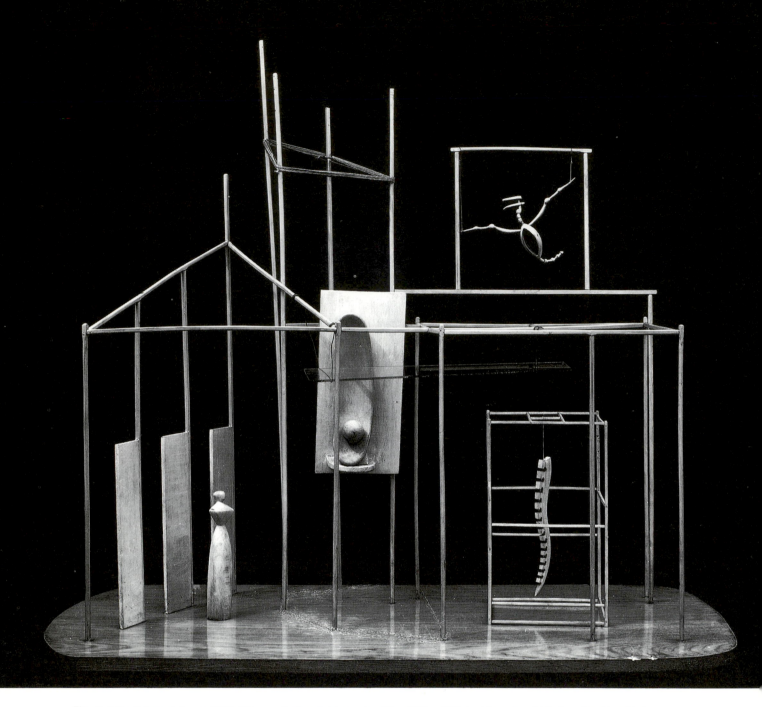

Fig. 6 *The Palace at 4 A.M.,* 1932–33, wood, glass, string, wire, 25 x 28¼ x 15¾ in. Museum of Modern Art, New York.

prop in its own space. On one side stands a woman, on the other side a vertebral column hangs in a cage; in the upper right a skeletal prehistoric bird is framed by a window, and in the center an upright pod holds a sphere.

Although the composition implies a narrative, the actors do not interrelate, either through action or shared iconography. Giacometti's various autobiographical explanations (for example, the woman represents a memory of his mother; the prototype was built out of matchsticks with a lover or, conversely, it was made after a night of impotence; the phallic stele represents him) are interesting but do not explain or increase the impact of the sculpture. *The Palace at 4 A.M.* eludes explication; it is persistently irrational, mysterious,

and evocative, with a de Chiricoesque sense of haunted architectural space. As its title indicates, it presents a fanciful world of fairy tales (a palace) and the irrational realm of dreams (four o'clock in the morning). The bird, woman, spine, and cage, the concepts of openness and closure, and the other components evoke myriad possibilities. In keeping with the spirit of Surrealism, this sculpture spurs the viewer to imaginative free association and daydreams, without limitation to any specific anecdotal, poetic, or erotic script.

The Palace at 4 A.M. pushed sculpture to its physical limits. It consists almost entirely of interior space; its skeletal forms are so insubstantial that the edifice seems unreal. Another sculpture completed in 1933, *Flower in Danger* [19], also seems to hover between being and nonexistence. Consisting of ultrathin linear forms and a fragile plaster flower, this sculpture literally trembles on the verge of destruction. As if he recognized that these sculptures of 1932–33 had reached the limits of constructive and intangible forms, Giacometti returned to more substantial and representational forms in his *Surrealist Table,* 1933 [20]. Created for the Surrealist group exhibition of 1933, this work emphasized sculpture as a tangible, ostensibly functional object, like the furniture, lamps, and decorative pieces Giacometti was designing for the interior decorator Jean-Michel Frank.

Such an extraordinary, almost contradictory, variety of forms and compositions characterized Giacometti's sculptures throughout his Surrealist years. In 1932 he created two sculptures of female nudes with completely antithetical conceptual and compositional formats. *Woman with Her Throat Cut* [18] presents a Surrealist fantasy of rape and murder. To convey this violent narrative, the horizontal composition was intended to lie directly on the floor. Using nearly abstract curved and jagged shapes, Giacometti eviscerated the female, exposing her spine and rib cage, which with her arched abdomen above define a conspicuously empty spatial center. Instead of woman as procreator, this work presents her as voided: a horrifying, yet visually fascinating skeletal corpse.

In contrast to this unprecedented treatment of the female, *Walking Woman* [17] is an idealized, refined nude, vaguely echoing the goddess image found in classical antiquity. The format is vertical and representational, with traditional solid volume and smooth sensuous forms. These two sculptures represent the extremes that would be merged and submerged in Giacometti's later works. His postwar female sculptures are figurative, with monolithic mass and formal standing poses, but they also have ravaged surfaces that do not invite closeness or touch. During his Surrealist period Giacometti explored his sexual fantasies; although he later repudiated the blatant works as "masturbation," the duality in his attitude toward women pulses beneath the surfaces of his later nudes.

In 1934 Giacometti completed the transition to monolithic mass, although still in a wide range of forms and compositions. To a certain extent *The Invisible Object* [21] made a rapprochement between the two stylistic extremes of *Woman with Her Throat Cut* and *Walking Woman. The Invisible Object* combines geometric abstraction with softer, figurative forms. The proportions and surfaces of the nude figure evolved from the slender anatomy of *Walking Woman,* but her head is highly stylized in a Cubist-derived geometry and she is confined within a rectangular frame, base, and tablet. The linear frame recalls the enclosing structures of *Three Figures Outdoors* and the cage-like constructions. As always with Giacometti, the frame establishes a separate, imaginary or metaphorical reality.

Even more than the abdominal void in *Woman with Her Throat Cut,* the compositional focus of *The Invisible Object* is an empty space defined and partially enclosed by the body's

forms (in this case, her hands). In making an invisible, thus undefinable, object the focus of the work, Giacometti created an image of metaphysical desire, of longing for what cannot be seen or understood. *The Invisible Object* anticipates his later work in several ways, including its concern with activating empty space in and around the sculpture and its philosophical angst over the nothingness of the void.

As in 1932 Giacometti again modeled completely antithetical sculptures in 1934: the representational figure, *The Invisible Object,* and the reductivist abstraction, *Cube* [23]. Actually a polyhedron, *Cube* presents an object of pure geometry without overt allusions. The artist later recalled that he returned to a more representational style after 1934 partially because he realized that his more abstract sculptures bore an uncomfortable similarity to the decorative objects designed for Frank. *Cube* may well have triggered that realization, and sometime later he returned to the plaster and incised a figurative self-portrait on the top facet, as if to negate or supercede the absolute abstraction of the sculpture.

The Invisible Object, Cube, and *Head/Skull* [22] reveal Giacometti's renewed interest in Cubism during 1934. When he returned to more monolithic mass, he reverted to the style that had originally liberated him from traditional sculptural solidity in the late 1920s. As he moved away from the more revolutionary compositions of the preceding years, the analytical method of Cubism, its definition of mass through simplified planes, and its structural stability allowed him to describe natural forms and establish their solidity yet still remain in the Surrealist realm of reverie and imagination. The use of Cubist techniques persisted in his later figurative works, particularly in several drawings and paintings of 1935–37.

The Invisible Object signaled the start of Giacometti's withdrawal from fully three-dimensional and constructed sculpture toward more frontally and pictorially conceived compositions. In the winter of 1934–35 he abruptly abandoned the narrative content and abstract vocabulary that he had devised with such remarkable variety and speed. After almost ten years away from traditional naturalistic art, Giacometti returned gropingly to a figurative style based on nature. His return to modeling heads from observed reality earned Breton's wrath, and Giacometti was expelled from the official group (although he continued his friendships with several dissident Surrealists). Giacometti's change of style and purpose occurred at the peak of international acclaim for Surrealist art. Although his works were included in many Surrealist exhibitions held in Europe and the United States, he no longer felt challenged by creating sculpture from imagination and set forth on a new path.

Period of Experimentation

During the ten years following Giacometti's break with Surrealism he struggled to redefine his art. Although he returned to figurative art based on nature, he was unwilling to espouse a merely descriptive style. In his early portraits of 1917–19 he had demonstrated his ability to capture personal likenesses, so what he sought during this period of experimentation was a new idiom that could capture a sense of visual reality without being tied to literal description. During 1935–45 he dwelt on a few narrow concerns, reworking them until he finally determined what form and direction his art should take.

At first he laboriously modeled several heads from life. His brother Diego and a

professional model named Rita Gueffier sat daily through 1938; the few heads that survive from this time reveal his return to naturalistic styles informed by realism, geometric stylization, and Rodinesque modeling. Around 1938 Giacometti started sculpting plaster figures without a model. In 1925 working without a model had led him to Cubist, abstract, and Surrealist styles; in 1938 it led him to a different extreme. His figures became smaller and smaller until by 1939 they were scarcely two inches tall. His years of experimentation continued in Geneva during 1942–45, although only a dozen or so tiny sculptures [29, 30] along with some drawings survive.

In a 1947 letter to art dealer Pierre Matisse, Giacometti described his diminutive sculptures as resulting from an inner compulsion to whittle the plasters down until a last touch of the modeling knife often caused them to disintegrate altogether. The process of working on each sculpture—translating perception and imagination into image—had become as important as the finished object. The process also involved a cathartic transformation from the violence of his earlier Surrealist imagery to a muted destructiveness toward the art object itself. These concepts became crucial to his postwar art.

The artist later explained that this small-scale work arose from a desire to grasp and convey the whole reality of his subject without succumbing to distracting descriptive details. He could only do so by viewing the figure or the head as if at a distance. Seen from afar a subject naturally appears small and indistinct, and Giacometti came to equate small size with distance.

Giacometti's experimentation with tiny sculptures in Paris in 1938–41 and in Geneva in 1942–45 undoubtedly arose from his personal artistic needs and resulted in his own perceptual observations. The development of the phenomenological theories of Edmund Husserl, Merleau-Ponty, and others during the thirties and forties, however, exerted a substantial influence on Giacometti's thoughts and art as he became increasingly fascinated with the process of seeing. In 1943–45 he met the Swiss critic Jean Starobinski, a leader of the emerging Geneva school of literary criticism based on Husserl's precept of seeking universals within particular phenomena. Phenomenological criticism examined recurrent themes or images to understand the innermost structures of individual consciousness. Such ideas may have reinforced Giacometti's own tendency toward a subjective perceptual art. Discussions with Starobinski introduced the artist to the basic concepts of phenomenology, but their impact became significant only after he returned to Paris and came into close contact with Merleau-Ponty.

As part of his quest for a sense of wholeness (understood through distance), Giacometti discovered in Geneva a useful compositional device. Virtually all the tiny heads and figures rest on solid cubic or double-cube bases. Always much larger than the head or figure would normally require for support, the bases act like *repoussoir* elements in painting. The contrast between the tiny figures and their large bases created the pictorial illusion of situating his subjects at a distance from the viewer. The relationship between figure and base also implies the vastness of the surrounding space and, by consequence, the frailty and insignificance of the human being in an immense, empty universe.

During this period Giacometti modeled one large sculpture, *Woman on a Chariot I*, c. 1942–43 [31], which predicated the type of figure that would dominate his later sculptural output: a standing female nude posed frontally with hands at the sides and feet anchored in a solid base. The features are blank, and the surfaces are enlivened with slight ridges and furrows.

From 1946 to 1952 Giacometti experienced a burst of creativity comparable in intensity and variety to that of 1926–34 but radically different in style. This sudden blossoming can be attributed to many factors connected with his return to Paris in September 1945. In his personal life he finally consummated and then terminated his nine-year relationship with Isabel Delmer. Shortly thereafter he settled into an unprecedented domesticity. In a room adjacent to the studio he began living with his young, high-spirited, adulatory mistress, Annette Arm. She left Geneva to join him in July 1946, and he married her in July 1949—dates that coincide closely with his sudden and sustained creativity. Once again Diego served as patient model and efficient studio assistant—a factor crucial to the production of plaster and bronze sculptures as well as to the many paintings of him in the studio.

In addition, the possibilities for exhibiting and publishing his work for the first time in more than ten years motivated Giacometti to a new level of productivity. After a small show in Paris in 1946 he worked feverishly in 1947 for a comprehensive exhibition at the Pierre Matisse Gallery (January–February 1948) and again with astounding speed and innovation in the next two years for shows at both Matisse's gallery (November–December 1950) and Galerie Maeght (June–July 1951). Unlike the preceding ten years of seemingly fruitless experimentation, this postwar period was characterized by the sudden birth of his signature style and wide-ranging new compositions.

Returning to Paris brought Giacometti renewed artistic and intellectual stimulation. He settled not only into the reassuringly familiar, private world of his studio but also into a milieu of tremendous excitement and activity as artists and intellectuals scattered by the war flocked to Paris. Giacometti enthusiastically returned to café nightlife, re-establishing contact with old friends and making new ones. By 1949 he seemed to know and be known by nearly every artist, writer, and critic in town, despite his solitary work habits. Among the intellectuals with whom Giacometti associated were Sartre and Merleau-Ponty, two philosophers who cofounded the periodical *Les temps modernes* and whose ideas dominated avant-garde thought in Paris.

EXISTENTIALISM. Having met in 1939, Sartre and Giacometti had become close friends before the artist left for Geneva, meeting at night in cafés for long discussions.[6] The mutual exchange of ideas occurred at a crucial time, when both artist and philosopher were formulating their mature beliefs. Sartre had defined most of the key concepts of his world view somewhat before Giacometti, both in literature, notably *Nausea* (1938), and in his philosophical treatise *Being and Nothingness* (1943). Since Giacometti was still struggling with his tiny sculptures and had not yet clarified his mature aesthetic when he met Sartre before and again after the war, the renewed friendship and discussions of that philosopher's "phenomenological ontology" undoubtedly contributed to the artist's new vision and sudden burst of creativity in 1946–52.

The concepts of Existentialism were formulated from the late 1920s through the 1940s by the German philosophers Martin Heidegger and Karl Jaspers. Influenced by the works of Søren Kierkegaard and Friedrich Nietzsche, they rejected rationalist systems of philosophy and emphasized instead the personal subjective search for being, and their treatises evinced preoccupations with dread, failure, anguish, and death. Adapting these ideas and tingeing them with Husserlian phenomenology, Sartre reformulated them into a more literary French

philosophy that emerged as the dominant mode of thought among intellectuals in Paris during the late 1940s and early 1950s. Sartre was recognized as the primary proponent, but strong affinities are found in the writings of Albert Camus, Beckett, and in various *romans noirs* and *films noirs*.

Sartre asserted that humanity is alone in the universe with no external spiritual being to offer meaning or structure to life. From one perspective this view implies a desolate void without structure or purpose and can therefore engender a primordial angst, especially anxieties about solitude and meaninglessness as well as inadequacies and despair concerning the awesome burdens inherent in accepting full responsibility for existence. From another perspective this view implies absolute freedom and self-reliance, wherein lies a humanism that can justify existence. In the famous lecture delivered in Paris in 1946, "Existentialism Is a Humanism," Sartre affirmed that people are free to create their lives by choice, consciously and unconsciously, and can therefore actively strive toward perfection. The persistent reaching for an unattainable goal provides the only purpose in an otherwise meaningless existence. As Camus concluded in his *Myth of Sisyphus* (1942), it does not matter that Sisyphus is condemned to push his stone forever uphill without reaching the top; it matters only that he persists, and "the struggle itself toward the heights is enough to fill a man's heart."

Giacometti did not evolve his postwar figurative art with the deliberate intention of creating an Existentialist art; his motivations were personal, instinctive, and aesthetic. Nonetheless Existentialist interpretations of Giacometti's art, although somewhat facile, are substantiated by the artworks themselves, especially those from 1946–52. A number of sculptures and paintings depict figures whose frail proportions and solitary stance within a large, often desolate space connote the essential isolation of the individual. In addition to such iconographic connections with Existentialism, Giacometti's art involved a profound philosophical investigation of the nature of the self. For Sartre and Giacometti, being is neither defined nor fully revealed by its apparent manifestations; it transcends description, although it is not separate from its phenomena, and so human consciousness remains always in flux.

An Existentialist bias also reverberates through Giacometti's commentaries about his art. In particular, he validated his mature art by describing his endless struggle to attain a goal that he could never quite reach, saying the quest alone justified his existence and his art. Greatly esteemed by Sartre and other writers and artists, this Sisyphean heroism was so compelling that many critics and admirers could appreciate Giacometti's work only through this rationale.

Although Giacometti never labeled himself as Existentialist, he did not deny that philosophical interpretation of his art until many years later. Indeed, Sartre's two widely influential essays on his art (published in French and English in 1948 and 1954–55) contributed to Giacometti's commercial and critical success. The two remained friends, although Giacometti quarreled with the writer over a trivial incident in 1962. Unfortunately, the thoroughness and ease with which his art was subsumed into the postwar vogue of Existentialist angst proved detrimental and later triggered a reaction by formalist critics who tended to ignore such connotations as unimportant or even embarrassingly emotional. Giacometti's canonization as an "Existentialist saint" falsely cast his tremendously varied output in an overly simplistic framework.[7] By tempting the viewer to see only the ideas in his art, the Existentialist interpretation risks rendering his sculptures and paintings as merely philosophical means to an end, thereby diminishing the visual excitement and subtleties of his

style and execution—the virtuosic lines in the paintings and drawings and energized space, powerful form, and rich play of light and shadow in the sculptures.

PHENOMENOLOGY. Partly because Giacometti had been introduced to Husserlian phenomenology during his stay in Geneva, he was receptive to the systematic theories of Merleau-Ponty, which offered rich possibilities for his searching intellect and undoubtedly spurred the formulation of his mature art. In *The Phenomenology of Perception* (1945), Merleau-Ponty thoroughly discussed perceptual matters on sensory and philosophical levels. Like Husserl, he examined the philosophical relationship between consciousness and the world and rejected the philosophical extremes of empiricism and subjectivism as artificial and limiting constructs. Merleau-Ponty postulated a philosophy of ambiguity in which reality can be described and intuited yet remains essentially enigmatic.

Merleau-Ponty's book offered pragmatic possibilities for artists. He examined specific optical phenomena in detail (including form, size, color, and two- and three-dimensional space), and he explained that phenomenal relations are relative and subjective. Space becomes an ambiguous realm in which form, depth, and size are defined by the individual viewer. Vision itself is not an objective tabulation of absolute facts but the combined experience of what can be seen and comprehended. Vision is thus sensory data synthesized by immediate, unconscious thought. Merleau-Ponty related certain phenomenal functions specifically to art, noting that in painting the gaze of the artist/viewer is the essential, active, almost primordial force needed to render lines on a two-dimensional surface into comprehensible three-dimensional shapes.[8]

These ideas are echoed in Giacometti's aesthetics. Merleau-Ponty's theories may have influenced Giacometti at first to explore figures and objects within a spatial context and subsequently in the mid-1950s to work toward a phenomenological realism based on the process of seeing and intuiting his subjects. In later years he referred to the impossibility of ever capturing in his art what he actually saw, partly because it continually changed. As Giacometti described in 1964:

You never copy the glass on the table; you copy the residue of a vision . . . Each time I look at the glass, it has an air of *re-making* itself . . . it really always is between being and not being.[9]

As with Existentialism, however, his art was not limited to any theoretical schema and cannot be considered wholly phenomenological, despite some of the artist's statements late in life. His mature works have a personal expressive power far beyond such theories.

Possibly stimulated by his exposure to theoretical phenomenology, Giacometti seems to have undergone a perceptual shock experience or a series of them during the mid-1940s. In later years he often referred to a profound change in the way he saw the people and things around him, although dates and details differ. In one account recalled in 1957, the artist described his experience in a Montparnasse movie theater in late 1945, when he suddenly noticed a discontinuity between normal (photographic) vision and the way he saw the world:

Until then . . . there was no distinction between my vision of the external world and that which passed on the movie screen. One was continuous with the other. Until the day when a genuine schism occurred: instead of seeing a person on the screen, I saw vague black *taches*

[blurs] that moved. I looked at the people around me and all of a sudden I saw them as I had never seen them. . . . Everything was different: depth, objects, colors, silence . . . and completely new . . . a sort of continual marvelling at everything. . . . That day reality became completely revalued for me; it became the unknown, but a marvelous unknown.[10]

Thus his visual understanding of reality underwent a total transformation, complete with phenomenological distortions, which he tried to convey in his art. The almost hallucinatory intensity of many postwar works supports this idea of an extraordinary alteration in perception. He perceived the familiar world as alien—figures as being extremely thin, forms as having a vertical pull and/or diminishing in the surrounding space, and space itself as receding in a disturbing manner that oppresses and unsettles forms. This difference in how Giacometti saw from 1946 on is essential to understanding not only his art but also his later comments on his art. When he spoke of copying nature or describing reality, he did not mean that he sought traditional resemblance or photographic realism; rather he hoped to capture that subjective and startling personal vision.

SURREALIST ECHOES. Another contributory factor to Giacometti's burst of creativity after returning to Paris was renewed contact with Surrealist art and ideas. Working in the physical environment of his tiny studio, he was at first surrounded by his earlier sculptures (fig. 7). Despite his repudiation of the official Surrealist group around Breton, Giacometti continued to socialize with many former adherents, including his close friend Leiris, and Georges and Diane Bataille, Ernst, and Marie-Laure de Noailles; even his doctor Théodore Fraenkel had been part of the Surrealist circle. The official Surrealist group reasserted its presence in Paris (albeit briefly) with a group show at Galerie Maeght in 1946. When Giacometti decided to show his new works in 1946, he exhibited at Galerie Pierre, where the former Surrealist art dealer Loeb still showed his primitive art collection [see 57]. The extent to which the Surrealist ethos remained in Giacometti's consciousness at this time can be judged by his essay "Le rêve, le Sphinx, et la mort de T." Published in 1946, this autobiographical essay is permeated by a Surrealist aura of nightmare and death.

Many of Giacometti's artworks from 1946–52 reverberate with a disturbing intensity that corresponds with the intent, if not the forms, of Surrealism. Several sculptures have an aggressive quality reminiscent of violent Surrealist themes. *The Nose,* 1947 [34], for example, evokes the threatening concept of *Point to Eye,* 1932 (see fig. 16). The evocative quality of the *Hand,* 1947 [35], recalls the focal motif of the earlier sculpture *The Invisible Object,* while its implied violence and anguish exceeds that of his *Caught Hand,* 1932 (Alberto Giacometti Foundation). Giacometti's mature drawing style, particularly as expressed in the strongly gestural pencil compositions of 1946–52 [56, 69], contains an element of Surrealist automatism. Many of the postwar works, such as the 1946 drawing of his mother [32], seem to echo the feeling expressed in his Surrealist prose poem, "Le rideau brun" (1933): "No human face is as strange to me as a countenance, which, the more one looks at it, the more it closes itself off and escapes by the steps of unknown stairways."

During Giacometti's Surrealist phase he had sought to convey mystery and a sense of the unknown through startling iconography. In his postwar works he tried to achieve a similar goal with mundane subjects, such as a face, figure, or studio interior. He still intimated that what was ordinary carried within it the potential for the mysterious. In his methods, although he emphasized working from visual reality, he also continued to value the impor-

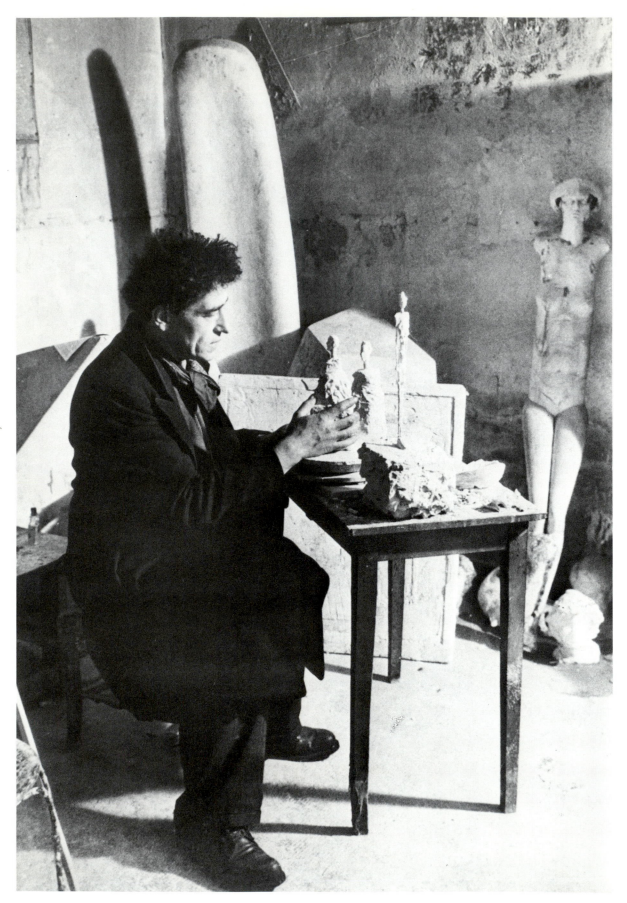

Fig. 7 Giacometti in his Paris studio, c. 1946. Photograph by Emile Savitry. Stiftung für die Photographie, Kunsthaus Zurich.

tance of memory and imagination as he had from 1925 through 1934. A number of sculptures from 1946–52, including *The Chariot* [48] and *Four Figures on a Pedestal* [51] of 1950, were based on imaginative interpretations of private memories. Thus his mature art did not necessarily break with general Surrealist intentions, only with their bizarre iconography.

Giacometti's postwar figurative art embodies an emotional expressionism beyond its general Surrealist antecedents. In 1951 he acknowledged that the tension and elongation of his figures and heads in space reflected a palpable violence that he perceived in reality and expressed in art.

[E]ven in the most insignificant head . . . if I start to want to draw, or paint, or preferably sculpt this head, it all gets transformed into a taut stretched form, always, it seems to me, of an extreme repressed violence, as if the form always goes beyond what the person is. . . . [I]t is above all a kind of core of violence.[11]

This violence he understood as inherent or implicit in existence—the force that allows life to persevere without being crushed. This fierce element is particularly strong in the two anatomical fragments of 1947: *Hand,* with its bony fingers outstretched as if beseeching, and *Head of a Man on a Rod* [36], with its hollow eye sockets and mouth gaping in a silent scream. *Dog,* 1951 [59], with its gaunt body and low-slung head and tail, has an expressionist presence far beyond animal genre.

Whatever the contributing causes may have been, within six years of his return to Paris, Giacometti had defined his mature style, creating many of his most memorable and varied compositions. Furthermore, the creations of this period have a visionary, sometimes almost hallucinatory quality, distinct from his later output.

Devoting his efforts with equal intensity to sculpture, painting, and drawing, he believed that the active interrelationship among the different media was essential to the fullest development of his art. Although in his youth he had worked in all three media, drawing and painting had become secondary from the mid-1920s until 1946. On a practical level the three media entailed different approaches for him after the war. For painting Giacometti used a model in repeated sittings over days, weeks, or even months. For sculpture he was more flexible, usually making busts from a model and nudes from memory. Even when he began a sculpture from a model, Giacometti often continued on it alone, sometimes leaving it for weeks or longer before returning to modify it. Occasionally, when he felt stymied in painting, he used his brushes on the plasters or bronzes around him. Drawing provided a relaxing third approach because it could be done quickly anywhere, without the anxieties he experienced with painting and sculpture. In fact, he credited drawing as the means toward his mature style. Perhaps most important, the alternation between laborious and spontaneous execution, between working from a model and from memory, kept a dialogue active between the two poles of his inspiration: phenomenological and imaginative vision.

Stylistically, this cross-fertilization led to his sculpture being pictorial in conception, that is, frontal, intended to be seen from a predetermined distance, often with lines incised into the surface. In general, the nervous energy of his painting and drawing sustained his work in the more intractable materials of sculpture, and the tactile forms of sculpture eventually lent a degree of solidity to the heads in his late paintings.

In 1946 after modeling several busts, Giacometti completed a sculpture that was a breakthrough for him—a thin walking woman on a long rectangular base, entitled *Night*. (Before it deteriorated, it was documented in the center of a photograph, fig. 8.) Unlike the tiny figurines of 1938–45, this woman is in motion. She provided the impetus for several subsequent works, including the first versions of Walking Man [40, 41, 42] and *Woman Walking between Two Houses,* 1950 [50]. From 1946 through 1952 Giacometti rapidly produced a number of figure and bust sculptures modeled in sizes ranging from tiny to life-size. Looking like materialized drawings in space, many are linear in overall form, scarcely wider than the metal rod armatures to which the plaster was applied. Literally skeletal, they have almost no plaster flesh on their metal bones and only rudimentary anatomical features, as in *Man Pointing,* 1947 [37], *Walking Man,* 1948 [40], *City Square II,* 1948 [41], *Three Men Walking II,* 1948–49 [42], *Tall Figure,* 1949 [43], *The Glade,* 1950 [49], and *Four Figures on a Pedestal.*

The peculiarly spectral quality of the ultrathin sculptures of 1946–52 recalls the abstract skeletal figures in several of his early Surrealist sculptures. *Man* and *Three Figures Outdoors* and even the curious flower stalk in *Flower in Danger* consist of linear figure-like forms rather than solid masses. In late 1947 Giacometti wrote about his recent thin figures: "I saw anew the bodies that attracted me in reality and the abstract forms which seemed to me true in sculpture; but, to put it briefly, I wanted to make the one without losing the other."[12] The need for quasi-abstract shapes recurs in later figures, such as the various Women of Venice, 1956, with rectangular torsos [82, 83].

The superthin figures were Giacometti's dominant but not exclusive sculptural style during the postwar years. Some busts and figures have greater physical substance, such as *Tall Figure,* 1947 [38]. Even when not extremely thin, the sculptures' elongated proportions create a strong vertical pull, evident in many sculptures from 1946 through 1952, including lost plasters photographed in his studio in 1946 (see fig. 8). This pronounced verticality characterized many later sculptures, even after he shifted to a more realistic style during the mid-1950s [70, 84]. This elongation of bodies and especially heads is also found in numerous paintings and drawings of the postwar period, such as *Tall Figure,* 1947 [39], *Standing Man,* c. 1949 [44], and *Standing Nude,* 1950 [56].

Although larger than the plasters of 1938–45, the postwar sculptures continued to reflect the artist's phenomenological interests in conveying a sense of the whole and establishing the figures within a definable space. "I felt I needed to realize the whole, a structure, a sharpness . . . a kind of skeleton in space."[13] Consequently, many figures are rooted to substantial bases in a variety of formats. In small and medium-sized sculptures, such as *City Square II* and *Three Men Walking II,* he continued to use relatively large bases to create the illusion of perceiving the figures at a distance. For the large standing figures using a disproportionately large base was not feasible, so he started tilting some bases forward—a practice he continued sporadically for years. In some tall figures he altered the anatomical proportions, making the feet larger and head smaller, so that as the viewer's eye travels up the sculpture the figure seems to recede in space [43, 82, 83].

During the years 1946–52 many of Giacometti's figures accentuate the space they occupy. Paradoxically, the more compressed his filiform figures became, the more they energized and dominated the space around them. A single skeletal figure or anatomical

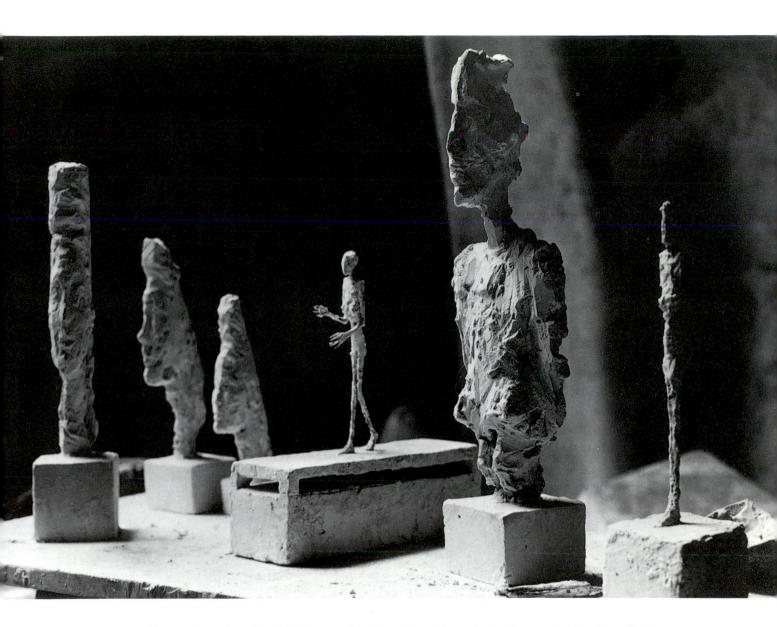

Fig. 8 Plasters in Giacometti's Paris studio, 1946. Photograph by Marc Vaux. Stiftung für die Photographie, Kunsthaus Zurich.

fragment could electrify the surrounding space, as in *Hand, Head of a Man on a Rod,* and *Chariot.* Drawing upon his experiments with spatial compositions in the sculptures of 1927–34, Giacometti explored the possibilities of involving the spatial environment to create an active sense of the void surrounding the figures. In his three essays published in *Labyrinthe* (1945–46), especially the article on Jacques Callot, Giacometti referred repeatedly to the powerful presence of the void, revealing his preoccupation at that time with perceptions of empty space. In Existentialist circles in Paris the concept of the abyss (*le gouffre*) was a recurrent theme. This fascination with space animated many of Giacometti's postwar works but diminished after 1952 in the sculptures and drawings.

In the multifigure compositions and those with significant bases, such as *City Square II, Three Men Walking II,* and *Woman Walking between Two Houses,* the spatial environment is the specifically urban context inspired by the streets of Paris. These small, skeletal figures isolated within vast city spaces express modern psychological and emotional responses to

urban life and interpersonal relations, disclosing a pronounced alienation. In addition to creating a sense of uneasiness and separation, the substantial bases of these sculptures paradoxically anchor the fragile, diminutive creatures to a reassuringly solid ground.

Giacometti's postwar sculptures have roughly modeled surfaces that descend from the late nineteenth-century Romantic aesthetic of the sketch—works not overly finished but capturing the spontaneity and personal touch of the artist during the creative process. Extensively developed by Rodin and other early modern sculptors, such active surfaces lend a vitality to the sculptures. Their variegated rhythms and the changing play of light and shade caused by the blobs and recesses of bronze suggest fleeting impressions and give the figures expressive power.

For Giacometti such modeling also served a phenomenological purpose. Because in the larger postwar sculptures he could not rely on the proportional contrast of an oversize base, Giacometti used irregularly finished surfaces to keep the sculpted figure conceptually distant. Bronzes such as *Tall Figure* [38] are perceived as figures at a distance, but when viewed too closely the corrugated surfaces dissolve or disintegrate into illegible smudges, not unlike the paint strokes in Impressionist and Pointillist paintings. Beyond this phenomenological function, Giacometti's sculptural execution contributes to the disturbing expressionist effect of the figures. The patches, ridges, and furrows of plaster and bronze obscure individual faces, obliterate familiar details, and suggest the craters and scars of ravaged flesh.

The obvious emaciation and anonymity of the postwar sculptures invited comparisons with the devastation of the recent war. When the sculptures were exhibited in New York in 1948, they elicited descriptions such as "the fleshless martyrs of Buchenwald" and "fugitives from Dachau."[14] Even when the associations were not specifically to wartime suffering, viewers understood them as metaphors for *la condition humaine*—images that transcend historical events and transitory emotional states to address or express fundamental aspects of human existence. In the words of one reviewer, his figures "are inevitably fragile and lonely looking; they seem to represent all that is joyless in the human lot. Stretched to the breaking point, they dominate more space than they fill, and this is their sole dignity."[15]

The Existentialist themes of alienation and angst and even the ontological tension between passive being and active existence were recognized: "in the tall, mysterious, emaciated, knotty forms . . . a sort of desperate struggle for survival seems to be going on."[16] Giacometti's use of massive bases to make some figures appear distant connotes their fraility within a vast void. The rough surface modeling renders the figures conceptually unapproachable and unknowable. The immobility of some figures implies the isolation of the individual within its own impenetrable space and consciousness. The walking figures who stride purposefully but without ever arriving at their destination echo the sentiments of Beckett's *Waiting for Godot* (1946-47, performed 1953) and Camus's *Myth of Sisyphus*. Multifigure sculptures such as *City Square II* and *Three Men Walking II* particularly emphasize those impressions: the figures approach and pass near one another unaware or unable to communicate.

While Giacometti's postwar works were not created either as deliberate images of humanity brutalized by the sociopolitical events of the era or as images of Existentialist angst, neither can they be entirely dissociated from their context. After the war many artists, especially in Europe, tended toward expressionist styles and pessimistic images that contrast

with the crisp geometric abstraction that had dominated the 1910–20s. While many artists embraced painterly abstractions—those of the CoBrA group, Tachistes, and L'Art Informel, for example—a significant number worked in figurative modes. Artists such as Francis Bacon, Graham Sutherland, Antonio Saura, Germaine Richier, and many others worked in styles that were both self-expressive and symbolic of the human condition. Their desolate visions stressed the helpless, solitary, destructive, and fragile qualities of human beings and their existence. By the late 1950s this tendency was so widespread that works by twenty-three artists were readily assembled in 1959 for *New Images of Man,* an exhibition at the Museum of Modern Art in New York.

Around 1952–54 Giacometti's art underwent subtle changes. The compositions became more narrowly concentrated, and their hallucinatory intensity moderated. In contrast to the sudden proliferation of novel and varied works in 1946–52, he produced few radically innovative compositions for the remainder of his career, preferring instead to work out the themes he had introduced earlier. He concentrated on the figures themselves, without the urban settings or overt spatial tensions of the compositions from 1946–52. He avoided the multifigure compositions of his postwar sculptures and even shied away from active poses, with their dramatic and narrative implications. Other than the Chase Manhattan Bank commission of 1959–60 [see 92, 93, 94], Giacometti modeled very few multifigure compositions or walking men from 1951 until his death. Instead he focused his efforts on two basic compositional formats: half-length portrait busts and standing nudes. Throughout the 1950s his primary models were Diego and Annette.

Along with this narrowing of compositional formats came discreet changes in style. During the 1950s in all media Giacometti often aimed at a greater naturalism, with fuller forms and recognizable details, such as facial features, hair, clothing. The expressionism inherent in the skeletal anatomies and spatial tensions of the works from 1946–52 were subsumed into the physical execution of each object, rather than expressed overtly in the overall composition. Increasingly the works after 1952 or so compel our interest primarily by subtle variations of forms and surfaces.

These changes may reflect the diminishing impact of the various sources of stimulation that had motivated the artist's remarkable productivity in the postwar years. Annette had become as much a fixture of his life as Diego, the brief resurgence of Surrealism in Paris had faded, and Existentialist and phenomenological ideas had become thoroughly integrated into his awareness. Assured of continued exhibitions and income, with both Maeght and Matisse as his regular dealers, Giacometti settled into a steady routine.

Because the sculptures of 1946–52 had emerged quickly, with little premeditation or revision, they have a potency and sense of urgency. The subsequent nudes and busts were often produced over longer periods of time and much reworked. The constancy of subjects and poses allowed Giacometti to expend his energy on their execution. Although still gaunt, the sculptures of the 1950s are rarely skeletal. Working with more physical substance, Giacometti explored the tangible nature of sculpture and developed more expressively modeled surfaces. His hands traveled restlessly up and down the forms—feeling, kneading, manipulating the material (fig. 9), especially the malleable clay used for the portrait busts. Besides his bare hands, he used a modeling knife and spatula to bite into the surfaces where he wanted to focus intensity, usually in the face and especially the eyes.

In some sculptures from the mid-1950s, the vertical tension characteristic of the earlier

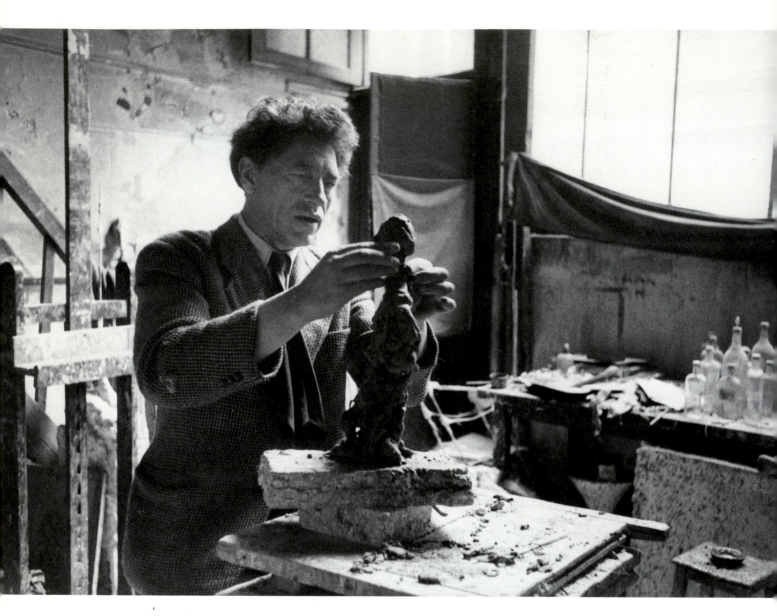

Fig. 9 Giacometti modeling a sculpture in his Paris studio, 1954. Photograph by Sabine Weiss.

postwar works can be discerned. *Large Head of Diego*, 1954 [70], appears almost knife-like, especially when seen straight on, although the upward pull in the head is balanced by the weightier mass of the shoulders. In profile, the head has considerable breadth, but the vertical tension is still evident through the surface modeling of the features and hair. This upward elongation tends to emphasize the expressive rather than the naturalistic import of this and other sculptures. The shift toward less attenuated, more substantial forms can be seen by comparing *Small Bust on a Column*, c. 1952 [64], with *Bust of Diego*, 1954 [71].

Some of the many busts of Diego from the mid-1950s have a more descriptive naturalism than that of the postwar figure sculptures. The 1954 *Bust of Diego*, which was modeled from life, has a naturalistic face and lifelike gaze, but this realism is countered and intensified by the more expressive surface modeling. The artist's finger streaks down the front of the sweater assert the physicality of the material and primacy of the modeling process over resemblance. The tiny lines incised across the eyes intensify the gaze rather than simply describe the physical shape. In Giacometti's words:

The strange thing is, when you represent the eye precisely, you risk destroying exactly what you are after, namely the gaze. . . . In none of my sculptures since the war have I represented the eye precisely. I indicate the position of the eye. And I very often use a vertical line in place of the pupil.[17]

The direct gaze was essential to Giacometti's figural works in all media because he felt that only it could convey the vitality and reality of his sitters.

The surfaces of this and many other sculptures are sharply incised. Giacometti had experimented with knife cuts in the 1927 heads of his mother and father and in the self-portrait cut into a facet of *Cube,* but only in the 1950s did he employ the technique insistently. The linear incisions function as a means of giving realistic focus to the eyes and face and as an expressionistic stylistic device. In a few busts, such as *Large Head of Diego,* the knife cuts in the face and through the eyes almost amount to mutilation. The idea of attacking or slicing the eye was a recurrent image in Surrealism, particularly the famous sequence in Luis Buñuel's film *Un chien andalou* (1928) or in Giacometti's *Point to Eye.*

The many standing nude sculptures from the 1950s and early 1960s cover a wide range, from several inches to more than nine feet in height and from pencil thin to more naturalistic figures with solid hips and breasts. Those with more realistic anatomies often tend to be less compelling than those that retain an overall stylization. Giacometti usually modeled the nudes, unlike the busts, from memory, so few can be described as truly naturalistic.

The most remarkable female figures of the 1950s were the series of women created for exhibition in the Venice Biennale and in Giacometti's retrospective at Bern in 1956. After the first figure, which has heavier body forms, most of the rest, including *II* [82] and *VI* [83], have flattened anatomies subsumed into a rectangular shape that retains a degree of abstraction within the representation. Balancing the stable torso are thin legs and tiny heads, which stretch upward as if about to disappear. The delicately modulated forms together with the flickering energy of the surface modeling give these figures a mysterious and ethereal rather than a naturalistic quality.

Giacometti's obsession with the female nude extends through his entire career and all media. In the sculptures of 1927–34 he had emphasized the biological nature of the female, at times with violent overtones. After the mid-1930s this element of overt sexuality disappeared, but the pose and execution of the later nudes reflect the artist's need to define and thereby master a female persona. All his sculptures of women after 1950 present an immobile and catatonically remote figure, a ritualistic totem like the 1926–27 *Spoon Woman,* although now in a representational mode with hands rigidly at the sides and feet anchored solidly. As passive objects of voyeuristic scrutiny, they submit to the artist's, and thus the viewer's, dominance. The aggressively striding men who approach them, as in *City Square II,* 1948, and the project for the Chase Manhattan Bank Plaza in 1960, are perpetually doomed to frustration because the women remain eternally unresponsive.

From another perspective these female figures also serve as archetypes of indestructible human nature. Despite the struggles that have ravaged their flesh, these women are immutable; their irreducible core has survived. Throughout his life, but especially from the late 1930s through the early 1960s, Giacometti made pencil and ink studies of many works of art, seeking to grasp what made them great. Among sculptures he favored ancient and primitive figures, including Cycladic fertility goddesses, Oceanic carvings, and especially Egyptian statues with their standing and walking poses and large staring eyes. Like these hieratic sources, Giacometti's figures have a mythic grandeur that is eternal.

After twenty years of devoting his efforts primarily to sculpture, Giacometti resumed painting in Paris in 1946 as part of his postwar burst of creativity. As a starting point he made many pencil sketches to regain familiarity with two-dimensional composition. He also drew upon the style hesitatingly formulated in various canvases executed in Switzerland during the 1930s. In three portraits done in 1932–34, he had experimented with realism and a Cubist-influenced stylization, but the breakthrough came in three paintings of 1937: *The Artist's Mother* [26] and two still lifes [27, 28].

In the two larger canvases the extensively reworked surfaces with scraped and over-painted areas attest to Giacometti's struggle as he tried to reconcile depth and surface, mass and line, representation and formal pictorial composition. Giacometti here appeared to hesitate between areas of sketchy, loose brushwork and an incisive use of thin lines, especially black lines. In the still lifes such lines establish a geometric spatial framework in the forms of the table, apple, and background wainscoting; this space functions both two-dimensionally and in shallow depth. In the portrait of his mother the face is built up of tiny white, gray, pink, and black lines, which provide physicality to the flesh without precisely delineating her features.

As with his sculptures, the paintings of the postwar period display a tremendous versatility in composition and execution. In 1946–52 he experimented with several multifigure compositions, a few set in urban contexts like the skeletal sculptures, but he quickly settled on a generic format—a single figure in an interior, usually seated in the studio. Around 1950 he also began painting and drawing a number of still lifes, studio interiors, and landscapes.

The postwar canvases reveal various treatments of the figure's pose and relationship to the surrounding environment. Often the entire figure is included, at times depicted close up, as in *Seated Man,* 1949 [46], while in other compositions it is situated within a larger three-dimensional space, as in *Diego Seated in the Studio,* 1949–50 [47]. In several canvases painted on visits to Stampa in 1947–50, Giacometti placed the figure within a remarkably detailed interior, as in *Seated Woman,* 1949 [45], and *The Artist's Mother,* 1950 [52].

In these last-named compositions the figure occupies a powerfully affective environment in which traditional pictorial space has been distorted. In these and other paintings from 1946–54 the relationship between the impassive figure and its immediate surroundings assumes an importance not found in his later work. Like the sculptures of those years, many of Giacometti's paintings explore the phenomenological distortions and psychological tensions between the figures and space. Such tensions are perhaps even more evident in the paintings, where the possibilities for illusion are greater.

The construction of space in painting generally reflects the artist's conception of the individual's relationship to the world. In the history of Western art each age has had its own systems for depicting space. Renaissance rules of perspective allowed artists to create illusions of three-dimensional space on two-dimensional surfaces; such realism corresponded with the cultural shift away from the medieval religious view to humanism and materialism. When artists—from Impressionists in the 1870s through Cubists and abstractionists in the 1910s—altered and finally rejected Renaissance space, they reflected a modern, less-positivist orientation to the world. When Giacometti recanted the formalist emphasis on two-di-

mensional painting, he adapted the spatial language (although not the styles) of early expressionists, such as Vincent van Gogh, to convey a subjective and disturbing vision.

Giacometti used traditional perspective techniques to construct a recognizable spatial ambiance. In *Seated Woman* and *The Artist's Mother* the many parallel lines (orthogonals) that describe the walls and furnishings recede diagonally, appearing to approach one another in the background. Giacometti violated the customary rules of perspective by making the orthogonals recede too quickly along acute diagonal paths and by tilting up the floor at an exaggerated incline. Because the space seems to rush away into the background, the figure, especially the head, seems to shrink and move backward under the stresses of the spatial warp. The insistent spatial recession and extreme proportional contrasts imply not only the artist's subjective vision but also a disturbing psychological or emotional imbalance. The artist's, hence the viewer's, experience of the world is unstable, discontinuous, even neurotic. Instead of an integration of figures with their ambiance, there is tension and dissociation, with the unequal body proportions and perspective combining to create a disturbing, almost nightmarish atmosphere.

Distorted spatial effects suffuse many of his paintings during 1946–54, from the complex interiors at Stampa to more subtle applications. In *Standing Nude*, 1951 [60], and *The Street*, 1952 [66], the orthogonals recede strongly to one side, creating a spatial pull that is doubly disturbing for being asymmetrical. In other scenes with few orthogonals, such as *Diego Seated in the Studio*, the floor is tilted up at so extreme an angle that the chair and background cot seem ready to slide away. Even when the figure is depicted half-length or close up with minimal surroundings, Giacometti exaggerated the anatomical proportions, elongating the body vertically to suggest the retreat of forms in space. Usually the heads shrink to a small narrow oval, while the somewhat nearer torso or legs seem to loom larger and almost impinge into the viewer's space, as in *Seated Man* and even in the more naturalistic paintings *Diego in a Red Plaid Shirt* [72] and *Annette* [73] from 1954.

In many of Giacometti's figure paintings the perspectival focus is the center of the figure's head, usually the eyes, which stare straight out at the viewer. Even when the orthogonals continue farther into the background, the head draws the viewer's eye back, creating a powerful struggle between the spatial setting and human subject. This obsessive emphasis on the subject's gaze developed most strongly at an early date in Giacometti's paintings and subsequently came to dominate his portrait drawings and sculptures as well.

Giacometti's anatomical exaggeration of a tiny head on a larger torso reflects a common phenomenological experience. Sometimes when an object, a head, for example, is stared at intensely, it can seem to recede and shrink. A blink of the eyes or shake of the head immediately dispels this perceptual illusion, but Giacometti cultivated such distortions. The psychological effect far exceeds mere phenomenological illusions, however. The figure's head seems to move away from the viewer, implying inaccessibility. Again and again in Giacometti's paintings and drawings there is an impression of unbridgeable alienation both between the figure and its environment and between that image and the viewer.

Giacometti's fascination with distorted space partially accounts for the frames he painted or drew around nearly all his images. He had begun this practice as early as 1917–18, but after 1946 it became almost standard. Recalling the Renaissance definition of a painting as a window on the world, this framing device opens up and encloses an imaginary three-dimensional reality. By isolating the figure in a remote and uncertain environment, Gia-

cometti marks off the figure's space as distinct from our reality. When asked why he used these framing outlines, he replied:

Because I do not determine the true space of the figure until after it is finished. And with the vague intention of reducing the canvas. I try to fictionalize my painting. . . . And also because my figures need a sort of no man's land.[18]

More than any other pictorial component, line defines and dominates Giacometti's postwar style. Spatial environment, descriptive form, color, movement, and texture exist within his lines or as deliberate foils to them. Within a few short years he developed a linear style of breathtaking variety and virtuosity.

Influenced in part by the many drawings he did during the 1940s, he used a thin brush like a pencil to draw lines repeatedly over, inside, and around the forms, defining without actually describing them, creating and simultaneously annihilating solid mass on the surface of the flat canvas. These lines function paradoxically as illusionistic descriptive elements and as autonomous fluid strokes on the surface of the canvas. The use of multiple vibrating contours that do not harden into firmly defined forms owes a strong debt to the late works of Cézanne, but Giacometti pushed the technique to a more expressionist end. The multiplicity of lines creates a sensation of speed, urgency, and instability. They function as the eye does in the act of perception, moving rapidly from part to part to construct a whole. The many lines keep the viewer's eye moving, bringing it inevitably back to a central focal point—usually the eyes—only to stir again and return once more. A Giacometti painting, like one of his drawings, functions not as a static statement of being but as a perpetually renewed action. The lines further act as inhibitors between viewer and subject, swirling around the forms they define as if perpetually in the process of becoming. The quickly drawn lines, hallucinatory rush of space, and ghostly quality of the figures with their fixed, but unseeing stares present a frightening vision. Giacometti's postwar works express identifiable fears and vague apprehensions, which are perhaps more disturbing for their lack of clarity, as if existence were unbearably oppressive.

With the exception of a few figure compositions executed in a dry-brush style, including several probably painted from sculptures or imagination [39, 44], Giacometti's canvases reveal a greatly varied use of line. In *Seated Woman* and *The Artist's Mother* lines define the forms, establish three-dimensional space, and emphasize the physical surface of the canvas. Such complex, detailed linearity is unusual, however, as Giacometti preferred to use incisive lines within a more painterly context. In some paintings, such as those of plaster sculptures in the studio [54, 61], he defines forms with only a few summary strokes. In others the lines are dense and painted in fluid strokes with a heavily loaded brush, as in *Seated Man* and *Still Life in the Studio,* 1950 [55]. Occasionally, the paint would flow and drip, causing an expressive texture that the artist would pursue in his late canvases. Many of his landscapes, such as *View from the Studio Window,* 1950 [53], and *Landscape at Stampa,* 1952 [67], have a particularly vigorous or elegant linearity. In these and other paintings the use of line to define forms in space is incisive, energetic, occasionally spare but more often cumulative, nervous, at times even neurotic, but always triumphant.

A number of the paintings from 1946–54 display vestiges of the sophisticated color sense he acquired in his youth, albeit now subsumed into a neutral tonality. In *Diego Seated in the Studio, Seated Woman, The Artist's Mother, The Street, Diego in a Red Plaid Shirt,* and

various landscapes [53, 67, 88], Giacometti tinged the dominant lines of black, white, and gray with pinkish and mustard-yellow areas and red, green, and blue accents.

Like the sculptures, the paintings became increasingly restricted in subject, pose, and execution around 1954. Giacometti modified his style toward greater naturalism but also toward an expressionism attained through painterly execution rather than overall composition. Although the seated figures remain within the context of an interior, the surrounding setting and artworks occupy less area and attention, with fewer orthogonals and details in the composition as Giacometti focused more on the head and gaze. After paintings such as *Annette, Diego in a Red Plaid Shirt,* and *Peter Watson* [74] in 1954, the postwar style of almost hallucinatory linearity and overt phenomenological distortions of space and anatomy moderated, although the unusually small heads recur in some canvases through the early 1960s. After about 1952–54 both line and color tended to be obscured by a vague gray atmosphere.

By the early 1950s Giacometti's methods of painting portraits had become invariable and almost neurotically exacting. To keep his eye at the same distance from his subject's face for every sitting, he arranged his easel and the model's chair at a precise distance (about 4½ feet) according to marks he had painted on the studio floor (visible in fig. 10). The sitter had to pose immobile and gaze directly at the artist. In a dialectical process between space and line/volume, Giacometti used long thin brushes with fine sable tips to define forms, especially the head, with black, white, and gray lines; a broader brush to smudge the precise strokes into a more atmospheric grayish space; then thin lines again to bring back the forms from the empty void.[19] Sometimes, especially after the mid-1950s, this process of working and reworking would create a thick surface that he would scrape down with a palette knife or dilute with turpentine, which occasionally made the surface shiny.

Because Giacometti often hesitated and agonized for weeks and months over each portrait, the assured and exuberant strokes that characterized the earlier paintings increasingly succumbed to a miasma of gray space. This process had begun earlier, but it became overwhelming in the fall of 1956, when he experienced an artistic crisis while painting the first portrait of Isaku Yanaihara, a visiting Japanese professor of philosophy [see 86]. The crisis took the form of an inability to capture Yanaihara's visage on canvas, which intensified Giacometti's already chronic anxieties. Rather than precipitating a radical stylistic change (as he later claimed), this experience resulted in the compulsive reworking of each composition and more undefined gray areas.

One aspect of this crisis may have been the artist's psychological need for constant challenge. By the time Yanaihara began to pose, Giacometti's art had settled into consistent, even repetitive formats. International acclaim was assured by the retrospectives presented in 1955–56 in London, New York, Bern, Krefeld, Düsseldorf, and Stuttgart as well as the Venice Biennale. Given his horror of slipping into a facile art and his tendency to cast himself as a modern Sisyphus, the crisis may have arisen from a need to rekindle his creative drive. Another factor may have been the intellectual presence of Yanaihara himself. An avowed Existentialist, Yanaihara posed in the studio over several months in 1956 and again in following summers; his philosophical views may have reawakened Giacometti's tendency to consider each work as predestined to failure, with only the struggle justifying continuation. By 1956 his laments of never managing to achieve what he sought had become a habitual refrain, but they took on a more despairing emphasis, more pronouncedly the attitude of the Existentialist hero.

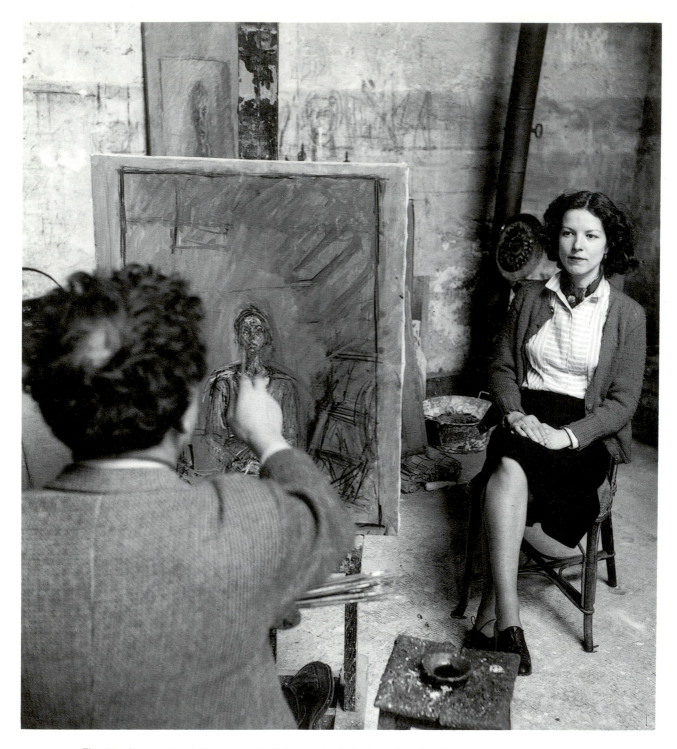

Fig. 10 Giacometti painting a portrait of Annette in his Paris studio, 1954. Photograh by Sabine Weiss.

The paintings of 1958, significantly the one year Yanaihara remained in Japan, reveal a renewed sureness of form. The virtuosic linearity of 1946–54 yielded to a more painterly style, with more strokes executed in gray with a broader brush. In two works from 1958, *Standing Nude* [85] and Yanaihara's portrait [86], incisive lines are fewer and less evident, although they provide essential focus and structure as in Yanaihara's eyes. The predominant impression remains a vision of shifting gray space that threatens to overwhelm the immobile, remote figure. Sartre viewed such paintings as struggles between being and nothingness,

with the artist bringing forth living forms from the void. He responded strongly to the intimation of isolation in Giacometti's canvases, noting that the artist: "would like us to see the seated [figure] he has just painted through layers of emptiness. . . . Nothing enfolds him, nothing supports him, nothing contains him: he *appears*, isolated in the immense frame of the void."[20]

Giacometti's friendship with Beckett may also have encouraged these traits in his painting from the mid-1950s on. The works of both men reflect their obsession with failure and compulsion to confront reality. For writer and artist, reality comprises a fundamental ambiguity between appearances and truth, separated and obscured by an impenetrable veil [see 46]. Perhaps the most visual similarity is their proclivity for a gray twilight setting. In Giacometti's words:

When I see everything in gray and in this gray all the colors I experience and thus want to reproduce, then why should I use any other color? I've tried it, because I never intended to paint only with gray and white. . . . As I worked . . . one color after the other dropped out, and what remained? Gray! Gray! Gray! My experience is that the color that I feel, that I see, that I want to reproduce . . . means life itself to me.[21]

Nearly all Beckett's novels and plays are set in a dim penumbra, where it is difficult to distinguish the real from the imagined. In *The Unnamable* (1952) Beckett wrote:

Whether all grow black, or all grow bright, or all remain gray, it is gray we need, to begin with, because of what it is, and of what it can do, made of bright and black, able to shed the former, or the latter, and be the latter or the former alone. But perhaps I am the prey, on the subject of gray, in the gray, to delusions.[22]

Drawing

Throughout Giacometti's life drawing was a means of clarifying his personal vision, which in turn facilitated what he wanted to do in other media. During his struggle to redefine his art in 1935–45 he made many sketches of artworks, often from reproductions, searching for underlying basic forms. The constant drawing led to a hard-won facility with line, which blossomed after the war. By the early 1950s he came to appreciate drawing as a fine art in itself, and his compositions became larger, more varied, and highly accomplished—paradoxically just as his sculpted and painted compositions became more restricted and concentrated.

Giacometti's choice of subjects and media during the 1950s and 1960s was affected to some degree by where he was working. In the Paris studio painted and sculpted portraits and nudes were his primary subjects, with occasional drawings of sculptures and other objects. On his annual visits to the familial homes in Switzerland, Giacometti made few sculptures, devoting his energies to painting and especially drawing. Virtually all his landscapes were done in Maloja and Stampa, depicting the surrounding mountains or garden outside the studio. He executed many still lifes there, usually dishes on the buffet and apples on a table and occasionally flowers in a vase [81, 90]. Without Diego for a model, Alberto often drew domestic interior scenes of his mother and Annette.

Giacometti distinguished between the casual drawings that he made spontaneously on any available scrap of paper and the more formal portraits and compositions that he executed carefully, usually on creamy white paper. Although he used a variety of materials, including

lithographic crayon and colored pencil [62, 63, 79], he preferred lead pencil sharpened to a fine point, the strokes of which could be erased and reworked. Unlike his sculptures and paintings, a typical bust-length drawing of the late 1950s would often require no more than fifteen or twenty minutes, while many small sketches of the early 1960s were finished much more quickly.

In his drawings Giacometti defined forms, especially figures, without resorting to traditional chiaroscuro modeling. At first his style was dramatically expressionist, as in *The Artist's Mother*, 1946 [32], and *Standing Nude*, 1950 [56]. In the latter, probably done from imagination or a recent sculpture, he literally attacked the paper with powerful lines and heavily reworked the drawing. In drawings such as *Jean-Paul Sartre*, 1946 [33], *Pierre Loeb*, 1950 [57], *Head of a Man*, 1951 [63], and *Seated Woman in a Room*, 1952 [69], the lines swirl over, around, and inside the forms that they define without literally describing them. The lines lead the viewer's eye hypnotically into the space of the surrounding environment and back to the surface of the paper, away to a sketchy area of geometry and back to the vortex of the head as if perception were caught in a centrifuge.

By the mid-1950s Giacometti had refined his drawing style. He sought more subtle relationships, and his draftsmanship reflected an astonishing facility and delicacy. The change can be readily discerned by comparing the 1950 *Standing Nude* with those from 1955 [79, 80]. In the mature drawings the use of line varies from descriptive to expressionist, delicate to vigorous, assured to extensively reworked. Some compositions cover most of the paper [77], while others have only a small head floating on the large white sheet [76, 78].

Within such variety several general observations can be made. His execution ranged between two contradictory poles: swirling lines and geometric structure. Many heads consist primarily of lines drawn with great speed, with the pencil rarely lifted from the paper. They cut across one another and across individual details with a spontaneity worthy of the automatism espoused by the Surrealists. Two or more layers of lines usually can be discerned: pale lines that appear quickly drawn and darker lines that bite into the paper as accents.

Within this continuous vortex a geometric structure exists, although in some images it may not be immediately apparent. Underneath and within the nervously energetic lines are verticals, horizontals, and diagonals that anchor and focus the composition. In figures the structural lines may be small and localized within the area of the eyes and nose, as in *Self-Portrait*, 1954 [75], and *J. R.*, 1959 [91]. In still lifes [81, 90] the structure is more comprehensive, providing a delicate latticework as a counterpoint to the rounded forms of flowers and dishes. Although the structural geometry of Cubism had disappeared from his mature sculptures, it had been quietly subsumed into his paintings and especially drawings to provide stability and serenity to the spontaneous expressiveness of his lines. So integral was this sense of structure that in some late drawings he could indulge in an almost baroque delight in curvilinear forms, as in *Annette with Hanging Lamp*, 1960 [95].

Many drawings have areas of subtle erasures. Giacometti carefully smudged parts of the heads to eliminate decisive contours, often effacing areas farthest from the viewer to make the head appear to issue from a palpable space. This sensation of forms emerging from emptiness was vital, and often his erasures create the effect more intimately than was possible in paintings. At first the erasures tended to darken the image, particularly noticeable in the 1950 nude and the *Head of Diego*, c. 1955 [78], where the dark smudging lends a ghostly immateriality to the face. By the mid-1950s Giacometti's mastery of line and forms

in space was superb and his erasures so discreet that in some drawings they can scarcely be detected at first glance. Frequently, he would cut a swath through a tangle of lines, like a shaft of sunlight streaming in from one side. These diagonal highlights of open space bring air into the composition, making the space breathe and pulsate.

The combination of fluid lines swirling through space, discreet compositional infra-structures, and selective erasures creates an effect of shifting planes and semitransparent constructions. These drawings exist beyond their intrinsic beauty as ceaseless fluctuations, implying the endless flow of perception and elusiveness of reality.

Expressionism Triumphant

Around 1959–60 Giacometti's paintings assumed a renewed intensity and bravura as he emerged from the hesitancy of the preceding years to work with passion and assurance (despite his plaints to the contrary). The style established in the mid-1950s became more gestural and emotively intense. In several paintings of Annette executed at Stampa in 1960–61 [see 96] he regained the virtuosity, rapid execution, and subtle color sense of his canvases of 1947–54. In most portraits painted at night in the Paris studio, the figures are marked by a powerful expressionism. The painted strokes became looser, more gestural, at times slashingly energetic, especially the black lines in the areas of the torso and hands [99], as if applied impatiently before he returned to the all-important head and gaze.

In the paintings of 1960–65 faces acquire an almost frightening intensity, sometimes appearing tangibly solid amid the lines or resembling a haunting mask of frenzied strokes. In some canvases the gray penumbra and penetrating gaze have a nightmarish quality, as in *Head of a Man,* 1961 [97]. In others the miasmic void diminished in importance as the figure emerged strongly from a scarcely defined setting, as in *Caroline,* 1961 [98]. During the last years of his life Giacometti largely relinquished both the phenomenological distortions of 1947–52 and the naturalism of the mid-1950s as he finally gave free rein to the expressionism that had long been inherent in his aesthetic.

This change toward a more overt expresssiveness occurred at first in painting and affected his sculpture slightly later, particularly the busts executed from 1962 until his death. When he was commissioned to create an outdoor work for the Chase Manhattan Bank, the large plasters he completed in 1960 did not fully reflect the expressionist passion then emerging in his paintings. Rather he reverted to the concepts of earlier sculptures. *Large Standing Woman IV* [92] reworks on a larger scale the nudes created during 1953–57, and *Monumental Head* [94] has the vertical emphasis characteristic of busts from those years. *Walking Man I* [93] takes up the striding pose of the walking men of 1948–50, although now with more substantial anatomy and richly variegated surface modeling. The overall concept of a standing woman, striding man, and observing head resurrects the group compositions of 1948–50, such as *City Square II* and *The Forest,* 1950 (Alberto Giacometti Foundation). The large scale of these works lends a greater physical presence than that of the earlier works, and their faces have an intense gaze, with hollowed sockets fixed un-blinkingly on some remote vista or inner-directed goal. The scale of the walking man puts his gaze on a personal, human level, but the woman's stare passes over all viewers, so that she seems especially remote and hieratic.

Even more than the sculptures of the 1950s, the late busts rely emphatically on their passionate execution. In the series of busts of Annette from 1962, Giacometti ranged from naturalistic depictions, as in *VII* [101], to those with distorted silhouettes and gouged surfaces, as in *IV* [100]. In most of his last sculptures the physique submits to the artist's kneading hands until the forms express angst and vitality as well as the vigor of the modeling process. The impact of the 1965 *New York Bust I* [104] and *II* [105] stems as much from the energy expressed in the material itself as from the intensity of gaze.

Giacometti's Legacy

For much of his career Alberto Giacometti seemed to embody the spirit of the avant-garde, first with his innovative Surrealist sculptures and later with his heroic struggle with figurative art that rejected easy solutions. But disengaged from his statements and the mythic image surrounding him, his mature art is traditional and even conservative by most avant-garde or modernist definitions. He rejected formalist aesthetics and emphasized the importance of the subject; his postwar sculptures and paintings consisted of figurative subjects in traditional poses, compositions, and media. Before his death he was one of the most famous artists of the modern era, but he recognized that his art stood at the end of a long art historical tradition rather than on the cutting edge of the new.

For fifteen years after his death this assessment seemed accurate. Yet with the rise of many expressionist figurative art styles in the past decade, the concepts underlying Giacometti's art have been revalidated. Rather than standing only at the end of a tradition he now seems something of a prophet, along with other postwar European artists such as Francis Bacon and Jean Dubuffet. Giacometti's sculptures, paintings, and drawings have an authenticity born of inner conviction and a mastery gained through long struggle. Compared with the raw emotionalism and fantastic imagery of contemporary Neo-Expressionism, Giacometti's art appears discreet. Its expressive impact arose not from a desire to convey emotion but from an attempt to create an art equivalent to his vividly experienced, personal vision. His is a complicated, varied, and subtly nuanced art that embodies an intensity and metaphysical content beyond his stated goals.

The figures in his postwar paintings and sculptures carry no consciously formulated message, yet they convey a powerful sense of alienation, an intimation of a spiritual core hidden beneath appearances, and a sense of the mystery inherent in the world. In his avowed quest to capture the actuality of external appearances, he succeeded in revealing an inner reality. His struggle to grasp a vision beyond his reach became manifest in the artworks themselves, in their paradoxes of subject and style: the rigid, often skeletal bodies of his sculptures enlivened by the modulated surfaces; the linear virtuosity of his paintings belied by the cloudy gray spaces; the vortices of pencil strokes anchored by a geometric infrastructure. Fugitive impressions of particular appearance have been studied, caught, discarded, and restudied in an intuitive blending of impressionist and expressionist elements until the process yielded an irreducible inner essence. Yet even this immutable core does not offer reassurance. His archetypal images of men and women as well as his still lifes and landscapes can never be completely free of the terrible uncertainty of existence. The flickering bronze surfaces and vibrating lines ensure that their reality remains provisional and inherently

elusive. Giacometti's universe presents a paradoxical vision of reality, defined and permanent yet fleeting and mutable—extremes of existence caught in an endless, symbiotic cycle that is simultaneously despairing and transcendent.

1. For discussion of the influences of ethnographic art on Alberto Giacometti's work see Krauss 1984 and Poley 1977.

2. Various publications on Giacometti have cited his initial exhibition at Galerie Jeanne Bucher and contact with André Masson et al. as 1928, but Brenson 1974, pp. 70, 135, established it as June 1929. According to Annette Giacometti (conversation with the author, March 18, 1988), Giacometti met Masson in April 1929, followed quickly by Michel Leiris and Georges Bataille.

3. In his article "Objets surréalistes," in Le surréalisme au service de la révolution, no. 3 (December 1931), Salvador Dali admired the sexual implications of Suspended Ball, citing "le creux féminin" of the ball and the idea of arousal without gratification. Maurice Nadeau in his History of Surrealism (1944) recalled how the sexual implications of the sculpture were widely recognized. Brenson 1974, pp. 62–65, interprets the sphere as male and the crescent as female. For an anlysis of Giacometti's Surrealist sculptures see Brenson 1974, Hohl 1971a, Okun 1981, and Krauss 1984.

4. See Giacometti's sketch (private collection, Bern) reproduced in Bach 1980, p. 275. Giacometti actually made and exhibited an enlarged plaster, but when no commission was received, that plaster eventually disintegrated.

5. Hohl 1971a, pp. 83, 101, reproduced p. 294, and Hall 1980, p. 12.

6. The meeting in 1939 was recorded in the diary of a friend and neighbor, Herta Wescher; see Lord 1985a, pp. 201–3. James Lord, in conversation with author (November 1987), confirmed that Giacometti had verbally noted errors in Simone de Beauvoir's account of the initial meeting, which she recalled in La force de l'age (Paris: Gallimard, 1960), pp. 499–500, as occurring through a mutual friend in spring 1941. From August to November 1939 Giacometti was away. From mid-1940 to March 1941 Jean-Paul Sartre spent nine months in a German prisoner-of-war camp, so the period when he and Giacometti first developed their friendship was brief (November 1939 to mid-1940 and April–December 1941). Their exchange of ideas was more fully developed after the artist's return to Paris in September 1945. De Beauvoir believed that Sartre influenced the artist, while Lord (who met Giacometti in 1952) feels that Giacometti significantly affected the philosopher's ideas. See also Lord 1985b, pp. 45–55; Michel Seuphor, "Giacometti and Sartre," Art Digest 29, no. 1 (October 1954): 14. According to Annette Giacometti (conversation with the author, March 18, 1988), the friendship continued until Giacometti's death, not ending in 1962 as described in Lord 1985a, pp. 467–68.

7. Kramer 1963, pp. 52–59.

8. Maurice Merleau-Ponty, The Phenomenology of Perception, trans. Colin Smith (1945; London: Routledge & Kegan Paul, 1962), pp. 243–66.

9. Giacometti, in Arts Council of Great Britain 1965, unpag.

10. Giacometti, interview with Georges Charbonnier, April 1957, in Charbonnier 1959, pp. 179–80.

11. Giacometti, interview with Charbonnier, March 1951, in Charbonnier 1959, p. 164.

12. Giacometti, letter to Pierre Matisse, 1947, in Matisse 1948, p. 43.

13. Giacometti, in "Skeletal Sculpture," Life (November 5, 1951): 152.

14. Respectively, Sartre, "The Search for the Absolute," in Matisse 1948, p. 16; and Jo Gibbs, "Attenuated Beauty," Art Digest 22, no. 9 (February 1, 1948): 13.

15. "Bust to Dust," Time (July 2, 1951): 78.

16. Allen Weller, "Coast to Coast: Chicago," Art Digest 28, no. 4 (November 15, 1953): 15.

17. Giacometti, interview for film by Ernst Scheidegger and Jacques Dupin, 1965–66, in Hohl 1971a, p. 171.

18. Giacometti, "Autres propos," 1965, in Pierre Schneider, *Alberto Giacometti dessins* (Paris: Galerie Claude Bernard, 1985), unpag.

19. For descriptions of his painting methods see Yanaihara 1961, pp. 18–24; and Lord 1965, pp. 6–7, 31–32.

20. Sartre 1954 (*Art News*): 28, 63.

21. Giacometti, interview with Gotthard Jedlicka, 1958, in Hohl 1971a, p. 282.

22. Samuel Beckett, *The Unnamable,* trans. Samuel Beckett (1953; New York: Grove Press, 1958), p. 17. For further discussion of the relationship between Giacometti's art and Beckett's writings see Hohl 1971a, pp. 210–11, 225, and Megged 1985.

What's All the Fuss About?
Giacometti and Twentieth-Century Sculpture

Reinhold Hohl

> People tell you, "Men have made sculptures for three
> thousand years—and done pretty well, too—without so
> much fuss."
>
> Sartre, "The Search for the Absolute" (1948)

Alberto Giacometti's stature as one of the most important sculptors of the twentieth century is at its zenith, and few would doubt his equally exceptional stature as a painter of portraits. Were it necessary to prove with facts and figures the current appreciation of Giacometti's sculptures, it would be sufficient to mention the New York auction sales from May 12, 1987, when his *Large Standing Woman I, II,* and *III* from 1960 fetched the sums of $3,080,000, $3,630,000, and $2,530,000 respectively. Each of these over life-size figures is, of course, an imposing presence as a work of art, standing frontally and motionless with arms pressed along the body, head erect, gazing straightforward beyond the here and now of contemporaneity, much like a sacred statue from an ancient cult. This effect makes a consideration of Giacometti's place in the art of this century all the more necessary.

Indeed, the artist's fame as a sculptor originated in two different periods with two different modes of working: Cubism and Surrealism, 1925–34, and postwar figuration, 1946–65. Yet the underlying concept of making compositions with a public, almost mythical, and to some extent monumental, significance was the same for both. Such a concept already sets Giacometti apart from the twentieth-century avant-garde. One work, *Model for a Square,* 1931–32 [15], bears out this idea of a meaningful monument. A later work, *City Square II,* 1948 [41], makes it clear that Giacometti's evolution does not conform to the textbook approach to modern sculpture. The progression from nineteenth-century anthropomorphic, allegorical, anecdotal sculpture in marble or bronze—Auguste Rodin's *Burghers of Calais,* 1889 (Hirshhorn Museum and Sculpture Garden, Washington, D.C.), for example—to twentieth-century nonobjective, constructivist public monuments—Antoine's Pevsner's *Developable Column of Victory,* 1946 (Kunsthaus Zurich)—to Minimalist and Conceptual sculpture does not apply to Giacometti. His bronze group of four walking men and a standing woman in *City Square II* is in all respects more akin to *The Burghers of Calais.*

In this light Giacometti can hardly be called a modernist, although modern sculpture does, of course, include the human figure as a contemporary theme represented in ever-

changing styles. Giacometti said, however, that he did not intend to make modern art as such, representing modern times and men, but sculptures and paintings that would hold their own compared with ancient, hieratic, and even sacred art. In this sense Giacometti's postwar Walking Men [40, 41, 42]—forever on their way to fulfillment—symbolize human aspiration, while his Standing Women [38, 43, 82, 83, 92]—static figures forever fulfilled—symbolize human continuity.

The link between the two main periods in Giacometti's oeuvre is a ten-year period during which the artist devoted himself to daily studies after nature; to busts and heads for which his brother Diego, model Rita Gueffier, friend Isabel Delmer, and a few others posed; and to the elemental motif of a rigidly standing figure. Each of these three periods must be considered separately to evaluate Giacometti's contribution to twentieth-century sculpture and to sculpture in general as the three thousand-year-old art of rendering the image of the human figure.

In 1927 Giacometti was working on an innovation. He wanted to make a freestanding sculpture of a head rendered exactly the way he saw it, for example, as a three-quarter view. A single vantage point is no problem at all in painting or in relief sculpture, where it is the norm. But how can it be done in a three-dimensional work that can be seen from all sides and yet should pointedly show one particular view? The sequence of Giacometti's naturalistic *Head of Joseph Müller I,* 1925 (private collection), through the 1927 heads of his parents [7, 8], to *Gazing Head,* 1927–28 [9], shows his progress toward this goal and—for that period—its solution, which gave him almost instant recognition as one of the most interesting sculptors of the avant-garde.

From the time of his arrival in Paris in 1922 Giacometti had been working as unnoticed as any other young foreigner. His sculptures of the 1920s document how he caught up with the modern art movements in Paris, where Cubist stylizations of figurative themes by Henri Laurens, Jacques Lipchitz, and others were as much the order of the day as the formal adoption of prehistoric and tribal art. Giacometti's sculptures of 1925–29 also demonstrate his outstanding gift for precise stereometric formulations and evocative reductions of genitalia to mere signs [3, 4]. In hindsight, these early works by Giacometti are already set apart from the average production of the time by their high sculptural quality and strong visual impact.

From 1930 on Giacometti was not just part of the history of twentieth-century sculpture, he made it, creating until 1934 compositions and constructions that, although very different from his earlier works, present Surrealist sculpture at its best and most enduring. To the ephemeral thrill of Meret Oppenheim's unsurpassable *Fur-Covered Cup, Saucer, and Spoon* and private perversity of Hans Bellmer's *Doll,* both 1936 (The Museum of Modern Art, New York), Giacometti's objects—movable constructions and board and cage settings for mythical psychodramas—added the concern for a general meaning and a monumental scale.

Sensing in the second half of 1934 that for him the time for Surrealist manifestations and mystifications was over, Giacometti decided that what he wanted to prepare then were a few studies after nature. So began the "period in-between," which led from an exceptional starting point in the history of modern art to a most exceptional result in the history of sculpture. This period has served to subsequent artists as an example of an obstinate pursuit heedless of momentary recognition or the likelihood of success. Instead of making a few studies, Giacometti worked for years on a few heads and busts—an endeavor that became almost legendary and rightly provokes the question: What was he fussing about?

The point was to model an individual head not in the way sculptors since antiquity have known it to be—namely a compact ovoid volume with individual proportions and features—but exactly as the artist sees it. As Giacometti discovered step-by-step, a head is an object at a given distance in space, surrounded by space, and seemingly reduced in size by the distance in respect to its actual size (but one never sees anything in its real, measurable size). But a head is also an individual entity, a person who returns the observing artist's gaze—a living existence.

After 1938 Giacometti's fuss was complicated by a second and equally new problem: the search for the sculptural representation of a remembered vision of a person together with the spatial experience that made the vision memorable. Giacometti wanted to transform the real sculptural object on which he was working with his fingers and a pocketknife into the image of an absent, remembered, and imagined person and at the same time to give the sculpture the quality of an imaginary object. Again, he transferred a painter's problem resolved with perspective or trompe l'oeil to the realm of freestanding sculpture. The problem was to create around the remembered figure an imaginary space distinct from the real space shared by the sculptural object, artist, and viewer. (The distinction between imaginary and real space is obvious in a painting representing an interior or a landscape and hanging in a museum or living room.) Giacometti's idea was perhaps not entirely new in sculpture since Medardo Rosso had attempted something similar in his impressionistic sculpture, *Conversation in a Garden,* 1893. Giacometti aimed not at an impression but at a re-creation of such a spatial vision as a convincing presence. During 1938–45, whether working after the model or from memory, Giacometti equated distance with the diminutive size and blurred details of his figures. By putting them on ever-larger pedestals, he found an equivalent for a painter's use of perspective. New phenomenological observations in 1945–46, when he made pencil sketches of people in the streets as studies connected with his idea of compositions with figures, helped Giacometti discover an entirely different effect of distance and space on the figures he saw. They seemed not tiny but tall and slim, or, to use Maurice Merleau-Ponty's observation made in 1945, they occupy only a vertical fraction of the visual field. Thus Giacometti arrived at the elongated, thin, massless, and seemingly weightless sculptures of his later oeuvre.

This all too brief summary of the novelties and consequences of Giacometti's studies begun in 1935 is sufficient to discredit the notion that this period was merely a return to representation after the abstract earlier works. On the contrary, it was the starting point of a hitherto unprecedented conception of figurative sculpture.

When Giacometti evolved the style of the slim, elongated figures in 1947, it was only partly the result of the new phenomenological studies. More important was his firm decision to end the period of solitary research and contribute figurative public monuments to postwar France. With that decision came a different scale and definitive style.

As Giacometti observed at this time, ancient commemorative and sacred figures—for example, Egyptian, archaic Greek, or Etruscan—have great impact precisely because they are hieratic, untouchable. They impose their authority on the worshiper or viewer because they must be approached frontally. It was the contrapposto of classical Greek sculpture— the balancing of the body's weight and posture between left and right legs and arms according to natural human behavior—that had reduced this authority of sculpture. The Byzantine and early medieval works of art Giacometti admired have no contrapposto nor do tribal idols anywhere in the world. Early in the twentieth century sculpture abandoned it to be

modern; Giacometti avoided it, therefore, in his Cubist compositions from the 1920s. This absence of contrapposto became a stylistic means to equal ancient art. Other means are the frontality, symmetry, and immobility of his figures, their serious straightforward gaze, how they walk with unbent knees, and the repetition of standing women on a common base and other devices for meaningful pedestals—for example, cages, boxes, chariots, or city squares. *The Chariot,* 1950 [48], reveals most clearly Giacometti's emulation of ancient cult figures because it refers to the Egyptian chariot he had seen while a student in Florence. Yet Giacometti camouflaged this allusion with his story about a pharmacy wagon from his more recent past.

The Women of Venice [82, 83] are likewise somewhat limited by their title, which alludes to the Venice Biennale of 1956. They are more fully understood as a group, with their solidarity signifying a monument to the continuity of the human species. Seen as such a monument, this work would by its kinship with and differences from Rodin's *Burghers of Calais* represent the twentieth century versus the nineteenth and again express something eternal versus historical. It is perhaps even more revealing for Giacometti's century that no such project of his ever materialized.

Giacometti's contribution to twentieth-century sculpture and painting, more than any public monument, gives voice to the modern individual, especially through a penetrating gaze. We find it in his late portraits based on a new, and very old, conception of portraiture—to re-create, not resemble, reality.

Modern portrait sculptors are generally satisfied with the correct rendering of individual physiognomy, cut of the hair, and fashion of the collar. Such a head or bust may have eyes with pupils, but its gaze is far from the sparkling glance of, for example, a bust by Gianlorenzo Bernini. That is as it should be. These modern works are memorial or ceremonial objects for a home, executive office, or town hall. An expressionistic portrait bust, however, speaks through its style and therefore is more a tribute to the artist's modernity than a testimony of the sitter's living presence. Thus these sculptures, too, are objects—stylistic specimens in an art collection.

Giacometti's ten busts of Annette of 1962–64 [100, 101] and his several busts of Diego of 1965 [104, 105] and *Elie Lotar* of 1964–65 (private collection, Paris) are portraits that ask to be acknowledged not only as likenesses or decorative objects but as existences no less alive and present than the models and the viewer. Grammatically speaking, they are not objects but subjects defined by a verb. Gazing directly back at us, they demand with undoubted authority that we position ourselves in front of them. They look, therefore, they are.

This was Giacometti's final "fuss" as we again know from his statements. His only goal when modeling a head, even when working without a model, was to render or to create the gaze, to which the entire face, neck, and posture contribute. The rendering of the eye proper, namely the pupil, iris, and cornea, seemed impossible to him. Unlike Bernini's heads, Giacometti's gazing heads do not really show eyes but instead a conglomerate of tissue, cartilage, and fissures that, together with the rest of the sculpture, appear as a most intense gaze. The more the shoulders are fragmented and the bust truncated, the more alive the figure seems to be; it is a kind of existing in extremis in spite of everything else. A comparison with one of the unnamable, unmovable, uneventful but incessantly speaking characters in Samuel Beckett's novels is not too farfetched; they are the badly treated objects of circumstances, and yet they do not cease to say "I."

These late works are also the center of the spatial situation they occupy. Their sculptural space is identical with their and our real space, yet they are removed from everyday space as if situated in an unpenetrable and irreducible sacred zone, as is Michelangelo's last work, the *Rondanini Pietà,* c. 1555-64, in Milan. (Giacometti last visited Milan in April 1963.) This pietà dominates the viewer's space and radiates a sacred aura, not because it is a religious work but because it fills the secular museum space in the Castello Sforzesco with its silence. In their silence Giacometti's last busts of Diego hold us at a distance by their singular gaze.

Did Giacometti create for the twentieth century a secular kind of sacred art? If so, that would not be a minor accomplishment. In a period in which we are almost totally at the will of political, social, economic, and many other kinds of necessities (as humankind has always been) and in which art represents us rightly as the object of these forces, Giacometti alone gave back to the human figure—at least in effigy as image—the power of a subject.

For too long has one heard the Giacometti saga about the extravagant change of size of his sculptures from nutshell to beanstalk, the eccentric story about his permanent fussing and failing, the exasperating interpretations of his figures as representing the misery and anguish of existence or of the artist's sexual impotence. His accomplishment—the depiction of the human figure as survivor—is exceptional, even extraordinary, in this century.

Catalog *Valerie J. Fletcher*

Notes on Giacometti's Sculpture Techniques and Casting

Over the course of his career Giacometti produced sculptures in various media and editions, usually modeling in plaster and often over metal armatures. Most plasters remained white, but some were painted as unique works and never cast, as with *Standing Man*, 1930 [14], and one version of *The Nose*, 1947 [34]. During his Cubist and Surrealist periods (1925–34) he often had someone else make casts of the original plaster in different media under his direction. A number were cast by his brother Diego into duplicate plasters or terra cottas, as was done with *Gazing Head*, 1927–28 [9], and *Head/Skull*, 1934 [22]. Some plasters were translated into marble, usually carved by Diego, as were *Gazing Head, No More Play*, 1931–32 (see fig. 5), and *Head/Skull*. The existence of several stone or plaster versions indicates that commissions were received for that work. Giacometti also had some of his Surrealist plasters, including *Suspended Ball*, 1930 (see fig. 2), *Model for a Square*, 1931–32 [15], *Point to Eye*, 1932 (see fig. 16), and *Flower in Danger*, 1933 [19], translated into wood by a Basque cabinetmaker named Ipusteguí, who lived nearby.

Many of Giacometti's early works were not cast until after his postwar fame brought a growing demand for all his work. Several plasters, such as the two Compositions of 1927 [5, 6] and *Reclining Woman Who Dreams*, 1929 [13], were rediscovered and cast during the 1950s and 1960s. In at least two instances the artist altered earlier works sometime before casts were made in the 1950s: he removed the ears from *Spoon Woman*, 1926–27 [4], and the bird form from *The Invisible Object*, 1934 [21]. Because Giacometti did not always model sculptures explicitly to be cast in bronze, a number exist as unique. Some early plasters did not survive, such as the large version of *The Cage* (see fig. 3). From other fragile plasters only one or two casts were made, as with *Three Figures Outdoors*, 1929 [12]. This was also true of some postwar plasters, as with *Walking Man*, 1948 [40]. Many plasters deteriorated without being cast into bronze, as did most of the tiny figures of 1939–45, the earliest versions of the Walking Men of 1946, and various standing nudes. Giacometti destroyed a number of works, some of which are known only through photographs.

After 1948–50, when the artist was represented by the two dealers Pierre Matisse and Aimé Maeght, bronzes could be made regularly. At first sculptures were cast into bronze only as needed for specific exhibitions and sale, usually one at a time through the early 1950s. As his sculpture became more sought after, bronzes could be cast several at a time and sometimes editions in their entirety. By the 1950s Giacometti generally modeled standing nudes in plaster and busts in oil-based clay: "I like to start working on a bust in [clay] and on figures and objects from memory in plaster."[1] Working in plaster tended to result in

delicate refinements of form, while the use of more malleable clay partially accounts for the more vigorously kneaded surfaces of the late busts. When the clay was ready, Diego would make a plaster cast to send to the foundry.

The artist used several foundries. After the war in Paris he most often used the Alexis Rudier Foundry, until it closed down in 1953 after Eugène Rudier's death. Thereafter most of his bronzes were cast by the Susse Foundry. For plasters already in Switzerland, such as the 1927 heads of his parents [7, 8], he used the Pastori Foundry in Geneva rather than transport the plasters to Paris.

After a bronze was cast it usually was brought back to the studio and patinated by Diego, but in later years bronzes were often patinated at the foundry. Alberto could be quite particular about patinas, although he acknowledged that he tried not to get too concerned about them because they could distract him from concentrating on essentials.

You can't worry about patina. . . . [I]n the natural bronze, the light glances over the surface; it has a special character. When the metal is darkened, there are shadows and depths. Perhaps it's best to show several casts of each piece in different patinas. But you can't get involved in all the little tricks.[2]

Since the artist did not always stipulate the same kind of patina, different casts of the same sculpture often have dissimilar patinas. These ranged from golden to warm brown to green brown to dark brown and even to black. Some patinas, especially those done by Diego during the mid-1950s, were modulated with small yellowish, reddish, or greenish areas over an underlying light brown. Alberto also painted some casts spontaneously, for example, when they were first brought back from the foundry or as they were being installed in an exhibition.

Usually his bronzes were cast in numbered editions of six, which often became seven with the addition of an artist's cast numbered 0/6. A few works were cast in smaller editions, such as the five bronzes of the 1932 *Woman with Her Throat Cut* [18]. Some sculptures cast after the mid-1950s were done in editions of eight, like *Dog,* 1951 [59], and his last busts [104, 105]. Before the height of Giacometti's international fame, little attention was paid to detailed written records on the numbering of editions, and so in some instances casts were accidentally misnumbered. This tended to occur when casts were made one at a time and upon occasion when early sculptures were cast years later without taking earlier casts into account. Thus *Tall Figure,* 1947 [38], has two casts numbered 1/6 and *The Glade,* 1950 [49], exists in two 6/6 casts. In another instance the artist deliberately exceeded his numbered editions to make special casts for the Fondation Maeght, Saint Paul-de-Vence, France, in 1964. These are marked "Fondation Maeght" or "FM" and include *Couple,* 1926 [3], *Glade, Dog,* as well as two Large Standing Women [see 92] and *Walking Man I–II* [see 93] of 1960.

Some sculptures were cast in bronze after the original plasters had been sold, usually by people in direct association with the artist. Such was the case with *Composition,* 1927 [6], *Reclining Woman Who Dreams,* and *Walking Woman,* 1932 [17], all cast at the instigation of various art dealers who brought the plasters to the artist's attention. The sculptor did strenuously object in one instance, when the Pittsburgh magnate G. David Thompson made stainless steel casts of two sculptures in the 1950s.

In accordance with French law, after the artist's death members of his immediate family selectively continued to make bronze casts, carefully controlling the numbering and patinas. These posthumous casts respond to two needs: completing editions already begun and

issuing editions of previously uncast original plasters. The latter category has preserved fragile compositions in durable bronze and revealed significant unknown works, especially early and very late sculptures. During the twenty years since the artist's death his widow has compiled records to document and clarify the complicated editions of his sculptures; that data will eventually be published in a catalogue raisonné.

1. Giacometti, in Alexander Watt, "Visages d'artistes: Giacometti," *Studio* 162, no. 820 (August 1961): 78.

2. Giacometti, in Hess 1958, p. 67.

1

Self-Portrait

1921
Oil on canvas
32½ x 28⅜ in.
Signed, LR: Alberto Giacometti
Alberto Giacometti Foundation, Zurich

Giacometti made self-portraits episodically through-out his life. The several drawings of himself done as a child are awkwardly serious; in 1917 he painted a bust-length self-portrait in a vigorous late Neo-Impressionist style; and in 1918 he made an incisive ink drawing (see fig. 1). This canvas was probably painted after his return from Italy in July and before his departure for Paris in late December. His largest painting until 1947, *Self-Portrait* was apparently intended as a deliberate summation of his artistic purpose and abilities. The composition is more complex than was usual for the artist at this stage, and he made a preliminary study of the head (private collection, Switzerland). Unlike most of his early paintings, this canvas depicts the full figure in a complex pose set within a spatial environment. Seated in his father's studio (the chair by Carlo Bugatti is visible in fig. 21), Giacometti presents himself as a painter confidently at work, formally attired in a blue suit, head held high, with a strong outward gaze. The three-dimensional forms are flattened and silhouetted into a decorative surface pattern tied to a geometric framework, and the sophisticated color scheme blends naturalistic with formalist needs. By demonstrating his mastery of the Post-Impressionist style learned from his father, Giovanni, and his godfather, Cuno Amiet, *Self-Portrait* marked the culmination of the young artist's youthful studies and signaled his imminent shift toward sculpture.

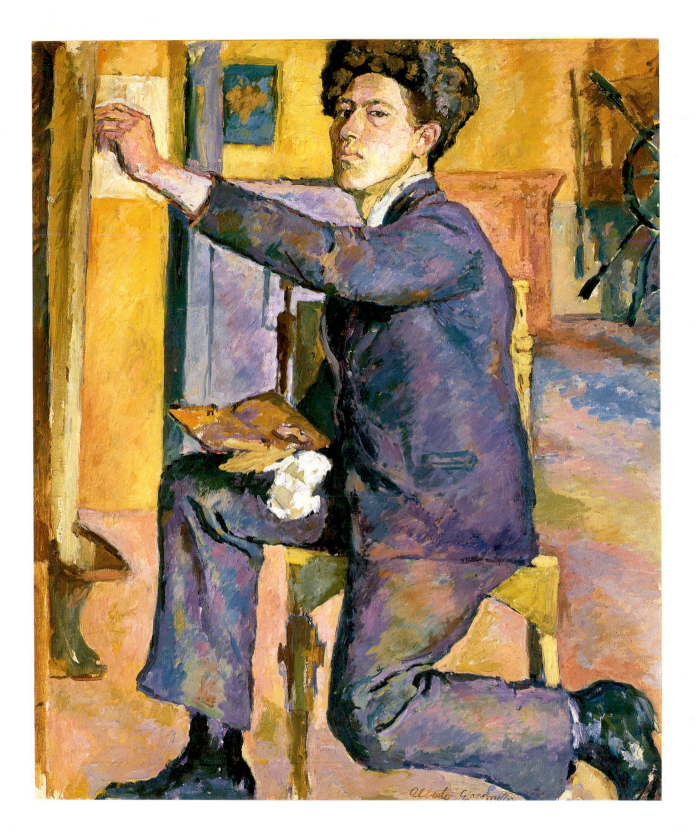

2

Self-Portrait

c. 1923
Oil on canvas mounted on fiberboard
21⅝ x 12¾ in.
Not signed or dated
Mr. and Mrs. Adrien Maeght, Paris

One of the few paintings executed after Giacometti left for Paris, this painting is more boldly Fauvist in style than the 1921 *Self-Portrait* [1]. He again presents himself as seen in a mirror: painting rather than sculpting and properly attired (throughout his life Giacometti usually wore a suit jacket and tie while working). This image is more confrontational than the 1921 work, with the artist seated frontally, close up, and gazing directly at the viewer. Despite its modest size this painting has a startling intensity, derived not only from the strongly defined forms and colors but also from the young artist's obvious self-confidence. Only one other painted self-portrait is known after this date, a small canvas of c. 1947 (private collection, Los Angeles), although he made a number of drawings of himself in the mid-1920s, mid-1930s, and in later years [75].

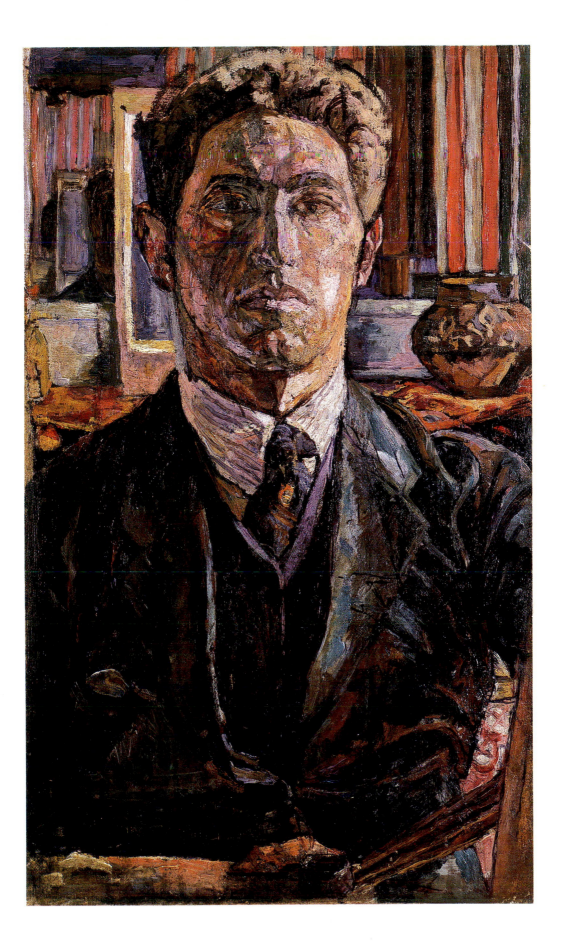

3

Couple (Man and Woman)

1926, cast after 1953
Bronze, 0/6, Susse Foundry
23¾ x 15 x 7 in.
Signed, rear base LR: A. Giacometti 0/6
Incised, rear base LL: Susse Fondeur Paris
Richard E. and Jane M. Lang Collection, Medina,
Washington

After Giacometti decided in 1925 to abandon traditional representational styles of art to explore more avant-garde modes, he turned to primitive art for inspiration in 1926–27. The rigidly frontal arrangement, totemic quality of the figures, and schematic indications of anatomy in *Couple* reflect the influence of several sources in primitive and prehistoric art, including African figure carvings, prehistoric and Cycladic female fertility icons, and possibly Celtic menhirs.[1] Several specific sources of African art were available to Giacometti during those years. In the collections of the Musée d'Ethnologie du Trocadéro (now Musée de l'Homme), he made drawings after prehistoric and ethnographic sculptures.[2] In 1925–26, as a result of a portrait commission, Giacometti renewed contact with Josef Müller, a noted Swiss collector of African and modern art. Giacometti also acquired a Bakota funerary figure in 1926; its central form may have inspired the ovoid shape of the woman in *Couple*.[3] African art had become so fashionable in Paris by the mid-1920s that it had been assimilated into Art Deco design; the stylized geometric details of *Couple* may reflect that *style nègre*.[4]

Man and woman are presented as icons of their genders. With their overall shapes and abbreviated anatomical markings, these figures exist as biological symbols rather than as individual personalities. The forms are monolithic and flattened, with surfaces in shallow relief. The male form consists of a columnar shaft, with abstracted genitalia and upward-pointing hand; the large eye (derived from Egyptian art) indicates a function as seer and intellect. The forms of the woman emphasize her sexuality. Her overall shape repeats that of her schematized vagina, while the shape of her mouth echoes her breasts and genitalia. A linear indentation on the back indicates her buttocks.

The original plaster *Couple* was exhibited in the Salon des Tuileries in 1926 (no. 865), where it was installed in a room with paintings by Fernand Léger and Piet Mondrian and a sculpture by Constantin Brancusi.[5] *Couple* was also exhibited as *Figures* in the Salon de l'Escalier (February 1928).

Although one unnumbered bronze was made before 1948 (formerly Christian Zervos Collection), the edition of six numbered casts was made during the 1950s, plus an artist's proof. Cast 1/6 belongs to the Alberto Giacometti Foundation in Switzerland and 4/6 to the Art Institute of Chicago; other casts are in the Museum of Modern Art in New York and private collections in New York and Paris. An additional cast was made in 1964 for the Fondation Maeght, Saint Paul-de-Vence, France. At least three casts have brownish mottled patinas, while three others have darker, more pristine finishes.

1. See Poley 1977.

2. Reproduced in Carluccio 1967, nos. 2–3, 5–9.

3. Brenson 1974, p. 56, n. 39.

4. See Krauss 1984, especially pp. 506–7, 528, n. 12.

5. Giacometti, letter to Pierre Matisse, April 17, 1955, in Wilhelm-Lehmbruck-Museum 1977, p. 79. The artist had misdated *Couple* to 1928 in his 1947 list of early works in Matisse 1948, pp. 24–25.

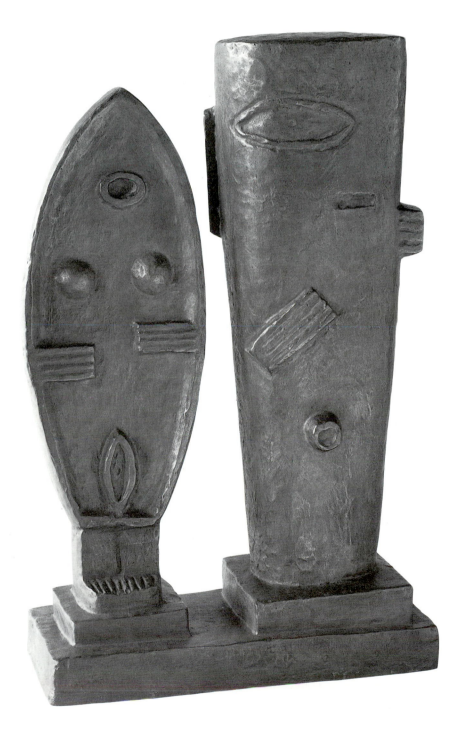

4

Spoon Woman

1926–27, cast 1954
Bronze, 3/6, Susse Foundry
57½ x 20¼ x 10 in.
Signed, above rear base: Alberto Giacometti 3/6
Signed, side base LL: A. Giacometti 3/6
Incised, rear base LR: Susse Fond. Paris
Solomon R. Guggenheim Museum, New York

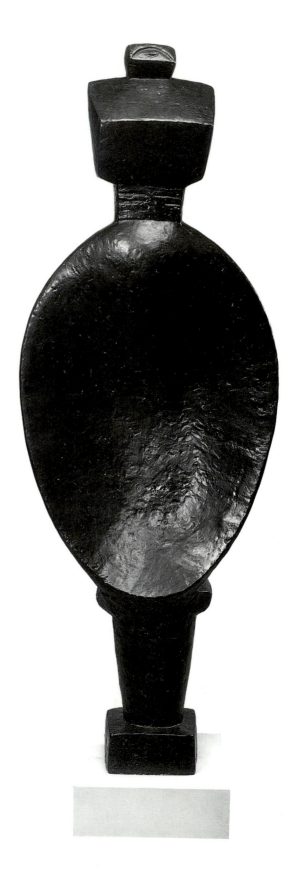

Although this sculpture is traditionally dated 1926, and the artist misdated it to 1932–33 in his hand-written 1947 checklist of his early works sent to his dealer Pierre Matisse, Giacometti confirmed its correct date in a subsequent letter: "I have a notebook made years ago with sketches of nearly all my sculptures done since 1925. *Spoon Woman* is listed there with precise [dates]. It was done in late 1926–early 1927 and was exhibited at the Salon des Tuileries in 1927 (I can still see where it was installed and Henri Laurens looking at it)."[1] It was exhibited again in the 1936 Surrealist group exhibition at Burlington Gallery in London.

At the time of its creation *Spoon Woman* was Giacometti's largest sculpture and first freestanding, monumental female figure. Its iconic frontality and immobility reflect its source in African art and anticipate aspects that characterize his subsequent female figures in 1932–34 and after 1946. The inspiration for this image was a type of anthropomorphic spoon carved by the Dan people of West Africa (fig. 11). Such spoons had been exhibited and published in Paris by the mid-1920s, including several in the show of African and Oceanic art presented at the Musée des Arts Décoratifs in November 1923–January 1924.[2] *Spoon Woman* presents the female as fertility symbol or totem. Her body consists largely of a simplified, spoon-like shape alluding to the womb as the receptacle of life. In addition to its specific source in the Dan spoons, the general concept of woman as fertility idol reflects Giacometti's lifelong admiration for totemic figures of ancient cultures, and he made at least two drawings in the late 1920s of the prehistoric Laussel Venus and Cycladic figures.[3]

The upper portion of *Spoon Woman* consists of a solid double-faceted block, surmounted by a smaller block with incised geometric details. Origi-

nally the large block had ears and the small block had a tiny ridge on top, which the artist later removed from the plaster (private collection, Paris).[4] In the original configuration with the ears, the large block clearly represented a head on its neck, with a kind of topknot, although now this form may be understood as a bosom above a narrow waist, with the small topmost element alone being the head. This treatment recalls the stylized female heads with geometric hairdos found on many Dan spoons, but the final forms here relate more to Brancusi and Cubism. The use of the linear "eye" and crescent may stem from Egyptian sources. In Western esoteric traditions the crescent often symbolizes the female essence and is associated with the moon.

The edition of six numbered bronzes, done in 1954 by the Susse Foundry, was apparently prompted by the forthcoming retrospective exhibitions in London, New York, Krefeld, Düsseldorf, and Stuttgart (all in 1955) and Bern (1956). All the casts have very dark patinas tending toward black. Cast 1/6 belongs to the Alberto Giacometti Foundation; 2/6 to the Mr. and Mrs. Raymond D. Nasher Collection in Dallas; 4/6 to the Art Institute of Chicago; other casts are in the Louisiana Museum in Humlebaek, Denmark, and a private collection in Europe. A special cast was made in 1964 for the Fondation Maeght.

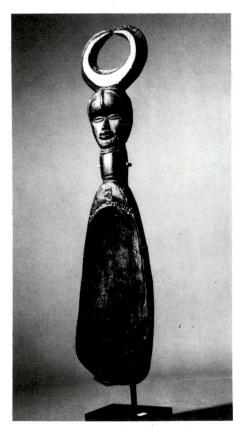

Fig. 11 Dan, Ivory Coast. Wunkirmian Rice Spoon, wood, 24 in. high. National Museum of African Art, Smithsonian Institution, Washington, D.C. Eliot Elisofon Photo Archives.

1. Giacometti, letter to Pierre Matisse, April 17, 1955, in Wilhelm-Lehmbruck-Museum 1977, p. 79. Brenson 1974, p. 225, no. 24, records Diego Giacometti as saying that the plaster was made in the studio at rue Hippolyte-Maindron in spring 1927.

2. See Krauss 1984, especially pp. 507–8, 528, n. 14. Hohl 1971a, pp. 79, 291, suggested a similar type of spoon from Papua New Guinea.

3. Reproduced in Carluccio 1967, nos. 2–3; the date of the Venus drawing can be inferred from the added sketches for sculptures of 1927–29.

4. Hohl 1971a, p. 39, reproduces a photograph of the plaster before modifications. According to Annette Giacometti's records (conversation with the author, March 16, 1988), the modifications were made years before, not in preparation for, the bronze casting. Brenson 1974, p. 225, no. 24, dates the alterations to c. 1950.

5

Composition

1927, cast after 1960
Bronze, 6/8, Susse Foundry
15¾ x 10⅝ x 9⅞ in.
Signed, side base LR: Alberto Giacometti 6/8
Incised, rear base: Susse Fondeur Paris
Mr. and Mrs. Harold E. Rayburn Collection, Davenport, Iowa

One of Giacometti's most abstract sculptures, *Composition* demonstrates his mastery of the geometric language of Cubism invented by Pablo Picasso and Georges Braque more than fifteen years earlier. This sculpture consists of solidly massed geometric volumes in a complex and dynamic balance. Three major masses, each rectangular with projecting ridges or prong-like shapes, are superimposed at angles. From one viewpoint the massing of geometric volumes recalls Raymond Duchamp-Villon's *Horse,* 1914 (Hirshhorn Museum and Sculpture Garden, Washington, D.C.). The forms are assembled so densely that *Composition* appears monumental despite its small size and surprises the viewer with dramatically distinct forms that emerge on each side when viewed in the round. The surface forms alternate from linear to massive, angular to rounded, shallow to high relief. Each side of the sculpture is different, and there is no simple front and back, unlike most of Giacometti's sculptures, which have a pronounced frontality. Although Giacometti later denied ever having made a purely abstract sculpture, *Composition* demonstrates the artist's command of nonrepresentational forms and sophisticated handling of three-dimensional sculptural masses.

Two other casts are in private collections in Paris.

6

Composition (Man and Woman)

1927, cast 1959
Bronze, edition of 8, Pastori Foundry
15½ x 17⅞ x 5⅞ in.
Signed, rear base: Giacometti "E.1"
Stamped, rear base: cire / Pastori / perdue
E. W. Kornfeld, Bern

In this sculpture, along with the other 1927 *Composition* [5], Giacometti attained pure geometric abstraction and demonstrated his mastery of Cubism's geometric and structural language. This sculpture incorporates different, equally complex compositions in both front and rear views, combining a frontal, pictorial approach with sculptural forms and space. Volumetric mass has been thoroughly dissected and reconstructed into a complex interpenetration of independent planes and geometric elements. As in many Cubist sculptures, empty space functions as an active component, with open passages having structural roles almost as significant as those of the solid forms. The liberation from traditional sculptural mass was a crucial lesson for Giacometti, setting him on the path toward the openwork and constructed sculptures of 1929–33 [11, 12, 13, 18, 19 (see figs. 2, 3, 6)].

In his sculptures of the late 1920s Giacometti devised a personal vocabulary of geometric forms that recur in various compositions but not always consistently enough to ascribe specific interpretations. Hollow hemispheres often represent heads, as in *Man*, 1929 [11], but here only one of the three fits that description. In several sculptures linear zigzag forms occur individually and in a repeated pattern, possibly representing a woman in one instance but purely abstract here. The horizontality of *Composition*, the two undulating horizontal elements visible in the rear view, and the "head" on top at one side all anticipate *Reclining Woman Who Dreams*, 1929 [13]. Literal interpretation of the geometric forms as figures in *Composition* is of secondary interest, for the impact of this work results primarily from its formal beauty.

According to art dealer Eberhard Kornfeld, the plaster original was acquired in 1929 by a friend of the artist, and it remained in his collection in Switzerland, virtually forgotten. When it was rediscovered thirty years later, Kornfeld arranged with the artist to have an edition of six numbered bronzes and two proofs cast by M. Pastori, a founder in Geneva whom Giacometti used to cast plasters already located in Switzerland rather than send them to the usual Paris foundries.[1] Cast 1/6 formerly belonged to the Milton Ratner Family Collection; 2/6 belongs to the Bündner Kunstmuseum, Chur. The other proof is in a private collection in Switzerland.

1. Eberhard Kornfeld, conversation with author, May 1987.

7

Head of the Artist's Mother

1927, cast 1960s
Bronze, edition of 2, Pastori Foundry
12¾ x 9 x 4⅜ in.
Signed, across rear base: Alberto Giacometti
Dated, front base LR: 1927
Incised, base LL: M. Pastori Cire perdue
Alberto Giacometti Foundation, Zurich

In 1927 Giacometti sculpted several heads of his parents. He accomplished a remarkable illusionism in the modeling of his mother's head. Approximately life-size, it appears naturalistic from the front, with eyes, cheeks, and nose in normal depth. Seen in profile, however, the head is less than three inches deep with the chignon accounting for another inch. The viewer realizes with a shock that the face was achieved illusionistically, as in painting. *Head of the Artist's Mother* is a transitional work between the naturalism of several heads Giacometti made in 1925–26 and the flatness of the 1927–28 *Gazing Head* plaque [9].

Now in a private collection in Switzerland, the original plaster of this sculpture remained in the studio at Stampa for more than thirty years (visible in fig. 21). Two bronzes were made for the family by the Pastori Foundry in Geneva; the other cast is in a private collection in Switzerland.

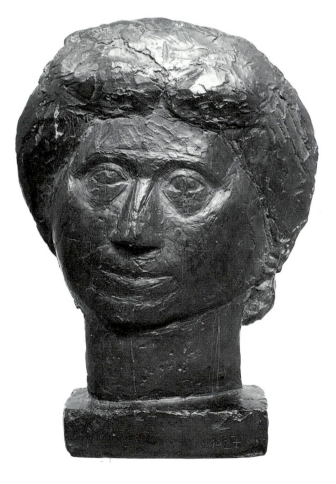

8

Head of the Artist's Father

1927, cast early 1960s
Bronze, 1/6, Pastori Foundry
10⅞ x 8½ x 5⅜ in.
Not signed or dated
Incised, LL: M. Pastori Cire perdue
Djerassi Art Trust, Stanford, California
San Francisco Museum of Modern Art only

Along with the head of his mother, Giacometti made five heads of his father in 1927, ranging from a naturalistic plaster to a nearly abstract marble. In this head he defined the facial features by scratches in the flat surface, rather than by modeling. As in etching and engraving, the artist used a sharp tool to sketch in the eyes, nose, mouth, moustache, and goatee; a horizontal line in one eye suggests the closed lid, while the other eye has a round pupil dug into the surface. These incised details introduce an expressive graphic element to modeled sculpture, a concern that recurs in Giacometti's oeuvre. Finely etched lines are used more discreetly in *Head of the Artist's Mother* [7] to give a vertical axis and focus to the eyes; Giacometti later incised his own features into the flat surface of *Cube,* 1934 [23].

Another cast belongs to the Alberto Giacometti Foundation.

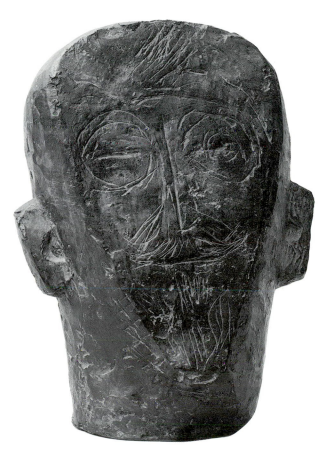

9

Gazing Head

1927–28, carved 1930
Marble
16⅛ x 14⅞ x 3¼ in.
Signed and dated, rear base: A. Giacometti 1930
Private collection, courtesy Stephen Mazoh and Co., Inc.,
New York

During the winter of 1927–28 Giacometti created a group of at least eight plaque sculptures. Most derived from a female body or head, but they do not literally depict their sources. The plaques perpetuate the totemic nature and frontal, planar format of the 1926 Couple [3], but they mark a distinct break with the constructed geometric approach of the two 1927 Compositions [5, 6]. The plaques embrace an almost pictorial two-dimensionality, a conceptual rather than physical space. Giacometti later recounted his reductivist struggle with these works:

In my studio I tried to reconstitute from memory alone what I had felt in the presence of the model in Bourdelle's atelier. . . . What I actually felt was reduced to a plaque standing in a certain way in space and having only two hollows which were, if you will, the vertical and horizontal aspects found in every figure. . . . I started by analyzing a figure, with the legs, head, arms and all seeming false, unbelievable. To be more precise, I gradually had to sacrifice and reduce, to leave off the head, arms, everything! Of the figure only a plaque remained. . . . I worked on that one all winter and two others of the same type.[1]

According to Diego Giacometti, Gazing Head was the first completed plaque, derived in part from two earlier reliefs.[2] Although essentially abstract, the shallow indentations in the surface may indicate a vertical nose and horizontal eye. Other plaques incorporated various geometric markings and were entitled Figure, Personnage, or most often Woman.

The plaques played a pivotal role in bringing the young Swiss artist his first Parisian fame. After the plaster Gazing Head had been exhibited at Galerie Jeanne Bucher, it was purchased in June 1929 by major art collectors Viscount Charles and Marie-Laure de Noailles, who subsequently became his patrons.[3] As a consequence of Bucher's bringing the plaster to André Masson's attention, Giacometti was introduced to the exciting Surrealist milieu. The plaques also may have influenced Max Ernst's early sculpture entitled Bird-Head, 1934–35 (Menil Collection, Houston), which was made after he worked with Giacometti in summer 1934.

From the original plaster Gazing Head, Alberto had Diego make at least four plaster casts for exhibition and sale. Three are in private collections in France. From one of the plaster casts, six numbered bronzes were made in the 1950s by the Susse Foundry. A plaster, a bronze, and a marble (carved 1929) belong to the Alberto Giacometti Foundation. This 1930 marble was carved on commission from the interior decorator Jean-Michel Frank for his client Templeton Crocker in San Francisco. It differs from the 1929 marble by having a clear demarcation between the primary rectangular shape and supporting plinth. A third marble belongs to the Stedelijk Museum in Amsterdam. Two terra cottas are in private collections in Paris.

1. Giacometti, interview with Georges Charbonnier, March 1951, in Charbonnier 1959, pp. 162–63.

2. Brenson 1974, p. 58, n. 44.

3. Brenson 1974, p. 70, n. 30; see also Fletcher essay, n. 2.

9

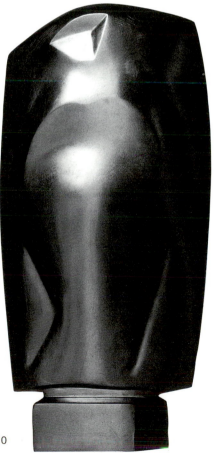

10

10

Woman

1927–28
Bronze, 4/6, Susse Foundry
21⅝ x 13⅝ x 3⅛ in.
Signed, rear base LR: Alberto Giacometti 4/6
Private collection, Paris

Woman is one of three plaques that clearly reveal their inspiration from a standing female nude. More naturalistic than the other known plaques, this sculpture has an elegantly sinuous silhouette, which echoes Alexander Archipenko's *Flat Torso,* 1915 (Hirshhorn Museum and Sculpture Garden), and foreshadows *Walking Woman,* 1932 [17]. *Woman* also relates to a decorative plaster Giacometti made in the 1930s for Jean-Michel Frank. That commission consisted of a flat vertical plaque mounted on an ornate base; a female nude was sketched in pencil on both sides of the plaque.[1] When the artist listed his early works for Pierre Matisse in late 1947, he cited only three of the plaques, including the plasters of *Gazing Head* [9] and this *Woman*.[2] Giacometti kept the plaster *Woman* in his studio for many years (now in the Musée National d'Art Moderne, Paris); it subsequently was cast in an edition of eight (numbered as six, plus two artist's casts). Another bronze belongs to the Musée d'Art et d'Histoire in Geneva.

1. Reproduced in Musée Rath 1986, p. 44.

2. Giacometti's checklist of early works, 1947, in Matisse 1948, pp. 24–25. Next to the sketch of *Woman,* Giacometti assigned a 1928 date, while Annette Giacometti has stipulated 1927 as its date, based on her records (conversations with the author, January and March 1988).

11

Man

1929, cast c. 1948–56
Bronze, 3/6
15½ x 12½ x 3⅝ in.
Signed, rear, lowest horizontal bar LL: 3/6 Alberto
Giacometti 1929
Hirshhorn Museum and Sculpture Garden, Smithsonian
Institution, Washington, D.C., gift of Joseph H. Hirshhorn

Derived from the 1927 Cubist Compositions [5, 6] and the 1927–28 plaques [9, 10], *Man* provides a transition between them and the cage-like constructions of the early 1930s. Its flatness and geometry, without suggestive subject matter, date the work to early 1929, before Giacometti's contact with Masson's Surrealist group. Like Jacques Lipchitz's "transparent" sculptures of the mid-1920s and Picasso's *Constructions (Maquettes for a Monument to Guillaume Apollinaire)* of late 1928 (Musée Picasso, Paris), *Man* consists of linear forms woven around open spaces. Giacometti later recalled that figures "were never for me a compact mass but like a transparent construction."[1] The sculpture's two-dimensional, open-frame structure presents a skeletal schema of three horizontal, three vertical, and two reverse diagonal bars. The hollow hemisphere (the head) atop the central vertical element along with the two legs below identify this formal symmetrical composition as a human figure.

Although a bronze existed by 1947, it is not clear when the full edition of six bronzes was completed. Like many of his early sculptures, the numbered edition was probably made during the 1950s. Cast 2/6 belongs to the Alberto Giacometti Foundation; three others are in private collections.

1. Giacometti, letter to Pierre Matisse, 1947, in Matisse 1948, pp. 36–37.

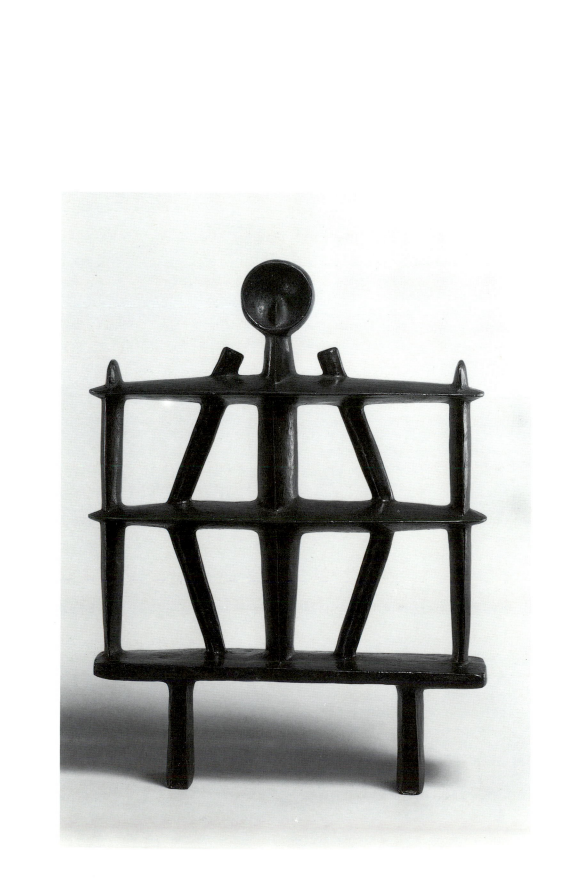

12

Three Figures Outdoors

1929
Bronze, unique
21¼ x 15⅛ x 3½ in.
Signed and dated, underside base: Alberto Giacometti / 1930
Incised, underside base: Epreuve unique
Art Gallery of Ontario, Toronto

Like *Man* [11], this rectangular, linear, openwork composition derived from Giacometti's abstract Cubist vocabulary of 1927, flattened into a plane like the plaques of 1927–28. The forms here are linear and elegant, actively encompassing the narrow spaces between them. The linear forms and their disposition make this an exceptionally delicate and beautiful composition, yet paradoxically they imply a violent and probably erotic narrative. The central zigzag form suggests a figure whose pose or movement is determined by the aggressive forms around it: the hanging gourd-like shapes in one upper corner, short diagonal lines in the other upper corner, and two pointed prongs that grasp or pierce the central motif. This composition is essentially abstract but presents a metaphorical drama in which delicate forms are controlled or threatened by stronger forms.

In keeping with Surrealist aesthetics, variable interpretations are possible depending on each viewer's imagination and subconsciousness. The two dominant motifs—the central zigzag form and the two thrusting prongs—together with the title suggest a sexual encounter in which a woman is assaulted by two men.[1] Since this sexual psychodrama occurs outdoors, the vertical forms at each side may signify buildings or trees, with branches or fruit in the upper corners.

The interpretation of this work as figures of opposite genders is supported by a photograph of the original plaster, which the artist later inscribed "Homme, femme, et fantômes (specters)." That the action occurs outdoors is indicated by the colors Giacometti applied to this photograph (private collection, Zurich). He left the central motif white but tinted the top horizontal blue (like the sky), the bottom green (like grass), the side verticals yellow, and the two prongs an aggressive red.

The schematic figure enclosed within a cage-like frame may reflect the influence of Oceanic art, especially the carved and painted *malanggans* from New Ireland and carved house posts from the Sepik River area of Papua New Guinea.[2] When Giacometti associated with the dissident Surrealists from 1929 on, he came in contact with Oceanic carvings. His friend Michel Leiris knew of such work, dealer Pierre Loeb had a fine *malanggan* and several Papuan carvings in his living room by 1929, and Max Ernst also owned a *malanggan*.[3]

The composition of *Three Figures Outdoors* relates to the first known decorative object designed by Giacometti for Jean-Michel Frank in 1930.[4] It was an abstract, linear wall piece, with a somewhat figurative form on the right pierced by a long pointed form from the left. Along with *Man* and *Reclining Woman Who Dreams* [13], the plaster of *Three Figures Outdoors* was published in Leiris's article in *Documents* (1929) and may have been exhibited that year or 1930 at Galerie Pierre. Art publishers E. Tériade and Christian Zervos selected this work for the *Exposition internationale de sculpture* at Galerie Bernheim in late 1929. The single bronze was apparently cast then (despite the marking "1930") because it appears in an installation photograph.[5]

1. Brenson 1974, p. 47.

2. Alan G. Wilkinson, *Gauguin to Moore: Primitivism in Modern Sculpture* (Toronto: Art Gallery of Ontario, 1981), p. 228.

3. See 1929 photograph of Loeb's apartment, reproduced in *L'aventure de Pierre Loeb: La galerie Pierre 1924–64* (Paris: Musée d'Art Moderne de la Ville de Paris, 1979), p. 27. The Ernst *malanggan* is reproduced in Krauss 1984, p. 517. Giacometti made several drawings of such carvings; see Carluccio 1967, nos. 5, 8.

4. See photograph in *Art et industrie* 8 (August 1930): 17, reproduced in Musée Rath 1986, p. 65.

5. Christian Zervos, "Notes sur la sculpture contemporaine," *Cahiers d'art* 4, no. 10 (1929): 465–73.

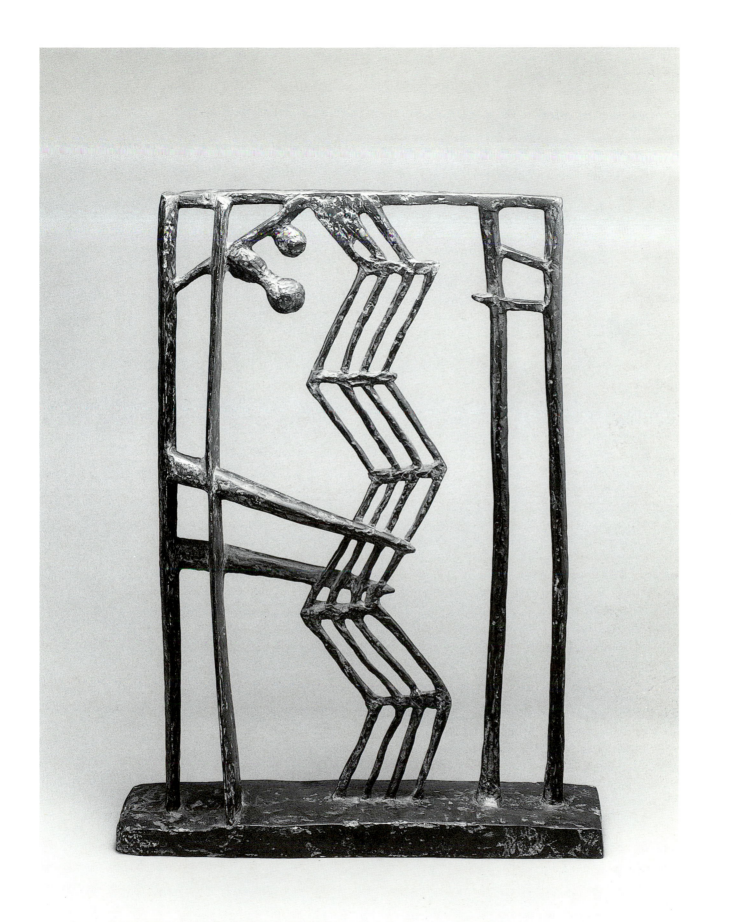

13

Reclining Woman Who Dreams

1929, cast late 1959
Painted bronze, 1/6, Susse Foundry
9¼ x 16⅞ x 5¾ in.
Signed, top rear base UR: Alberto Giacometti 1/6
Incised, top rear base UL: Susse Fondeur Paris
Hirshhorn Museum and Sculpture Garden, Smithsonian
Institution, Washington, D.C., gift of Joseph H. Hirshhorn

As in the 1929 *Man* [11] and *Three Figures Outdoors* [12], this openwork sculpture consists of a few geometric components assembled in a rhythmic balance incorporating open voids as active elements. The theme of a reclining woman has a long art historical tradition, dating at least to the ancient Greeks. Giacometti's treatment of the theme in another sculpture of 1929 (Alberto Giacometti Foundation), with full, rounded forms suggestive of a nude, seems to refer obliquely to that tradition. In *Reclining Woman Who Dreams,* however, fleshy anatomy has been omitted. Instead, two undulating horizontal bands supported by three vertical posts and topped with a hemispherical head at one end establish the reclining motif. In the French title, *Femme couchée qui rêve,* "couchée" means "in bed" and "sleeping," not simply "reclining"; so the wavy planes on supportive posts suggest a rumpled bed. Metaphorically, the rhythmic movement adds a light, floating effect, alluding to the flux of dreams. These curving elements echo the biomorphic forms espoused by many Surrealist artists during the 1920s (in 1929 Giacometti had become friendly with Masson, Joan Miró, and Jean Arp, all of whom used biomorphic styles). The fluidity of the undulating planes suggests that the realm of dreams is pleasurable, securely anchored to the posts at both ends. Yet the three small diagonal bars piercing the top wavy plane add a disturbing accent.

A photograph of the original plaster *Reclining Woman Who Dreams* appeared in Leiris's article on Giacometti in *Documents* (1929), and one bronze was cast before 1947. In late 1959, at the instigation of art dealer Lawrence Rubin, Giacometti authorized an edition of six numbered bronzes plus an artist's proof to be cast by the Susse Foundry. Several bronzes were painted white to resemble the plaster. Cast 0/6, a painted bronze, belongs to the Alberto Giacometti Foundation. The unpainted 2/6 cast is in the Öffentliche Kunstsammlung Basel, Kunstmuseum.

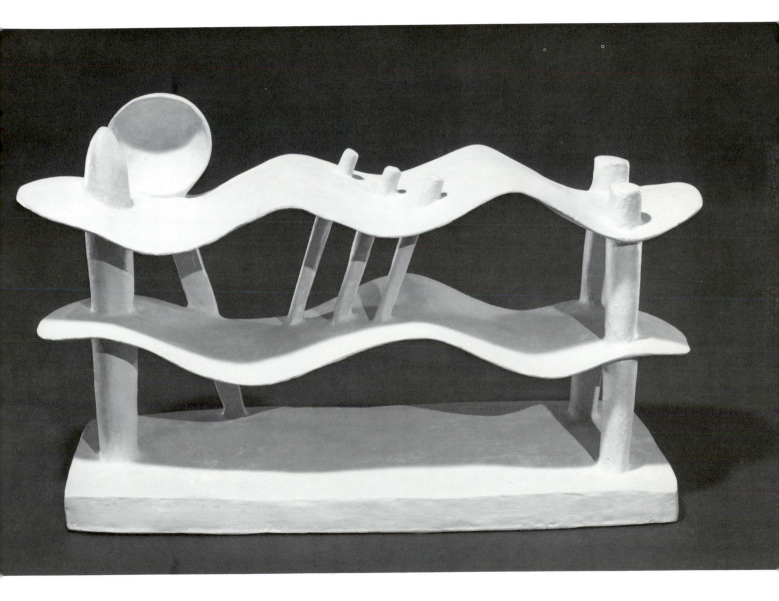

14

Standing Man

1930 (or 1928)
Painted plaster, unique
26¾ x 19½ x 7¾ in.
Incised, rear base LR: Alberto Giacometti / 1930
Hirshhorn Museum and Sculpture Garden, Smithsonian
Institution, Washington, D.C., gift of Joseph H. Hirshhorn
Hirshhorn Museum and Sculpture Garden only

Stylistically, the frontality and flatness of *Standing Man* recall the 1926 *Couple* [3] and the 1927–28 plaques [9, 10]. According to Annette Giacometti's records, this plaster was executed in 1928, before the openwork sculptures of 1929–34.[1] Because the sculpture was signed and dated "1930" by the artist sometime before its sale in 1938, that date has been traditionally accepted.[2] One possible explanation could be that Giacometti created the plaster in 1928 and modified it in 1930, perhaps adding the painted hues and surface incisions. Alternatively, he may have completed the piece in 1928 and signed and misdated it ten years later when it was sold.

Standing Man has a single distinct feature within its sinuous outline: a carved ovoid mouth. This detail, combined with the variegated surfaces, creates a mysterious and subliminally disturbing effect. The artist painted the white plaster pale blue on the front, black on the back and sides, and dark red on the base. The surfaces have been incised with crosshatchings, as were several plaques, but here the lines were covered over with loosely brushed paint. On the front a number of long erratic lines were then scratched into the surface, exposing the white plaster. These incisions, along with the mouth open as if in a scream, suggest an assault, an impression that belies the elegance of the silhouette.

Although identified as a man when purchased in 1938, the figure's gender is ambiguous. The ovoid mouth recalls the vaginal symbol used on the woman in *Couple,* and the frontal, immobile pose forecasts Giacometti's later female figures. Along the side of the base is a snake-like, wriggling line that echoes the spermatazoa Edvard Munch painted on the frames of his paintings of women.

This unique plaster was a finished work, never intended to be cast in bronze. It was acquired in June 1938 by Saidie May of Baltimore from Galerie Pierre in Paris. On loan to the Baltimore Museum of Art from 1938 to 1951, it formed part of their collection until 1957.

1. Annette Giacometti, conversations with the author, March 16 and 18, 1988.

2. Giacometti may have consigned the sculpture to Galerie Pierre as part of his 1929 contract or in conjunction with two exhibitions there that included his work: *Miró-Arp-Giacometti* in spring 1930 and *Où allons-nous?* in spring 1931. It apparently remained with Pierre Loeb until sold.

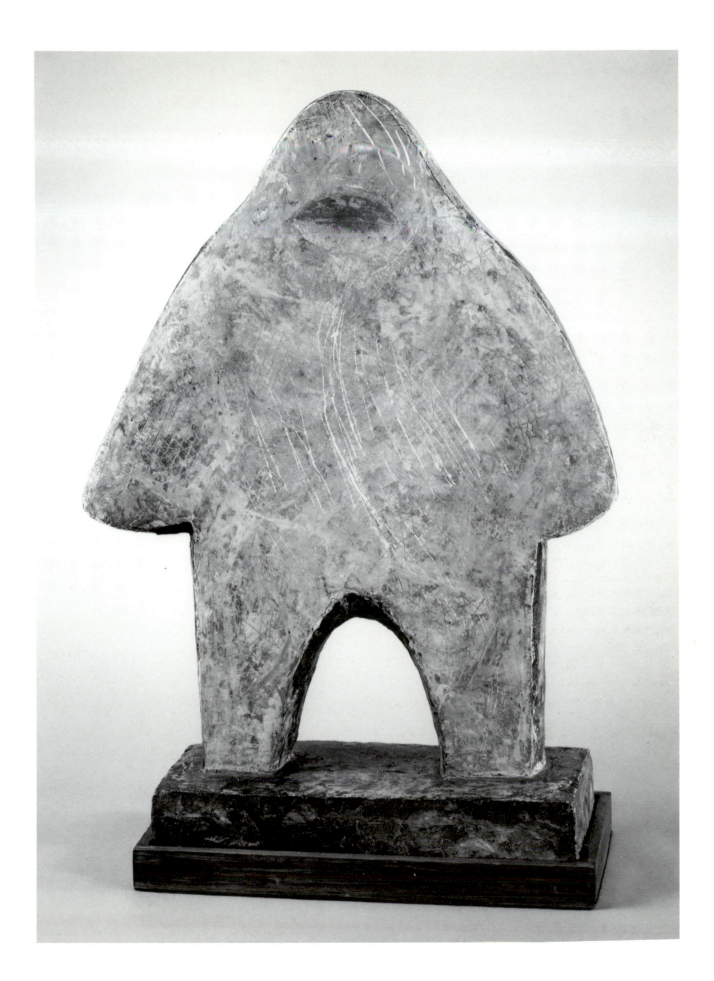

15

Model for a Square

1931–32
Wood
7⅝ x 12⅜ x 8⅞ in.
Not signed or dated
Peggy Guggenheim Collection, Venice (Solomon R. Guggenheim Foundation)

Unlike the other tabletop or platform sculptures of the early 1930s (see figs. 4, 5), *Model for a Square* does not refer to children's games. After modeling the original in plaster, Giacometti had the Basque cabinetmaker Ipusteguí translate this composition into wood, possibly with Diego's assistance. *Model for a Square* was intended to be enlarged in stone to a scale of more than six feet high and twelve feet wide. Giacometti later wrote that he had wanted the sculpture to be placed outdoors where people could touch it and even sit and walk on it, somewhat like Noguchi's sculptural playgrounds.[1] Although no commission was received to execute the sculpture on a large scale, Alberto and Diego made plaster enlargements of the individual elements (no longer extant, the tallest is visible in fig. 7; see also 1932 drawing [16a]). The general concept of this composition—a monumental, multicomponent sculpture intended for a public urban space—recurred later in his figurative style, notably in *City Square II*, 1948 [41], and the project for the Chase Manhattan Bank Plaza, 1960 [92, 93, 94].

Although entirely abstract, the forms in *Model for a Square* have been interpreted symbolically by art historians Reinhold Hohl and Michael Brenson as male and female. Their explanations differ radically and do not entirely reconcile with the use of abstract forms in Giacometti's other sculptures of 1927–34. For example, Brenson perceives the stele-like and zigzag forms as female, while Hohl sees them as a tree and serpent in the Garden of Eden; Giacometti identified another stele as himself in *The Palace at 4 A.M.,* 1932–33 (see fig. 6). Brenson sees the cone as male, Hohl as female; the artist may have combined genders in his 1934 cone sculpture of a pregnant woman entitled *1 + 1 = 3* (private collection).[2] Whatever personal symbolism

these forms may have had for Giacometti, the enlarged *Model for a Square* would have been appreciated first for the visual strength and beauty of the abstract forms, with their associative and symbolic aspects operating subliminally and without restriction to specific interpretations.

1. See Giacometti's sketch (private collection, Bern), reproduced in Bach 1980, p. 275, which indicates the monumental scale. See also the photograph caption in *Cahiers d'art* 7, no. 1–2 (1932): 341; and Giacometti's statement in Matisse 1948, p. 42.

2. See Brenson 1974, pp. 65–68; Hohl 1971a, p. 79; and Guggenheim Museum 1974, pp. 29–30. See also Angelica Rudenstine, *Peggy Guggenheim Collection, Venice* (New York: Abrams, 1985), pp. 329–36.

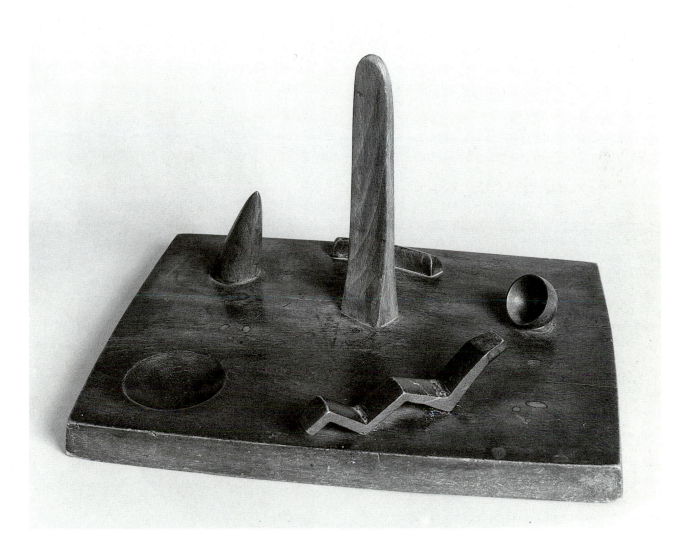

16a

The Artist's Studio (toward the front)

1932
Pencil on paper
12⅞ x 19⅜ in.
Signed and dated, LR: Alberto Giacometti 1932
Inscribed, LR: dessin de mon atelier que vous m'avez fait
tant la grande joie de/ne pas le trouver détestable
Öffentliche Kunstsammlung Basel, Kupferstichkabinett

16b

The Artist's Studio (toward the back)

1932
Pencil on paper
12½ x 17¾ in.
Signed and dated, LR: Alberto Giacometti 1932
Öffentliche Kunstsammlung Basel, Kupferstichkabinett

In contrast to the graphic vitality, crosshatching, and shading of his youthful draftsmanship, Giacometti's drawings from 1925–35 tend toward an illustrative or documentary style. Usually depicting his own sculptures, they are not studies for sculptures but drawings after them, a practice he continued through his later years. In these two compositions he expanded this descriptive approach to include his entire studio at 46 rue Hippolyte-Maindron, which he occupied from 1927 until his death.

According to Hohl, these drawings were made as a pair for a lovely Italian aristocrat, Nadina Gonzaga (later Countess Visconti), who visited his studio three times in spring 1932.[1] Using a single uninflected line to define objects, Giacometti described the narrow, high-ceilinged space filled with his recent Surrealist sculptures. In the view toward the front, *The Palace at 4 A.M.* (see fig. 6) in progress occupies the trestle worktable in the center. On the right are the plaster abstract elements (no longer extant) enlarged from the wood *Model for a Square* [15], which stands on a table to the right. The plaster *Spoon Woman* [4] and a small Cubist sculpture [possibly 5] occupy another table on the right. On the adjacent table stands the *Hour of the Traces*, 1931 (Tate Gallery, London), while the sphere from *Suspended Ball*, 1930 (see fig. 2) hangs from the key in the door. On the floor stands *The Cage*, 1930–31 (see fig. 3), a painting of a man, and a lost version of a reclining woman. On the floor at left are two marbles, *Caresse*, 1932 (Musée National d'Art Moderne), and the plaque *Woman*, 1928 (private collection, Paris), along with the plaster *Landscape (Head)*, 1931–32 (no longer extant). Along the left wall is a narrow staircase leading up to a small balcony; the staircase appears in many later paintings.

In the view toward the back of the studio, on the left is the small *Model for a Square* again, *Walking Woman*, 1932 [17], and a modest bookshelf that appears in the relief *Still Life*, c. 1935–36 [25], and *Diego Seated in the Studio*, 1949–50 [47]. On the back wall in the center, the relief sculpture of a spider woman, 1930 (location unknown), hangs above the bed. At the time this drawing was made, the artist lived in the studio, although he often slept in nearby hotels, and his Italian visitor had presented the artist with a new coverlet for the bed. After the war the aging cot would appear in many paintings and drawings.

1. Hohl 1971b, pp. 352–65.

16a

16b

17

Walking Woman

1932, reworked 1933–36, cast 1955
Bronze, 4/8, Fiorini Foundry
59 x 9½ x 15½ in.
Signed, base: Alberto Giacometti IV–IV
Museum of Fine Arts, Boston, Henry Lee Higginson and
William Francis Warden Funds

Walking Woman was Giacometti's first life-size representational figure, but it was only a partial figure in the first and final versions. Although this sculpture was modeled during the same year as other more radical compositions, including *Woman with Her Throat Cut* [18], in *Walking Woman* Giacometti returned to the traditional theme of a female nude. Yet the peculiar triangular indentation below the breasts, combined with the lack of head and arms, creates a disturbing tension between the familiar and the unreal.

The figure's movement is more symbolic than active; she barely walks with legs kept close together—a pose recalling the ancient Egyptian figures that Giacometti often studied. The flattened, subtly differentiated anatomy evokes Cycladic idols (fig. 12) that he admired, although a more modern source for the sensuously refined modeling and body form restricted to a narrow vertical plane might have been Archipenko's *Flat Torso*.

The date of this sculpture is established as early 1932 because the plaster original appears in the studio drawings done that spring [16]. That original (or possibly a plaster cast of the original) was modified for the Surrealist group exhibitions at Galerie Pierre Colle in Paris (June 1933) and Burlington Gallery in London (June 1936), where it was displayed with the title *Mannequin* (fig. 13). For these shows Giacometti added a head consisting of the neck scroll from a cello, first painted black then white, and arms; the right arm ended in a claw-like hand, with feathers for the left hand. During the 1936 exhibition Giacometti had the head, arms, and hands removed to restore this work to a more pristine, traditional appearance in keeping with his recent shift to representational art. In subsequent years other Surrealists developed a penchant for mannequin images, using both real

and simulated store mannequins, notably the sixteen such figures by Ernst, Marcel Duchamp, Man Ray, Dali, Miró, and others who dominated the Surrealist exhibition at Galerie Beaux-Arts (January–February 1938).

From its inception this figure stood directly on the ground as indicated in the 1932 studio drawings and in photographs of the 1933–36 *Mannequin*. The lack of a base brought the figure into the real space of the viewer and gave it a tenuous balance. By the time it was cast into bronze it had a base, possibly added when the sculpture's final state was established in 1936. Another version, often known as *Headless Woman* (Peggy Guggenheim Collection, Venice) to distinguish it from this work, lacks the indentation in the torso and has subtle differences in modeling. Although it bears the date 1932–36, research has demonstrated that it too was executed in 1932.[1] That plaster was cast by Guggenheim in 1960–61 in an edition of six, with a seventh bronze in 1969.

The plaster *Walking Woman* (now in a private collection, Paris) was acquired by Erica Brausen of London's Hanover Gallery, who obtained the artist's permission to cast an edition of four bronzes in 1955. Cast 2 belongs to the Moderna Museet in Stockholm; 3 to the Baltimore Museum of Art. In 1965–66 the edition was expanded to six bronzes; those casts are in a private collection and the Tate Gallery. The edition was completed several years later under Annette Giacometti's supervision; one cast belongs to the Louisiana Museum; the other to a private collection in Paris.

1. See Ronald Alley, *Catalogue of the Tate Gallery's Collection of Modern Art* (London: Tate Gallery, 1981), pp. 276–77; Brenson 1974, pp. 168–70; and Angelica Rudenstine, *Peggy Guggenheim Collection, Venice* (New York: Abrams, 1985), pp. 336–41.

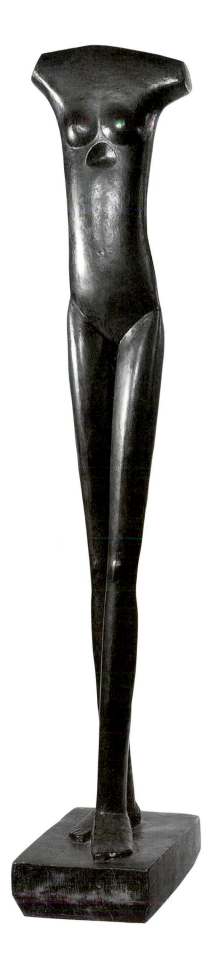

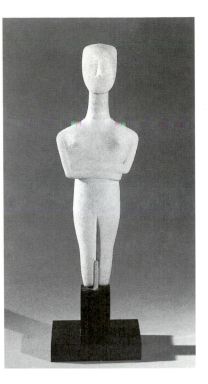

Fig. 12 Cyclades, Greece. Female Figure, c. 2400 B.C., marble, 15 x 15⅛ x 2 in. National Museum of Natural History, Smithsonian Institution, Washington, D.C., gift of Joseph H. Hirshhorn.

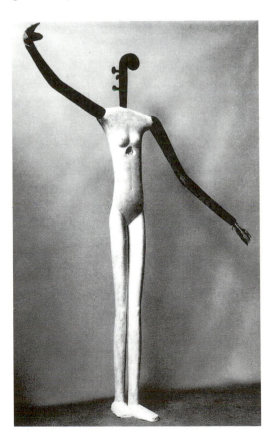

Fig. 13 *Mannequin*, 1933–36, plaster, painted wood, feathers, 67 in. high (no longer extant) (from Dupin 1962, p. 216).

18

Woman with Her Throat Cut

1932, cast 1940
Bronze, 1/5, Alexis Rudier Foundry
9 ⅛ x 35 x 25 in.
Not signed, dated, or inscribed
Peggy Guggenheim Collection, Venice (Solomon R.
Guggenheim Foundation)

One of Giacometti's most innovative and powerful sculptures, *Woman with Her Throat Cut* developed from several earlier works. In 1930 he made a semi-abstract sculpture, *Woman in the Shape of a Spider* (location unknown [depicted hanging over the bed in 16b]), followed in 1931–32 by a large plaster reclining woman entitled *Anguished Woman in Her Room at Night* (no longer extant). In 1932 he sketched out a more naturalistic reclining woman (no longer extant [depicted on the floor in 16a]) and made two pencil studies of spiky creatures with sharply aggressive limbs, a phallus, and long necks (Musée National d'Art Moderne).[1]

Art historical antecedents exist for recumbent figures in the throes of extreme emotional or physical states. Gianlorenzo Bernini's *Saint Theresa,* 1645–52 (Santa Maria della Vittoria, Rome), experiences a mystical ecstasy, and Rodin's *Martyr,* 1885 (Rodin Museum, Philadelphia), has fallen onto the ground with limbs awry, but Giacometti's composition has an unprecedented sexuality and violence. Whereas the motif of the reclining woman in Giacometti's 1929 sculpture [13] implied dreaming, here it refers to sex and death.

The forms of this sculpture make anatomical and biological allusions rather than literally describing a woman's body. The torso consists of a spiky rib cage below and an arched, rounded abdomen with breasts above; in between is an open space where the womb would be. Two splayed legs extend from the lower end of the torso, and from the top end a spine-cum-windpipe with a small nick in it terminates in a tiny head. One arm bends over the neck and ends in a phallic pod; the other arm becomes a large, scooped, flower-shaped hand. In early photographs by Brassaï of the original plaster, the pod rests in the petaled hand—an obvious sexual allusion.[2] The entire sculpture was intended to lie directly on the floor. Seen from above, this image, although scarcely descriptive, powerfully portrays the body of a naked woman who has been raped and murdered.

Many Surrealists were fascinated with images of violence and sex, including Georges Bataille and Masson, who did a series of massacre drawings in 1931 depicting men attacking women with knives.[3] In Giacometti's sculpture *Man and Woman,* 1929 (Musée National d'Art Moderne), he had revealed his predilection for combining aggression with violence. Whereas in the 1929 sculpture the male hovers threateningly, the 1932 sculpture depicts only the woman, utterly destroyed by his actions. In a reminiscence of his childhood, "Hier, sables mouvants" (May 15, 1933), Giacometti recalled how he often lulled himself to sleep with a violent fantasy. At night near a castle, he would slay two men, then commit rape:

After tearing off their dresses, I raped two women, one thirty-six years old, all dressed in black with a face like alabaster, then her daughter, garbed in floating white veils. The entire forest echoed their screams and moans. I killed them too, but slowly.[4]

From the Surrealist perspective (predominantly male and Freudian), woman is presented in this sculpture as vulnerable but still threatening. Curved organic shapes contrast with sharply pointed ones, particularly evident in the pairing of the sensuously rounded abdomen with the fanged shapes of the lower rib cage (possibly implying that the enticing outer appearance conceals a dangerous menace). From a different perspective, this contrast of rounded and jagged forms suggests the viciousness with which the woman's soft flesh has been ravaged.

A horrifying, repugnant, symbolic image, *Woman with Her Throat Cut* presents forms that on

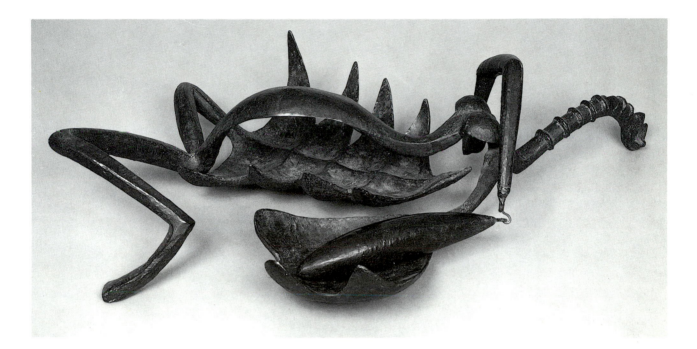

a purely visual level are extraordinary and fascinating. The complex shapes intricately interwoven with open spaces are compelling in themselves. Yet this visual attraction can be seditious, for it tends to remove the subject of sexual violence from prominence by inviting admiration for the overall design, promoting an implicit acceptance of the pain, destruction, and degradation of woman portrayed in this sculpture.

The first two bronzes were made from the original plaster in 1940, but the three casts made in 1949 had to be done from one of the earlier bronzes because the plaster had badly deteriorated. The Guggenheim cast was the first; the second is in a private collection in New York. Cast 3/5 is in the Alberto Giacometti Foundation; 4/5 belongs to the Museum of Modern Art in New York; and 5/5 to

the Scottish National Gallery of Modern Art in Edinburgh.

1. See Hall 1980; Hohl 1971b; and Rudenstine, *Peggy Guggenheim Collection, Venice* (New York: Abrams, 1985), pp. 341–47.

2. Reproduced in Maurice Raynal, "Dieu—table—cuvette," *Minotaure* 3–4 (1933): 46–47.

3. Reproduced in André Masson, "Massacres," *Minotaure* 1 (1933): 57–61.

4. Giacometti 1933, pp. 44–45.

19

Flower in Danger

1933
Wood, metal, plaster, string
22 x 30¾ x 7 in.
Signed, base LR: Alberto Giacometti
Alberto Giacometti Foundation, Zurich

Flower in Danger is an elegant image of potential destruction. A wood rod is held bowed in tension by a single filament, a catapult-like device that threatens a fragile, white flower suspended from a thin wire support. Constantly on the verge of action, the implied menace conveys an apprehensiveness more effective than actual movement. This abstract drama, with its delicate balance between vitality/beauty and destruction, offers a metaphor for life itself.

In this sculpture the materials are used effectively not only to contrast colors and textures but also to emphasize narrative meaning. The bent wood evokes bows and catapults, while the white plaster flower stands out as exceptionally fragile and symbolically pure. Curiously, the flower seems to resemble a stylized human mask, and its thin wire support may be understood as a skeletal figure (prescient of Giacometti's postwar sculptures). This anthropomorphic reading adds a human dimension to the metaphorical interpretation.[1] In 1945 Alexander Calder created a sculpture with a similar concept. In his abstract stabile *Bayonets Menacing a Flower* (Washington University Art Museum, Saint Louis), a tiny white flower is suspended on a thin wire across from aggressively sharp black forms.

Giacometti's constructed sculptures date only from 1930–33. *Flower in Danger* was constructed in early 1933: it does not appear with *Palace at 4 A.M* and *Hour of the Traces* in the studio drawings made in spring 1932 [16a–b] but is prominently featured on the trestle worktable in a studio photograph by Brassaï published in late 1933.[2] The concept of constructed sculpture had originated in Picasso's Cubist assemblages of 1912–14; subsequent artists across Europe (including Russia) had developed a wide variety of types. Unlike most constructivist sculptors, Giacometti did not usually assemble his works from metal and wood but modeled them in plaster over wire armatures. In keeping with Surrealist ideas, he was concerned primarily with the subject matter; actual execution by the artist's own hand was unimportant—an attitude he rejected after 1934.

Like *The Palace at 4 A.M.* (see fig. 6), this construction reduced sculptural mass to an absolute minimum. The thin, taut forms suffuse the surrounding space with energy—a lesson that served Giacometti well in the postwar sculptures. After *Flower in Danger* Giacometti returned to more traditional monolithic mass in 1934, with *The Invisible Object* [21], *Head/Skull* [22], and *Cube* [23].

1. Brenson 1974, pp. 171–72, interprets this sculpture (also known as *Fil tendu*) as symbolizing or presenting a male/female sexual struggle. The wire and plaster element may represent a man while the crescent bow and small wood element indicate a woman and child.

2. Reproduced in Maurice Raynal, "Dieu—table—cuvette," *Minotaure* 3–4 (1933): 47.

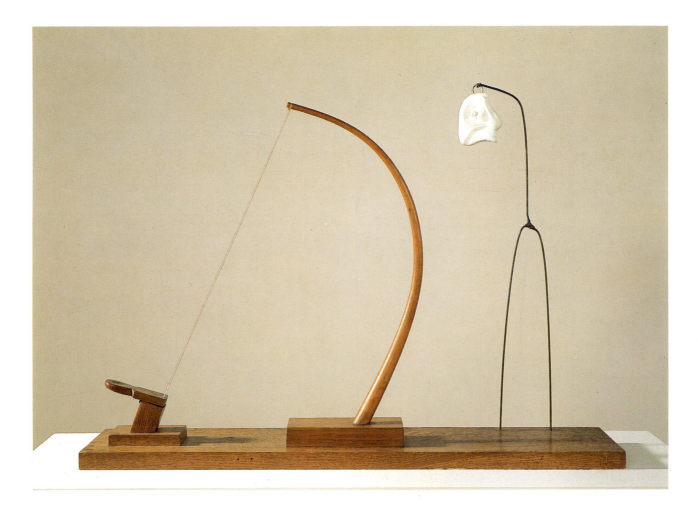

20

Surrealist Table

1933, cast 1969
Bronze, unique
56½ x 40½ x 16⅞ in.
Signed and dated, rear L: Alberto Giacometti 1933
Musée National d'Art Moderne, Centre National d'Art et de
Culture Georges Pompidou, Paris

The concept for this sculpture may have evolved from Giacometti's tabletop sculptures (see figs. 4, 5). Another contributory source may have been René Magritte's painting *The Difficult Passage,* 1926, in which a disembodied hand lies on a table, overlooked by a baluster topped with a one-eyed head.[1] *Surrealist Table* also relates to a decorative commission for a plaster overmantle that Giacometti designed for Jean-Michel Frank during the 1930s. Known only through a photograph, this mantle has a female bust on the left, with plaster drapery over the front edge.[2]

Surrealist Table was originally intended for a corridor or hallway.[3] The sculpture is frontal, with its rear edge flat to fit flush against a wall. Charles and Marie-Laure de Noailles, who purchased the plaster from the Surrealist exhibition at Galerie Pierre Colle (June 1933), placed it in a hallway in their house, like a real table. In such a setting it must have fulfilled the Surrealist love of ambiguity and surprise. The bust, the hand, the polyhedron appear as tangible objects in the real world yet they remain remote and mysterious, like the famous phrase in *Les chants de Maldoror* (1869, published 1874) by Comte de Lautréamont about the beauty of an accidental meeting of a sewing machine and an umbrella on an operating table. *Surrealist Table* may have been directly inspired by the Lautréamont quote, for at the time several other Surrealists were interested in Lautréamont's work, and Giacometti made a drawing entitled *Meeting in a Corridor,* 1933 (Musée National d'Art Moderne), depicting an umbrella and other objects on a tall table.[4] Furthermore, in a home the objects on *Surrealist Table* would mingle with mundane objects that could be picked up, but these cannot, tricking the inhabitants with their deceptive accessibility.

The table itself appears unstable; for example,

the top does not cover one leg completely, and all the elements are weighted to one side. There is a tension between the abstract polyhedron form and the figurative elements, and the disembodied hand with no function is disturbing. *Figure,* 1935 [24], has a similar combination of female head on a geometric table with a polyhedron and hands.

Hohl considers this sculpture as alluding to an artist's worktable (in the original plaster a mortar and pestle was evident where only a dish remains now). He also considers it a tribute to contemporary artists, including Fernand Léger (the veiled bust recalls several female heads with flowing hair in his paintings of the 1920s) and Constantin Brancusi (the leg of repetitive diamond shapes resembles the *Endless Column* of 1918–20).[5]

The original plaster entered the collection of the Musée National d'Art Moderne in 1951; this unique bronze was cast in 1969.[6] An ink drawing of the sculpture also belongs to that museum.

1. Hohl 1971a, pp. 102, 294.

2. Reproduced in Musée Rath 1986, p. 38.

3. Giacometti, notation in Matisse 1948, p. 41.

4. Reproduced in *Le surréalisme au service de la révolution* 5 (May 1933): 41. Man Ray made a more literal drawing to illustrate the Lautréamont citation in André Breton and Paul Eluard, "Enquête," *Minotaure* 3–4 (1933): p. 101. In 1933 Dali made fifty-two etchings to illustrate *Les chants de Maldoror* (Paris: Editions Albert Skira, 1934).

5. Hohl 1971a, pp. 102, 294; and Hohl, in Guggenheim Museum 1974, p. 29.

6. For conservation of the original plaster, see Chantal Quirot, "La table surréaliste," *Cahiers du musée national d'art moderne* 11 (1983): 170–71.

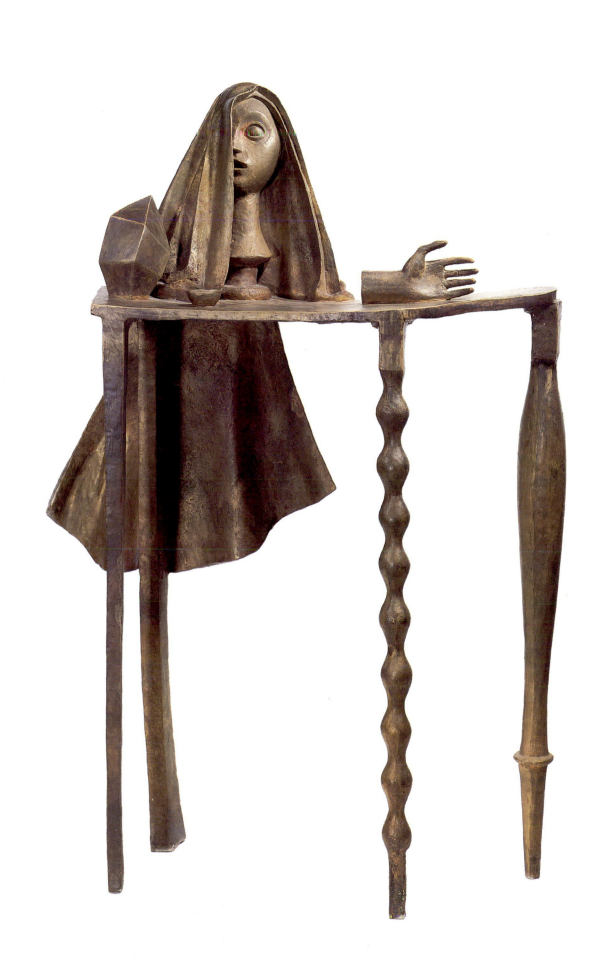

21

The Invisible Object (Hands Holding the Void)

1934, cast 1935
Bronze, 1/6, Alexis Rudier Foundry
60¼ x 13¼ x 9¼ in.
Signed and dated, top rear base: Alberto Giacometti
1935 1/6
Incised, rear base LR: Alexis Rudier Fondeur Paris
The Saint Louis Art Museum, Friends Fund

This sculpture was Giacometti's first life-size representational figure complete with head and arms, yet its intent was entirely Surrealist. The slender body, derived from *Walking Woman* [17], half-sits on a support that tilts forward so that the figure seems to stand with legs bent as if poised for movement. Yet the rectangular tablet inexplicably balanced on her lower legs inhibits motion, thereby producing a subliminal element of helplessness and frustration.

The figure holds her hands out in front, folded around an invisible object, symbolizing the emptiness of a metaphysical void. In French the variant title, *Mains tenant le vide,* makes a pun on "now the void," as if prognosticating a permanent state of being. By making an unseen, indefinable, unknowable concept the focus of the composition, Giacometti created an enigmatic image that invites speculation and imaginative reverie. The entire image, from the tenuously held hands around the void to the body's forward tilt and strangely fixed eyes, is an image of unfulfilled metaphysical desire. The powerful symbolic use of empty space and the philosophical angst over "nothingness," as well as the immobility of the standing frontal female nude, anticipate Giacometti's later work. In a poem of 1933, the artist wrote:

I turn in the void and I gaze in broad daylight at space
 and the stars
that flow through the liquid silver that surrounds me . . .
I seek gropingly to grasp in the void
the invisible white thread of the marvelous
which vibrates and from which facts and dreams escape
with the sound of a stream over living, precious little
 stones.[1]

A hieratic and totemic work, *The Invisible Object* bears comparison with the mystery of primitive and ancient sculpture. The overall composition may have derived from a female wood figure almost six feet tall from the Solomon Islands (fig.

14), which had long been on display in the Museum für Völkerkunde in Basel (Giacometti visited Basel in November 1932). Another possible source was a wood figure from Papua New Guinea in the von der Heydt Collection, Museum Rietberg, Zurich. The motif of the hands may have originated in an Egyptian statue of Queen Karomama (Musée du Louvre, Paris) carrying an invisible idol to Isis, which Giacometti drew many years later (see fig. 18).[2] Curved, open hands in various positions had also been extensively utilized in modern sculptures by Rodin.

The figure in *The Invisible Object* is set against a rectilinear frame that recalls the enclosed cage structures of *Three Figures Outdoors* [12] and *The Cage* (see fig. 3). It sets the figure in an imaginary locale distinct from real space, but it also serves as a formal device because it provides an abstract geometric frame as a foil for the softer forms of the figure. On one side is a strange ovoid form, usu-

Fig. 14 Bougainville, Solomon Islands. Female Figure, painted wood, 69 in. high. Museum für Völkerkunde, Basel.

ally identified as the head of a bird (or possibly a fox). Its meaning is unclear, perhaps a sexual symbol or morbid omen (for example, bird-like demons of death occur in Polynesian art).

At first Giacometti had experimented with a naturalistic head (visible in fig. 7) but was dissatisfied with it. André Breton recounted the artist's fortuitous discovery of a metal mask in the Paris flea market.[3] Without knowing the mask's purpose (it was a prototype protective mask developed by the French Medical Corps during World War I), Giacometti used its shape to model a new head (Ny Carlsberg Glyptothek, Copenhagen) to replace the realistic head.

From the original plaster of *The Invisible Object* (Yale University Art Gallery, New Haven), three bronze casts were made in 1935 by the Alexis Rudier Foundry. Two have golden patinas, including 3/6, which belongs to the National Gallery of Art, Washington, D.C. Cast 2/6 with a dark patina and no foundry mark belongs to a private collection in California. During (or possibly before) the early 1950s, Alberto instructed Diego to remove the bird form. Four more casts were then made (c. 1954–55) by the Susse Foundry, all with dark patinas. Cast 0/6 is in a private collection in New York; 4/6 belongs to a private collection in Italy; 5/6 to the Albright-Knox Art Gallery in Buffalo; and a special cast was made in 1964 for the Fondation Maeght. Giacometti made an etching of the sculpture in 1934–35 (Museum of Modern Art, New York).

1. "Charbon d'herbe," in Giacometti 1933, p. 15; see similar translation in Wolf 1974, p. 38

2. Hohl 1971a, pp. 104, 298, n. 15; Guggenheim Museum 1974, p. 22; and Krauss 1984, pp. 504–5.

3. André Breton, "Équation de l'objet trouvé," *Documents* 34, no. 1 (June 1934): 17–24.

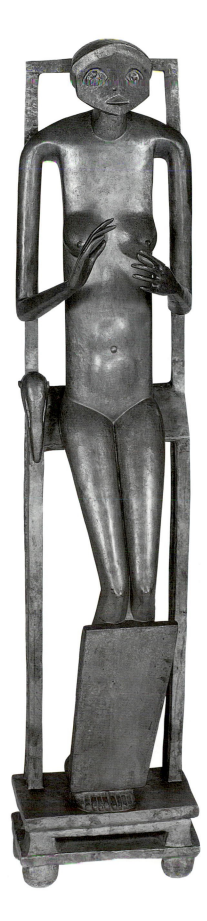

22

Head/Skull

1934, cast 1950s
Bronze, 1/1
7 x 7½ x 8⅝ in.
Signed, R side head along bottom: A Giacometti 1/1
Hirshhorn Museum and Sculpture Garden, Smithsonian
Institution, Washington, D.C., gift of Joseph H. Hirshhorn

Originally called *Head of a Man,* this sculpture and related versions were entitled by Giacometti *Head/Skull* after World War II, although because of its style it has often been called *Cubist Head.*[1] There is a marked contrast between the two sides of the work. From one profile it resembles a head with solid facial planes, while from the other side it suggests the hollowed out, bony structure of a skull, as if to suggest that death lurks just below the surface. The Hirshhorn Museum *Head/Skull* differs from all other known versions. Instead of having two shallowly recessed eyes, this version has one eye cut out. The resultant gaping hole increases the haunting effect, intimating the utter emptiness of a skull devoid of life.

Head/Skull expresses the artist's obsession with death. It recalls his descriptions of the death of the Dutchman Pieter van Meurs, which had traumatized Giacometti in 1921 and which he always said profoundly changed his life. In 1923 he made a drawing of a skull (Robert and Lisa Sainsbury Collection, University of East Anglia, Norwich, England) and painted a small still life of a skull resting on a book (private collection, Paris)—a format found in some late works by Cézanne. In 1951 Giacometti described a disturbing experience:

[B]it by bit, the difference between seeing a skull before me or a living person became minimal. . . . The skull finally takes on a living presence. . . . On the other hand, working from a living person . . . I came to see through to the skull. . . . One day while drawing a girl's head, it suddenly struck me that the only thing that remained living was the gaze. The rest of the head gradually became transformed into the equivalent of a dead person's skull. . . . What makes the difference between a dead and a living person is the gaze. And I wondered if it wouldn't be interesting to sculpt such a skull.[2]

Giacometti may have been prompted to model *Head/Skull* not simply by a Surrealist morbidity but specifically by the deaths of two people he knew: a young acquaintance, Robert Jourdan, whose corpse Giacometti found one morning in April 1932,[3] and his father, Giovanni, in June 1933. *Head/Skull* may also be a form of self-portrait, especially when compared with several self-portrait drawings from 1923–24, 1934–35, and 1937.

The Hirshhorn Museum also owns the plaster from which this single bronze was cast. Giacometti gave the plaster to Man Ray, probably in 1935, in exchange for photographs Man Ray had made in 1932 and 1934–35 of Giacometti's Surrealist sculptures for publication in *Cahiers d'art.* Man Ray had also made several portrait photographs of Giacometti (see frontispiece). Pittsburgh collector G. David Thompson acquired the plaster from Man Ray.[4]

Several plasters, marbles, and terra cottas exist, all with shallowly recessed eyes. From their creation they were widely exhibited in Surrealist group exhibitions (in New York, Paris, Copenhagen, and London in 1934–36). Of the three known plasters (aside from the Hirshhorn variant), one was acquired before the 1940s by Pierre Bruguière; one is now in the Alberto Giacometti Foundation; another remained in the artist's family until 1987. Two white marbles exist (one in the Mr. and Mrs. Raymond D. Nasher Collection, Dallas; the other formerly in the James J. Sweeney Collection, New York). A terra cotta must also have existed in 1934 because it was exhibited in January 1935 and belonged to a private collection in Versailles by 1947. An edition of seven or eight bronzes (numbered as six) was cast in the 1950s. Most are in private collections (including two 4/6 casts), and 1/6 belongs to the Art Institute of Chicago. In 1934 Giacometti made an etching of *Head/Skull* (Museum of Modern Art).

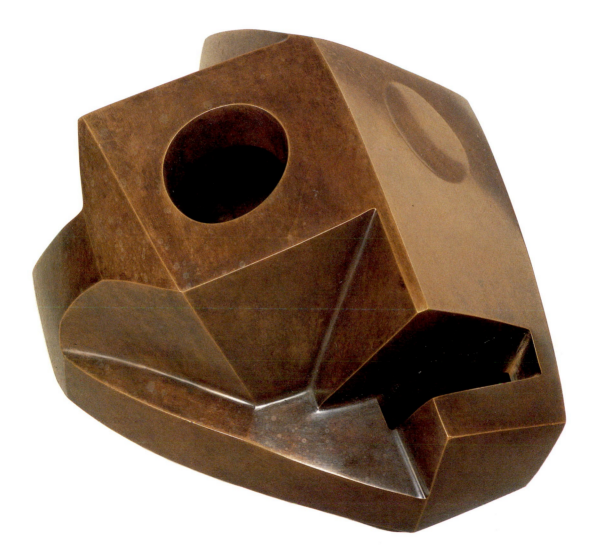

1. Plaster illustrated in E. Tériade, "Aspects de l'expression plastique," *Minotaure* 5 (1934): 42, as *Tête d'Homme;* in Giacometti's 1947 letter to Pierre Matisse, in Matisse 1948, p. 41, as *Tête/ Crâne.*

2. Giacometti, interview with Charbonnier, March 1951, in Charbonnier 1959, pp. 165–66.

3. The incident as remembered by the artist, Diego, and others is recorded in Lord 1985a, pp. 134–36.

4. In his autobiograpy, *Surrealist Portrait* (London: André Deutsch, 1963), p. 252, Man Ray recounted having received several sculptures from Giacometti for the photographs he made. The provenance and casting information was confirmed by Juliet Man Ray, conversation and correspondence with author, 1984–85.

23

Cube

1934 (with incised self-portrait, c. 1936–46), cast 1954–62
Bronze, 1/2, Susse Foundry
37 x 23½ x 23½ in.
Signed, front LL: Alberto Giacometti 1/2
Incised, lower rear: Susse Fondeur Paris
Alberto Giacometti Foundation, Zurich

Completed in early 1934, *Cube* is actually an asymmetrical polyhedron of twelve facets. Its monolithic form, with no evident symbolic allusions, appears to be a purely formal composition without meaning, but related works and alternate titles provide clues to possible interpretations. According to the artist, the original source of inspiration was a polyhedron in Albrecht Dürer's *Melancholia I* engraving of 1514 (fig. 15), which had been included in the Dürer/Rembrandt print exhibition at the Musée du Petit Palais in Paris in spring 1933.[1]

Giacometti first represented a version of *Cube* in a drawing of 1933 entitled *Lunaire*, where it was contrasted with a floating female head/moon. When the plaster *Cube* itself was first exhibited and published in 1934, it was entitled *Pavillon nocturne* and stood on a four-legged base, possibly with wheels. According to Brenson, this nocturnal pavilion was to have stood outdoors and reflected lunar light, possibly as an element in a multipart sculpture—a highly poetic function.[2]

Given Giacometti's propensity for male/female polarities, the use of *Cube* in *Lunaire*, where it is paired with a female head/moon, suggests that *Cube* may have had a male connotation. In *Surrealist Table* [20] and *Figure*, 1935 [24], a similar form is juxtaposed with apparently female busts, although in all three works the head is androgynous. Sometime later Giacometti confirmed the male connotations of *Cube* by incising a frontal self-portrait head on the top facet. This also acccounts for his later statement that he had never really made abstract sculpture except for *Cube,* which he considered a male head.[3] The self-portrait may have thus been done as a deliberate gesture during the late 1930s, when he repudiated his Surrealist sculptures for a representational style.[4] Or he may have executed it spontaneously after returning to his

Paris studio in the late 1940s, when the two *Cube* plasters sat in a corner adjacent to his worktable (visible in fig. 7).

At least two plasters exist, which remained in the possession of the artist's family. In 1987 the one without the self-portrait was promised to the Musée National d'Art Moderne, although it is in deteriorated condition. One bronze was cast from each plaster before the artist's death; the one without the self-portrait belongs to the Fondation Maeght.

Fig. 15 Albrecht Dürer. *Melancholia I,* 1514, engraving, 9½ x 7⅜ in. National Gallery of Art, Washington, D.C., Rosenwald Collection.

1. Giacometti later cited Dürer's print as the source to his wife, who in turn mentioned it to their friend Michel Leiris; see Brenson 1974, p. 201, n. 50. Giacometti had copied another Dürer print as early as 1914–15 (reproduced in Carluccio 1967, no. 1).

2. The original plaster bases for the Cubes are no longer extant; illustrated in E. Tériade, "Aspects de l'expression plastique," *Minotaure* 5 (1934): 42. Exhibited with base at Kunsthaus Zurich (1934) as *Pavillon nocturne*. Exhibited in *Thèse, antithèse, synthèse* at the Lucerne Kunstmuseum (1935), no. 33, as *Partie d'une sculpture*. See Brenson 1974, p. 177; Hohl 1971a, pp. 104–5.

3. Lord 1965, p. 49.

4. Hohl dates the self-portrait to 1936–38; see Guggenheim Museum 1974, pp. 28, 45, n. 43.

24

Figure

1935
Ink on paper
11⅛ x 7⅞ in.
Signed and dated, LR: Alberto Giacometti 1935
E. W. Kornfeld, Bern

Although most of Giacometti's drawings from 1925–35 document his Surrealist sculptures, several small ink drawings are more imaginative. Such ink drawings rely on thin, uninflected black lines with virtually no modeling or reworking; the graphic complexity of this work lies in its disciplined cross-hatching. In *Figure* Giacometti combined the abstract geometric forms found in many of his sculptures of 1927–34 with the figurative interests that began to re-emerge in 1932–34. The stylistic contrast between figurative forms and rectilinear geometry is found in *The Invisible Object* [21] and *Still Life*, c. 1935–36 [25].

Figure relates particularly to *Surrealist Table* [20], where a veiled androgynous bust, unattached hand, and polygon occupy a table. This drawing has a more human figure, with the gesture and glance focused on the polygon as if to assert that the human element dominates inanimate abstraction. The jagged form on the right poses a threat, although not an intimidating one since the form is immobile. Originally the figure's left hand emerged from this ragged edge, but it is barely visible now because that area has been rubbed away. The square table leads the eye into a black void, establishing a second focus: the human being versus the nothingness of the void.

25

Still Life

c. 1935–36
Bronze, 3/8, Susse Foundry
19¼ x 27⅛ x 1⅛ in.
Signed, LR: Alberto Giacometti 3/8
Private collection, Paris

Relief sculpture is exceptional in Giacometti's oeuvre. Only two are known, both done in plaster during the late 1930s. The other relief is known through a photograph taken by Emile Savitry of the artist's studio c. 1946 (see fig. 7), where a partially obscured plaster appears to depict a landscape with two trees. In *Still Life* Giacometti presents a modest subject: the small bookshelf in the studio [visible near the bed in 16b and near Diego in 47]. On the shelf are several mundane objects, including two books, two pens or brushes, and a glass. Featured by itself on top is a small bust of a woman, possibly a head of Rita Gueffier, a professional model who posed daily from 1935 to 1938. A photograph taken of the studio c. 1936–38 by Bruguière shows this bookshelf with a remarkably similar plaster *Head of Rita* on a cubic base.[1]

When Giacometti returned to representational art in 1935, he focused on sculpture and drawing. Relief sculpture offered a ready combination of two- and three-dimensional art. Although modeled from solid material, the relief allows for illusionistic effects, such as the modest use of pictorial perspective in the bookshelf, combined with the actual depth of the small bust, which stands out slightly from the background. *Still Life* anticipates Giacometti's postwar paintings and drawings in its use of an enclosing frame and in its subject matter taken from the daily objects in his studio [see 55].

1. The Bruguière photograph is reproduced in Musée Rath 1986, p. 86. Two plaster heads of Rita without bases are reproduced in Dupin 1962, pp. 227–28, 230.

26

The Artist's Mother

1937
Oil on canvas
24 x 19¾ in.
Not signed or dated
Private collection
Hirshhorn Museum and Sculpture Garden only

From about 1925 on Giacometti had ceased painting in his Paris studio, although he occasionally painted during visits to Switzerland. In autumn 1937 he completed three canvases that laid the groundwork for his postwar painting style. Here he portrayed his beloved, white-haired mother in her habitual black dress. Her forceful personality is implicit in her direct gaze. The effectiveness of this portrait resides not in resemblance or characterization but in its execution. The face consists of countless strokes layered over and around one another, building up a dense surface. She is set against a background organized into a geometric schema. The right side is divided into vertical sections, while the left has predominantly horizontal segments. This stable, essentially abstract structure is partially negated by scratchy, hatching strokes, as if a struggle exists between the secure and the chaotic. Even in the face, although to a much lesser degree, there is a barely discernible infrastructure within the layers of strokes. The dialectical process between the geometric framework and the nervous, rapid brushstrokes characterizes many of Giacometti's mature paintings, as in *The Artist's Mother,* 1950 [52], where the geometry nearly overwhelms the small figure, and in *Peter Watson,* 1954 [74], where the linear setting provides a sense of stability.

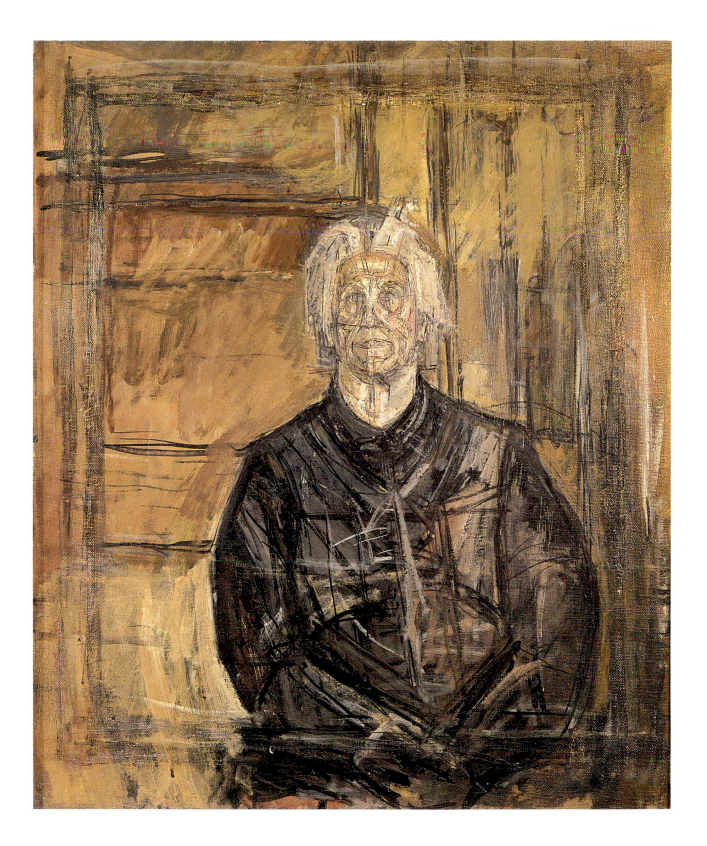

27

Still Life with Apple

1937
Oil on canvas
29⅛ x 30⅛ in.
Signed and dated, LR: Alberto Giacometti 1937
Private collection
Hirshhorn Museum and Sculpture Garden only

When Giacometti returned to figurative art in 1935, he directed his attention primarily to sculpture. In painting three canvases in 1937, the influence of Cézanne was crucial, particularly in two still lifes of apples. The subject had been one of Cézanne's signature themes, but his were usually complex images composed of other fruit, objects, and drapery. Giacometti had long been familiar with such compositions; emulating his father, he had painted a Cézannesque watercolor, *Still Life with Apples* (private collection, Europe), in 1920.

Although Giacometti had seen Cézanne's art on visits to Italy in 1920–21 and in Paris during the 1920s, the paintings from 1937 suggest more immediate or recent influence. Giacometti undoubtedly was responding to the stimuli of several events in 1936, which marked the thirtieth anniversary of Cézanne's death. The Musée de l'Orangerie presented an exhibition of his works, and articles were published in several magazines, including *L'amour de l'art*, *Le point*, and *Renaissance*. Also in Paris several noteworthy studies on Cézanne were completed, including John Rewald's dissertation at the Sorbonne, Maurice Raynal's book, and Lionello Venturi's two-volume catalogue raisonné with sixteen-hundred illustrations. Among the lessons Giacometti learned from Cézanne's art was the method of defining forms with multiple outlines that mediate between solid forms and their surrounding space.

According to Diego, Alberto started this painting at Maloja with several apples, but "there was more than enough to do with one."[1] The single apple provides a focus for the subtle composition and complex brushwork. The contrast in scale of the tiny apple to the solid table below and empty space above creates a grand effect unexpected in such a humble motif. Overall the canvas has a for-

mal geometric structure that is partially negated by layers of paint. As in Cézanne's late watercolors, multiple black lines and patches of subdued color define forms without clearly delineating them. Repeated lines establish and then contradict boundaries, as if the forms in space eluded the artist or kept shifting. This painting testifies to Giacometti's quest for form and structure, which he insistently denied and then reaffirmed. His struggle is evident in the execution of this work. Some areas are thinly painted while others have been covered repeatedly. Giacometti painted several frames on the canvas to contain the composition but scratched them out and overpainted several times, as if unsure how to define the limits of the image. This dialectical approach to form and space, to representation versus painterly substance, would characterize his later paintings. Unlike the gray tonality in most of his later paintings, the color scheme here is naturalistic, with the yellow apple on the white cloth providing coloristic focus amid the brown wood of the sideboard and background.

1. Diego Giacometti, June 17, 1977, in Lord 1985a, p. 183.

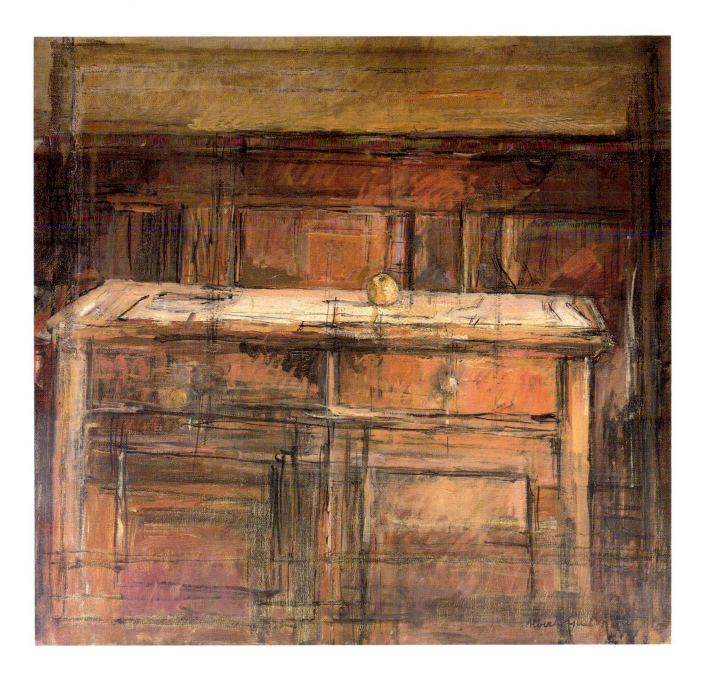

28

Still Life with Apple

1937
Oil on canvas
10½ x 10½ in.
Not signed or dated
Private collection, New York

Because Giacometti painted scarcely a dozen canvases between 1925 and 1946, it is noteworthy that he made two versions of this subject. Focusing on the single object in the family home apparently allowed him to concentrate on stylistic concerns and develop the beginnings of his mature art. Compared with the larger 1937 canvas with the same title [27], this painting looks more assured and spontaneous. The coloristic distinctions here between yellow fruit, white cloth, and brown wood paneling are clearly established. The thin black lines are exquisitely incisive, and the struggle between two- and three-dimensional space has been harmoniously resolved. The slightly raised viewpoint and smaller spatial setting focus attention on the apple, while in the larger painting the spatial environment seems to overwhelm the tiny fruit. In the larger canvas overpainted lines can just be discerned outlining the size and composition of this smaller still life. After revising the larger work repeatedly, Giacometti may have narrowed his focus and quickly executed this painting.

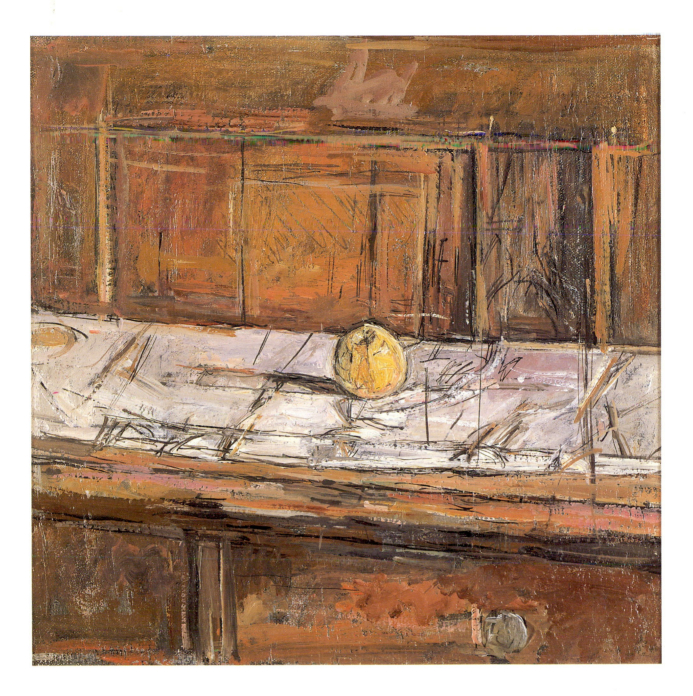

29

Small Bust on a Double Base

c. 1940–41
Bronze, L. Thinot Foundry
4½ x 2½ x 2¼ in.
Signed, rear base: A. Giacometti
Incised, base: Thinot Paris
Private collection, Paris

30

Small Standing Man on a Base

c. 1940–41
Bronze, L. Thinot Foundry
3¾ x 2½ x 1½ in.
Signed, rear base: A. Giacometti
Incised, base: Thinot fdr
Private collection, Paris

In his period of experimentation during 1935–45, Giacometti sought to grasp the entirety of his subject, usually a bust or standing figure. To convey that sense of wholeness, he portrayed each as if seen from afar. Thus the disproportionately large bases were intended to create the illusion that the figures are located at a distance, where they appear small and indistinct, yet retain a sense of reality.

After the various busts of 1935–38, which had ranged from life-size to small, in 1939–40 Giacometti became obsessive about tiny scale:

To my horror my statues got even smaller after 1940. . . . All my figures stubbornly shrank to one centimeter high. Another touch with the thumb and whoops! no more figure.[1]

These two sculptures were done in the Paris studio before the artist's departure in late December 1941 for Geneva, where he continued to model diminutive figures. Although photographs of the artist's studio in the late 1940s document numerous tiny figures and busts, most did not survive.

In the course of making these tiny works, the artist questioned the ontology of the sculptural object, reducing figurative sculpture to its physical minimum, as he had done earlier in a different style with *Flower in Danger* [19]. By reducing a figure to almost nothing, Giacometti made its relation to the surrounding space meaningful, implying the frailty and insignificance of the human subject in a vast, empty universe. Precisely at the time he was obsessed with tiny figures, Giacometti expressed his enthusiasm for the images in Jacques Callot's prints with their "multitude of miniscule people . . . often emerging from the white void." He admired "the great gaping void in which gesturing figures are exterminated and abolished."[2]

1. Giacometti, interview with Jean Clay, in Jean Clay, "Alberto Giacometti," *Réalités* (Paris), no. 215 (December 1963): 135–45.

2. Giacometti, "A propos de Jacques Callot," *Labyrinthe* 7 (April 15, 1945): 3.

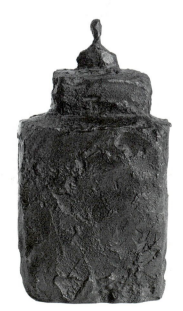

29

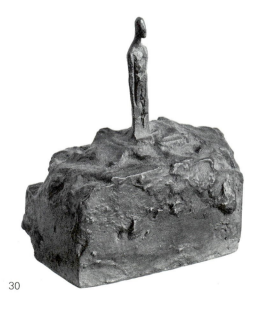

30

31

Woman on a Chariot I

c. 1942–43, cast c. 1962
Bronze, 6/6, Susse Foundry
63½ x 15¾ x 14½ in.
Signed, R side of base LR: Alberto Giacometti
Incised, rear base LR: 6/6 Susse Fondeur Paris
Sara Hildén Foundation, Sara Hildén Art Museum,
Tampere, Finland

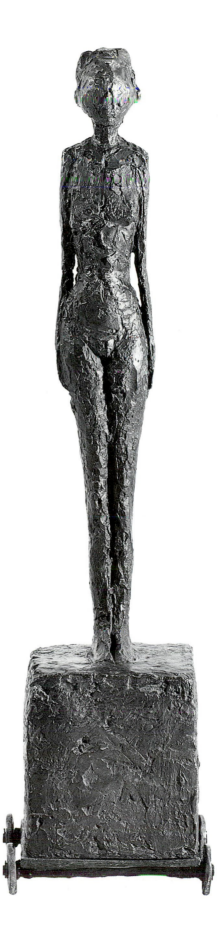

Unlike the tiny figures on large bases, this nude is
nearly life-size. That it was modeled at the Maloja
house may partially account for the disparity
between this sculpture and those Giacometti created
in his hotel room in Geneva during the early 1940s.
Woman on a Chariot I seems to have been a break-
through work, although he did not follow up on
its forms until 1946–47. The anatomy is more
naturalistic than his later highly stylized nude
sculptures, a transition from the soft body of the
1932 *Walking Woman* [17] to the 1947 *Tall Figure*
[38]. Distantly derived from Rodin but now
becoming more clearly his own, the surface model-
ing of *Woman on a Chariot I* forecasts his postwar
style in a more subdued manner. The forms are
delicately variegated, with some particularization in
the hands, although the face is nearly blank.

The original plaster figure stood on a four-
wheeled wood dolly. A practical application of the
wheeled base was that the large figure could be
moved back and forth so that the artist could study
perceived changes in its phenomenological size.
The irony of the wagon-like base is implicit: the
woman's feet are fixed to it so she can be rolled
around but cannot control her mobility. She is a
plaything or prisoner to be pushed around by the
artist. As a subtle touch, the wheels themselves are
tilted and wobbly, making her ride precarious.
(However, this effect probably occurred as the
metal pins and washers became worn, well after
the plaster was modeled.)

Giacometti had painted facial details and a
necklace on the white plaster, and by mid-1943 he
had also executed a life-size nude on the studio wall
adjacent to the plaster.¹ Lacking the Cézannesque
qualities of the 1937 canvases, this mural (private
collection, Switzerland) was painted from the
sculpture, a practice he resumed after the war [see

32

The Artist's Mother

1946
Pencil on paper
19½ x 13¾ in.
Signed and dated, LR: Alberto Giacometti 1946
Private collection
Hirshhorn Museum and Sculpture Garden only

39]. After remaining at Maloja for many years, the plaster passed to Giacometti's doctor and in 1986–87 was acquired by the Wilhelm-Lembruck-Museum in Duisburg. Bronzes from the numbered edition of six belong to the Staatsgalerie Stuttgart, a private collection in Chicago, and two private collections in Paris.

1. On his first visit to the Giacometti house at Maloja in summer 1943, Swiss photographer Ernst Scheidegger saw and photographed the completed plaster and painting. His photograph is reproduced in Bündner Kunstmuseum 1986, p. 40 (German edition), p. 44 (French and English edition).

This drawing was probably done during Giacometti's first visit to Switzerland in spring 1946 after having resettled in Paris in September 1945. It reveals the sudden and powerful transformation of his style in all media in that short period, after years of seemingly fruitless experimentation. He made two very similar drawings of this image; since the other is more extensively erased and resketched, it may have been the first working study, while this drawing presumably presents the artist's final version. Here the dark pencil strokes vigorously define the head, which is scarcely identifiable as his mother (she once complained that his mature style made her look like a witch). The head seems pulled upward, providing a vertical tension on the otherwise empty sheet of paper. The face is divided: the left side starkly expressionist with dark strokes, while the right is almost vacant—a powerful, disturbing, almost schizophrenic image.

Alberto Giacometti
1946

33

Jean-Paul Sartre

1946
Pencil on paper
11¾ x 8⅞ in.
Signed, LR: Alberto Giacometti
Private collection, New York

After meeting Sartre in 1939, Giacometti saw him often in 1939–41 and from late 1945 through the mid-1950s and sporadically thereafter.[1] Giacometti made at least four drawings of the writer-philosopher, all dating from 1946–49. Like most people who sat for Giacometti, Sartre was fascinated by the artist's draftsmanship and concentration. He described the function of the lines in this and other drawings by his friend:

One day when he had undertaken to draw me, Giacometti burst out astonished, "What density, what lines of force!" I was more astonished than he, for I think my face rather flabby, like everyone else's. But the fact is that he saw every line in it as a centripetal force. Seen that way, the face turns back on itself like a loop which closes in on itself. . . . Note how many lines . . . are inside the form they describe . . . they represent intimate relations of the being with itself. All these lines are centripetal: their purpose is to tighten, contract; they force the eye to follow them and always lead it to the center of the figure.[2]

A similar half-length depiction formerly belonged to the Milton Ratner Family Collection. Two drawings of the head alone belong to a private collection and to the Hirshhorn Museum.

1. For details of their early friendship see Fletcher essay, n. 6.

2. Sartre 1954 (*Art News*): 64.

Alberto Giacometti

34

The Nose

1947, cast late 1950s
Bronze suspended by twine-covered steel wire in iron frame,
1/6, Susse Foundry
Overall: 32 x 28½ x 15⅜ in.
Head: 16⅜ x 28½ x 3⅜ in.; cage: 32 x 18 x 15⅜ in.
Signed, bottom neck: Alberto Giacometti 1/6
Incised, front bottom neck: Susse Fondeur Paris
Hirshhorn Museum and Sculpture Garden, Smithsonian
Institution, Washington, D.C., gift of Joseph H. Hirshhorn

Despite the artist's vociferous disclaimers, Giacometti's connections with Surrealism were still near the surface after his return to Paris, particularly in 1946–47 as he renewed contacts with his prewar friends. Although its representational form and modeling style place *The Nose* with Giacometti's other postwar busts and figures, this sculpture clearly relates to the artist's earlier Surrealist works. The frame from which the head is suspended consists of the same metal and shape as the cage used in *Suspended Ball* (see fig. 2). By using the basic format of the 1930 construction that had brought him instant acclaim but substituting a human head for the earlier abstract forms with their sexual innuendoes, he made a parallel bid for fame based on his new figurative style. With its elongated proboscis, *The Nose* also recalls *Point to Eye*, 1932 (fig. 16), in which a long, pointed form threatens the eye of a tiny head. In the 1947 sculpture the relationship is reversed. Instead of aiming at the head, the elongated form extends outward from the head, penetrating the space beyond the cage as if to assault the viewer—a fanciful violence characteristic of Surrealism. Similar forms can be found in drawings and paintings by Yves Tanguy and Dali. The concept of a head held within a spatial framework in *The Nose* may owe a debt to the *malanggans* of New Ireland, beloved by the Surrealists; Giacometti made drawings of three such carvings during the 1940s.[1] The overall shape of the head was likely inspired by a bamboo and bark helmet mask of the Baining tribe of New Britain, on display in 1947 at the Basel Museum für Völkerkunde, which Giacometti had visited.[2]

Two variant original plasters of *The Nose* exist. One is more vigorously modeled and has painted ocher accents on the eyes, mouth, and spiral down the nose. Its effect is heightened by the

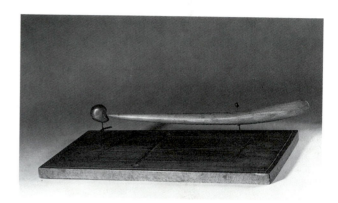

Fig. 16 *Point to Eye,* 1932, wood and metal, 4¾ x 24 x 14 in. Musée National d'Art Moderne, Centre National d'Art et de Culture Georges Pompidou, Paris.

contrasting textures and colors of the plaster, paint, metal cage, and coarse rope. Acquired by the Alberto Giacometti Foundation in 1963, that plaster remains unique, with no bronzes cast from it. The unpainted plaster variant (private collection, Paris)[3] served as the source for the edition of seven bronzes (numbered 0/6–6/6, plus an artist's proof) by the Susse Foundry. Although the exact casting date is not documented, the edition was probably begun in the mid- or late 1950s and finished in the early 1960s; an additional cast may also have been made in the 1960s. Cast 2/6 is in a private collection in New York; 3/6 is in a private collection (formerly in the Milton Ratner Family Collection, sold May 1984); 4/6 belongs to the Museum Ludwig in Cologne; 5/6 belongs to the Solomon R. Guggenheim Museum in New York; and 6/6 is in a private collection in Geneva. Two artist's proofs are in private collections in Paris.

1. Reproduced in Carluccio 1967, no. 5.

2. Reproduced in Hohl 1971a, fig. 62, p. 295.

3. Reproduced in Dupin 1962, p. 236.

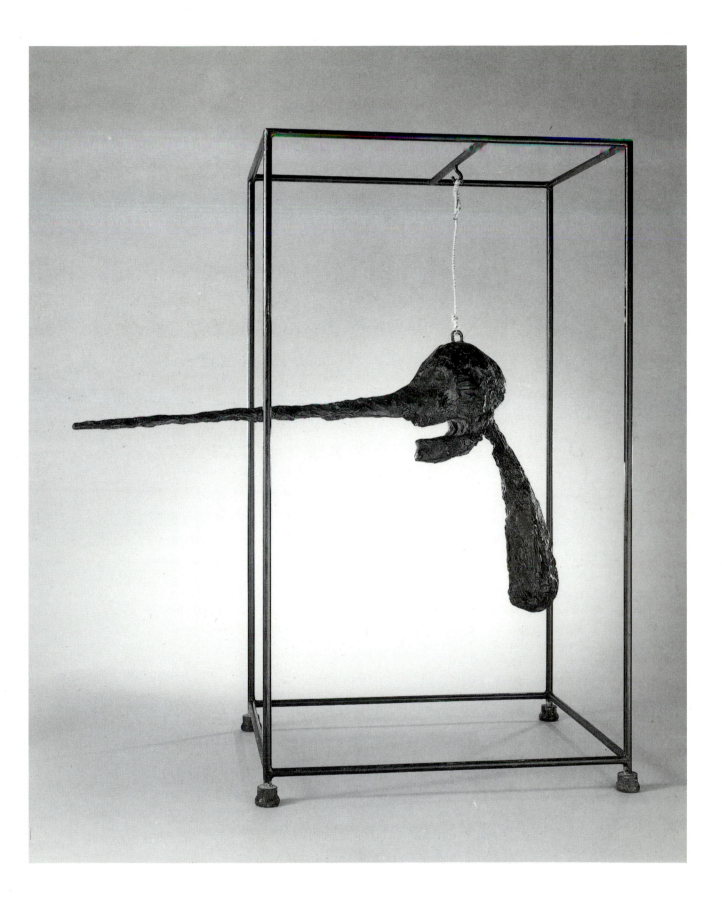

35

Hand

1947
Bronze, 1/6
22½ x 28⅝ x 1¼ in.
Signed, lower edge shoulder: A. Giacometti 1/6
Private collection, Montreal

Like *The Nose* [34], this work uses only part of the body for great emotional effect and recalls an earlier Surrealist sculpture. In *Caught Hand*, 1932 (Alberto Giacometti Foundation), Giacometti incorporated a wood hand into a constructed mechanical device so that the fingers are on the verge of being mauled. In contrast, the impact of *Hand* arises from the anatomy itself. The arm extends horizontally, perched precariously on a metal rod, with the bony fingers reaching out as if in mortal supplication. Executed barely two years after the end of the war, *Hand* readily evokes images of emaciated prisoners in concentration camps, although the artist did not set out to create such a topical image. When Alberto and Diego attempted to flee Paris in June 1940, they saw dismembered bodies after a German bombing, including a woman's arm torn off at the shoulder. In July 1946 the caretaker of the building where Giacometti lived and had his studio, Tonio Pototsching, died in bed from cancer. The artist helped lay out the cadaver and subsequently wrote an essay entitled "Le rêve, le Sphinx, et la mort de T.," in which he described the corpse: "The limbs were spare as a skeleton, outstretched, spread apart, cast away from the body."[1]

Five years later Giacometti wrote a poem, several lines of which seem appropriate for *Hand:*

A blind man extends his hand in the void (in the dark? in the night?)
The days pass and I daydream of catching, stopping that which flees.[2]

Art historical precedents for this sculpture can be found among the sculptures of large single hands executed by Rodin c. 1885–1905. Giacometti was certainly aware of those hands, which relied on exaggerated modeling of muscles and flesh for visual and emotional impact. In contrast Giacometti obtained intensity by skeletal means. Another source may have been a slightly curved wood arm from Easter Island, which Giacometti's friend Pierre Loeb had owned and had given to Picasso sometime before 1942 (Picasso made drawings from it in 1945 and later did a vertical sculpture of an arm in 1959).[3]

Of the edition of six numbered bronzes of *Hand,* two are in private collections in New York and cast 5/6 belongs to the Alberto Giacometti Foundation. The plaster, whose surface retains more sharply modeled nuances, is also in the Giacometti Foundation.

1. Giacometti 1946, p. 12.

2. Giacometti, "Un aveugle avance la main," *XXᵉ Siècle,* n.s., no. 2 (January 1952): 72.

3. Reproduced in Pierre Loeb, *Voyages à travers la peinture* (Paris: Bordas, 1946), p. 46.

36

Head of a Man on a Rod

1947, cast c. 1948–56
Bronze, 6/6, Susse Foundry
21¼ x 5⅞ x 6 in.
Signed, base: 6/6 Alberto Giacometti
Incised, base: Susse Fondeur Paris
Private collection, New York

Unlike most of Giacometti's busts, this sculpture has obvious emotional connotations. With head tilted back, hollow sightless sockets, and mouth open as if screaming, *Head of a Man on a Rod* evokes multiple associations in a psychological drama reminiscent of his earlier Surrealism. Although not intended as an overt symbol, it could represent humanity beseeching or straining against fate, prey to a primal fear. The neckless head mounted on a metal rod also suggests the barbaric practice of decapitating one's enemies and mounting their heads on pikes. This sculpture was most likely inspired by such a human skull (covered with wax, chalk, paint, and beads) from New Ireland, on view in 1947 at the Basel Museum für Völkerkunde, which Giacometti had visited.[1]

Throughout his adult life Giacometti was haunted by the idea of death and its imminence. He often spoke of the death of an older man that he had witnessed in 1921, and his sculpture *Head/Skull* [22] implied the presence of death within the living. *Head of a Man on a Rod* may reflect the recent horrors of the war and the 1946 death of Tonio Pototsching that occurred in the room adjacent to Giacometti's. In his essay "Le rêve, le Sphinx, et la mort de T.," he described "the head thrown back, the mouth open. . . . I looked at that head which had become an object . . . insignificant. At that moment a fly approached the black hole of the mouth and slowly disappeared inside."[2]

Giacometti went on to describe in dramatic terms how this death reinforced an experience he had a few months earlier:

At that time I started to see living heads in the void, in the space that surrounded them. When I first perceived clearly the head that I was watching become closed off and immobile in an instant, definitively, I trembled with terror as never before in my life, and a cold sweat ran down my back. It was no longer a living head but an object—an object that I was seeing like any other object, but at the same time not like just any other object, but as something alive and dead simultaneously. I cried out in terror, as if I had just crossed a threshold, as if I were entering a world never before seen. All living beings were dead, and this vision was often repeated, in the subway, in the street, in the restaurant, with my friends. The waiter at Lipp's who froze, leaning over me, mouth open, having no rapport with the preceding moment, mouth open, eyes congealed in an absolute immobility.[3]

Thus *Head of a Man on a Rod* encompasses allusions not only to the dead Tonio, but also to the artist himself terrified into an involuntary scream, and to his visionary revelation of other individuals immobilized in the void.

Giacometti's first version of a head mounted on a rod on a cube base was a tiny sculpture done c. 1939. It is a straightforward composition without movement or emotional overtones, as are the three later heads of Diego raised on short rods—one modeled c. 1948 (private collection) and two plasters made in 1956–59 with unique bronze casts (Alberto Giacometti Foundation). Of the six numbered bronzes of the 1947 *Head of a Man on a Rod*, one belongs to the Museum of Modern Art in New York, and three to private collections in New York, London, and Paris. One cast has a bronze head on a plaster base. An unnumbered cast was also made in 1964 for the Fondation Maeght. The Alberto Giacometti Foundation owns a very similar, but slightly smaller plaster called *Head on a Rod* (19⅗ inches high), from which no bronzes have been cast. Its head is less tilted, with more gouged surfaces, and is accented with a few painted strokes.

1. Reproduced in William Rubin, "Modernist Primitivism: An Introduction," in *Primitivism in Twentieth-century Art* (New York: Museum of Modern Art), vol. 1, p. 34.

2. Giacometti 1946, p. 12.

3. Ibid.

37

Man Pointing

1947
Bronze, 5/6, Alexis Rudier Foundry
69¾ x 37 x 24 in.
Signed, top rear base: 5/6 A. Giacometti
Incised, base: Alexis Rudier Fondeur Paris
Des Moines Art Center, Coffin Fine Arts Trust Fund

In preparation for his upcoming exhibition at the Pierre Matisse Gallery in 1948, Giacometti worked feverishly to produce many new sculptures. He later recalled how he had hurriedly reworked *Man Pointing*.

I did that piece in one night between midnight and nine the next morning. That is, I'd already done it, but I demolished it and did it all over again because the men from the foundry were coming to take it away. And when they got here, the plaster was still wet.[1]

Unlike the smaller emaciated figures, the life-size *Man Pointing* confronts the viewer at eye level. Unprecedented in sculpture, this stick figure suited the zeitgeist of the war's aftermath—perhaps a positive metaphor for civilization emerging from the years of physical and psychic horror. The pose arouses speculation about what he is pointing to: is he merely giving directions to a passerby, or might he be signaling the path to some brighter future or great beyond?

Some time between 1947 and 1951 Giacometti incorporated a bronze cast of *Man Pointing* into a two-figure composition, with the man's left arm curved around but not touching a standing plaster figure on a large plaster base. Entitled *Group of Two Men* and known only through an unidentified, undated photograph (fig. 17), this composition was not cast in bronze and did not survive.[2] The inclusion of a second figure changes the meaning because the man can be understood as pointing the way to a friend, with a protective or embracing gesture. Such narrative interpretations of this two-figure composition may not have satisfied the artist, for in all his other multifigure sculptures there is no suggestion of communication to bridge the isolation of the individual.

Of the edition of six numbered bronzes, cast 1/6 belongs to the Museum of Modern Art, 2/6 to

the Baltimore Museum of Art, 3/6 to the Tate Gallery, 4/6 to a private collection in London, and 6/6 to a private collection in New York.

1. Lord 1965, p. 34.

2. In the checklist for his exhibition at Galerie Maeght in 1951, the sculpture was listed as no. 28, "*Group of Two Men,* 1947–51, painted plaster and bronze," and the solitary *Man Pointing* was illustrated as *Fragment.* See *Derrière le miroir* 39–40 (June–July 1951), unpag. (which served as exhibition catalog for the Maeght show).

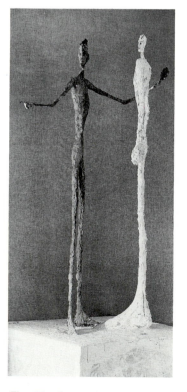

Fig. 17 *Group of Two Men,* c. 1947–51, bronze and plaster, approx. 85 in. high (no longer extant).

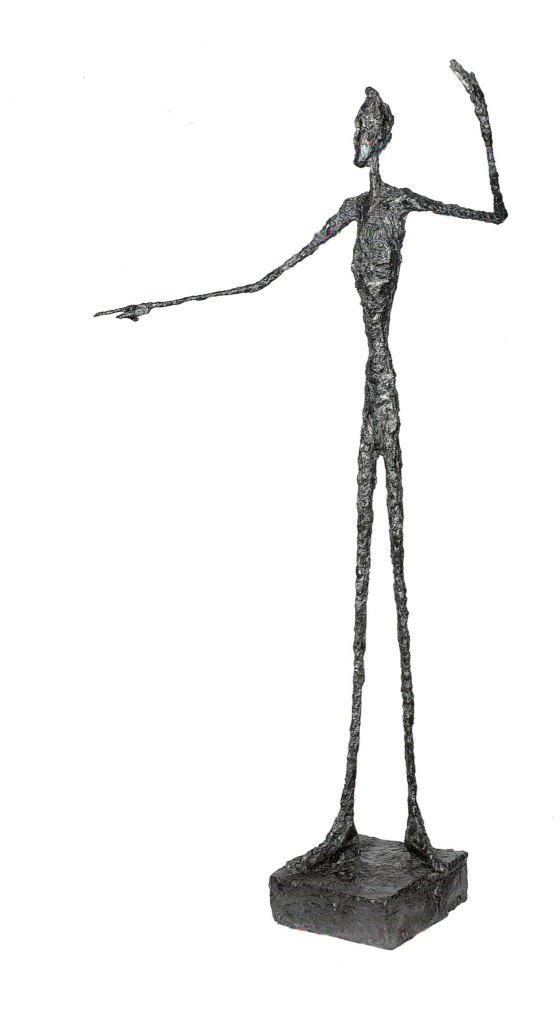

38

Tall Figure

1947
Bronze, 1/6, Susse Foundry
79¼ x 8⅜ x 16⅝ in.
Signed, top base UL: 1/6 Alberto Giacometti
Incised, top base UC: Susse Fondeur Paris
Hirshhorn Museum and Sculpture Garden, Smithsonian
Institution, Washington, D.C., gift of Joseph H. Hirshhorn

In dramatic contrast to the myriad tiny figures that had preoccupied Giacometti from 1939 through the early 1940s, *Tall Figure* stands nearly seven feet tall. He made the transition from small to large in 1946, when he modeled several plaster standing women, which no longer survive.[1] Expressing the artist's ideas, Sartre wrote of the postwar figures:

One does not approach a sculpture of Giacometti. . . . [W]e have intimations of them, we divine them, now we are on the point of seeing them: another step or two, and we are about to have them; one more step, and everything vanishes: there remain the corrugations of the plaster; these statues only permit themselves to be seen from a respectful distance.[2]

During the late 1930s in Paris and early 1940s in Switzerland, Giacometti studied Egyptian sculptures and tomb paintings and often drew them, sometimes from the original objects in the Louvre but more often during the 1940s from reproductions, especially the large color illustrations in books by copyist Nina Davies.[3] Continuing this practice through the early 1960s (fig. 18), Giacometti absorbed into his art a comparable hieratic quality and sense of timeless grandeur. Mysteriously iconic, this immobile, nearly faceless figure asserts her presence and commands silent attention.

Tall Figure was Giacometti's largest figure sculpture since the nearly abstract stone work (approximately eight feet high) of 1930–33 commissioned for the garden of Charles and Marie-Laure de Noailles in Hyères (private collection, Fontainebleau).[4] The 1947 *Tall Figure* remained his tallest representational figure until the Large Standing Women, 1960 [see 92].

This particular figure, indeed this particular cast, did much to establish and define Giacometti's postwar reputation, especially in the United States. It was included in his first postwar exhibition in

Fig. 18 Drawing after Egyptian sculpture, c. 1960, ink on paper, 11½ × 8¼ in. Private collection, Paris.

1948 at Pierre Matisse Gallery and was cited in published reviews. In 1958–60 it appeared in various group exhibitions in museums in Dallas, Houston, Detroit, Milwaukee, Minneapolis, Kansas City, Los Angeles, San Francisco, Colorado Springs, and Toronto. It was included in the Giacometti retrospective at the Museum of Modern Art in 1965, which also traveled to Chicago, Los Angeles, and San Francisco. *Tall Figure* consequently became one of the most recognized of his images along with the various walking men compositions.

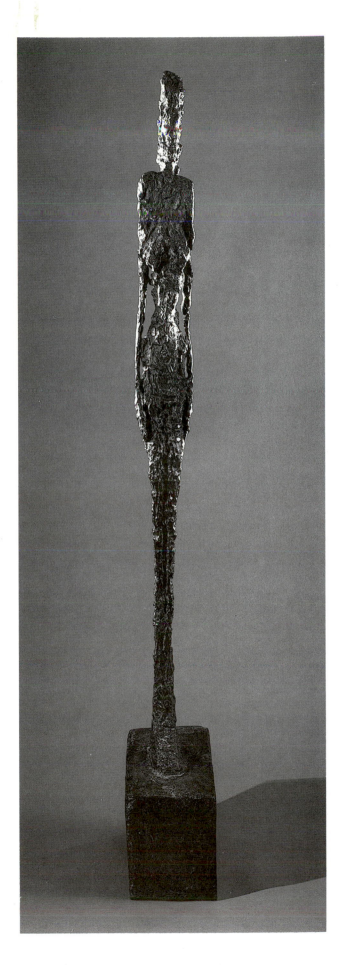

From the original plaster an edition of eight (six numbered, plus one or two misnumbered casts or artist's proof) exists. The Hirshhorn Museum cast is the original 1/6, purchased directly from Pierre Matisse.[5] Another bronze numbered 1/6 was cast by the Alexis Rudier Foundry before 1954 for G. David Thompson, an avid Giacometti collector who often went directly to the artist rather than through his official dealers; it now belongs to a private collection in Switzerland and is on loan to the Alberto Giacometti Foundation. Another bronze numbered 1/6 has belonged to the Giacometti Foundation since 1965; it was cast in February 1957 and purchased through the Galerie Maeght in August 1957. (Because the surface where the number is incised is irregular, this may actually be the 4/6 cast.) Bronze 3/6 was acquired during the 1950s by the Lannon Foundation and now belongs to the Art Institute of Chicago. Another bronze is in a private collection, and a Susse cast belongs to a private art trust in Switzerland.

1. Photographs of the lost plasters (28 3/8 and 49 1/4 inches high) are reproduced in Dupin 1962, p. 235.

2. Sartre 1948, in Matisse 1948, p. 11.

3. Giacometti destroyed most of his drawings from 1942–45, but several copies of Egyptian sources, including statues of standing women, are reproduced in Carluccio 1967, nos. 24–27.

4. Brenson 1974, pp. 95–102, 147–48.

5. Confirmed by Matisse in letter to author, June 28, 1982.

39

Tall Figure

1947
Oil on canvas
54½ x 16¼ in.
Signed and dated, LR: Alberto Giacometti 1947
Pierre Matisse Gallery, New York
Hirshhorn Museum and Sculpture Garden only

On several occasions Giacometti made paintings of individual sculptures, in this case probably the 1947 *Tall Figure* [38]. The surroundings and individual features are not articulated as they are in most postwar paintings of Diego and Alberto's future wife, Annette. The sketchy, dry style differs from the insistent linearity of the paintings done from a live model and here emphasizes the remoteness and mystery of the figure. Giacometti did not make preliminary drawings for paintings or sculptures, and paintings such as this are few. Although he had begun this practice with drawings after some Surrealist sculptures during the early 1930s, from the late 1940s on he believed that an artwork in one discipline could actively stimulate the creation of works in other media and thereafter he often made drawings or prints based on the sculptures in his studio.

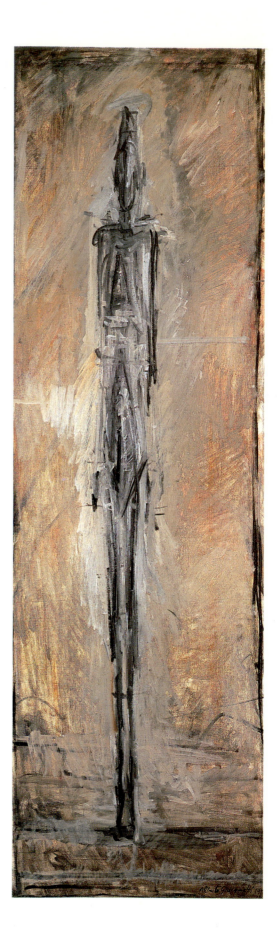

40

Walking Man

1948
Bronze, 1/2
26½ x 4½ x 11⅝ in.
Signed, top base LL (upside-down): A. Giacometti
Hirshhorn Museum and Sculpture Garden, Smithsonian
Institution, Washington D.C., gift of Joseph H. Hirshhorn

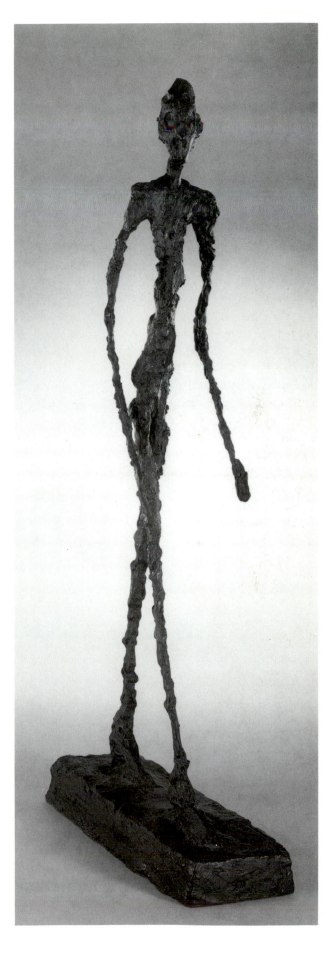

Just as his standing women sculptures continue a long-established art historical tradition, Giacometti's walking men refer to various sources. Those antecedents range from Egyptian statues of pharaohs with one foot slightly forward to the vigorous stride of Rodin's *Walking Man,* 1878, revised 1905. Giacometti was certainly familiar with those sources: he made several drawings of Egyptian walking figures and he undoubtedly knew the 1905 *Walking Man* on view at the Musée Rodin in Paris.

Curiously, Giacometti's development of the walking pose in 1946–49 may have evolved from the tentative step of the ancient pharaoh to the more dynamic stride. Although it is difficult to determine a precise sequence because several early plasters are no longer extant, two large versions from 1947 were composed with a short, hesitant step. One had an arm gesturing out to the side, as if *Man Pointing* [37] had been modified into a forward pose.[1] In the extant life-size *Walking Man,* 1947 (Alberto Giacometti Foundation), he modified the pose by bringing the hands close to the body, still with little space between the feet. In the Hirshhorn Museum *Walking Man* he evolved the pose further, with a more emaciated body and a slightly longer stride.[2] The skeletal anatomy and pose of this sculpture relate it to the figures in *City Square II,* 1948 [41], and *Three Men Walking II,* 1948-49 [42]. Like those sculptures, this figure may have been conceived in an urban context.[3] Or, since Giacometti once spoke of *Man Walking Quickly in the Rain,* 1948, and *Man Crossing a Square in the Sun,* 1949 (both Alberto Giacometti Foundation), as representing himself, this and his other walking men may be considered to some degree as images of the artist. (Giacometti had unusually long arms, as in the Hirshhorn Museum sculpture.) In *Man Crossing a Square in the Sun,* Giacometti made the pose more

41

City Square II

1948, cast 1949
Bronze, 1/6, Alexis Rudier Foundry
9½ x 25 x 17⅜ in.
Signed, side base LL: A. Giacometti 1/6
Incised, side base: Alexis Rudier Fondeur
Albert A. List Family Collection, New York

dynamic by tilting the torso further forward and lengthening the stride; this pose proved to be definitive, for it recurs in the monumental walking men of 1960 [93].

The Hirshhorn Museum bronze was intended as the first of six casts, but only two casts were made; the second, which is painted, is in a private collection in London. The plaster original apparently did not survive.

1. See photographs by Patricia Kane Matisse, reproduced in Matisse 1948, pp. 10, 17, and Limbour 1948, p. 254.

2. According to Annette Giacometti's records, this sculpture dates to 1947–48 (conversation with author, March 25, 1988).

3. Sartre 1954 (*Art News*): 26, described the Hirshhorn Museum sculpture as a man seen in passing in the rear-view mirror of an automobile.

The scale and format of this sculpture recall the Surrealist tabletop pieces of 1931–33, notably *Man, Woman, and Child* (see fig. 4), *No More Play* (see fig. 5), and especially his early idea for an urban sculpture, *Model for a Square* [15]. While the dramas presented in the earlier works were abstract and symbolic or imaginary, *City Square II* refers to a familiar scene based on everyday life. The practice of depicting figures in an urban context had long existed in painting and graphic art, but in the 1940s it was still relatively novel in sculpture. Rodin had composed the multifigure *Burghers of Calais*, 1886 (Hirshhorn Museum and Sculpture Garden), for a city square, but his sculpture rearranged rather than broke with traditional commemorative monuments, as he tried to integrate the bronze figures into actual urban space. In *City Square II* Giacometti did not attempt a heroic representation of historic individuals but presented instead miniature figures in their own separate, imaginary space—like his Surrealist compositions, a motif for contemplation and free association.

Virtually faceless, these anonymous figures stride forward without seeing or speaking to each other in an understated psychological drama of solitary existence. In his 1954 essay on Giacometti, Sartre spoke of his own experience with urban agoraphobia in Paris after being freed from a prisoner-of-war camp in 1941 and related this to Giacometti's work:

[D]istance for him is not voluntary isolation, nor is it recoil: it is requirement, ceremony, an understanding of difficulties. It is the product—as he himself has said—of powers of attraction and forces of repulsion. . . . He has sculptured men crossing a square without seeing each other; they crisscross irrevocably alone, and yet they are *together*. . . . Between things, between men connections have been cut; emptiness filters through everywhere, each creature secretes his own void.[1]

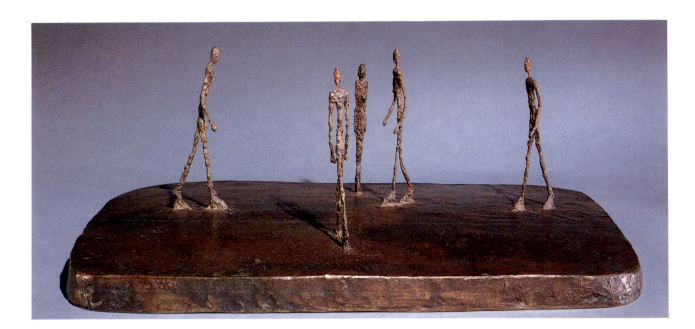

From 1947 to 1952 Giacometti made a number of multifigure drawings and paintings in urban settings, but these tended to be somewhat sketchy, as if he were getting a feel for the theme. In contrast the relationships of shapes and voids in *City Square II* are carefully determined. The figures consist of only a few linear forms, either quite straight (as in the legs and torsos) or slightly curved (as in the feet and heads). They are nearly as abstract as those in the geometric compositions of 1931–33; their forms and variegated surfaces present a satisfying rhythm across the shiny flat base.

Two versions exist of this composition, the second one distinguished by slightly larger figures placed somewhat differently. Most significant, here the male figure near the center edge has been shifted so that instead of aiming past the immobile woman he now heads more directly at her. This change introduces another element to the theme of solitary individuals: the striding male seeking an immobile, iconic female. In Giacometti's drawings and paintings of figures in city settings, movement is dictated by compositional needs, with women and men walking, standing, and sitting. The change between *City Square I* and *II* indicates the start of his sexual stereotyping, which would become constant after 1950.

Casts of *City Square I* belong to the Museum of Modern Art (1/6), Peggy Guggenheim Collection (3/6), Wadsworth Atheneum in Hartford (5/6), the Öffentliche Kunstsammlung Basel (6/6), and private collections in New York (2/6) and Chicago (4/6). Other casts of the second version belong to the National Gallery of Art and a private collection in London; cast 5/6 was destroyed in a fire.

1. Sartre 1954 (*Art News*): 26–27.

42

Three Men Walking II

1948–49
Bronze, 5/6, Alexis Rudier Foundry
29¾ x 12¼ x 13 ⅛ in.
Signed, top base front center: A. Giacometti 5/6
Incised, rear base LR: Alexis Rudier Fondeur Paris
The Art Institute of Chicago, Edward E. Ayer Endowment in
memory of Charles L. Hutchinson

Like *City Square II* [41], this composition depicts figures in an urban setting. Speaking of his multi-figure compositions of this period, Giacometti once remarked:

In the street the people astound me and interest me more than any sculpture or painting. Every second the people stream together and go apart, then they approach each other to get closer to one another. . . . They unceasingly form and reform living compositions in unbelievable complexity.[1]

The elaborate, formal geometry of the base serves a dual function. Giacometti's aim may have been to create the phenomenological illusion of distance, but in putting the anonymous figures on a significant base he raised them above mundane existence, like the heroes of countless public monuments.

Three Men Walking exists in two versions, each cast into a numbered edition of six bronzes. In the first the figures are farther apart on a wider, squatter base. Casts belong to the Alberto Giacometti Foundation, the Museum of Modern Art, and two private collections in New York. This second version is known as *Three Men Passing* because the figures are closer together. From certain viewpoints two heads overlap to the point of appearing as one, suggesting that the figures are anonymous and could be interchangeable. Casts of the second version belong to the Dallas Museum of Art and a private collection in Switzerland. A special cast was made with a brown patina by the Susse Foundry in 1964 for the Fondation Maeght.

1. Giacometti, interview with Jean-Raoul Moulin, 1964–65, in Jean-Raoul Moulin, "Je travaille pour mieux voir," *Les lettres françaises* (Paris), no. 1115 (January 20, 1966): 17, in Hohl 1971a, p. 278.

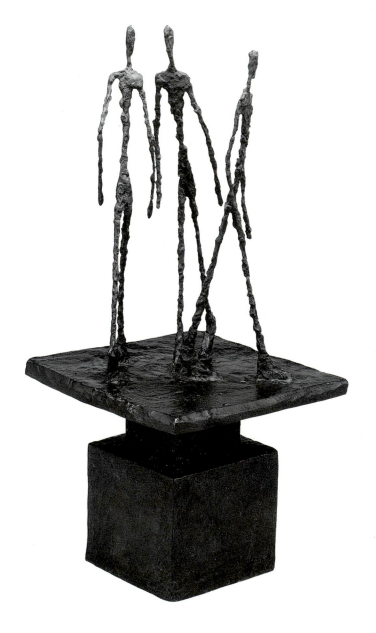

43

Tall Figure

1949, cast mid-1950s
Bronze, 3/6, Susse Foundry
65¼ x 6¼ x 13½ in.
Signed, base LR: Alberto Giacometti 3/6
Incised, base LL: Susse Fondeur Paris
The Museum of Fine Arts, Houston, gift of Robert Sarnoff

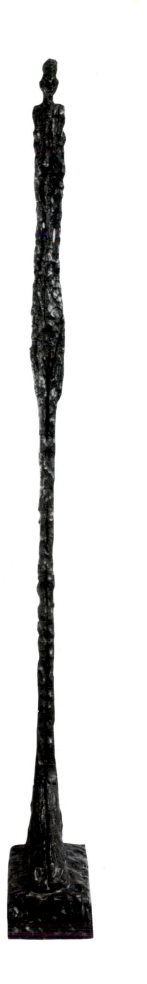

Unlike *Tall Figure* [38], with its somewhat substantial mass, this sculpture is uncompromisingly thin and flat. The female figure is so elongated that it seems to pull the eye upward from the unusually large feet (more than ten inches long) through the nearly abstract body to the tiny head (less than two inches wide) with its topknot of hair. The ultrathin figures have several precedents in art history, notably Etruscan sculptures. The Louvre, which Giacometti frequented, has two such figures, and two more belong to the Archaeological Museum in Florence, which he had visited in 1920. More immediate sources, however, exist in the artist's own work of the 1930s. In 1930 he made a group of three plaster figures outdoors in Maloja (no longer extant); although essentially abstract, they forecast the thinness, flatness, and verticality of the 1949 *Tall Figure*.[1] In the mid-1930s he also designed lamp bases for Jean-Michel Frank, including several thin vertical ones (58½ to 61 inches high), each with a female head.

Bronze casts of *Tall Figure* were exhibited at Pierre Matisse Gallery in November–December 1950 and Galerie Maeght in June–July 1951. Cast 1/6, which belongs to the Alberto Giacometti Foundation, was made by the Alexis Rudier Foundry in 1949–50, but the numbered edition was completed later at the Susse Foundry. Other casts belong to the Tate Gallery, Moderna Museet in Stockholm, and a private collection in Milwaukee. The Museum of Modern Art owns a painted bronze.

1. Reproduced in Maurice Raynal, "Dieu—table—cuvette," *Minotaure* 3–4 (1933): 40.

44

Standing Man

c. 1949
Oil on canvas
28½ x 11¾ in.
Signed, LR: Alberto Giacometti
Mr. and Mrs. James W. Alsdorf, Chicago

As in his sculptures of 1946–49 Giacometti executed a few paintings and drawings of figures in spatial settings, mostly interiors and city streets. He made few paintings of a single standing man, and like *Tall Figure* [39], this figure may have been painted from a sculpture, possibly from an early, life-size plaster version of *Walking Man,* 1947 (no longer extant). Behind the figure is a Parisian street, delineated with barely perceptible pale gray lines mostly overpainted with pale pinkish gray. The street recedes into the distance with disturbingly exaggerated perspective, as in *The Street,* 1952 [66].

The figure is simplified and anonymous, with none of the specificity of Giacometti's painted portraits of live models. Visually, it is curiously compelling; from a short distance, the brushstrokes on the flat surface appear most evident, but from farther away the figure appears three-dimensional, almost hovering in front of the canvas.

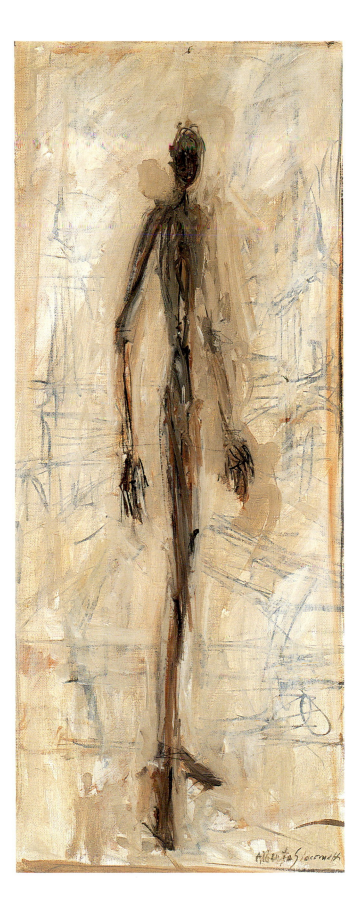

45

Seated Woman (Annette at Stampa)

1949
Oil on canvas
34⅝ x 23⅜ in.
Signed and dated, LL: Alberto Giacometti 1949
Morton G. Neumann Family Collection, Chicago
Hirshhorn Museum and Sculpture Garden only

Although Annette Arm first became involved with Giacometti in 1943–45 during his Geneva sojourn, she did not meet his mother, Annetta, who was living nearby at the time. Only after their marriage in Paris in July 1949 did Annette accompany him on visits to the family homes in Stampa and Maloja. This painting therefore constitutes a kind of family document, depicting his young bride seated in the living-dining room at Stampa shortly after their wedding.

Although his studio was nearby, the artist repeatedly posed members of his family in this particular spot in front of the bedroom door. (He did a portrait of Diego there as early as 1920). The familiar surroundings (see fig. 20), especially the furniture and intricate design of the oriental carpet, seemed to fascinate Giacometti during 1947–50. In this and several other paintings [see 52], he constructed a complex spatial environment compulsively filled with lines. Within this maelstrom of orthogonals, the figure seems small and remote—an unsettling image of distance and Existential "otherness" quite alien to the domestic intimacy normally associated with the subject.

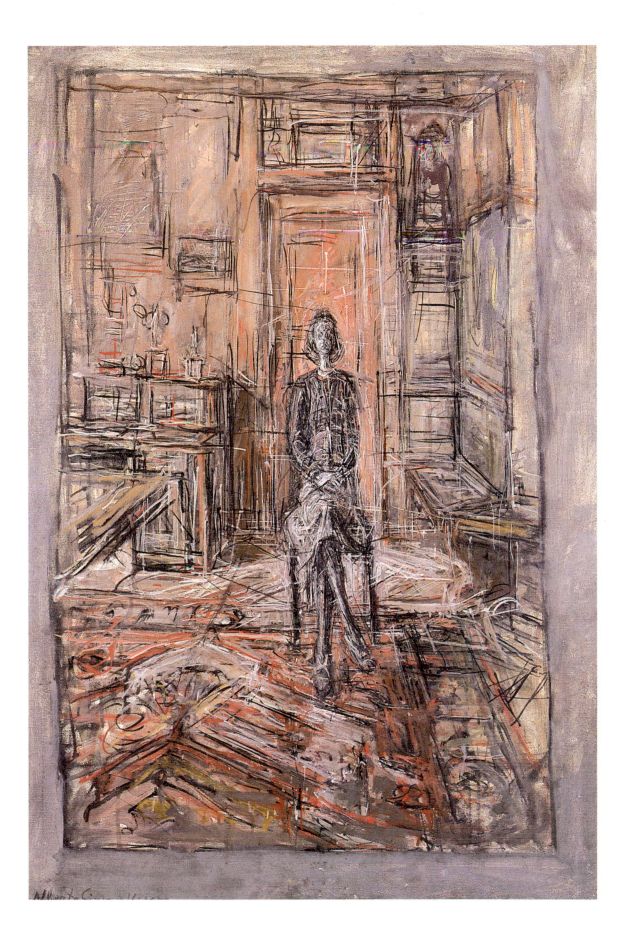

46

Seated Man

1949
Oil on canvas
30 x 15½ in.
Signed and dated, LR: Alberto Giacometti 49
Morton G. Neumann Family Collection, Chicago

Unlike many of the figure paintings of 1949–50 [see 45, 47, 52], this composition confines Diego within a narrowly defined space. He is locked in by the geometric schema of the wall behind him; the predominantly vertical lines enhance the elongation of his head, which is framed by an unobtrusive square. The use of shallow space concentrates attention on the canvas surface, emphasizing the extraordinary complexity and expressiveness of the lines.

Although this painting portrays the artist's brother, it was not intended as a literal description of Diego. For Alberto, art was a confrontation with the reality of another person. He preferred familiar models because he knew their features and could concentrate on trying to capture that intangible quality of being alive.

The great adventure is to see something unknown emerge each day, in the same face, that is greater than all the trips around the world. . . . I do not work to create beautiful paintings or sculpture. Art is only a means of seeing. No matter what I look at, it all surprises and eludes me. . . . It's as if reality were continually behind curtains that one tears away . . . but there is always another. . . . That is what makes me work, compelled to understand the core of life. And to carry on, knowing that the closer one gets to the goal, the further it retreats.[1]

1. Giacometti, in André Parinaud, "Entretien avec Alberto Giacometti," *Arts-lettres-spectacles,* no. 873 (June 1962): 1, 5.

144

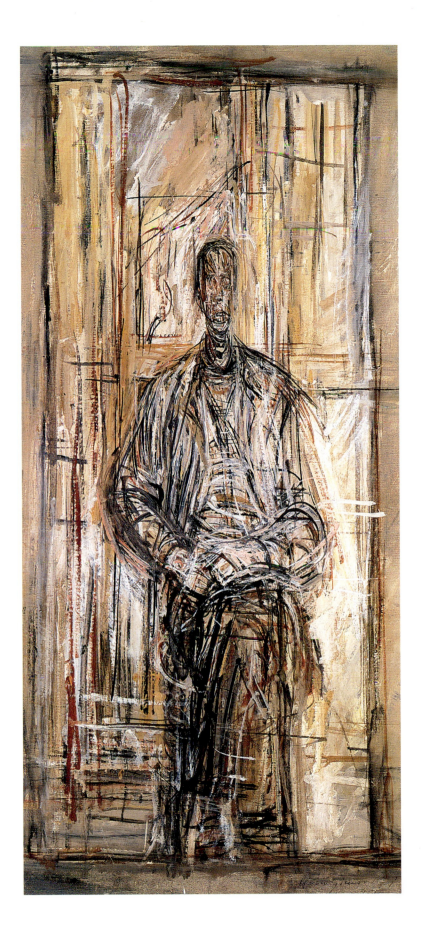

Diego Seated in the Studio

1949–50
Oil on canvas
32 x 26 in.
Signed, LR: Alberto Giacometti
Private collection, New York

Giacometti made at least four paintings of Diego in the studio in 1949–50 (others belong to the Tate Gallery and private collections). In these nearly identical compositions Diego sits with legs crossed; behind him is the aging studio cot with canvases propped up on it, and to the right is the rickety bookcase with small sculptures. The artist apparently felt drawn to this composition, making his brother pose repeatedly without variation—just as Cézanne had done half a century earlier for the portrait of his dealer Ambroise Vollard (fig. 19). The coincidence may have been more than fortuitous, inasmuch as Giacometti admired Cézanne's art and knew that particular painting. Giacometti's working methods echo Cézanne's in a number of ways: both insisted that their models pose for hours without moving, both made drawings after older artworks throughout their careers, and both were often unhappy with the results (after Vollard had posed every morning for 115 sittings, Cézanne supposedly abandoned the painting as unfinished, although he said he was not dissatisfied with the shirtfront).

The composition of this painting reflects Giacometti's interest in phenomenological distortions. He establishes two directions of movement within the pictorial space. The perspective defined in the furnishings and rear studio wall leads the eye off to the left, while the subtle attenuation of the figure provides a vertical axis. The floor tilts up precariously, and Diego's upper body seems to recede slightly. In execution there is a similarly understated tension between the wet black and white lines and the broader, indeterminate gray strokes.

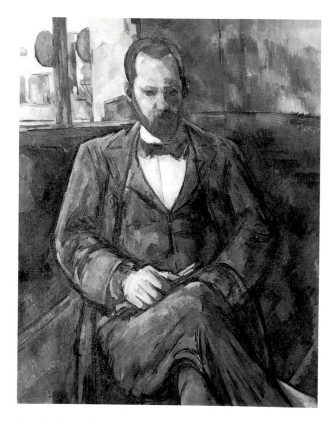

Fig. 19 Paul Cézanne. *Ambroise Vollard,* 1899, oil on canvas, 39½ x 32 in. Musée du Petit Palais, Paris.

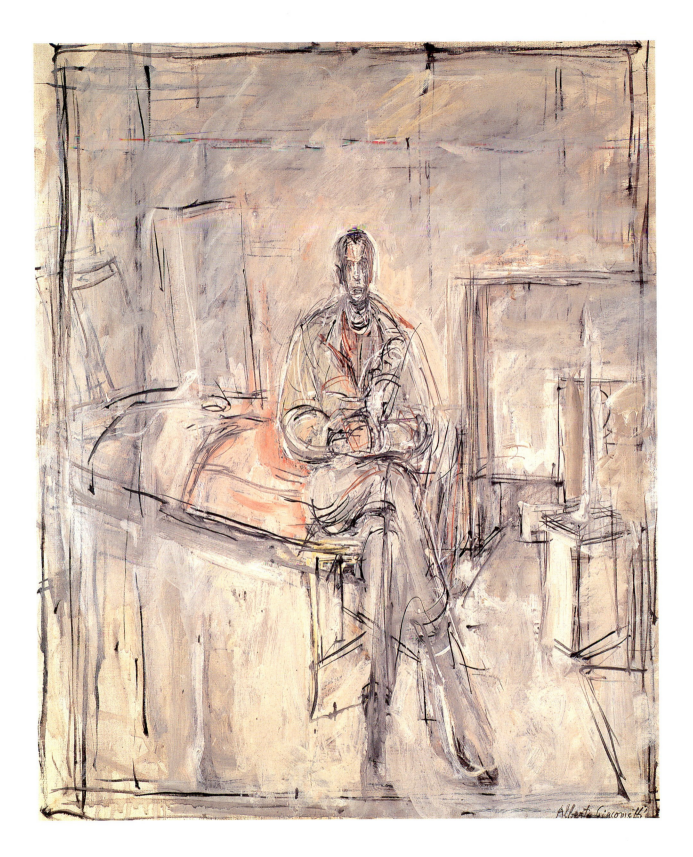

48

The Chariot

1950
Bronze on wood base, 4/6, Alexis Rudier Foundry
64⅝ x 27 x 26⅜ in.
Signed, base plate LL: A. Giacometti 6/6
Incised, base plate LL: Alexis Rudier Fondeur Paris
National Gallery of Art, Washington, D.C.,
gift of Enid A. Haupt

According to Diego Giacometti and André Thirion, *The Chariot* was created in response to a commission from the nineteenth arrondissement of the city of Paris for a memorial sculpture in a neighborhood square. Commemorating a teacher, Jean Macé, the sculpture was to replace a monument destroyed during World War II.[1] Although *The Chariot* was rejected as inappropriate for the purpose, Alberto had it cast in bronze and included it in his 1950 exhibition at Pierre Matisse Gallery and in subsequent shows of his work.

As in other sculptures of the immediate postwar years, the source of inspiration was a memory. After Giacometti had been hit by a careening automobile in October 1938, he was taken to Bichat Hospital and then transferred to the Rémy de Goncourt clinic, where he was intrigued by the medicine cart pushed around by the nurses. He made several drawings of the cart, with its two small wheels in front and two large ones in back.[2] When he wrote to Pierre Matisse in 1950, he cited this source somewhat inaccurately and noted that the sculpture resulted from a combination of spontaneous memory and formal concerns.

[T]his sculpture comes from the [clanking] wagon of the Bichat hospital which was wheeled in the rooms and which astounded me in 1938. The Chariot was realized by the necessity again to have the figure in empty space in order to see it better and to situate it at a precise distance from the floor.[3]

As was the case with his Surrealist sculptures, the composition of *The Chariot* ostensibly emerged suddenly from his memory. "In 1947 I saw the sculpture before me as if already done, and in 1950 it was impossible not to realize it, although it was already situated for me in the past."[4] The description of the sudden emergence of this image has a dramatic simplicity that conveniently omits the 1942–43 version [31]. That first *Woman on a Char-*

iot, which had incorporated a functional four-wheeled wagon, still stood in the Maloja house, a painted plaster not yet cast into bronze and not in evidence in Paris.

An art historical source for this wheeled image has been identified by Hohl: a unique Egyptian battle chariot from the Eighteenth Dynasty, the only one of its kind to survive, which Giacometti had seen in the Archaeological Museum in Florence in 1920.[5] Beyond this specific source Giacometti's *Chariot* evokes images associated with several ancient civilizations, such as the chariot battles and races of Rome and Greece. Like the *Charioteer* of Delphi, Giacometti's figure holds her arms forward as if to grasp the reins, but unlike the images from antiquity, this figure is female and iconic rather than male and descriptive.

An edition of seven bronze casts (numbered 0/6–6/6) exists. Cast 1/6 with a golden patina belongs to the Museum of Modern Art. Cast 2/6, which is painted, is in a European private collection. Cast 3/6 belongs to the Alberto Giacometti Foundation. The National Gallery of Art cast is considered 4/6, despite its 6/6 marking, according to Annette Giacometti. Cast 5/6, which is also painted, is in the Mr. and Mrs. Raymond D. Nasher Collection in Dallas. The other cast 6/6 has a darkish patina and belongs to a private collection in New York. *The Chariot* appears in a 1950 painting, *Annette Seated in the Studio* (private collection, London).

1. Lord 1985a, pp. 197–98, 304–6.

2. Ibid.

3. Giacometti, letter to Pierre Matisse, 1950, in Matisse 1950, p. 3.

4. Ibid., pp. 12–13.

5. Reproduced in Hohl 1971a, p. 295, fig. 56.

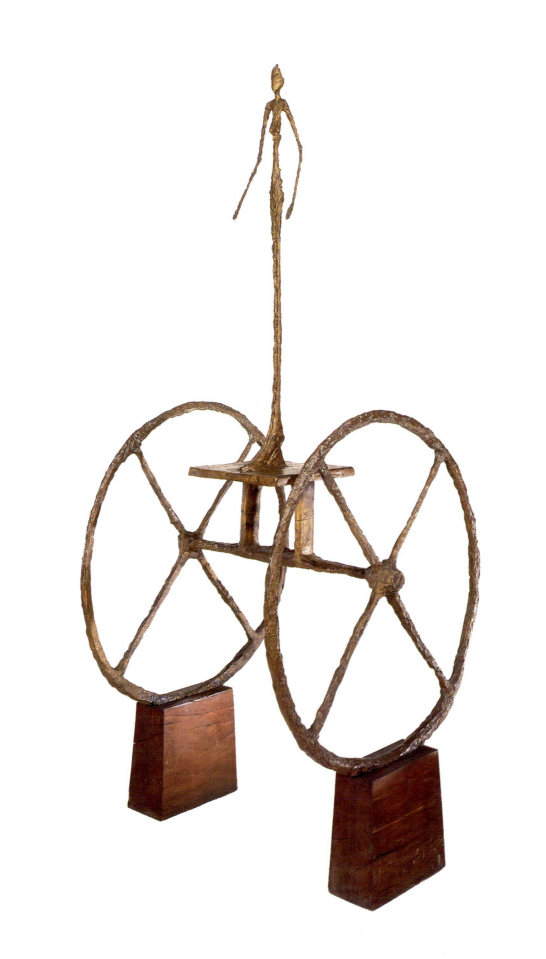

49

The Glade: Composition with Nine Figures

1950
Bronze, 6/6, Alexis Rudier Foundry
23⅜ x 20½ x 25¾ in.
Signed, base: Alberto Giacometti
Incised, base: Alexis Rudier Fondeur Paris 6/6
Mr. and Mrs. David A. Wingate, New York

This work was one of three multifigure sculptures completed in spring 1950, the others being *The Forest: Composition with Seven Figures and a Head* (Metropolitan Museum of Art, New York, promised gift) and *City Square: Composition with Three Figures and a Head* (Hirshhorn Museum and Sculpture Garden). By his own account Giacometti had not set out to make these multifigure compositions but had left a number of independent plaster figures standing around and was struck by how they looked ensemble. All three originally were titled *City Square,* but Giacometti soon saw in them more evocative subjects.

Every day during March and April 1950 I made three figures (studies) of different dimensions and also heads. I stopped without quite reaching what I was looking for but unable to destroy these figures which were still standing up or to leave them isolated and lost in space. I started to make a composition with three figures and one head, a composition which . . . was done before I had come to think about it. . . . A few days later, looking at the other figures which, in order to clear the table, had been placed on the floor at random, I realized that they formed two groups which seemed to correspond to what I was looking for. I set up the two groups on platforms without changing their positions and afterwards worked on the figures altering neither positions nor dimensions. To my surprise, the *Composition with Nine Figures* seemed to realize the impression I had received when seeing a glade [clairière] (it was like a pasture grown wild, with trees and shrubs on the edge of a forest) which had greatly intrigued me.[1]

Allowing random chance to play an active role and then accepting subconscious free-association memories *post facto* is quintessentially Surrealist, although the figurative style is not.

When the artist provided the anecdote about the source of these sculptures, he warned that such titles should not be allowed to limit the viewers' responses to the works.

If, for example, in [*Composition with*] *Nine Figures,* once made, I recognized a glade that I wanted very much to paint last spring, it is not for that reason, however, that I did the sculpture. They are nine studies of figures which found themselves together by accident and formed a composition, a composition which I was vaguely looking for . . . as if involuntarily I came to realize impressions felt long before and which I saw in the sculpture only when done. . . . If one thinks, regardless of one's self, of a forest or a room or of sand, it is all very well, but one must not say it in advance as it falsifies and limits. One should be able to think of anything.[2]

An edition of seven bronzes (numbered as six, with two casts marked 6/6) were made; some are painted. Cast 1/6, painted green, belongs to a private collection in Los Angeles; 2/6 to the Alberto Giacometti Foundation; 5/6 to a private collection in New York; and the other 6/6 to the Thyssen-Bornemisza Collection in Lugano, Switzerland. An additional cast made in 1964 belongs to the Fondation Maeght.

1. Giacometti, letter to Pierre Matisse, 1950, in Matisse 1950, pp. 5–6, 9.

2. Ibid., p. 3.

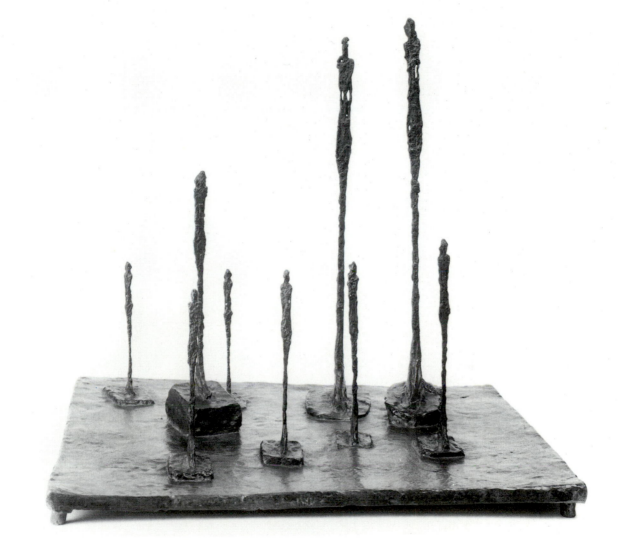

50

Woman Walking between Two Houses

1950
Bronze, glass, paint, 1/6, Alexis Rudier Foundry
12 x 21¼ x 3¾ in.
Signed, right side: A. Giacometti 1/6
Incised, rear LL: Alexis Rudier Fondeur Paris 1/6
Alberto Giacometti Foundation, Zurich

Giacometti described this sculpture as a "small figure in a box between two boxes which are houses."[1] In contrast to *City Square II* [41], where the tiny figures seem lost in a vast open space, this composition conveys a psychological sense of closure, even claustrophobia, as if the woman was an unwitting prisoner within her bronze and glass environment.

This tiny figure derived from a 1946 plaster entitled *Night* (visible in the middle of fig. 8), which had been intended as a maquette for a public monument, possibly a war memorial.[2] *Night* may have evolved from a 1943 drawing *Tightrope Walker;*[3] if so, it adds a subtle connotation of the

metaphysical precariousness of the thin striding figure. The figure in *Woman Walking between Two Houses* was Giacometti's last walking woman; from 1951 on only male figures would stride forward, while female nudes would stand immobile.

Other casts of this sculpture are in the Musée National d'Art Moderne and private collections in Paris and Dallas.

1. Giacometti, letter to Pierre Matisse, 1950, in Matisse 1950, p. 24.

2. Hohl 1971a, p. 134.

3. Reproduced in Matisse 1948, p. 28, no. 15.

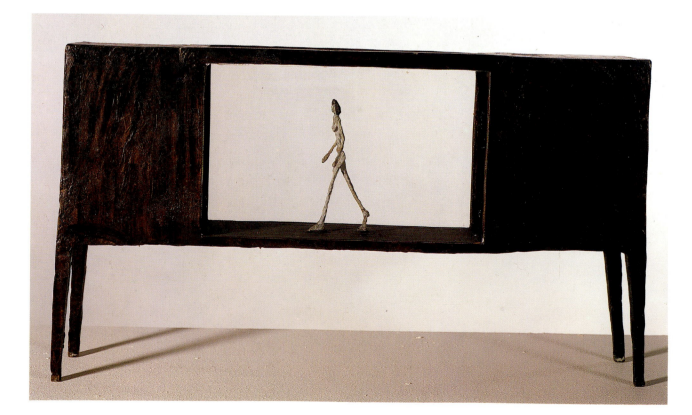

51

Four Figures on a Pedestal

1950, painted 1957
Painted bronze, 5/6, Alexis Rudier Foundry
30½ x 16 x 6⅜ in.
Signed, top base R edge: A. Giacometti 5/6
Incised, rear base LR: Alexis Rudier Fondeur Paris
Carnegie Museum of Art, Pittsburgh, gift of Mr. and Mrs.
Henry J. Heinz II

Like a number of sculptures from 1946–52, *Four Figures on a Pedestal* was created from memory rather than live models. According to the artist, the four women were prostitutes in a neighborhood brothel that had been outlawed in 1946: "I saw them often, especially one evening in a small room, rue de l'Echaudé, very close and menacing."[1] In another comment about this sculpture Giacometti revealed his ambivalence toward women, whom he tended to both despise and adore.

> I have often thought of the four figures on the base somehow as the devils that came out of the box and of women that I saw sometimes in reality, attractive and repulsive at the same time.[2]

The massive rectangular base serves as an equivalent to the vast space that the artist perceived as existing between him and the objects of his desire/repulsion. The solid block establishes the figures at a distance and anchors them immovably.

This cast was painted by Giacometti in 1957, two years after it had entered the Carnegie Museum collection. Although he had painted his sculptures as early as 1922–25, the practice became more frequent after 1946. In addition to his belief in the creative interchange between painting and sculpture, the habit resulted in increased realism for some sculptures. Here the beige flesh tones and black details (especially eyes and hair) add an anatomical precision to the otherwise highly stylized forms.

Cast 1/6 was also painted by the artist and now belongs to the Alberto Giacometti Foundation. Unpainted casts belong to the Tate Gallery and a private collection in Boston.

1. Giacometti, letter to Pierre Matisse, 1950, in Matisse 1950, pp. 16–17.

2. Ibid., p. 3; see also pp. 14–15.

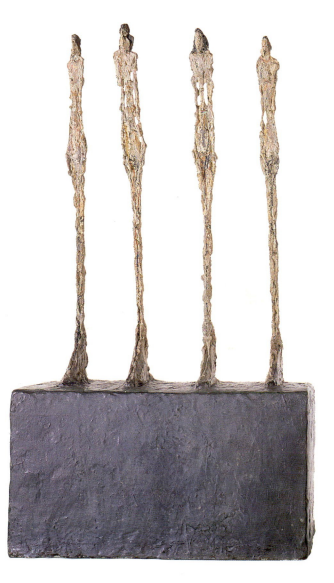

52

The Artist's Mother

1950
Oil on canvas
34⅝ x 23½ in.
Signed and dated, LL : Alberto Giacometti 1950
The Museum of Modern Art, New York, acquired through
the Lillie P. Bliss Bequest

Although this painting ostensibly depicts a real person in a domestic interior, Giacometti has transformed the mundane into a strange and wonderful universe, where the components of his postwar style are brought together in one of his most complex and virtuosic compositions. Very attached to his mother, who died in January 1964 at age ninety-three, the artist visited her every year in Switzerland, where she served as model for many works. As in the portrait of Annette from the preceding year [45], Giacometti seemed inspired by the familiar setting of the living-dining room in the family home at Stampa (fig. 20). This canvas presents his linear painting style at its sharpest and most sophisticated, with tight brushwork and subtle coloration undisturbed by the looser gray strokes characteristic of his paintings after the mid-1950s.

Fig. 20 Giacometti and his mother in the family home at Stampa, 1964. Photograph by Henri Cartier-Bresson.

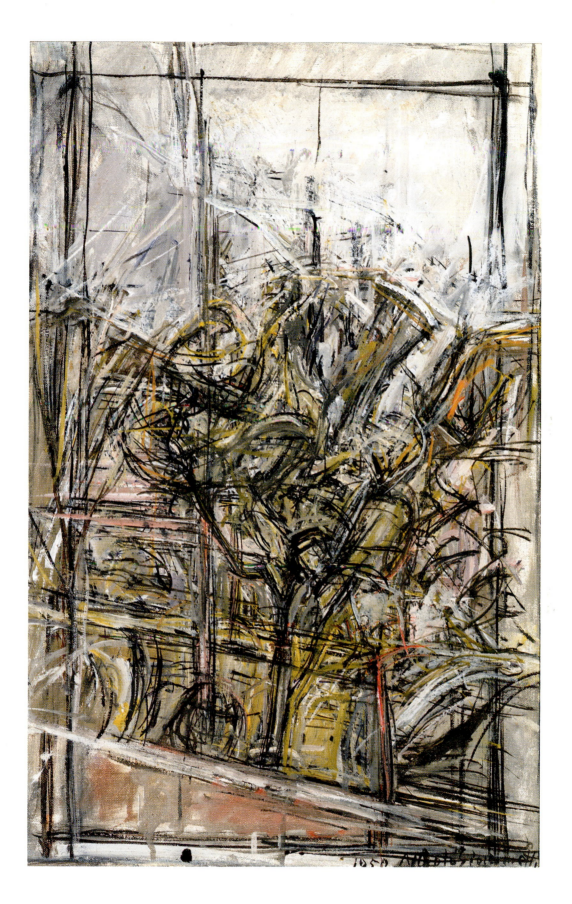

157

54

The Studio

1950
Oil on canvas
25⅜ x 18¼ in.
Signed and dated, LR: 1950 Alberto Giacometti
Mr. and Mrs. James W. Alsdorf, Chicago

Giacometti's postwar burst of creativity transformed the ambiance of his tiny studio, which by 1950 had become crowded with dozens of new sculptures. Most of his plasters had an eerie, haunting presence characteristic of his postwar art; working among them Giacometti responded to their cumulative impact. From 1950 through 1954 he made several paintings and many drawings and lithographs of the sculptures in the studio. The surrounding space is grayish brown, with incisive black lines defining the shapes and contributing a subdued gestural expression to the canvas.

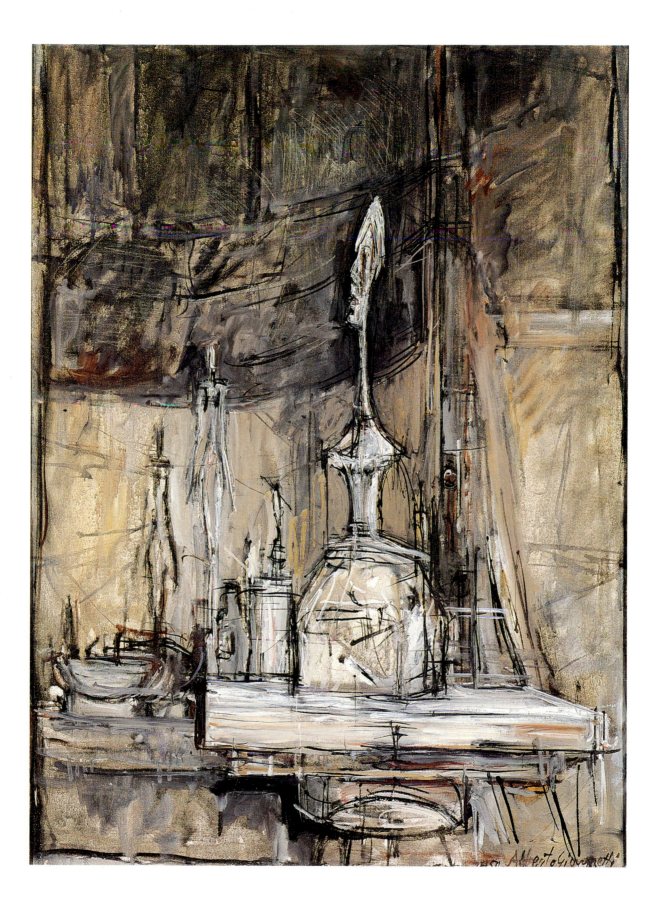

55

Still Life in the Studio

1950
Oil on canvas
19 x 17 in.
Not signed or dated
Private collection, Washington, D.C.

From 1950 through 1957 Giacometti painted a number of still lifes of objects in his Paris studio, which was incredibly cluttered with cigarette butts, bottles, brushes, and plaster. (He once remarked that the only artist with a messier studio was Francis Bacon.)[1] A visitor in the early 1950s described the table with bottles that the artist painted more than half a dozen times (visible in fig. 9).

Under the big window is a long table entirely covered with squeezed tubes of paint, palettes, paintbrushes, rags, bottles of turpentine. Like figures, the bottles stand shrouded in layers of dust chipped away from Giacometti's sculpture. Here sculpture and painting mix intimately.[2]

This still life of bottles also includes several sculptures: in left center a white plaster or marble plaque of 1927–28, possibly a version of *Gazing Head* [9], and on the right a couple of standing female figures atop a large base.

Despite the seeming casualness of the subject, the composition is carefully balanced. The image is painted frontally, parallel with the picture plane, so that the forms exist not only as objects but as two-dimensional shapes in a rhythmic composition. This still life appears to have been executed rapidly with a brush fully loaded with paint. The subtle colorism is characteristic of the years 1947–52, with subdued greens, yellows, and blues amid black lines. This painting predates the other known versions of this motif from 1953–57 (private collections, Europe, and Art Gallery of Ontario, Toronto).

1. Francis Bacon, comment to John Rewald, who recounted it to author, November 19, 1986.

2. Alexander Liberman, *The Artist and His Studio* (New York: Viking, 1960), pp. 277–78, with photograph of worktable reproduced on p. 285.

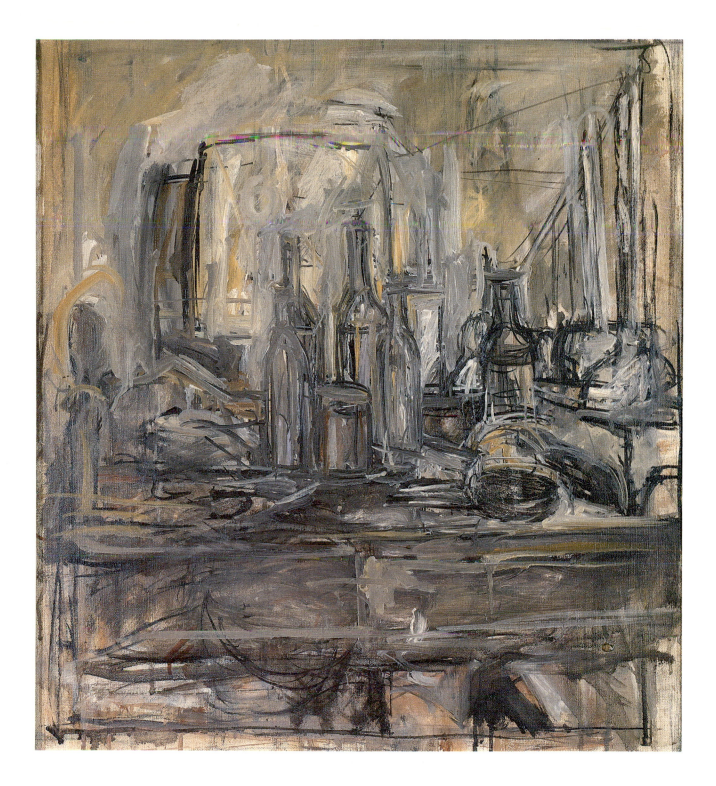

56

Standing Nude

1950
Pencil on paper
24 x 18½ in.
Signed, LR: Alberto Giacometti
Inscribed, LR: Pour Max Ernst très affectueusement
Duncan MacGuigan, New York

As with the painted *Tall Figure* [39], this nude may have been either drawn from imagination or based on one of Giacometti's recent sculptures. The figure has been erased and redefined repeatedly (traces of a taller figure are clearly evident); these dark lines reveal the artist's vehement struggle to define the image. For Giacometti drawing was a necessary antidote to the lengthy labor involved in making sculptures. In the words of his contemporary, the American sculptor David Smith:

[D]rawings remain the life force of the artist. Especially is this true for the sculptor, who, of necessity, works in media slow to take realization. And where the original creative impetus must be maintained during labor, drawing is the fast-moving search which keeps physical labor in balance.[1]

1. David Smith, lecture at Tulane University, New Orleans (March 21, 1955), in Garnett McCoy, ed., *David Smith* (New York: Praeger, 1962), p. 137.

57

Pierre Loeb

1950
Pencil on paper
20⅝ x 15⅜ in.
Signed and dated, LR: Alberto Giacometti 1950
Albert Loeb, Paris

Giacometti made several drawings of the noted art dealer—founder and owner of Galerie Pierre on the rue des Beaux-Arts in Paris—whom he had known since 1929, when Loeb had given him a one-year contract. In 1946, when Giacometti had the first exhibition of his new postwar art at that gallery, he made three sketches of his friend (Albert Loeb Collection, Paris). In 1950 the artist completed two ambitious drawings showing him seated cross-legged in an interior crowded with artworks. In one (Edouard Loeb Collection, Paris) the dealer sits in an armchair at home and the figure shows evidence of being reworked with erasures.[1] In this drawing the dealer also sits casually, apparently in his gallery with desk and telephone at hand. He is surrounded by primitive masks from his collection hanging on the wall above and canvases standing stacked in the corner. The delicate tracery of lines establishes a geometric spatial setting dominated by the small, strongly drawn head.

1. The 1946 and other 1950 drawings are reproduced in *L'aventure de Pierre Loeb: La galerie Pierre 1924–1964* (Paris: Musée d'Art Moderne de la Ville de Paris, 1979), nos. 67, 68, pp. 27, 69.

58

Sculptures in the Studio (Heads in Profile)

1950
Pencil on paper
25¾ x 19¾ in.
Signed and dated, LR: Alberto Giacometti 1950
The Art Institute of Chicago, gift of Morton G. Neumann

Like *The Studio* [54], this drawing depicts several
plaster sculptures from 1947–50 in the Paris studio.
The repetition of four very similar heads in profile
has a cumulative visual and psychological effect.
The biting lines capture the curved forms of the
heads, with little need for reworking. A related
drawing is in a private collection in Connecticut.

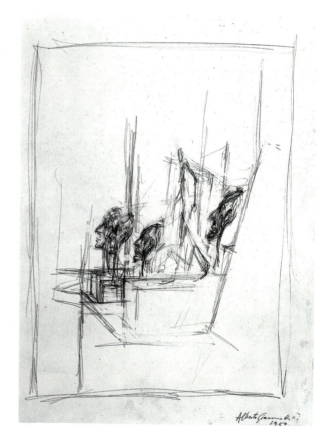

59

Dog

1951, cast 1957
Bronze, 3/8, Susse Foundry
17½ x 38⅛ x 6¼ in.
Signed, base LR: Alberto Giacometti 3/8
Incised, base L edge CL: Susse Fd Paris
Hirshhorn Museum and Sculpture Garden, Smithsonian
Institution, Washington, D.C., gift of Joseph H. Hirshhorn

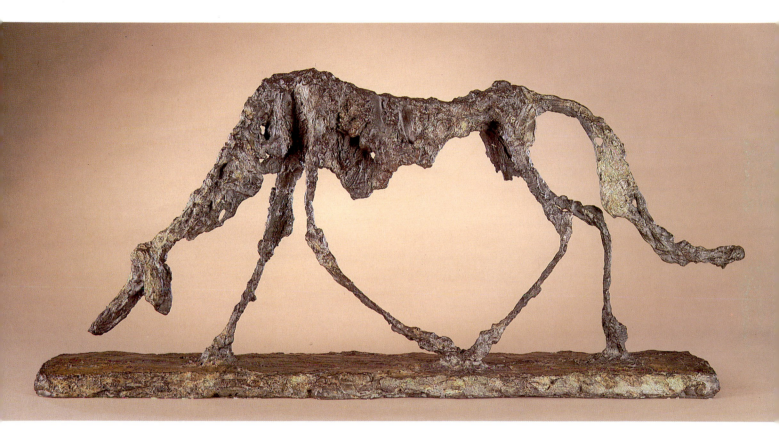

Supposedly in a single day in 1951 Giacometti executed a group of animal sculptures in plaster, roughly life-size—two horses, a cat, and a dog. In addition to *Dog, Cat* (Alberto Giacometti Foundation) was cast in bronze, but the horses are no longer extant. In the mid-1950s he told the writer Jean Genet that *Dog* was a form of self-portrait: "One day, I saw myself in the street like that. I was the dog."[1] In 1964 Giacometti recalled in greater detail the genesis of the sculpture:

For a long time, I'd had in my mind the memory of a Chinese dog I'd seen somewhere. And then one day I was walking along the rue de Vanves in the rain, close to the walls of the buildings, with my head down, feeling a little sad, perhaps, and I felt like a dog just then. So I made that sculpture. But it's not really a likeness at all. Only the sad muzzle is anything of a likeness.[2]

After returning from his walk, the artist executed the sculpture immediately, "so as to get rid of the hound once and for all."[3] The rapid modeling of the animal sculptures in plaster, in contrast to his normally slow process of reworking portrait sculptures, recalls his Surrealist method of pulling a complete image from memory. After the 1951 group Giacometti did not model any more animal works.[4] Rather animals became the preferred theme

Standing Nude

1951
Oil on canvas
24⅜ x 9 in.
Signed and dated, LL: Alberto Giacometti 1951
Djerassi Art Trust, Stanford, California

of his brother Diego, who incorporated them as recurrent motifs in his furniture designs from the mid-1950s until his death.

Dog appears in an illustration Alberto made for *Derrière le miroir* in 1951 and is a recurrent motif in half a dozen lithographs of his studio in 1954.[5] First exhibited at Galerie Maeght in 1951, the plaster *Dog* sat in Giacometti's studio until it was cast in 1957 in an edition of eight signed and numbered bronzes by the Susse Foundry at the request of Galerie Maeght. It subsequently became one of Giacometti's most popular images. Cast 1/8 belongs to the Alberto Giacometti Foundation; 4/8 was acquired in 1958 by the Museum of Modern Art. Other casts are in private collections in Chicago, Los Angeles, and Europe. An unnumbered, specially commissioned cast belongs to the Fondation Maeght.

1. Giacometti, in Genet 1957, p. 11.

2. Giacometti, in Lord 1965, p. 21.

3. Giacometti, in Alexander Watt, "Visages d'artistes: Giacometti," *Studio* 162, no. 820 (August 1961): 78.

4. In 1965 he made a lithograph of animal skeletons on display in the Museum of Natural History, published in *Paris sans fin* (Paris: E. Tériade, 1969), unpag.

5. See Lust 1970, nos. 11, 13, 15, 21, 23, 92.

Unlike the 1947 *Tall Figure* painting [39], this nude was evidently painted from a live model.[1] By 1949 Annette had become essential to Giacometti's creativity, spending countless hours posing for paintings and drawings, usually in the studio but also in their adjoining bedroom. Here she stands in a corner of the studio by a cot and bookcase, her youthful body transformed into a specter with emaciated legs and arms. The figure has a Gothic verticality and immateriality within the narrow canvas, and the head is a small narrow oval, as if almost squeezed out of existence. Giacometti created an unstable environment with limited pictorial space by exaggerating the perspective: the studio recedes off to the right, and the floor tilts up at a steep angle.

Another painting of the same size and style, dated 1950, shows Annette clothed and seated in the same setting (Öffentliche Kunstsammlung Basel, Kunstmuseum).

1. Annette Giacometti recalls having posed for this canvas (conversation with the author, March 16, 1988).

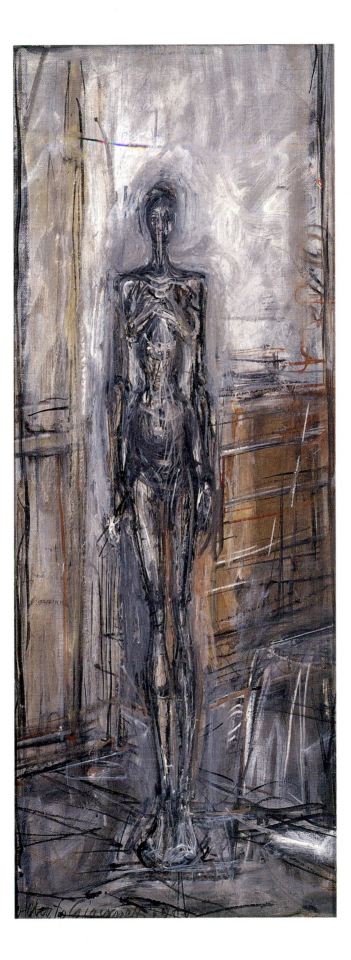

61

The Studio

1951
Oil on canvas
28¾ x 23 ⅝ in.
Signed and dated, LL: Alberto Giacometti 1951
E. W. Kornfeld, Bern

A visitor in the early 1950s described Giacometti's studio, which opened off a narrow entryway (see fig. 23):

His studio is a small room, about fifteen feet by twelve. One window takes up a whole wall. Since the studio is on the ground floor and the courtyard is only six feet wide, the light that streams in is gray and dull. The overall impression is of monochromatic grayness. . . . The walls are gray; the sculpture gray and white, interspersed with the sepia accent of wood or the dull glint of bronze. . . . In the darker corners of the room the long, narrow, life-size figures of white plaster seem like apparitions from another planet. One is surrounded by beings never encountered before.[1]

Although barely defined by a few lines in the gray penumbra, several figure sculptures can be discerned, including the plaster *Tall Figure* [43], *Man Pointing* [37], two heads, and two small walking men [possibly 40] as well as canvases turned to the wall. This was his private world, inhabited by personages of his own creation. When asked how he felt drawing his own sculptures, he said:

Sometimes I'm surprised I was so good, and sometimes that I missed the mark so far. But of course when drawing them one sees them in an entirely different way, one sees their mood rather than their form.[2]

1. Alexander Liberman, *The Artist and His Studio* (New York: Viking, 1960), p. 277.

2. Giacometti, in Lust 1970, p. 74.

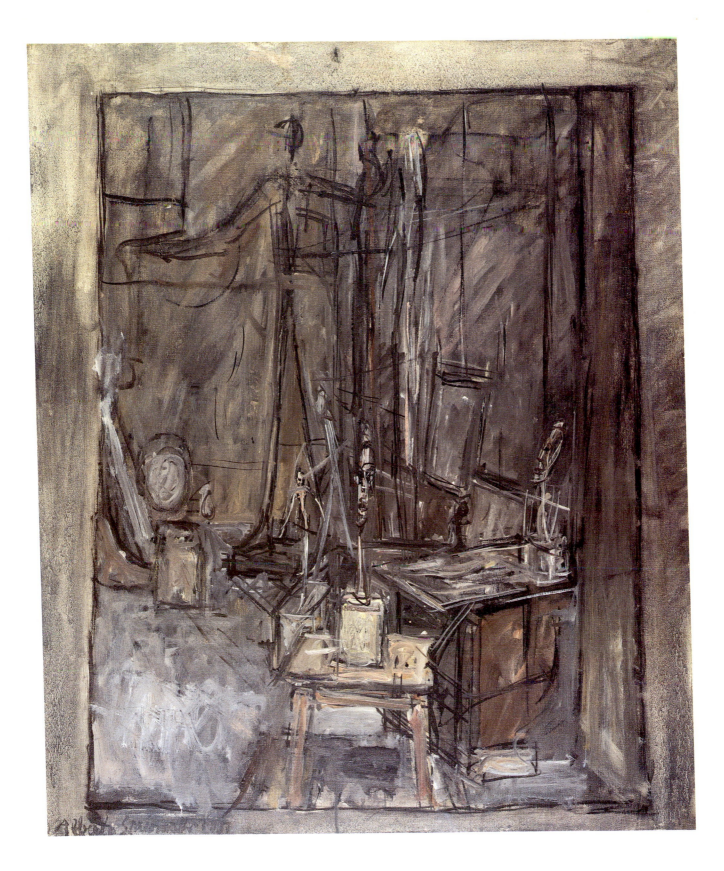

62

Project for a Book V (Walking Man)

1951
Lithographic crayon on paper
15½ x 11⅝ in.
Not signed or dated
Fondation Maeght, Saint Paul-de-Vence, France

63

Head of a Man

1951
Lithographic crayon and pencil on paper
15⅜ x 10⅞ in.
Signed and dated, LR: Alberto Giacometti 1951
The Museum of Modern Art, New York,
gift of Mr. and Mrs. Eugene Victor Thaw

Giacometti's early printmaking experience had been mostly limited to etchings small in size and edition. Around 1950 he became interested in lithography, and during the next fifteen years he made more than three hundred prints. In 1951 he made a number of drawings in lithographic crayon intended for publication in book form, but the project was never realized. Most depict multifigure compositions in imaginary urban or interior settings. According to Giacometti's widow, *Head of a Man* was based on Diego while the figures in the background were derived from sculptures Alberto was then working on in the studio; the overall composition, however, was drawn from imagination.[1] Because lithographic crayon cannot be readily erased, these works are characterized by vigorous, dark lines that have a spontaneity and assurance not found in his more delicate pencil drawings. *Project for a Book V* has an effective economy of line (particularly in the left leg, which is scarcely defined beyond the foot). The strolling man has the immediacy of a real figure who has just paused to look out at the viewer.

1. Annette Giacometti, letter to the Department of Painting and Sculpture, Museum of Modern Art, New York, February 27, 1973.

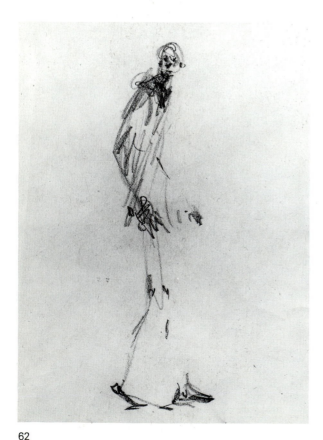

62

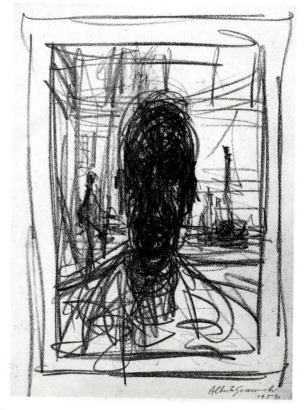

63

64

Small Bust on a Column

c. 1952
Bronze, Susse Foundry
60 x 7⅞ x 8⅞ in.
Signed, lower rear base: Alberto Giacometti
Private collection, Paris

This rarely exhibited sculpture anticipates the three better-known sculptures of Diego on a stele from 1958. Often Giacometti tried to establish his figures at a distance that could be not be bridged, but in this and the later three bronzes he wanted the bust to confront the viewer directly. "In these sculptures I tried to make an eye. I raised the head on a base until the eye is at eye-level. You see an eye." He also remarked that "this is very important . . . just where the eye hits the sculpture."[1]

The use of a stele or columnar base to support the bust draws on a long tradition, dating at least to the ancient Greeks and Romans. In *Small Bust on a Column* the extremely thin proportions of the head contrast with the solidity of the base. So delicately modulated are the forms of the head that the human element appears ephemeral. This tenuous fragility contrasts with the later three busts on a stele, which have substantial anatomical forms.

1. Giacometti, in Hess 1958, pp. 67, 34.

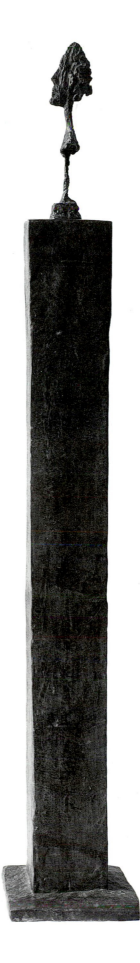

65

The House across the Street

1952
Oil on canvas
27½ × 15⅜ in.
Signed, LR: Alberto Giacometti
Mr. and Mrs. Adrien Maeght, Paris

Although Giacometti executed more than one hundred architectural and urban images, few are paintings and nearly all those date from the late 1940s and early 1950s. Most of his city scenes were prints done later, especially the lithographs he drew in 1965 for *Paris sans fin*. *House across the Street* depicts buildings on the rue Hippolyte-Maindron, across from the artist's studio. The painting appears to have been completed quickly; the pastel colors and fluid black lines are fresh and assured, undisturbed by the extensive reworking characteristic of his figure paintings.

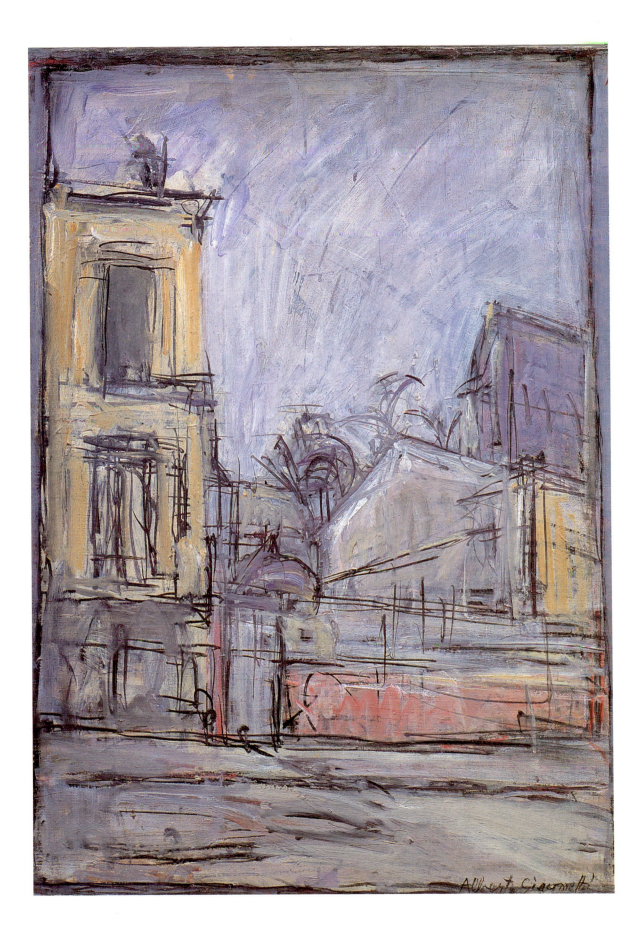

66

The Street

1952
Oil on canvas
28¾ x 28½ in.
Signed and dated, LR: Alberto Giacometti 1952
Ernst Beyeler, Basel
Hirshhorn Museum and Sculpture Garden only

The theme of urban space recurs in Giacometti's work from 1946–52. A psychological uneasiness usually runs as an undercurrent, but in this vista down a typical Parisian street spatial tension occupies center stage. Giacometti depicted a street that he saw nearly every day, the rue d'Alésia near his studio in Montparnasse; he generally ate his afternoon meals at the Café Le Gaulois on the corner of this street and the rue Didot. The viewpoint in *The Street* is very low so that the foreground becomes prominent, first looming up and then receding too rapidly into the distance. This type of exaggerated perspective occurred in a number of paintings of urban scenes in the late nineteenth century, including some by Claude Monet and Camille Pissarro, but most pronouncedly in the expressive cityscapes and landscapes by Edvard Munch and Vincent van Gogh.

With his sensitivity to spatial perceptions, Giacometti undoubtedly noted the contrast between the breadth of the Parisian boulevards and his small cluttered quarters, and he admitted to attacks of agoraphobia. Once while walking along a street he told an acquaintance that he felt as if the buildings were about to topple on him.[1]

This composition held Giacometti's interest through several works in different media. In a pencil drawing dated 1952 (private collection, New York) he portrayed a similar scene, with an automobile standing small and solitary by the curb. He made another, less clearly delineated painting of the same composition as *The Street*.[2] That sketchier canvas served as the basis for a color lithograph, *Rue d'Alésia,* made in 1954 in an edition of two hundred.

1. Herbert Lust, conversation with author, August 1986.

2. Reproduced in Dupin 1962, p. 110.

174

69

Seated Woman in a Room (Annette Sewing)

1952
Pencil on paper
19¾ x 12⅞ in.
Signed and dated, LR: Alberto Giacometti 1952
The Art Institute of Chicago, gift of Mrs. Potter Palmer

Giacometti's facility with pencil and pen became extraordinary during the 1950s. In *Seated Woman in a Room* the lines dart across the paper to define the furniture and objects. A vortex of lines establishes the head as the focal point, although it remains an abstract oval without features or details. This drawing retains some of the vehemence found in drawings from the immediate postwar years but moderated and transformed into the lighter tracery that characterizes many drawings of 1954–56. This domestic scene takes place in the artist's bedroom adjacent to the studio. In late 1945 Giacometti had rented this second room where he and Annette lived in spartan surroundings.

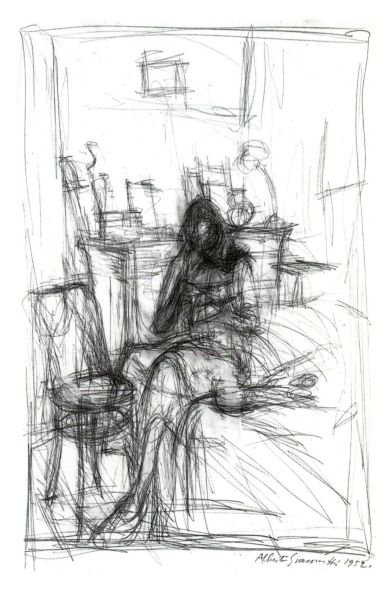

70

Large Head of Diego

1954
Bronze, 1/6, Susse Foundry
26½ x 15⅜ x 8¾ in.
Signed, back shoulder LL: Alberto Giacometti
Incised, back shoulder LL: 1/6 Susse Fondeur Paris
Robert B. Mayer Family Collection, Chicago

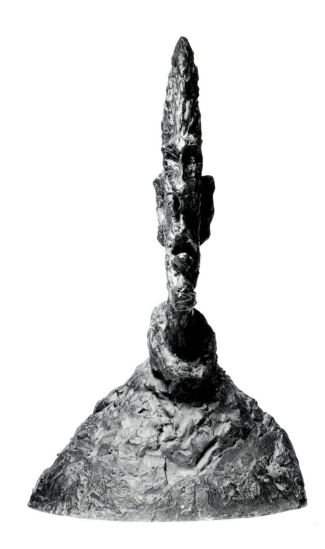

When viewed from different vantage points, *Large Head of Diego* seems to be two distinct heads. From the front the head is narrow; the effect is like looking straight on at a knife edge. From the side the profile is full-bodied and dramatically silhouetted, completely contradicting the frontal view. *Small Bust on a Column* [64] anticipated this effect, and Giacometti experimented with it in several smaller busts of 1954. This dichotomy recalls, conceptually at least, the 1946 drawing of his mother [32]. Both works contrast two aspects of the person depicted—the tangible and substantial (the solidity of the profile in this bust) versus the immaterial and indefinable (implied by the way the head seems to recede and almost disappear in the frontal view). The proportional forms of the *Large Head of Diego* also convey a subtle duality. The massive shoulders, with their horizontal bulk and downward curve, weigh the head down, yet the elongated head exerts an upward pull.

This sculpture is also powerfully expressive in its execution, for Giacometti sliced through the forms using a modeling knife. In addition to supplying a focused intensity to the eyes, these cuts suggest ravaged flesh and imply violence.

Giacometti's largest bust until *Monumental Head,* 1960 [94], *Large Head of Diego* exists in a bronze edition numbered 0/6–6/6. Cast 3/6 belongs to a private collection in the United States, 4/6 to the Alberto Giacometti Foundation, and two casts to private collections in England. A cast in addition to the numbered edition is in a private collection in Paris.

69

Seated Woman in a Room (Annette Sewing)

1952
Pencil on paper
19¾ x 12⅞ in.
Signed and dated, LR: Alberto Giacometti 1952
The Art Institute of Chicago, gift of Mrs. Potter Palmer

Giacometti's facility with pencil and pen became extraordinary during the 1950s. In *Seated Woman in a Room* the lines dart across the paper to define the furniture and objects. A vortex of lines establishes the head as the focal point, although it remains an abstract oval without features or details. This drawing retains some of the vehemence found in drawings from the immediate postwar years but moderated and transformed into the lighter tracery that characterizes many drawings of 1954–56. This domestic scene takes place in the artist's bedroom adjacent to the studio. In late 1945 Giacometti had rented this second room where he and Annette lived in spartan surroundings.

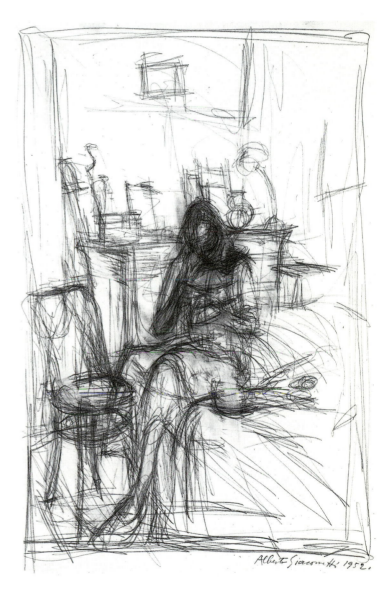

70

Large Head of Diego

1954
Bronze, 1/6, Susse Foundry
26½ x 15⅜ x 8¾ in.
Signed, back shoulder LL: Alberto Giacometti
Incised, back shoulder LL: 1/6 Susse Fondeur Paris
Robert B. Mayer Family Collection, Chicago

When viewed from different vantage points, *Large Head of Diego* seems to be two distinct heads. From the front the head is narrow; the effect is like looking straight on at a knife edge. From the side the profile is full-bodied and dramatically silhouetted, completely contradicting the frontal view. *Small Bust on a Column* [64] anticipated this effect, and Giacometti experimented with it in several smaller busts of 1954. This dichotomy recalls, conceptually at least, the 1946 drawing of his mother [32]. Both works contrast two aspects of the person depicted—the tangible and substantial (the solidity of the profile in this bust) versus the immaterial and indefinable (implied by the way the head seems to recede and almost disappear in the frontal view). The proportional forms of the *Large Head of Diego* also convey a subtle duality. The massive shoulders, with their horizontal bulk and downward curve, weigh the head down, yet the elongated head exerts an upward pull.

This sculpture is also powerfully expressive in its execution, for Giacometti sliced through the forms using a modeling knife. In addition to supplying a focused intensity to the eyes, these cuts suggest ravaged flesh and imply violence.

Giacometti's largest bust until *Monumental Head,* 1960 [94], *Large Head of Diego* exists in a bronze edition numbered 0/6–6/6. Cast 3/6 belongs to a private collection in the United States, 4/6 to the Alberto Giacometti Foundation, and two casts to private collections in England. A cast in addition to the numbered edition is in a private collection in Paris.

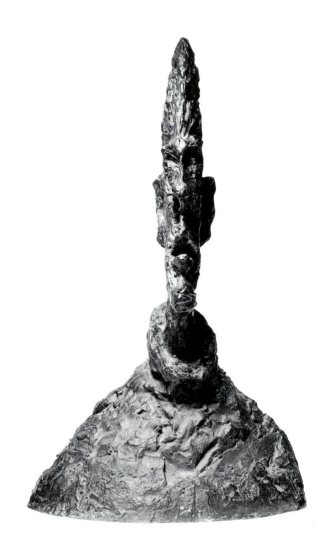

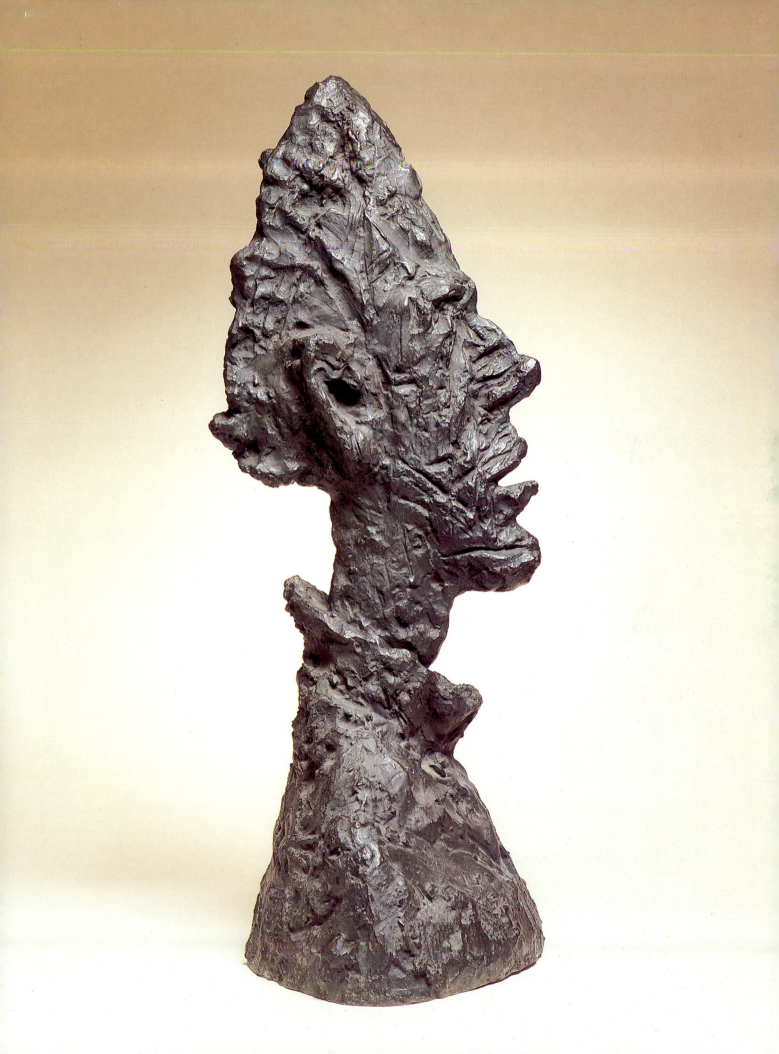

71

Bust of Diego

1954
Bronze, 2/6, Susse Foundry
15¼ x 13¼ x 8 in.
Signed, side LL: 2/6 Alberto Giacometti
Incised, lower rear: Susse Fondeur Paris
Hirshhorn Museum and Sculpture Garden, Smithsonian
Institution, Washington, D.C., gift of Joseph H. Hirshhorn

After 1952 Giacometti moved toward more substantive and naturalistic forms in his sculpture. Often the face has an intimate realism, especially when modeled directly from a sitter, as was this bust, rather than from memory. The small incisions in the forehead, eyes, and cheeks heighten the naturalism of the face as well as add an expressive element. In contrast to the delicate modeling of the head, the torso's surfaces are kneaded and gouged; the two long marks Giacometti made with his thumb give the work a vertical axis and amplify the tiny knife lines in the eyes.

Of the bronze edition one 0/6 cast belongs to the Musée National d'Art Moderne and another 0/6 cast painted grayish white is in the Mr. and Mrs. Raymond D. Nasher Collection, Dallas. The Walker Art Center in Minneapolis has cast 1/6 with a dark brown patina. The Hirshhorn Museum cast has a patina characteristic of those done by Diego, with mottled areas of green and yellow amid the predominant brown. A cast of *Bust of Diego* was included in the display of more than eighty Giacometti works at the Venice Biennale of 1962, where he was awarded the grand prize for sculpture.

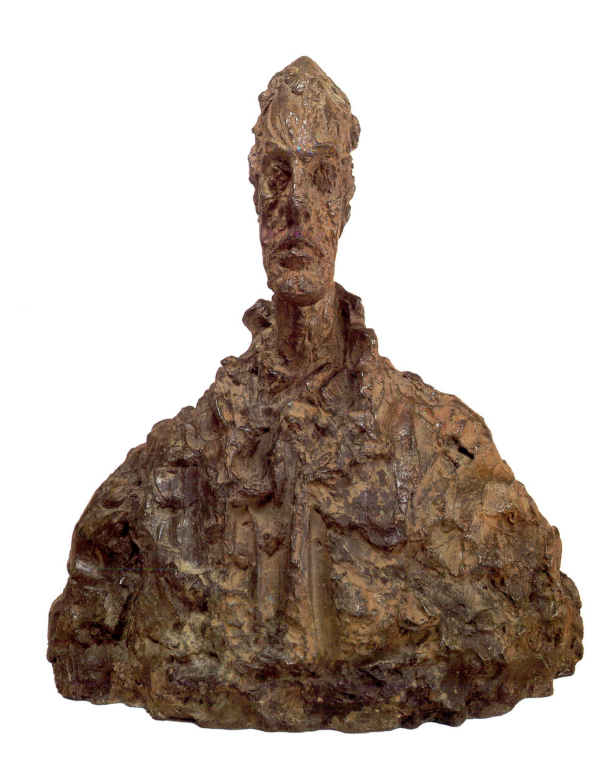

72

Diego in a Red Plaid Shirt

1954
Oil on canvas
31⅞ x 25¾ in.
Signed and dated, LR: Alberto Giacometti 1954
Mr. and Mrs. Adrien Maeght, Paris

First exhibited in Giacometti's second show at Galerie Maeght (May 1954), this canvas epitomizes his painting style at its most accomplished prior to the crisis in late 1956. Rather than the deeper perspectival space found in some paintings of 1947–52 [45, 52, 66], Giacometti retained just enough depth to situate the figure within an illusionistic setting and define the body's forms as rounded solids in space. Posed close to the picture plane, Diego's massive torso appears almost tangible, while the small head seems farther away. Curiously, the nose is startlingly solid and immediate, appearing to project from the canvas (Giacometti often said that he wished he could correctly paint a nose from nature). Balancing this understated spatial give-and-take are the nuances of color and differentiated textures of the brushwork. The gray areas are modulated with almost imperceptible yellows and blues, while the red plaid shirt provides a central focus vying with the face. The fine lines are varied and exuberant, from the long, thin black strokes in the peripheral studio setting to the countless short red, white, and black lines that enliven the head and shirtfront. Giacometti's postwar love affair with lines culminated in 1954 with paintings such as this one, *Annette* [73], and *Peter Watson* [74]; after 1956–57 he used broader, more gestural strokes.

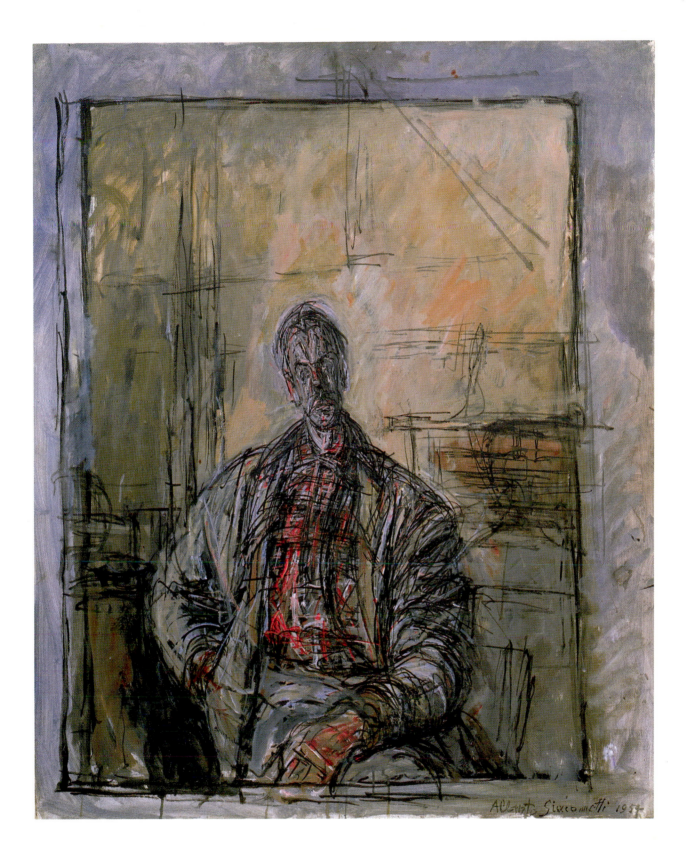

73

Annette

1954
Oil on canvas
25⅝ x 21½ in.
Signed and dated, LR: 1954 Alberto Giacometti
Staatsgalerie Stuttgart
Hirshhorn Museum and Sculpture Garden only

Like *Diego in a Red Plaid Shirt* [72] from the same year, this painting has the delicate color and sharp linear brushstrokes developed by Giacometti in the late 1940s. Although remnants of understated, but effective colors (yellow in the wall, some blue in the lower right, and a few reddish strokes) are visible, overall *Annette* has the gray tonality characteristic of his paintings from the mid–1950s through 1965. Several years later Genet described how delicately colored one of Giacometti's paintings appeared in the artist's poorly lit, dingy studio and how in daylight it took on a startling relief and reality. He recounted how Giacometti kept the studio somber, even refusing to let the dust be cleaned off the window so as not to change the quality of the light.[1]

The strong black lines throughout *Annette* were painted with a vigorous assurance that would falter in 1956–57, then re-emerge in a more calligraphically expressionist style in his last paintings. Here incisive lines define the figure and with a minimum of strokes establish the surrounding spatial setting: stacked canvases on the right, stove on the left, diagonal staircase in the upper right. Yet these fluid strokes transcend their descriptive function and can be appreciated solely as paint.

The naturalistic anatomy in *Annette* differentiates it from the emaciated, anonymous figures of 1946–50 and demonstrates clearly Giacometti's shift to a more descriptive style in the mid–1950s. Quite unlike the anatomy in *Standing Nude* [60], the flesh of the belly and breasts has a soft fullness. Here Annette's rounded face, curly hair, and deep brown eyes are realistically portrayed (in 1946 Simone de Beauvoir had written that "her eyes devoured the world.")[2] A visitor to the studio in the early 1950s described Annette:

[She] is about five feet four, like a slender girl of fourteen. . . . [H]er youth, her beauty, a poetic quality of mood are a contrast to Giacometti's somber brooding. . . . She has the naive and innocent expression of a child, and laughs often with a girl's laughter.[3]

The combination of the close-up pose and vivid, texturally luscious brushstrokes seems to put the figure in the viewer's space. The emphasis here on the picture plane contrasts markedly with the 1949 painting of Annette at Stampa [45], where she seems to shrink in a vast space. The realism of this painting differs equally from the more gestural style of *Standing Nude*, 1958 [85].

1. Genet 1957, p. 11.

2. Simone de Beauvoir, diary entry, Geneva, May 22–23, 1946, in Hohl 1971a, p. 276.

3. Alexander Liberman, *The Artist and His Studio* (New York: Viking, 1960), p. 279.

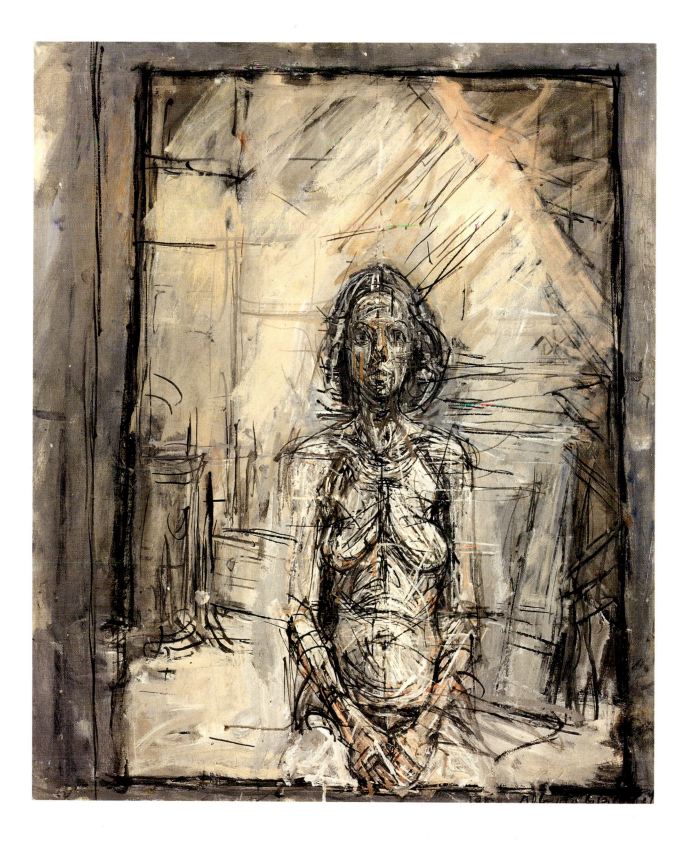

74

Peter Watson

1954
Oil on canvas
28⅜ x 23⅜ in.
Signed and dated, LR: Alberto Giacometti 1954
Alberto Giacometti Foundation, Zurich

Art connoisseur and publisher of *Horizon* magazine, Peter Watson was a wealthy Englishman who divided his time between Paris and London after the war. In his diary entry of March 1946, art dealer John Bernard Myers described him as "tall, lean, with a fine bony face. He has a quick intelligence and a warm heart."[1] Watson knew many artists (his portrait had also been painted by Pavel Tchelitchew) and formed a significant art collection, including works by Bacon and Giacometti. In 1956 Watson died unexpectedly in his London home.

This portrait is one of the last paintings in which Giacometti situated the figure within a space that has depth and a complex structure. Perched on the edge of the studio cot, the figure is surrounded by rectangular shapes indicating canvases and portfolios stacked on and around the bed. The horizontal and vertical lines in the walls above complete this geometric schema, which locks the figure into its own small space. With the top of his head just below the center of the painting, the figure occupies barely a fifth of the canvas area. Painted with the same black, white, and dark gray strokes as his environment, the figure is distinguished from it by the focused density of lines in the face and body. With its empty eye sockets and painterly grisaille, the face has a spectral quality.

This composition followed a bust-length portrait of Peter Watson done the preceding year (Museum of Modern Art).

1. John Bernard Myers, *Tracking the Marvelous: A Life in the New York Art World* (New York: Random House, 1983), p. 64.

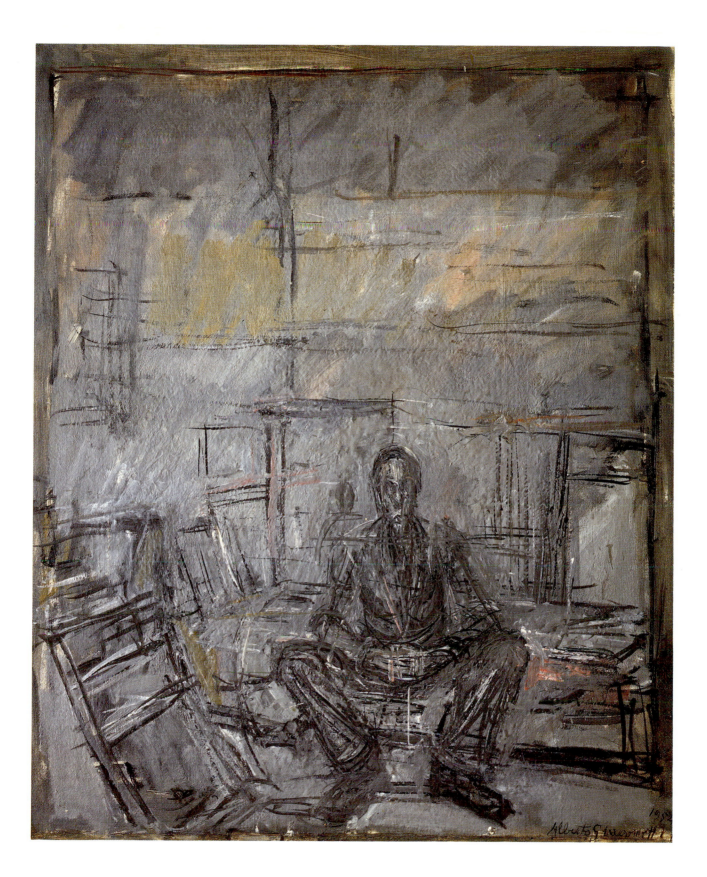

75

Self-Portrait

1954
Pencil on paper
19¼ x 12½ in.
Not signed or dated
Private collection
Hirshhorn Museum and Sculpture Garden only

Aside from a painted self-portrait done during the postwar period, all Giacometti's known self-portraits after 1923 are drawings. A pattern to the timing of these images is difficult to determine until a catalogue raisonné is completed. He seems to have done several self-portraits while trying to adjust to the art scene in Paris (1923–25) and then again during the mid-1930s, just as he was undergoing a major aesthetic change. During the mid-1950s, as his art settled into a few predominant formats, he made a number of pencil self-portraits, all frontal with a direct intense gaze. This and another very similar drawing from the same year (private collection, London) present his image as a delicate vision, both beautifully executed and slightly disturbing. The thick, unruly hair has a surprising vitality, as if going up in flames, while the face has the serious, almost suffering quality associated with his mythic persona of the tragic artist. As Giacometti himself said about his art, "One must create a vision and not merely something that one knows to exist."[1] The drawing itself is a marvel of subtle pencil lines and shadings. It appears to have been done quickly and forcefully, then softened by erasing and smudging small areas. The image vacillates between solidity and translucency, as if hovering between existence and non-being. Such ambiguity eloquently testifies to the artist's chronic sense of striving without success for his vision of reality.

1. Giacometti, in Alexander Watt, "Paris Letter: Conversation with Giacometti," *Art in America* 48, no. 4 (1960): 101.

76

Jean Genet

1954
Pencil on paper
19¾ x 12¾ in.
Dated, LR: 1 septembre 1954
Private collection, Paris

According to Genet, he met Giacometti in 1953 and thereafter saw him regularly during the next four years.[1] The artist painted his portrait twice (Musée National d'Art Moderne; Galerie Beyeler, Basel). Giacometti also made numerous drawings of the author in 1954–57. In this and another drawing (private collection, Bern) Giacometti depicted Genet leaning to one side, which conveys an air of casualness and instability. These drawings are characterized by soft, fluid pencil lines depicting a penetrating gaze and bald head. During his repeated sittings Genet was impressed with the ambiance of Alberto's studio and in 1957 he wrote an evocative essay, *L'atelier d'Alberto Giacometti*. Excerpts were published in *Derrière le miroir* (June 1957), with the entire essay appearing in book format the following year. Because of their busy schedules, the two men saw each other less frequently during the early 1960s.

1. Genet 1957, p. 7. A drawing similar to the one exhibited here is reproduced on p. 5.

77

Annette at Stampa

1954
Pencil on paper
23⅛ x 16 in.
Signed and dated, LR: Alberto Giacometti 54
Private collection, New York

During the mid-1950s Giacometti made many of
his most complex drawings, often elaborate geo-
metric compositions on large sheets of cream-
colored paper. As in the paintings done at Stampa
in 1949–50 [45, 52], this drawing and several others
of his wife and mother in 1953–57 depict a quies-
cent figure within a carefully constructed interior.
Annette's head occupies the center of the composi-
tion, so that the entire linear scaffolding becomes a
foil for her outward gaze.

78

Head of Diego

c. 1955
Pencil on paper
19½ x 6¾ in.
Signed, LR: Alberto Giacometti
Inscribed, across bottom: Pour Herbert Lust en souvenir de
son / voyage à Paris / Paris 13 juillet 1956.
Herbert Lust, Greenwich, Connecticut

Inscribed by the artist as a gift to writer and collec-
tor Herbert Lust, this work dates from 1955 or
slightly earlier. Unlike the 1954 drawings *Jean
Genet* [76] and *Annette at Stampa* [77], *Head of Diego*
relies on dense lines, heavily reworked and deliber-
ately smudged with an eraser. As a result the head
has a mysterious, haunted air, swathed in a heavy
gray mist from which it emerges. The frontal pose
and intense, disturbing stare invite comparison
with the religious arts of older eras, such as the
Mesopotamian sculptures of Gudea, Byzantine
mosaics of God and saints, and Gothic sculpture,
examples of which Giacometti had copied in draw-
ings. *Head of Diego* particularly resembles a
drawing he made of an ancient Egyptian sculpture,
Head of Amenemhet III and a sculpture of King Sol-
omon on the façade of Notre Dame cathedral.[1]

1. Reproduced in Carluccio 1967, nos. 20, 65.

79

Standing Nude

c. 1955
Colored pencil on paper
13½ x 10 in.
Signed and dated, LR: Alberto Giacometti / vers 1955
Private collection
Hirshhorn Museum and Sculpture Garden only

Giacometti's countless drawings of nudes range
from the dark dense expressionism of the 1950
composition [56] to the solid realism and mysteri-
ous quality of the Sainsbury nude [80]. This work
has strokes of blue, green, yellow, and red vigor-
ously woven in an open rhythm on creamy white
paper. Giacometti had used colored pencils in his
youth and returned to them around 1950, but such
drawings are relatively rare in his oeuvre. He pre-
ferred gray lead, the repeated strokes of which
could be smudged and erased to suggest a palpable
space engulfing the forms [78].

80

Standing Nude

1955
Pencil on paper
35⅛ x 19 in.
Signed and dated, LR: Alberto Giacometti 1955
Robert and Lisa Sainsbury Collection, University of East
Anglia, Norwich, England

One of Giacometti's finest drawings, this exceptionally large standing nude combines a weightless incorporeality with palpable form. The figure hovers in white space, and areas of the body have been smudged into a ghostly immateriality. Yet the forms of the body, especially the head and torso, with its soft hourglass shape, convey an impression of three-dimensional flesh. The pencil lines swarm over, around, and through the anatomy, depicting elements such as the staring eyes with realism and defining others with expressionistic vigor. Lines through the elbows, wrists, knees, shins, and ankles seem to bind the nude into immobility and counteract the figure's verticality.

Alberto Giacometti 1955.

81

Still Life on Sideboard

1955
Pencil on paper
12 x 17¾ in.
Signed and dated, LR: Alberto Giacometti 1955
Sidney Janis Gallery, New York

On visits to Stampa, particularly during the mid-
1950s, Giacometti was attracted repeatedly to the
theme of dishes arranged on the buffet in the din-
ing room. Most of these still lifes are pencil
drawings, although at least one oil painting is
known. In the complex composition of this draw-
ing, Giacometti played the rounded shapes of the
dishes against the rectilinear structure of the wood
wall behind them. Although legible as an image,
this drawing is primarily a delicate abstract pattern,
in which large areas of white paper convey a sense
of light and air. Giacometti drew a very similar still
life on his visit the following year (Fondation
Pierre Giannadda, Martigny, Switzerland).

82

Woman of Venice II

1956
Bronze, 4/6, Susse Foundry
47¾ x 6⅛ x 13 in.
Signed, base LL edge: 4/6 Alberto Giacometti
Incised, rear base lower edge: Susse Fr
Private collection, Montreal

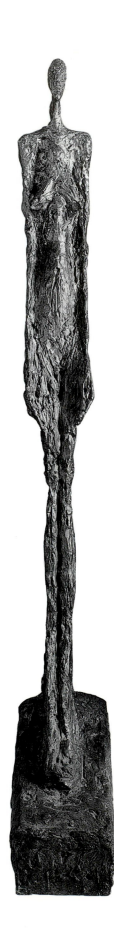

After the tall figures of 1947-49, Giacometti
sculpted smaller figures, notably a group of female
nudes in 1953–54 (ranging from a few inches to
22½ inches high). In preparation for exhibitions of
his work at the Venice Biennale and Kunsthalle in
Bern, both scheduled to open in June 1956, he
modeled a group of fifteen standing female figures
on a scale about three-quarters life-size (41¼ to
52¾ inches high). Ten of the plaster figures were
displayed in Venice (in groups of four and six) as
"works in progress," and five plasters (entitled *Fig-
ures I–V*) were shown in Bern. The nine sculptures
that survived became known as Women of Venice
regardless of where they had been shown.

According to David Sylvester, the figures were
created as different states of the same figure, mod-
eled from the same clay on a single armature.
Whenever the artist liked a version, Diego made a
plaster cast of it. Alberto would then continue to
rework the clay into a different figure, which
Diego would also cast into plaster.[1]

The differences among these figures in height,
anatomical proportions, and bases suggest that the
numbering might not accurately indicate the
sequence in which they were originally modeled.
For example, figure *IV* and possibly *V* appear to
follow from *I;* they have emphatic, naturalistic
anatomies with broad shoulders and narrow waists,
similar to the 1953–54 female sculptures. Figures *II*
and *III,* however, have flattened, rectangular torsos
(with arms attached fully to the body), which
closely relate to *VI–VIII.* The surviving nine fig-
ures were apparently renumbered when the artist
selected them from the fifteen original plasters for
casting into bronze. Of these nine, most came from
the Venice installation, although figure *VIII* was
one of those shown in Bern.

Nearly all the women have very small heads—

83

Woman of Venice VI

1956
Bronze, 2/6, Susse Foundry
52¾ x 6¼ x 12¾ in.
Signed, rear base LR: 2/6 Alberto Giacometti
Incised, rear base: Susse Fondeur Paris
Meadows Museum, Southern Methodist University, Dallas,
Algur H. Meadows Collection

one of the artist's recurrent phenomenological
deceits. Figure *II* combines a soft naturalism in the
torso with delicate and subtly modulated surfaces.
The golden patina of this particular cast adds an
elegant, warm texture. Figure *VI* is the tallest in
the group; its narrow verticality culminates in a
knife-like face with a sharp-edged front profile,
balanced by the curved hairdo. The slightly open
mouth adds a note of expectation.

Other casts of *II* belong to private collections
in London, Paris, New York, and Los Angeles and
to the Louisiana Museum and the Fondation
Maeght, which also has a cast of *VI*.

1. David Sylvester, "Giacometti: An Inability to Tinker," *Sunday Times* (London), July 1965, in Hohl 1971a, p. 281.

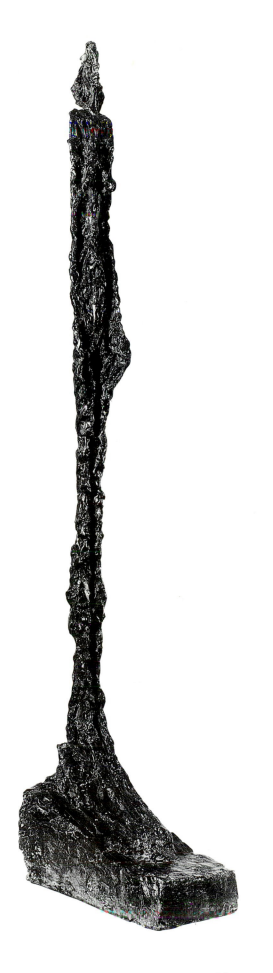

84

Bust of Diego

1957
Bronze, 1/6, Susse Foundry
23⅞ x 9¾ x 6⅜ in.
Signed, side LL: Alberto Giacometti 1/6
Incised, rear LC: Susse Fondeur Paris
Hirshhorn Museum and Sculpture Garden, Smithsonian
Institution, Washington, D.C., gift of Joseph H. Hirshhorn

In the many busts of his brother, Giacometti never repeated himself, although certain characteristics recur during the last twenty years of his career. Compared with the naturalistic bust modeled from life in 1954 [71], this bust appears highly stylized, with the vertical exaggeration usually associated with the sculptures of the late 1940s. The combination of the head, which appears narrow from the front and wide from the side, and the broad shoulders recalls the format of the *Large Head of Diego* [70], although the wing-like shape of the torso also anticipates *New York Bust I,* 1965 [104]. The golden patina of this cast lends a warmth to the vigorously modeled surfaces.

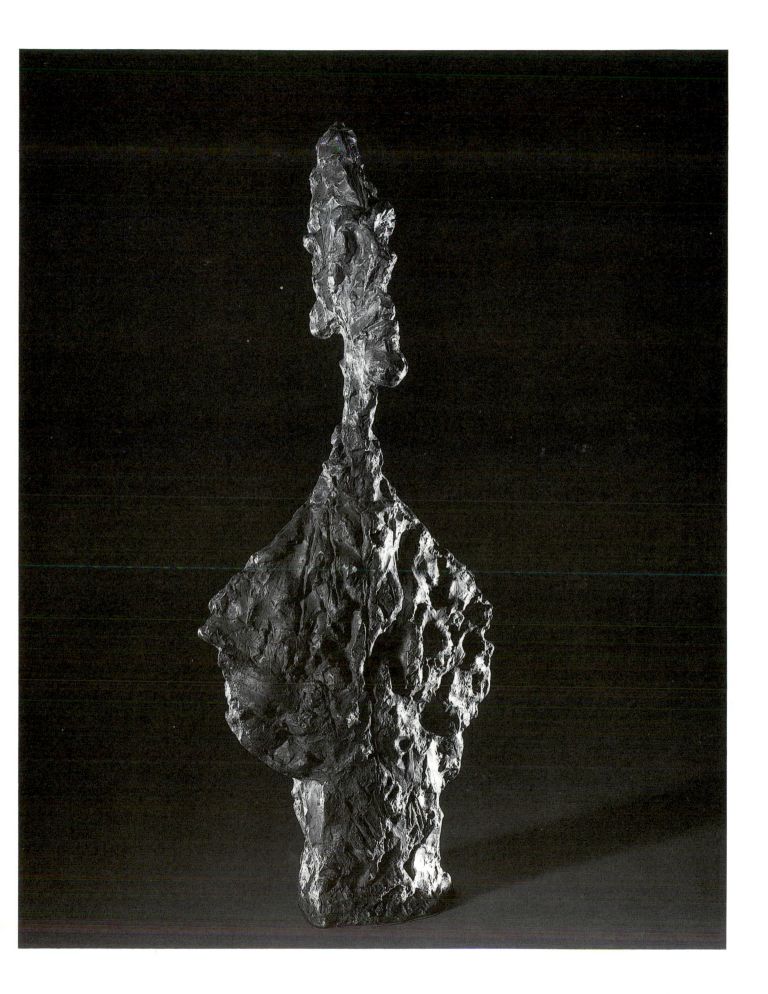

85

Standing Nude

1958
Oil on canvas
61¼ x 27½ in.
Signed and dated, LR: 1958 Alberto Giacometti
Galerie Jan Krugier, Geneva
Hirshhorn Museum and Sculpture Garden only

Emerging from the painting crisis of the preceding two years, Giacometti painted several large canvases of Annette nude in 1958 (two others belong to the Detroit Institute of Arts and Kunstsammlung Nordrhein-Westfalen, Düsseldorf). He had made paintings of his wife posing nude in the studio throughout the 1950s [60, 73], but those from 1958 are distinguished by a larger scale and different execution. Unlike the earlier nudes, this figure is isolated from the specific context of the studio, without indications of furniture or other artworks. The 1958 nudes were painted with more gestural strokes and were obviously overpainted several times, with peripheral areas of the canvas left bare. Annette's body has been defined naturalistically, even realistically, then obliterated with broad gray strokes and redefined with thin black and white lines.

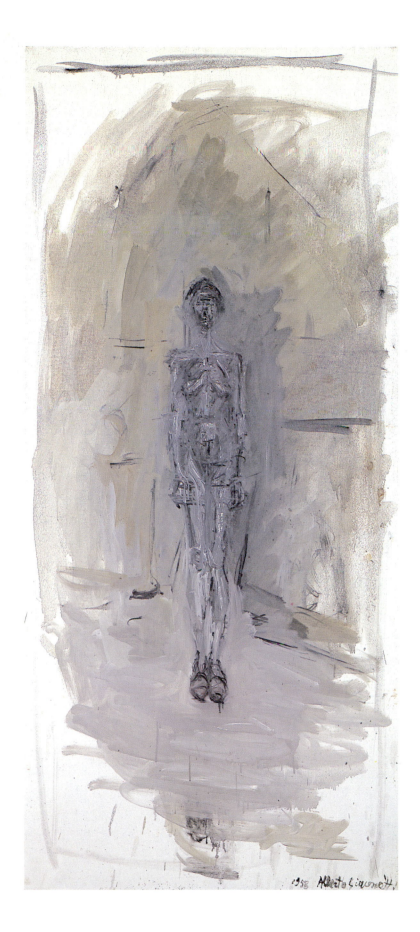

86

Isaku Yanaihara

1958
Oil on canvas
36 x 15½ in.
Signed and dated, LR: Alberto Giacometti 1958
Private collection, New York

On leave from his university in Osaka, thirty-six-year-old Isaku Yanaihara came to Paris in 1954 to pursue advanced study of Existentialist philosophy, which he had already espoused in Japan. He quickly sought out Sartre but did not meet Giacometti until November 1955, when he interviewed the artist for an article intended for a Japanese newspaper. Yanaihara began to pose only in September 1956, shortly before his scheduled departure, which consequently had to be delayed. Giacometti became obsessed with painting the professor's image, and at the artist's request Yanaihara returned to pose in subsequent summers through 1961, except for 1958 when he remained in Japan and published his Parisian diary notes.[1] At least a dozen paintings and one sculpted bust of Yanaihara are known, but this is the only depiction attributed to 1958. It may have been painted in 1959 and the artist inscribed it erroneously at a later date; or Giacometti may have begun the portrait during Yanaihara's visit in 1957 and completed it from memory in 1958.[2]

Although one painting of Yanaihara consists only of thin black lines on plain white canvas (Alberto Giacometti Foundation), most portraits—especially those from fall 1956 and summer 1957—have heavy, nebulous gray washes that isolate and overwhelm the figure. In this portrait the subject is relatively small, leaving far more gray space than figure on the canvas, and the head seems small, barely able to assert itself against the void.

The execution reveals indications of a struggle between linear structure and formlessness. One shoulder almost disappears, and the upper part of the head is defined by multiple outlines that make the head seem to recede and re-emerge. The head is shiny from extensive reworking with washes of paint thinned by turpentine to erase the preceding image. Part of the face has also been scraped away with a palette knife and repainted. Unlike the paintings of 1956–57, however, here more incisive lines and stronger forms return, although they remain relatively few, enough to dominate the prevailing dark gray ambiance. A geometric infrastructure of lines (vestiges of canvases stacked in the background and the diagonal staircase in the upper right) anchors the frontal figure within its space and provides stability. Only a few short lines describe the eyes (each socket is defined by a cross within a circle), establishing a focus for the image.

1. Lord 1985a, pp. 369–76, 384–85, 388.

2. Although Giacometti nearly always painted portraits in front of his models, he twice acknowledged painting from memory. To Genet he mentioned two canvases executed from memory (Genet 1957, p. 7), and according to Yanaihara's diary, on at least one occasion Giacometti spoke of having reworked Yanaihara's portrait alone during the night (Yanaihara 1961, p. 18).

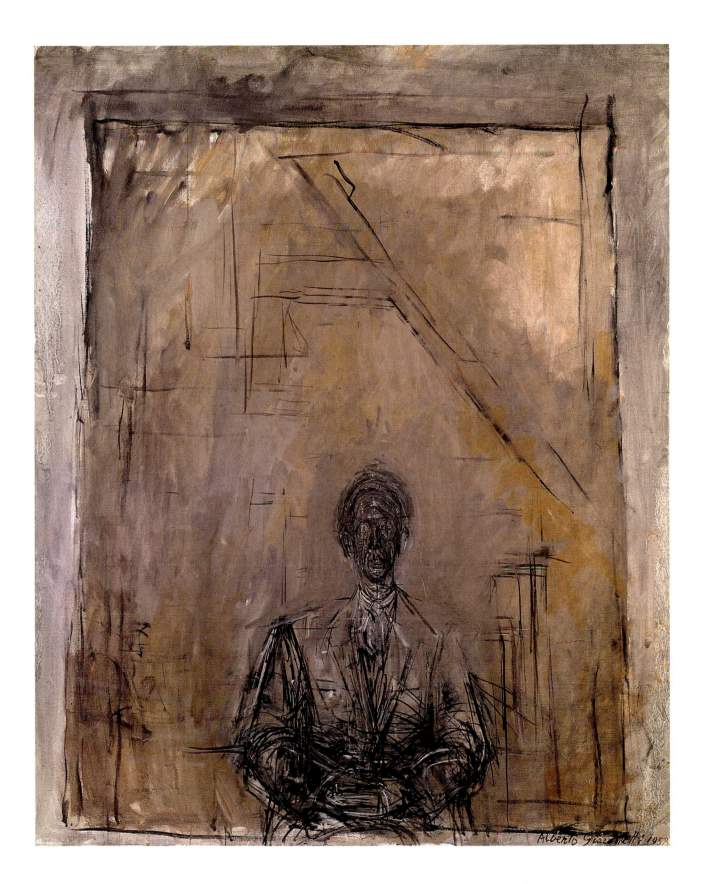

87

Aïka

1959
Oil on canvas
36¼ x 28¾ in.
Signed and dated, LR: Alberto Giacometti 1959
Ernst Beyeler, Basel
Hirshhorn Museum and Sculpture Garden only

This portrait has a delicate harmony of grays and muted roses, accented by incisive black lines; those in the upper right have a stunning calligraphic bravura rare in Giacometti's mature style. The model was a schoolgirl from Nice, the daughter of a talented tailor who made clothes for various artists, including Giacometti. Aïka Sapone recently recalled the sittings for this first portrait:

It was Giacometti who asked if he could paint my portrait. I had gone to Paris with my father for one week in November 1959 during a school vacation. It was my first trip to Paris. He asked my father if he could do my portrait.

Giacometti usually slept during the day and worked at night, but because I was only fifteen, he arranged to work in the afternoon. We would meet in a café near la rue d'Alésia after he awoke around two or two-thirty and, following his coffee and eggs, we would go to his studio where I would pose for two hours. He never used electric light during the three weeks I posed for the portrait—he worked with the existing daylight. The body itself in the portrait was painted rather quickly but the head was repainted at every sitting because he wasn't satisfied. When my father used to come for me at five o'clock, he would tell Giacometti how much he liked it and he answered that he thought my father was right, but the following day the head was always repainted.

Although Giacometti spoke to me a great deal, and always in Italian, I said very little because when I would respond, he would ask me not to move. I had to remain absolutely still. He would talk about people we knew, about [Antoni] Calvé, [Hans] Hartung, Picasso, etc. . . . and everything that was happening in Paris at that time. At one point, I remember his saying that he didn't know what made him think he could do my portrait because he wasn't capable of it, and that it was Picasso who could. He explained that all faces looked the same to him, that he didn't see any differentiating characteristics. His great problem, he said, was that he was unable to capture resemblance.

Since I had been absent from school during this time, I finally had to interrupt the sittings after three weeks to return to Nice. In February of the following year, I returned to Paris with my father so that Giacometti could finish the portrait. During the interim, however, the portrait was shown at the Galerie Maeght in Paris. That February Giacometti started another canvas [for] two more weeks. . . . [The second painting was later exhibited in the retrospective at the Fondation Maeght in 1978 and is reproduced in the catalog.] Since Giacometti thought the second portrait unfinished, he gave me the first, which he considered to be a more beautiful painting.[1]

1. Aïka Sapone, letter to author, October 1987.

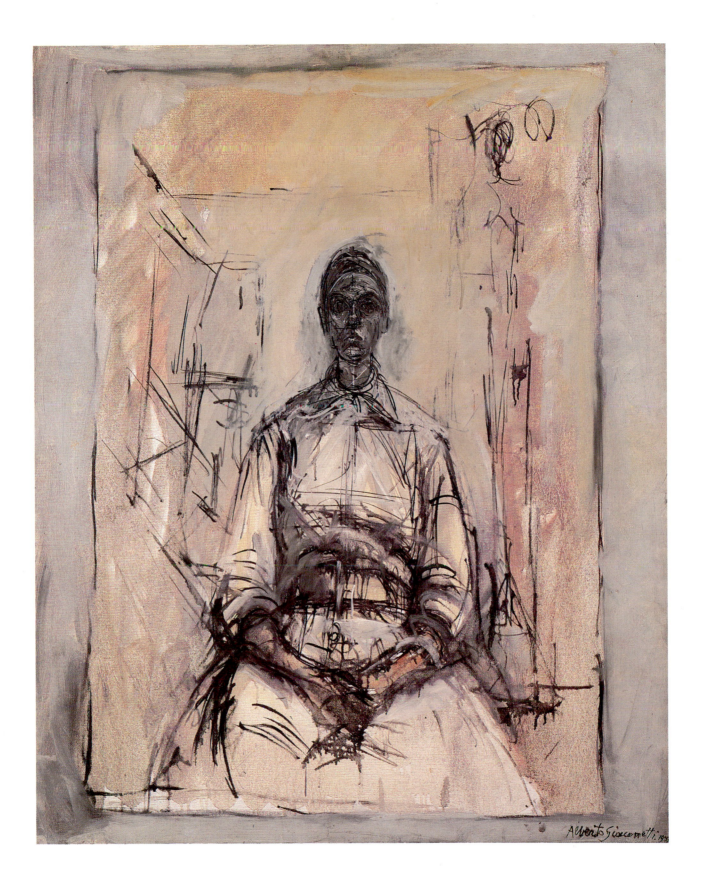

88

Garden at Stampa

1959
Oil on canvas
23⅝ x 19⅝ in.
Signed and dated, LR: 1959 Alberto Giacometti
Private collection, Switzerland
Hirshhorn Museum and Sculpture Garden only

89

Landscape at Stampa

1960
Oil on canvas
21¾ x 18¼ in.
Signed and dated, LR: Alberto Giacometti 1960
Sidney Janis Gallery, New York
San Francisco Museum of Modern Art only

For his annual visits to Switzerland after the mid-1950s, Giacometti increasingly preferred to go during the autumn and winter. Since the house at Maloja was high in the mountains, where it snowed early, he usually stayed at Stampa. In his many paintings of the garden he used the same basic composition, focusing on a tree seen from the studio window [53].

Garden at Stampa is one of three such paintings done on a single visit in 1959. Exercising her authority, his mother made him give one to each immediate family member: brothers, Diego and Bruno, and nephew, Silvio Berthoud. Ever the dutiful son, Alberto immediately complied.[1] Perhaps because there was no question of extensive reworking, this painting has a particular freshness. Generally, even after the crisis with figure painting in 1956–57, Giacometti did not revise his landscape paintings as much as he did the portraits; the canvases done at Stampa often appear to have been executed quite rapidly.

In *Garden at Stampa* and *Landscape at Stampa* the painterly execution indicates the change in Giacometti's painting from his postwar style with its phenomenological concerns to a greater surface expressionism in 1959–65. The numerous wet black strokes bear witness to frenetic speed and nervous energy. The pastoral scene has been transformed into a dense, lush screen of black trunks and branches with foliage painted with vigorous gestural strokes. In *Garden at Stampa* the vortices amid the trees are stabilized by the tall vertical element at left and the horizontal ledge in the foreground, but even these were executed with evident speed.

1. Bruno Giacometti and Silvio Berthoud, conversations with author, May 1987.

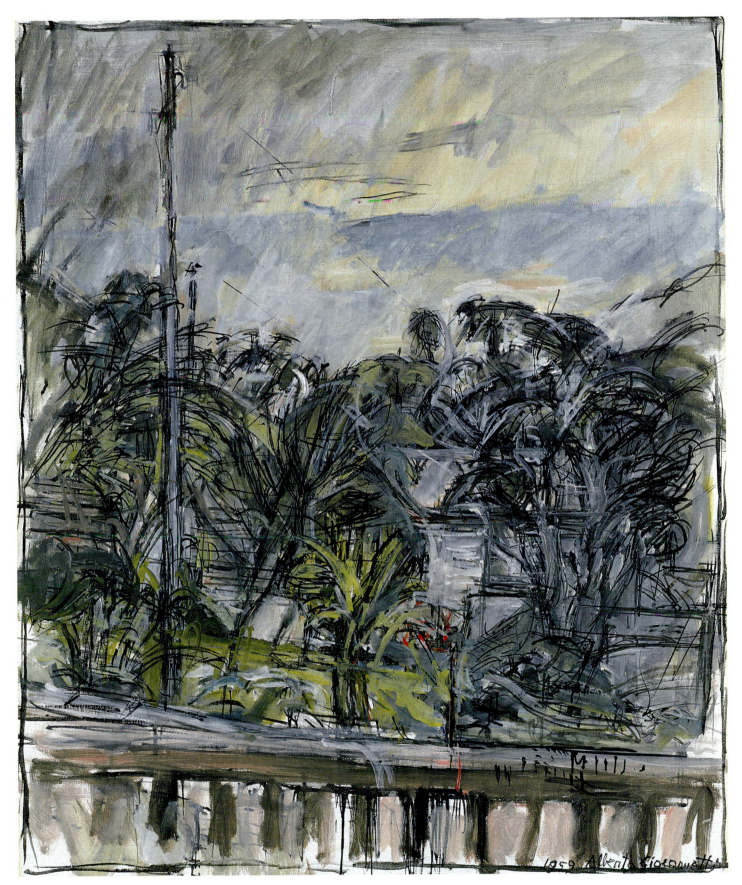

1959 Alberto Giacometti

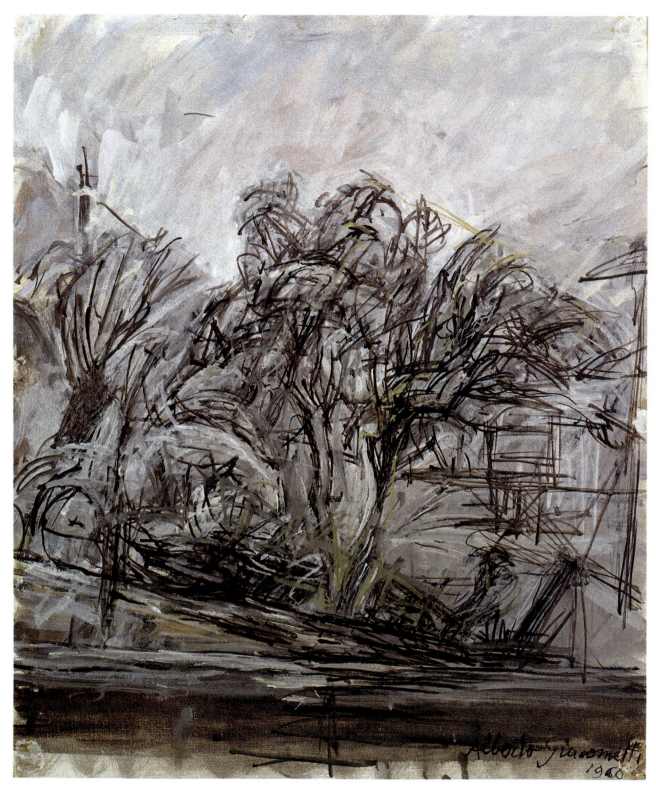

89

90

Still Life: Vase with Flowers

1959
Pencil on paper
19⅝ x 12⅝ in.
Signed and dated, LR: Alberto Giacometti 1959
Private collection
Hirshhorn Museum and Sculpture Garden only

On his annual visits to Stampa Giacometti often drew and painted still lifes, usually of apples or flowers on a table in the studio or dishes on the buffet in the dining room [81]. The artist had done still-life drawings with flowers as early as 1913 and again in 1918–20.[1] Of the dozen or so known drawings of flowers from c. 1954–60, this example is exceptionally complex and accomplished. The rounded shapes of the blossoms and vase play against a rectilinear background in an elegant contrapuntal rhythm. The flowers have a realism that contrasts with the abstract setting. The open planes and lines that supercede the forms create an impression of light-filled airiness and spatial transparency.

1. Reproduced in Fondation Giannadda 1986, nos. 1, 17, 19, pp. 259, 261.

91

J. R.

1959
Pencil on paper
18½ x 12 in.
Signed and dated, LR: Alberto Giacometti 1959
John Rewald, New York

Art historian John Rewald is best known for his scholarly books on Impressionism, Post-Impressionism, and Cézanne. Although his primary area of expertise is French art from the 1860s to the 1920s, Rewald has been friendly with many European artists. Visiting Giacometti's studio on several occasions in the late 1950s and early 1960s, he admired the paintings and drawings more than the sculptures.[1] As a result of their rapport (reinforced by their enthusiasm for Cézanne), the artist made this portrait. *J. R.* has the strict frontal pose, minimal spatial context, economy of means, and geometric infrastructure characteristic of Giacometti's rapidly executed late drawings. In addition to the longer vertical strokes in the wall and shirt-front, the dense lines in the face are securely anchored to a grid of short verticals and horizontals, with circles around the eyes providing central focus, as in the Yanaihara painting [86].

1. Rewald, conversation with author, November 19, 1986.

92

Large Standing Woman IV

1960
Bronze, 0/6, Susse Foundry
106 x 13⅛ x 22 in.
Signed, base LR: Alberto Giacometti 0/6
Incised, rear base: Susse Fondeur Paris
Los Angeles County Museum of Art,
gift of Gloria and David L. Wolper

In 1956 architect Gordon Bunshaft completed designs for the sixty-story Chase Manhattan Bank building to be constructed with a large plaza in the Wall Street district of New York. In 1958 a committee consisting of Bunshaft, Alfred Barr and Dorothy Miller of the Museum of Modern Art, James Sweeney of the Guggenheim Museum, Robert Hale of the Metropolitan Museum of Art, and Perry Rathbone of the Boston Museum of Fine Arts selected Giacometti over Calder and Noguchi to submit designs for a sculpture project. It would have been the first modernist outdoor art project in the financial district. Since Giacometti would not travel to New York to see the site, a cardboard scale model was sent to him in Paris. Bunshaft originally wanted an enlarged version of *Three Men Walking* [42], but Giacometti envisioned a different multifigure composition. From tiny maquettes of a striding man, standing female, and an observing head (private collection, Paris), Giacometti started work in 1959 on seven large plasters, which filled his tiny studio (see fig. 25). In 1960 he completed work on four nude female figures, two walking men, and a monumental head [93, 94].

The four female figures average nearly nine feet tall (92⅞ to 109½ inches) and are his largest sculptures. Their size and grouping recall two earlier attempts at large outdoor sculptures. On a visit to Maloja in the early 1930s, Giacometti had made a plaster sculpture of three tall, abstract, thin figures standing in a field (no longer extant).[1] The most significant antecedent for Giacometti's Chase Manhattan project was the 1948 *City Square* sculpture [41], where several men stride past an immobile woman in an urban plaza.

Whether Giacometti intended to use all seven sculptures or only one male, one female, and one head—and precisely how they would be placed in the Chase Manhattan Bank Plaza—remain unclear. For the 1962 Venice Biennale he installed the bust, two striding men, and two standing women, which he intended to be seen as individual works and as an ensemble. For the Fondation Maeght he made a special arrangement in 1964 of both men, two women, and the head. The artist may not have made a final determination; he did not submit a final composition to the New York committee. He was dissatisfied with the four female figures and regretted having made them quite so large, remarking to Lord in 1964, "It isn't desirable to do large things, in either painting or in sculpture." Rather the more approachable scale of *Man Pointing* was "the maximum size."[2] In conversation with Jean vanden Heuvel, Giacometti also remarked, "I hate that figure. It's over seven feet tall. I did it one afternoon about two years ago."[3] However, when he finally visited New York in late 1965, Giacometti became enthusiastic about the site of the recently completed bank (constructed 1961–64) and spoke of making a single figure at least twenty-three feet tall. No such sculpture materialized (although Diego constructed an armature for it), and in autumn 1972 a forty-two foot aluminum sculpture, *Four Trees* by Jean Dubuffet, was installed on the plaza.[4]

The plasters of the four women were each cast by Susse Foundry in numbered editions of six plus an artist's cast, and the Fondation Maeght bronzes. Other casts of *IV* belong to the Norton Simon Art Foundation in Pasadena, California, two private collections in New York, the Bündner Kunstmuseum in Chur, Switzerland, and Louisiana Museum.

1. Photograph reproduced in Maurice Raynal, "Dieu—table—cuvette," *Minotaure* 3–4 (1933): 40.

2. Lord 1965, p. 34.

3. Giacometti, in Jean vanden Heuvel, *A Conversation with Alberto Giacometti* (typescript, 1962), p. 1.

4. See Monroe Denton, "The Chase Manhattan Project," in Evans 1984, pp. 109–14; and Bach 1980. See also Hohl 1971a, pp. 185–86; Meyer 1968, pp. 198–200; and Harriet Senie, "Studies in the Development of Urban Sculpture" (Ph.D. diss., New York University, 1980), pp. 453–56.

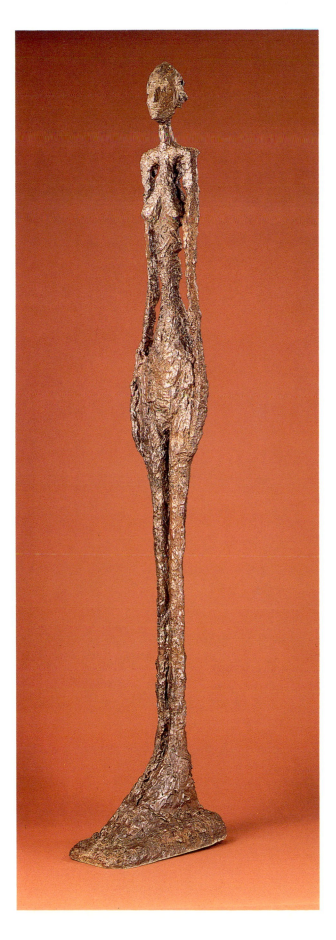

93

Walking Man I

1960
Bronze, 3/6, Susse Foundry
71¾ x 10½ x 38 in.
Signed, base front L: Alberto Giacometti 3/6
Incised, rear base: Susse Fondr Paris
Albright-Knox Art Gallery, Buffalo, gift of Seymour H. Knox

For the Chase Manhattan Bank commission [see 92 for discussion of the project] Giacometti returned to the walking man format that had fascinated him from 1946 to 1950. During the 1950s he had executed very few walking figures and none on a large scale. Although the sculpture's eyes are almost on the viewer's level, the figure remains essentially remote, staring out at an unseen goal. With its gnarled, devastated surfaces, *Walking Man I* stands as a symbol of humanity always striving, ever seeking, never at peace. The roughly modeled surfaces shimmer under different light conditions, as if indicating the transient nature of reality, and the figure's nervous energy activates the surrounding space.

This composition exists in two similar versions. Each was cast by the Susse Foundry in numbered editions of six, plus an artist's cast, and additional casts with special patinas were made in 1964 for the Fondation Maeght. In 1961 *Walking Man I* was shown in the Carnegie Institute Museum of Art's *International Exhibition of Contemporary Painting and Sculpture* in Pittsburgh, where it won the prize for sculpture. Casts of *I* belong to the Carnegie and to two private collections in New York. Slightly larger, *II* has a more rectangular base; casts belong to the National Gallery of Art, Art Institute of Chicago, Herbert F. Johnson Museum at Cornell University in Ithaca, Kröller-Müller Rijksmuseum in Otterlo, Netherlands, and a private collection in Switzerland. Casts of both *I* and *II* belong to two private collections in Paris and London.

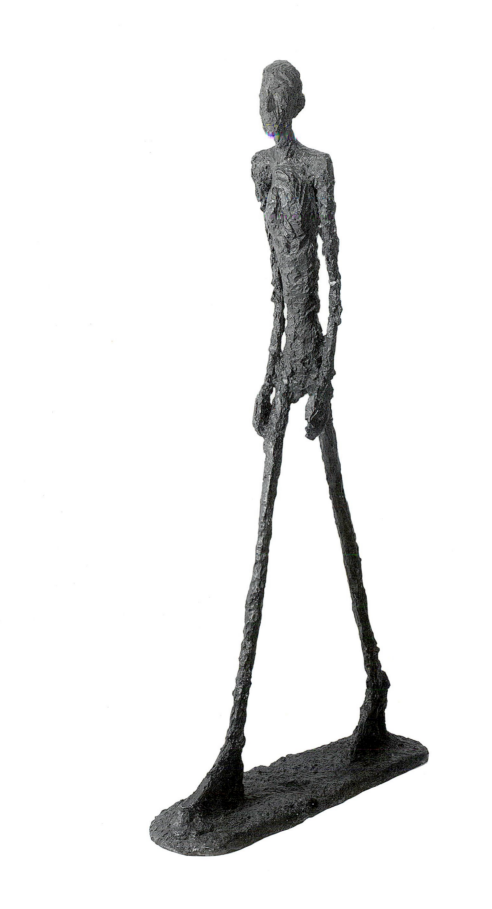

94

Monumental Head

1960
Bronze, 1/6, Susse Foundry
37¼ x 11⅞ x 14⅜ in.
Signed, side base LL: Alberto Giacometti 1/6
Incised, rear base LR: Susse Fondeur Paris
Hirshhorn Museum and Sculpture Garden, Smithsonian
Institution, Washington, D.C., gift of Joseph H. Hirshhorn

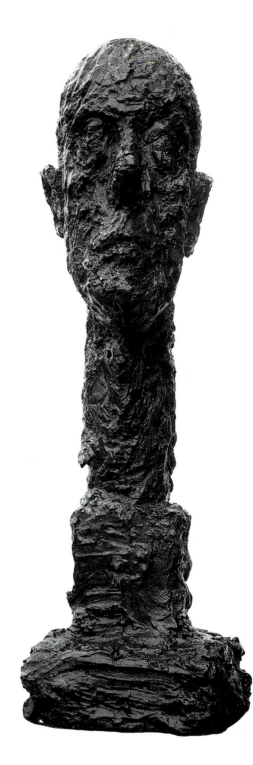

According to Hohl, the correct title is *Head on a Pedestal*,[1] but this sculpture is usually known as *Monumental Head*. Along with two walking men [93] and four standing women [see 92 for discussion], this head was created as one of the components envisioned by Giacometti for the Chase Manhattan Bank Plaza. The idea of the observing head dates back in Giacometti's oeuvre to the 1927–28 *Gazing Head* [9]. The concept of a male head observing female nudes occurred in several sculptures of 1950, including *The Forest* and *The Cage* (both Alberto Giacometti Foundation). Rodin's *Thinker*, 1880 (Rodin Museum, Philadelphia), had played a somewhat analogous but more narrative function in *The Gates of Hell*, 1880–1917 (Rodin Museum). *Monumental Head* may represent Giacometti surveying his sculptural creations.

As usual with Giacometti's male busts the model was Diego, although this work was executed largely from memory. The composition is strongly vertical, with horizontal finger marks across the base. The corrugated surfaces capture and reflect sunlight in complex and dramatic patterns. Dominating the center of the tiny studio for many months (see fig. 25), this head is Giacometti's largest bust. Its monumental quality exceeds the impact of a typical portrait bust and reflects the artist's study of the colossal head of Emperor Constantine from the late Roman period on view in the Capitoline Museum, which he sketched on a visit to Rome in 1959 or 1960.[2]

Of the edition of six numbered bronzes and an artist's cast, one is in the Museum of Modern Art; another in the Louisiana Museum. Others belong to private collections in London and Basel. A special cast, with a different color patina, was made in 1964 for the Fondation Maeght.

1. Hohl 1971a, p. 186.

2. Hohl, in Guggenheim 1974, pp. 32, 46, n. 61. The ballpoint-pen drawing is reproduced in Carluccio 1967, no. 52.

95

Annette with Hanging Lamp

1960
Pencil on paper
19¾ x 12⅞ in.
Not signed or dated
Fondation Maeght, Saint Paul-de-Vence, France

At Stampa Giacometti sketched domestic scenes as early as 1915 and was particularly drawn to them during the 1950s. From 1958 on he often centered the compositions on the kerosene lamp hanging over the dining table (visible in fig. 20). A prosaic fixture, here the lamp is an elaborately curved, almost baroque motif that dominates the upper half of the paper. Annette's oval head appears small, vying with the spherical lamp element. Her head is further linked with the lamp by diagonal erasures, like shafts of light.

96

Annette

1961
Oil on canvas
21⅝ x 18⅛ in.
Signed and dated, LR: Alberto Giacometti 1961
Hirshhorn Museum and Sculpture Garden, Smithsonian
Institution, Washington, D.C., gift of Joseph H. Hirshhorn

From 1961 through 1965 Giacometti painted a number of bust-length portraits of Annette. Several done on visits to Switzerland depict her wearing a red sweater (another dated 1961 belongs to the Robert B. Mayer Family Collection in Chicago). This canvas was probably painted in August, when he and Annette made a special visit for his mother's ninetieth-birthday celebration. A similar painting is shown in progress in a photograph of the artist at

work in the Stampa studio in 1960 (fig. 21). The Hirshhorn Museum painting has a vivid coloration characteristic of Stampa paintings executed in daylight in contrast to those, such as *Annette* [99], painted at night under the single electric light in the Paris studio. In addition to the bright color, the assured execution in the Hirshhorn composition is reminiscent of paintings from the early 1950s.

Fig. 21 Giacometti painting a portrait of Annette in his studio at Stampa, 1960. Photograph by Ernst Scheidegger.

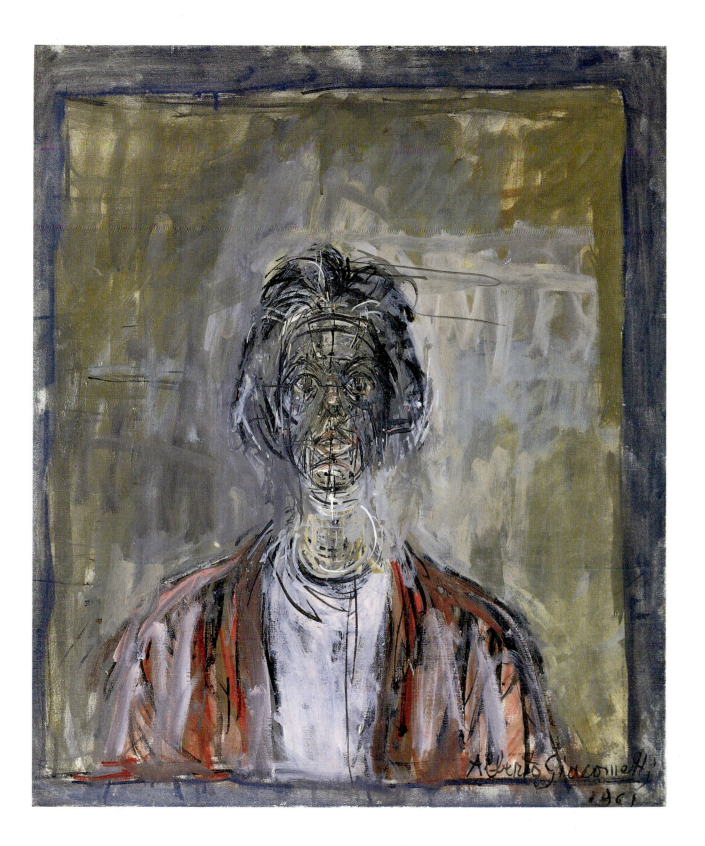

97

Head of a Man (Diego)

1961
Oil on canvas
17¾ x 13¾ in.
Signed, LR: Alberto Giacometti
Hirshhorn Museum and Sculpture Garden, Smithsonian
Institution, Washington, D.C., gift of Joseph H. Hirshhorn

In the last four years of his life Giacometti painted a number of frontal, bust-length images of Diego, usually modest in size (from 18 to 26 inches high). These canvases are characterized by a dark gray tonality and nightmarish intensity comparable to the sculpted busts of the next four years. From the somber space emerges a gaunt, heavily repainted, almost black head dominated by eyes transfixed in an unnatural stare. Prominent black eyes are characteristic of Egyptian paintings from Faiyûm, which Giacometti admired; he kept a reproduction of a Faiyûm work pinned up on his wall for years.[1] Devoid of descriptive details, Diego's visage here represents the human psyche, apparently prey to an indefinable, but frightening emotion.

Two similar paintings (same year and size) belong to private collections, and four are in the Alberto Giacometti Foundation.

1. Seen by Jean vanden Heuvel in 1962; in Jean vanden Heuvel, *A Conversation with Alberto Giacometti* (typescript, 1962), p. 2. Years earlier a private collector had also seen a Faiyûm image on Giacometti's studio wall; Mr. and Mrs. James W. Alsdorf, conversation with author, September 1985.

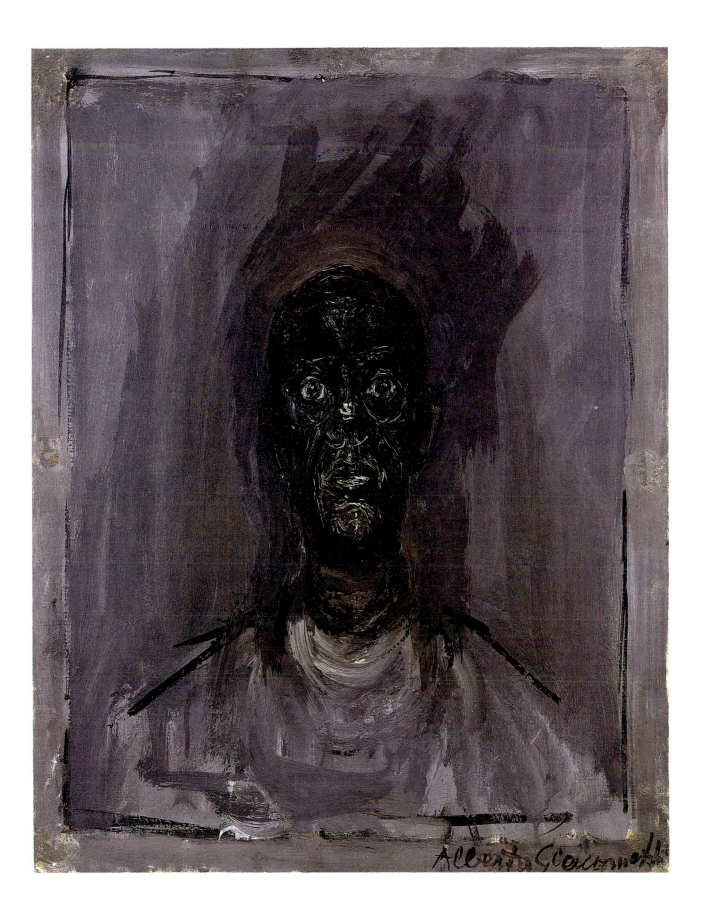

98

Caroline

1961
Oil on canvas
39½ x 32 in.
Signed and dated, LR: Alberto Giacometti 1961
Ernst Beyeler, Basel
Hirshhorn Museum and Sculpture Garden only

Giacometti had long been fascinated by prostitutes, and during the last years of his life he became enamored of a vivacious Parisian demimondaine and occasional petty thief called Caroline (real name Yvonne), who was thirty-seven years younger than he.[1] They first met in October 1959 in a café-bar, and from May 1960 until his death she posed regularly for him. "She sits for me almost every evening from nine to midnight or one o'clock. In the past few years there haven't been more than four or five evenings that we haven't worked."[2] Already accustomed to nocturnal life, Caroline suited Giacometti's work habits, and he routinely paid for her time. She would also drive Giacometti, who had neither car nor driver's license, around Paris.

In the Caroline paintings Giacometti developed a style in which the face becomes paradoxically more three-dimensional and ghostly; defined repeatedly with black, white, and gray lines, her face appears to emerge from the canvas surface. Her gaze seems fixed on something beyond the viewer with a disturbing intensity. The rest of her body is portrayed with rapid, gestural strokes; often peripheral areas of the canvas are left bare. To some extent the strong impact of the Caroline paintings may be attributed to a renewed vigor the artist felt as a response to the attractive scandalous model, as he had been invigorated by Annette's vitality after the war and provoked to a crisis by Yanaihara's presence in 1956.

Giacometti completed at least six paintings of Caroline in the first year and more than two dozen total. Nearly all are canvases of significant size (ranging from 36 to 51 inches high, with one measuring five feet). Examples are in many public and private collections, including the Art Institute of Chicago, Saint Louis Art Museum, Tate Gallery, Musée National d'Art Moderne, Öffentliche Kunstsammlung Basel, Robert B. Mayer Family Collection in Chicago, and private collections in New York, Paris, and London. Giacometti modeled one bust of Caroline in 1961 (cast in an edition of six); bronzes belong to the Alberto Giacometti Foundation, Hirshhorn Museum and Sculpture Garden, and two private collections in Paris.

1. See Lord 1985a, pp. 400–40, 478–83, 512–16.

2. Giacometti, interview for ORTF television film by Jean-Marie Drôt, Paris, November 19, 1963, revised 1966; in Hohl 1971a, p. 282.

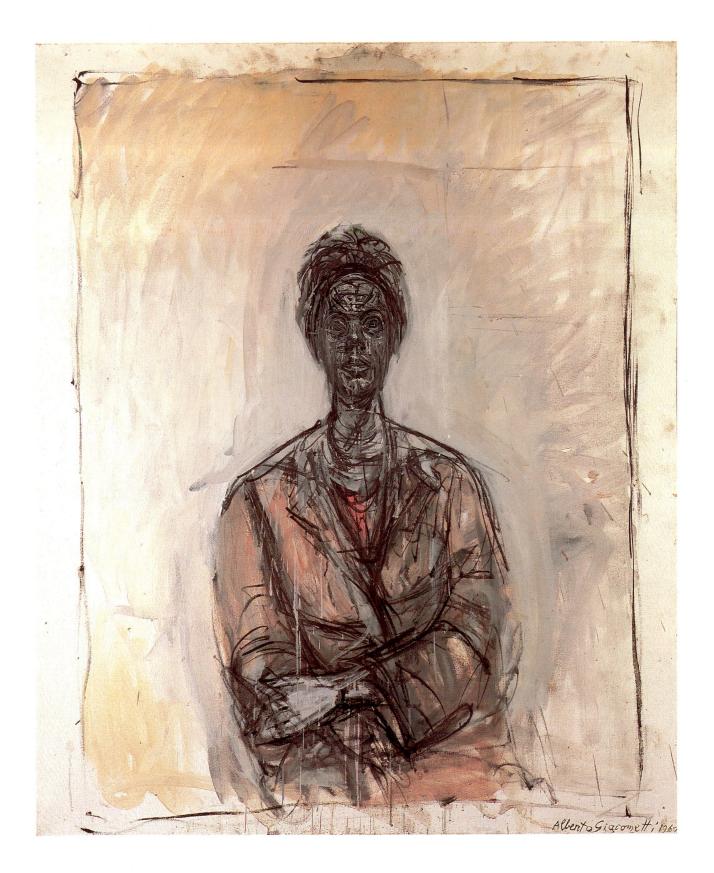

Alberto Giacometti '1961

99

Annette

1961
Oil on canvas
45¾ x 35 in.
Signed and dated, LR: Alberto Giacometti 1961
Jacques and Natasha Gelman Collection, New York
Hirshhorn Museum and Sculpture Garden only

Many paintings done during the last five years of Giacometti's life display an almost savage power and frenzied execution. Painted at night in his Paris studio under the lone electric bulb hanging from the high ceiling, *Annette* has a stark, desolate quality unlike the lighter-keyed portrait made at Stampa the same year [96]. Here the strokes are gestural, at times slashingly energetic, especially the black lines in the torso and hands. The jagged strokes create a raw, aggressive effect, while the obsessive repainting seems to isolate the head. The figure, with gaze fixed on some remote, inner-directed vista, has an intimidating monumentality.

Giacometti denied any deliberate expressive intentions in his late work: "I'm incapable of expressing any human feelings at all in my work. I just try to construct a head, nothing more."[1] *Annette* belies the artist's words (possibly he insisted on the purely descriptive intent of his art to forestall excessively romantic and Existentialist interpretations by others). The disturbing intensity of *Annette* recalls instead his declaration a decade earlier that art must be inherently subjective and expressive because it conveys observed reality through the artist's psyche: "Although one may want to copy a head as exactly as possible . . . the result will not resemble at all that head! . . . It responds to the sensibility of he who made it."[2]

The almost anguished energy in the execution reflects the artist's total immersion in the process of creation. The act of painting transcended traditional emphasis on the finished artwork. Giacometti's extraordinary concentration became manifest in his late works, lending a sense of "otherness," of *terribilità*, to his portraits. In the dialectical process between blank canvas and resemblance (the familiar features of his model), he experienced a feeling of

acute vitality and meaningfulness—his raison d'être. In an emotional statement about his life and art, he explained that he made art for deeply personal reasons:

to bite into reality, to defend myself, to nourish myself . . . to advance as much as possible on every level in every direction . . . to be as free as possible . . . to try to see better and understand better what is around me . . . to discover new worlds.[3]

1. Giacometti, in Lord 1965, p. 28.

2. Giacometti, interview with Georges Charbonnier, March 1951, in Charbonnier 1959, p. 163.

3. Giacometti, "Ma réalité," *XXᵉ Siècle*, n.s., 9 (June 1957): 35.

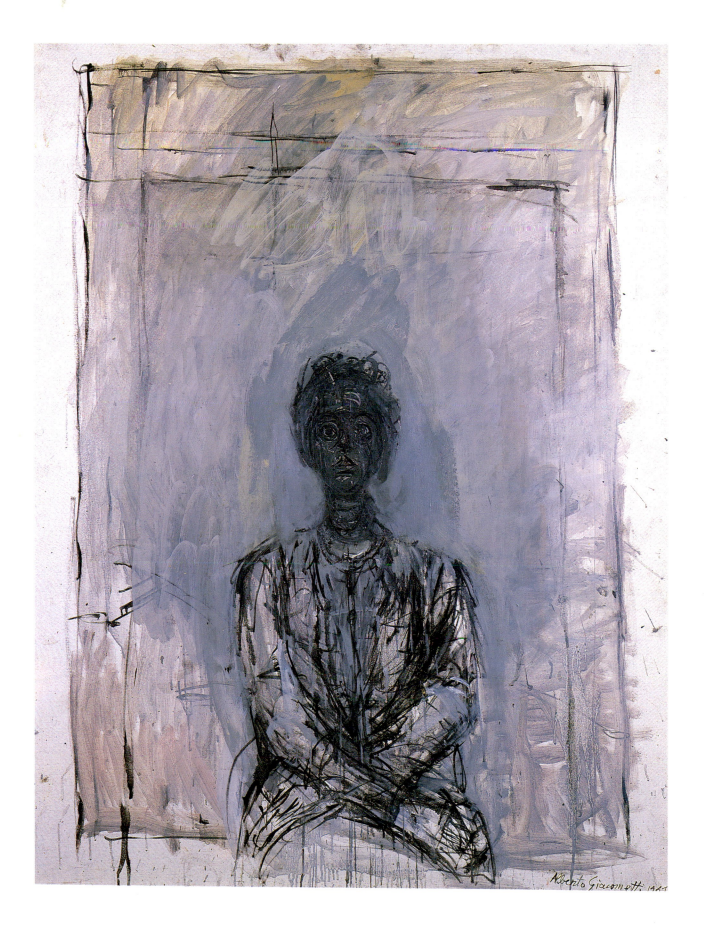

Alberto Giacometti 1961

100

Annette IV

1962
Bronze, 1/6, Susse Foundry
22⅞ x 8¾ x 9¾ in.
Signed, rear base LR: Alberto Giacometti
Incised, rear base LR: 1/6 Susse Fondeur Paris
The Marion Koogler McNay Art Museum, San Antonio,
Sylvan and Mary Lang Collection

In 1962 Giacometti executed a series of eight busts of his wife, with a ninth in 1964 and a tenth in 1965. Although not counted as part of the series, there is also a bust of Annette from 1960; its style is somewhat more realistic and restrained. This series constituted a change from his working methods of the preceding decade, when he had customarily used his wife as a model for paintings and drawings while basing most of his sculpture busts on Diego.[1]

The busts of Annette exemplify the artist's late style, which was more overtly expressionist. As in the last busts of Diego from 1965 [104, 105], the gaunt head strains forward, as if to channel its energies into the hypnotic gaze. *Annette VII* is the most naturalistic of the series, with its full hairdo and recognizable face. In *Annette IV* the modeling is almost violent. The shoulders and base are marked by large gouges, as if the clay had been pulled, twisted, and torn, leaving gaping losses in the silhouette and finger marks across the base.

Cast 0/6 of *IV* belongs to the Tate Gallery; other casts of *IV* belong to the Sara Lee Corporation in Chicago and a private collection in Paris.

1. For photographs of the artist modeling one of the clay originals in front of Annette, see Herta Wescher et al., "Alberto Giacometti: Aufnamen von Franco Cianetti," *Du* 22 (February 1962): 4–5.

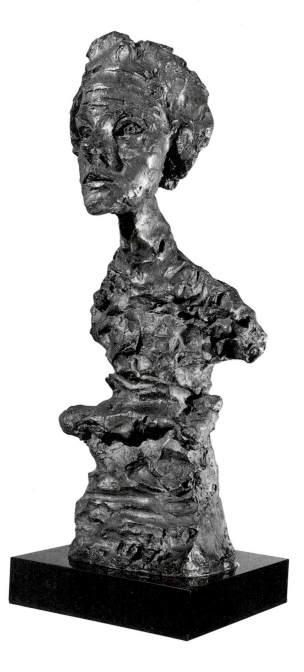

101

Annette VII

1962
Bronze, 2/6, Susse Foundry
18½ x 10¾ x 7½ in.
Signed, top base LL: 2/6 Alberto Giacometti
Incised, top rear base LR: Susse Fondeur Paris
San Francisco Museum of Modern Art,
gift of Mr. and Mrs. Louis Honig

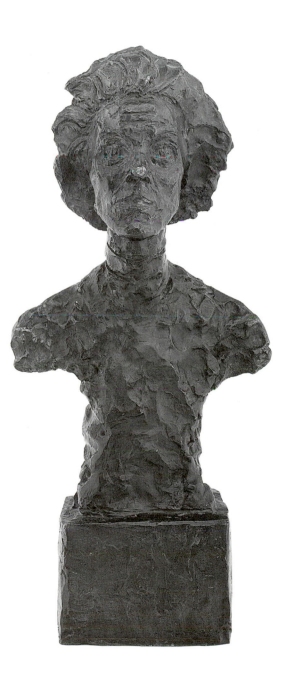

102

Annette III

1962
Pencil on paper
19⅞ x 12¾ in.
Signed and dated, LR: 3 Alberto Giacometti 1962
Private collection, Paris
Hirshhorn Museum and Sculpture Garden only

In 1962, the same year he modeled the Annette busts [100, 101], Giacometti made a series of six drawings of her face isolated on a sheet of cream-white paper. They range from a soft naturalism to the starkness of this image. Centered on the paper, the face has been denuded of peripheral details to accentuate the wide, staring eyes. Although by this time Giacometti had distanced himself from the Existentialist vogue of the postwar years, this drawing suggests the individual overwhelmed by the void, fully aware of her isolation.

103

Hotel Room IV

1963
Pencil on paper
19⅝ x 13 in.
Not signed or dated
Alberto Giacometti Foundation, Zurich

From the time he first came to Paris in 1922, Gia-
cometti preferred to live in hotels, rather than settle
in a permanent abode. During the 1920s and 1930s
he often slept in inexpensive hotels near his studio,
and in Geneva during 1942–45 he stayed in the
modest Hôtel de Rive; at least one drawing of that
interior survives (private collection, New York).
Despite increasing financial success during the
1950s and early 1960s, he steadfastly refused to
move into an apartment, preferring the spartan sur-
roundings of his tiny studio and adjacent bedroom,
with occasional stopovers in better hotels.

In February 1963 Giacometti was operated on
for stomach cancer; after two weeks in the clinic,
he stayed in the Hôtel Aiglon at 232 boulevard
Raspail until he was well enough to go to Stampa.
While recuperating, he made six drawings of the
hotel room, all centered on a table and chair by a
window. Using an article of clothing to imply the
owner's presence is a traditional form of symbol-
ism, and in this drawing his overcoat sits in the
chair as if it were animate. Giacometti used era-
sures to indicate sunbeams streaming in from the
window on the left.

104

New York Bust I (Diego)

1965
Bronze, Susse Foundry
21⅝ x 7⅞ x 5½ in.
Signed, lower rear: Alberto Giacometti
Incised, lower rear: Susse Fondeur Paris
Private collection, New York
Hirshhorn Museum and Sculpture Garden only

In 1965 Giacometti modeled several busts of
Diego and the photographer Elie Lotar. Compul-
sively revising them from the models and from
memory over weeks and months, Giacometti con-
sidered them works in progress with no absolute
state; each permutation was as important as the
others. These busts from the last months of Gia-
cometti's life have particularly intense gazes and
gouged surfaces. Natural shapes are distorted: the
heads jut forward with little solidity in back; the
cheeks are more concave than rounded, the torsos
are stylized into abstract shapes (like wings in *I* or
a ⊤ or cross in *II*). These distortions emphasize the
noncorporeal, expressive nature of these portraits.
Although Giacometti denied any deliberate emo-
tionalism in his art, his rejection of descriptive
normalcy in these busts creates a sense of yearning
and subdued anguish.

The titles of these busts refer to Giacometti's
retrospective at the Museum of Modern Art; both
were added to that show, which he visited in late
1965 (his only trip to the United States). Left in his
studio after his death, the plasters were cast in
numbered editions of eight. Casts of *I* belong to
private collections in Paris, New York, London,
and Switzerland. Another cast of *II* is in a private
collection in Geneva.

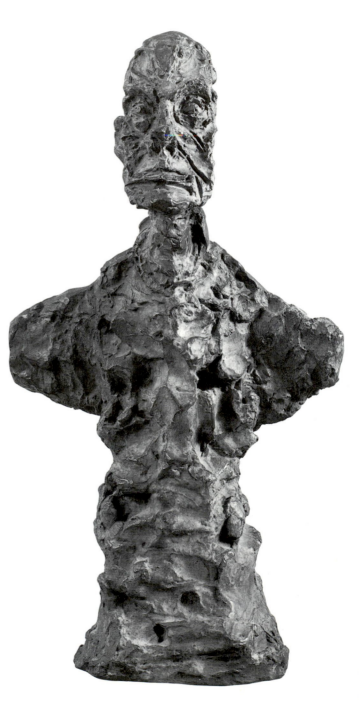

105

New York Bust II (Diego)

1965
Bronze, Susse Foundry
18½ x 9⅞ x 7⅛ in.
Signed, lower rear: Alberto Giacometti
Incised, lower rear: Susse Fondeur Paris
Private collection, Paris

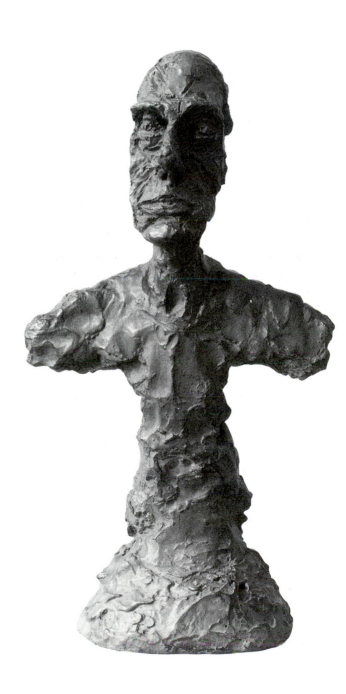

Chronology

1901–09

Born October 10, 1901, in Borgonovo, a Swiss village near Stampa in the Italian-speaking Bregaglia Valley, to Giovanni Giacometti (1868–1933), a Post-Impressionist painter, and Annetta Stampa Giacometti (1871–1964). Godson of Cuno Amiet (1868–1961), a Fauvist painter, and distant cousin of painter Augusto Giacometti (1877–1947). Eldest of four children: Diego (1902–1985), who worked closely with Alberto in Paris for nearly forty years; sister Ottilia (1904–1937); and Bruno (born 1907), who became an architect. In 1904 family moved to Stampa; in 1906 into residence they occupied henceforth, along with a summer house ten miles away in Maloja Pass from 1909 on.

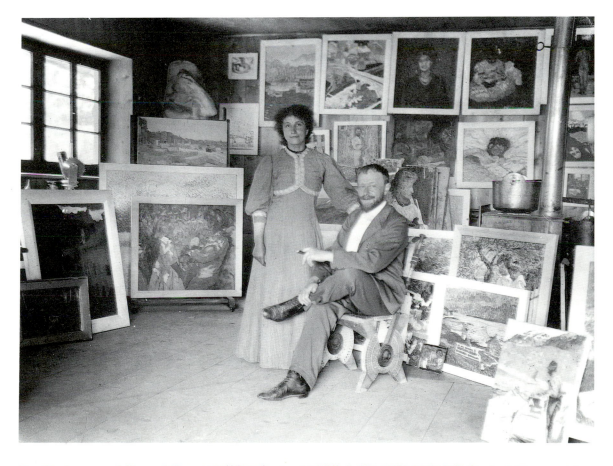

Fig. 22 Annetta and Giovanni Giacometti (Alberto's parents), 1911, in Giovanni's studio in Switzerland. Photograph by Gertrud Dübi-Müller. Stiftung für die Photographie, Kunsthaus Zurich.

Around 1910–12 began to draw voraciously, capturing everyday objects and people around him and often copying reproductions of artworks from books in father's studio. In 1913 executed first painting, a still life of apples, and first watercolor, a landscape, followed in late 1914–early 1915 by first portrait busts of Diego and Bruno. From September 1915–April 1919 attended Evangelical Secondary School, a boarding school in Schiers. Read extensively, including the lyric poets Friedrich Novalis and Heinrich Heine in German. In 1917–18 drawing style became more refined, with increased sense of two-dimensional design (see fig. 1). Made color portrait drawings of schoolmates in attic studio; also Fauvist landscapes in watercolor and oil. Under influence of father and godfather, admired the art of Ferdinand Hodler, Paul Cézanne, and Paul Gauguin and painted in a Neo-Impressionist, occasionally Fauvist style. Attracted by Auguste Rodin's sculpture, which influenced the first bust of his mother in 1916. Became sterile from an attack of mumps in 1917 or 1918.

1919–21

In April 1919 left school, neither completing term nor graduating. Worked in father's studio. In autumn 1919 went to Geneva to attend Ecole des Beaux-Arts to study drawing and painting; also enrolled in Ecole des Arts-et-Métiers to study sculpture; left Geneva after six months. In late April–early May 1920 accompanied father to Venice; visited Biennale (seeing works by Cézanne and Alexander Archipenko for the first time); admired Tintoretto's paintings, mosaics of San Marco, Giotto's frescoes in Padua. Returned to art studies in Geneva in late summer–early autumn 1920. From mid-November 1920 to July 1921 studied on his own in Italy. Spent one month in Florence; impressed by an Egyptian portrait bust. In December 1920 went to Rome; remained for seven months, living with cousins and attending a drawing class. Painted portraits and landscapes; made numerous drawings after older art, including Egyptian, early Christian, Renaissance, and Baroque. In March–April 1921 visited Naples; impressed by Roman art in museum; visited temples of Paestum and ruins of Pompeii. Returned to Switzerland in mid-summer 1921. In September 1921 en route to Venice witnessed death of older traveling companion, Dutchman Pieter van Meurs, which had a profound impact.

1922–24

Arrived in Paris January 9, 1922, to study sculpture under Antoine Bourdelle; settled there in Montparnasse neighborhood, although until 1925 returned to Switzerland every few months, including military service in August–October 1922, and thereafter continued to visit nearly every year. Continued to attend Bourdelle's class at Académie de la Grande Chaumière through 1925 and intermittently for two more years. Worked often on own, including weekly visits to Louvre to study older art. Read Georg Hegel.

1925–27

In February 1925 Diego came to Paris; they shared a studio in Montparnasse at 37 rue Froidevaux. Around 1925 stopped painting for twenty years in Paris, although continued intermittently on visits to Stampa. As vice-president of Salon des Tuileries, Bourdelle allowed him to exhibit one traditional portrait and one avant-garde sculpture each year in 1925, 1926, and 1927, including *Couple,* 1926 [3], and *Spoon Woman,* 1926–27 [4]. Also exhibited with his father in a Zurich gallery (October–November 1927). Visited studios of Jacques Lipchitz and Henri Laurens; influenced by their Cubist sculptures of preceding decade. Probably saw work of Constantin Brancusi and Raymond Duchamp-Villon. Frequented ethnographic art collections in Musée d'Ethnologie du Trocadéro (now Musée de l'Homme). Created sculptures from imagination rather than from model and usually in Cubist-derived style (two Compositions, 1927 [5, 6]), but also in modes influenced by primitive art, notably African, Oceanic, and Cycladic (*Couple* and *Spoon Woman*). In 1927 also executed several flattened portrait heads of parents [7, 8]. In spring 1927 took a tiny dilapidated studio (later with adjacent bedroom for himself and workroom for Diego) at 46 rue Hippolyte-Maindron, where he worked and to a large degree lived (despite the lack of amenities) until his death.

1928–29

Exhibited sculptures with group of Italian painters in Salon de l'Escalier (February 1928) and again in a gallery (March–April 1929). Became more fluent in French. Completed flat plaque sculptures in winter 1927–28, including *Gazing Head* [9] and *Woman* [10]. Exhibited two plaster plaques at Galerie Jeanne Bucher (June 1929). In spring 1929 was befriended by André Masson, through whom met Antoin Artaud, Jean Arp, Georges Bataille, Robert Desnos, Max Ernst, Michel Leiris, Georges Limbour, Joan Miró, Jacques Prévert, Raymond Queneau, and others who had been closely involved in Surrealism but had left or been expelled from the official group. In 1929 created linear openwork sculptures, including *Man* [11], *Three Figures Outdoors* [12], and *Reclining Woman Who Dreams* [13], and signed one-year contract with Pierre Loeb, dealer in Surrealist art. Also in 1929 first published article on his art appeared in Bataille's journal *Documents;* written by Leiris (poet, writer, and African ethnologist who remained a close friend).

1930–31

Constructed sculptures in cage-like and game-board formats with mysterious, violent, and sexual implications (see figs. 2–4). In *Miró-Arp-Giacometti* exhibition at Galerie Pierre (spring 1930), *Suspended Ball,* 1930 (see fig. 2), attracted attention of André Breton and Salvador Dali. Accepted their invitation to join official Surrealist group; participated in activities until 1935, attending meetings and contributing sculptures to Surrealist exhibitions starting at Galerie Pierre (May–June 1931) and eventually across Europe during the 1930s. In June 1930 suffered acute appendicitis in Paris; was operated on in Switzerland. To earn money designed lamp bases, vases, and other objects, implemented to large degree by Diego, for interior decorator Jean-Michel Frank from 1930 until the war began.

1932–33

Continued to create innovative Surrealist sculptures with aggressive and morbid themes, including *No More Play,* 1931–32 (see fig. 5), and *Woman with Her Throat Cut,* 1932 [18]. Completed delicate constructions *The Palace at 4 A.M.,* 1932–33 (see fig. 6), and *Flower in Danger,* 1933 [19]; also modeled two figurative versions of a headless *Walking Woman,* 1932 [17]. First solo exhibition, at Galerie Pierre Colle in Paris (May 1932). Christian Zervos published article on his work in *Cahiers d'art* (1932), including photographs by Man Ray of seven sculptures. While visiting family in Maloja in summer 1932, painted two portraits of father, who died a year later. Brother Bruno and sister Ottilia planned their weddings. Contributed several works to Surrealist group show at Galerie Pierre Colle (June 1933), including *Surrealist Table,* 1933 [20], *The Palace at 4 A.M.,* and a modified *Walking Woman.* In last issue of *Le surréalisme au service de la révolution* (May 15, 1933), published three poems and a reminiscence of childhood fantasies. Published note on *The Palace at 4 A.M.* in Tériade's periodical *Minotaure* (December 1933).

1934–35

Dissatisfaction with abstract and constructed sculpture grew; preferred more figurative forms, notably *The Invisible Object* [21] and *Head/Skull* [22], both in 1934. In summer 1934 took Ernst to Switzerland where they made sculptures from natural stones. First solo exhibition in the United States, at Julien Levy Gallery in New York (December 1934), consisted of twelve sculptures of 1927–34, from *Gazing Head* to *Invisible Object* and *Head/Skull.* Various sculptures of 1930–34 were included in international Surrealist exhibitions in Brussels, Zurich, Lucerne, Copenhagen, Paris, London, Tokyo, and New York during 1934–37 and Mexico City in 1940. In late 1934 decided to return to naturalistic art and was consequently expelled from Surrealist group. Louis Aragon and Leiris remained friends.

1936–41

Began friendship with André Derain and Balthus. Concentrated on modeling a few portrait heads from live models; Diego sat every morning for nearly five years. Isabel Delmer (née Nicholas, later Lambert and Rawsthorne), a journalist's wife and occasional artist's model, posed for two heads in

1936–37 and became the object of Giacometti's unrequited passion until late 1945. In autumn 1936 New York art dealer Pierre Matisse purchased one of 1932 Walking Women plasters. From 1937 closer friendship with Pablo Picasso. While on annual visit to Stampa in 1937, executed several seminal paintings, most significantly *The Artist's Mother* [26] and two still lifes [27, 28], which present basics of postwar style. In October 1937 nephew, Silvio Berthoud, was born in Geneva to sister Ottilia, who died shortly afterward. Around 1938 started sculpting figures without a model and gradually pared down the plasters until by mid-1939 sculptures were barely two inches tall [29, 30]. In October 1938 was knocked down in the place des Pyramides by a careening automobile, breaking right foot; thereafter walked with slight limp. In August 1939 visited Venice for a week with Diego; spent September to mid-November in Maloja. In 1939 met Jean-Paul Sartre and Simone de Beauvoir; artist and philosopher had mutually influential discussions; friendship continued after the war. Exhibited *Walking Woman* and *The Palace at 4 A.M.* in *Art of Our Time* at Museum of Modern Art in New York (1939); *Palace* then entered museum's collection. In June 1940 tried unsuccessfully to flee Paris with Diego.

1942–45

From January 1, 1942, lived for duration of war in small unheated room at Hôtel de Rive in Geneva, near his mother and nephew. A circle of young Swiss and émigré admirers formed around him, including his mistress and future wife, Annette Arm (born 1923), whom he met in October 1943. Continued to model obsessively reduced figures and heads. Also completed one large sculpture at Maloja in 1942–43, *Woman on a Chariot I* [31]. Made increasing numbers of drawings, especially copies of older art from reproductions; destroyed nearly all. In 1945 wrote articles on Laurens and Jacques Callot for new periodical *Labyrinthe* published by Albert Skira. Returned to Paris September 17, 1945; renewed affair with Isabel Delmer until year's end.

1946–49

After visiting Geneva in spring 1946, allowed Annette Arm to join him in July 1946 in Paris, where she soon began posing. Picasso was frequent visitor to the studio. Renewed friendship and lengthy discussions with Sartre, whom he drew several times [33]. Influenced by phenomenological theories of Maurice Merleau-Ponty. Met Louis Clayeux, a young art dealer who introduced him to Galerie Maeght. Published "Le rêve, le Sphinx, et la mort de T." in last issue of *Labryinthe* (December 1946). Sudden burst of creativity in 1946 resulted in distinctive postwar style. Created portrait drawings and busts and elongated, usually extremely thin, figures with expressively modeled surfaces, such as *Man Pointing,* 1947 [37], and *Tall Figure,* 1949 [43]. Most figures have severe, frontal stare; female figures usually stand immobile [38, 43] while most males stride forward [40, 41, 42]. Several compositions situated figures in urban space, such as *City Square II,* 1948 [41], and *Woman Walking between Two Houses,* 1950 [50]. Also executed sculptures of partial figures, notably *The Nose* [34] and *Hand* [35], both in 1947, which recall Surrealist influences. Diego served more actively as skilled assistant, making plaster casts, arranging for bronzes to be cast at foundries, and often patinating them. Returned to painting, which with a few exceptions during the 1930s Giacometti had abandoned around 1924–25. Most depict figures, usually seated in studio or other interior; many canvases during these years characterized by spatial distortion [45, 52, 66]. Drew continually, partly as means of resolving difficulties encountered in sculpture and painting. Also returned to etching, which he had ceased in 1935. In 1946 recent works exhibited at Galerie Pierre, first solo show in Paris since 1932, and published in *Cahiers d'art.* Recent sculptures exhibited at Galerie des Arts in Paris (June 1947). Completed many works for retrospective of sculptures, paintings, and drawings at Pierre Matisse Gallery (January–February 1948), first solo exhibition in New York since 1934. For accompanying catalog contributed letter outlining early artistic development, with sketches of most significant Cubist and Surrealist sculptures. Sartre also contributed "The Search for the Absolute," an essay that viewed Giacometti's art as Existential. Matisse became primary American dealer, a relationship that lasted many years. Articles on work appeared in art periodicals, including *Magazine of Art* (1948). Married Annette in July 1949; she and Diego would remain principal models.

Fig. 23 Exterior of the studio at 46 rue Hippolyte-Maindron, 1950s. Photograph by Sabine Weiss.

1950–52

In 1950 continued to create sculptures of thin figures mounted on prominent bases, such as *The Chariot* [48] and *Four Figures on a Pedestal* [51]; also group of multifigure sculptures, notably *The Glade* [49]. Made four animal sculptures, including *Dog* [59] in 1951. In addition to portraits, paintings and drawings of 1950s also depict still lifes and landscapes [53, 55, 67, 81], mostly from visits to Stampa, and occasional cityscapes in Paris [65, 66]. Urged on by commission from Edouard Loeb, began making lithographs, especially of studio crowded with sculptures; several published in *Derrière le miroir*. Exhibited fifty works in two-person show with Masson at Kunsthalle Basel (May–June 1950), organized by old friends Lukas Lichtenhan and Christoph Bernouilli. Second exhibition at Pierre Matisse Gallery (November–December 1950) led to critical and financial success. Refused invitation to exhibit at Venice Biennale of 1951. First exhibition at Galerie Maeght in Paris (June–July 1951) included sculptures and paintings; Aimé Maeght, assisted by Clayeux, became primary European dealer until mid-1964. Museums began acquiring: *City Square* and two paintings by Basel Kunstmuseum in 1950, and *Woman with Her Throat Cut* and *City Square* by Museum of Modern Art

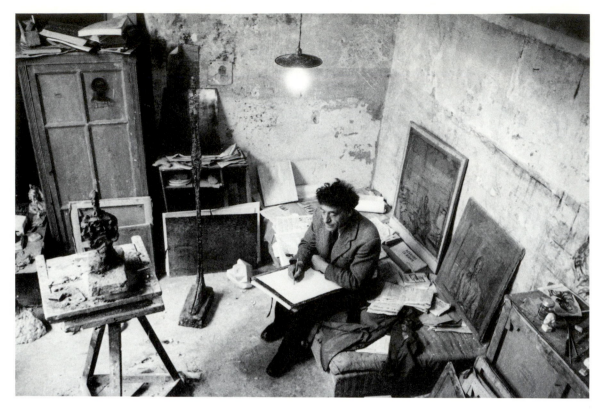

Fig. 24 Giacometti drawing in his Paris studio, 1954. Photograph by Sabine Weiss.

in 1949, followed by *The Chariot* in 1951 and *Man Pointing* in 1954. Private collectors, especially in the United States, amassed significant works through the 1950s, including G. David Thompson of Pittsburgh. Articles on work appeared in *Time* and *Life* in 1951. After 1951 friendship with Picasso cooled. In 1952 published article on Georges Braque and met James Lord. Diego began making bronze furniture.

1953–54

Lived increasingly in evenings and at night: rising after noon, worked until six or seven P.M., usually painting from models; after supper worked until midnight, often from a model; after late dinner and drinks, returned to work until dawn, usually on sculptures from memory. Busts and figures became less attenuated, with more solid, rounded forms. Executed numerous busts of Diego; some tended toward a more realistic style [71], while others emphasized sharp outlines and vertical distortions developed earlier [70]. Compositions henceforth limited to single figures, usually standing female nudes modeled from memory. Colors gradually disappear from paintings in favor of gray, black, and white; distortions of space and anatomy lessen. In summer 1954 did drawings for commemorative medallion of Henri Matisse. During the 1950s sculptures became increasingly well known and were included in many group exhibitions in Europe and the United States. Solo shows at Arts Club of Chicago (November–December 1953) and his third at Pierre Matisse Gallery (fall 1954). Second exhibition at Galerie Maeght (May 1954) included paintings and drawings as well as sculptures; Sartre contributed essay on Giacometti's paintings for catalog published in *Derrière le miroir*; essay published in English the following year. Although they had met by 1939, closer friendship with Samuel Beckett in 1953–54 led to long conversations at night. In 1953–57 did several paintings and drawings of Jean Genet [76], who published essay, *L'atelier d'Alberto Giacometti* in 1957–58. Saw Balthus less frequently.

1955–56

Continued to produce many portrait busts and paintings emphasizing direct frontal gaze. Drawings became more complex, assured, and delicate [78, 79, 80, 81]. In 1955 retrospectives by Arts Council of Great Britain in London (June–July), organized by David Sylvester, and by Solomon R. Guggenheim Museum in New York (June–July); separate traveling show went to Krefeld, Düsseldorf, and Stuttgart (May–October). In January–May 1956 created series of fifteen standing female figures expressly for exhibitions. One group of ten [82, 83] displayed in French pavilion at Twenty-eighth Venice Biennale. Another group of five installed simultaneously in a retrospective—forty-six sculptures, twenty-three paintings, and sixteen drawings covering forty years—at Kunsthalle in Bern, organized by Director Franz Meyer. Growing financial success did not significantly change lifestyle. While painting portrait of Japanese philosophy professor Isaku Yanaihara in September–December 1956 experienced crisis that led to obsessive repainting of figures, especially heads, with little attention to the background, which usually became an indeterminant gray.

1957–58

Directed major energies to painting. Yanaihara returned for July–August 1957 to pose daily and returned for sittings in summers of 1959–61. Met Igor Stravinsky, who posed for drawings. Published article on Derain in February 1957. Successful third exhibition at Galerie Maeght (June 1957) of recent sculptures, paintings, and drawings; catalog included essay by Genet. Recent works also exhibited at Pierre Matisse Gallery (May 1958). In 1958 received honorable mention from Guggenheim International for small gray painting. Swiss photographer Ernst Scheidegger published first book on the artist in 1958, consisting of earlier writings and recent photographs of artist and work.

1959–60

In response to invitation to submit proposal for multifigure outdoor sculpture for Chase Manhattan Bank Plaza in New York, worked in 1959 on seven large plasters, which were completed in 1960 although never installed: *Large Standing Woman I–IV* [92], *Walking Man I–II* [93], and *Monumental Head* [94]. Made etchings to illustrate book of Leiris's poems in 1959. Style grew more intense and expressionist: became obsessed with physical presence and intensity of the face, especially the gaze, in each painting and sculpture. In October 1959 met prostitute Caroline and began painting her in late May 1960. Solo exhibition at Galerie Klipstein & Kornfeld in Bern (July–August 1959) and World House Galleries in New York (January–February 1960). Included in *New Images of Man* at Museum of Modern Art (1959).

1961–63

Canvases executed with powerful gestural strokes and hypnotic emphasis on face [97, 98, 99]. Continued to paint Caroline through 1965. In spring 1961 made plaster tree as stage set for Beckett's *Waiting for Godot*. Last busts of Annette, especially the series of ten done in 1962–65 [100, 101], Diego [104, 105], and other models have obsessive gaze, vigorously modeled surfaces, and distorted silhouettes. Fourth exhibition at Galerie Maeght (June 1961); all twenty-two sculptures and twenty-four paintings sold almost immediately. Equally successful exhibition at Pierre Matisse Gallery (December 1961). Awarded sculpture prize for *Walking Man I* at Carnegie Institute's 1961 *International Exhibition of Contemporary Painting and Sculpture*. Visited Venice in October 1961 to see French pavilion at the Biennale where following year exhibited large selection—forty-two sculptures, forty paintings, and some drawings—which with Diego he installed personally; received grand prize for sculpture. From 1961 on was increasingly acclaimed and interviewed by journalists and critics for print articles, radio, and film. Entire February 1962 issue of *Du* devoted to his work; Jacques Dupin and Scheidegger compiled first monograph on his work, published by Maeght in 1962. Largest retrospective—one hundred six sculptures, eighty-five paintings, one hundred three drawings—to date at Kunsthaus in Zurich (December 1962–January 1963). Exhibited fifty-four paintings and sculptures at Phillips

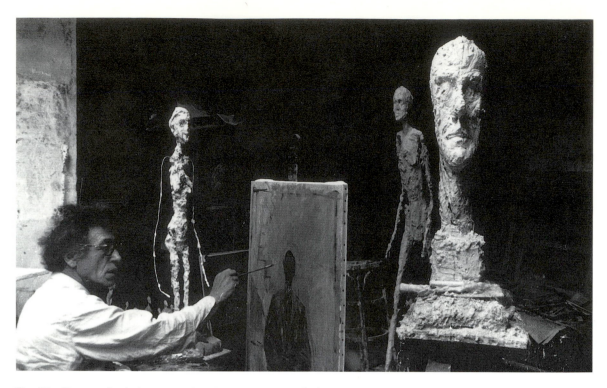

Fig. 25 Giacometti painting a portrait, with *Walking Man I* [93] and *Monumental Head* [94] in progress, 1960. Photograph by Ernst Scheidegger.

Collection in Washington, D.C. (February–March 1963). Exhibition at Galerie Krugier in Geneva (May–July 1963). Galerie Beyeler in Basel acquired Thompson's Giacometti collection (more than one hundred forty works) and exhibited it (July–September 1963). Quarreled with Sartre in 1962. Met Francis Bacon. In February 1963 was operated on in Paris for stomach cancer; recuperated in Stampa.

1964–66

Mother died in January 1964. Elie Lotar, down-and-out Rumanian photographer whom he had met many years earlier, began posing on weekends in late 1963 and more often through 1965, resulting in three busts. Completed few sculptures and paintings in last year of his life. In 1964 received Guggenheim International Award for painting. Major retrospectives in 1965–66: two hundred works assembled by Arts Council at Tate Gallery in London (July–August 1965) and partially reassembled at Louisiana Museum in Humlebaek, Denmark (September–October 1965); and one hundred forty works at Museum of Modern Art (June–October 1965), which traveled to Art Institute of Chicago, Los Angeles County Museum of Art, and San Francisco Museum of Modern Art. Despite dislike for travel, visited all three exhibitions, going twice to London. Stedelijk Museum in Amsterdam exhibited drawings (November–December 1965). Group of Swiss citizens acquired most of Thompson's collection to establish the Alberto Giacometti Foundation in 1964-66; artist contributed eighteen works to bring the total to more than one hundred. Fondation Maeght was established, including a sizable collection of his work, at Saint Paul-de-Vence near Nice; after formal opening in July 1964, Clayeux and Giacometti broke off relations with Galerie Maeght. Scheidegger and Dupin made thirty-minute film on artist, showing him at work. Lord published book describing artist's painting methods. Executed one hundred fifty lithographs, with text, entitled *Paris sans fin*, published by E. Tériade in 1969. In November 1965 received French Grand Prix National des Arts and also honorary doctorate from University of Bern. Left Paris in December 1965 for Cantonal Hospital, Chur, Switzerland; died there of heart failure on January 11, 1966. Was buried in village where he had been born.

Selected Bibliography

For comprehensive bibliography (including artist's writings, statements, and interviews, exhibition catalogs, critical studies, and monographs) see Hohl 1971a.

American Federation of Arts 1977

Alberto Giacometti: Sculptor and Draftsman. New York: American Federation of Arts, 1977. Exhibition catalog with essay by L. A. Svendsen. Traveled (1977–79) to Neuberger Museum, State University of New York, Purchase; Edwin A. Ulrich Museum of Art, Wichita State University, Kansas; John and Mable Ringling Museum of Art, Sarasota, Florida; University Art Museum, University of Texas at Austin; Denver Art Museum; Seattle Art Museum; Columbus Gallery of Fine Arts, Ohio; Oklahoma Art Center, Oklahoma City; Jacksonville Art Museum, Florida; Newark Museum, New Jersey.

Arts Council of Great Britain 1955

Alberto Giacometti. London: Arts Council of Great Britain, 1955. Exhibition catalog (Arts Council Gallery) with essay by D. Sylvester.

Arts Council of Great Britain 1965

Alberto Giacometti: Sculpture, Paintings, Drawings 1913–1965. London: Arts Council of Great Britain, 1965. Exhibition catalog (Tate Gallery) with essay by D. Sylvester.

Arts Council of Great Britain 1986

Giacometti. London: Arts Council of Great Britain, 1986. Exhibition catalog with 1964 interview by D. Sylvester. Traveled (1986) to Whitworth Art Gallery, University of Manchester; City of Bristol Museum and Art Gallery; Serpentine Gallery, London.

Bach 1980

Friedrich Teja Bach. "Giacomettis 'Grande Figure Abstraite' und seine Platz-Projeckte." *Pantheon* 38 (July–September 1980): 269–80.

Brenson 1974

Michael F. Brenson. "The Early Works of Alberto Giacometti 1925–1935." Ph.D. diss., Johns Hopkins University, 1974; reproduced without illustrations, Ann Arbor: University Microfilms, 1986.

Brenson 1979

Michael F. Brenson. "Looking at Giacometti." *Art in America* 67, no. 1 (January–February 1979): 118–20.

Bündner Kunstmuseum 1978

Alberto Giacometti: Ein Klassiker der Moderne 1901–1966 (Skulpturen, Gemälde, Zeichnungen, Bücher). Chur, Switzerland: Bündner Kunstmuseum, 1978. Exhibition catalog. Traveled (1978–79) to Museum des 20. Jahrhunderts, Vienna.

Bündner Kunstmuseum 1986

The Photographer's View: Alberto Giacometti. Chur, Switzerland: Bünder Kunstmuseum; and Zurich: Kunsthaus Zurich, 1986. Exhibition catalog, with essay by F. Meyer (German and English/French editions).

Carluccio 1967

Luigi Carluccio. *Giacometti: A Sketchbook of Interpretive Drawings.* New York: Abrams, 1967, published originally as *Le copie del passato.* Turin: Botero, 1967.

Centro Cultural Arte Contemporáneo 1987

Giacometti Familia: Giovanni, Augusto, Alberto, Diego. Mexico City: Centro Cultural Arte Contemporáneo, 1987. Exhibition catalog, with essays by R. Hohl, D. Marchesseau, P. Schneider, B. Stutzer. Traveled to Barcelona, Fundación Joan Miró.

Charbonnier 1959

Georges Charbonnier. *Le monologue du peintre.* Paris: René Juillard, 1959, pp. 159–70 (transcripts of two interviews from 1951 and 1957).

Clair 1983

Jean Clair. "Alberto Giacometti: 'La pointe à l'oeil'." *Cahiers du musée national d'art moderne* 11 (1983): 62–99.

Dupin 1962

Jacques Dupin. *Alberto Giacometti.* Paris: Maeght, 1962.

Dupin & Leiris 1978

Jacques Dupin and Michel Leiris. *Alberto Giacometti.* Paris: Maeght, 1978. Published in conjunction with exhibition at Fondation Maeght, Saint Paul-de-Vence, France.

Evans 1984

Tamara S. Evans, ed. *Alberto Giacometti and America.* New York: City University of New York, 1984. Essays by W. Rotzler and others.

Fondation Giannadda 1986

Alberto Giacometti. Martigny, Switzerland: Fondation Pierre Giannadda, 1986. Exhibition catalog, with essays by H. C. Bechtler, J. Dupin, G. Giacometti, R. Hohl, E. W. Kornfeld, A. Kuenzi, J. Lord, J. Soldini.

Forge 1974

Andrew Forge. "On Giacometti." *Artforum* 13 (September 1974): 39–45.

Fundación Juan March 1976

Giacometti: Colección de la Fundación Maeght. Madrid: Fundación Juan March, 1976. Exhibition catalog.

Genet 1957

Jean Genet. "L'atelier d'Alberto Giacometti [excerpts]." *Derrière le miroir* 98 (June 1957): 3–26; entire text published, Décine, France: Barbézat, 1958.

Giacometti 1933

Alberto Giacometti. "Poème en 7 espaces," "Le rideau brun," "Charbon d'herbe," "Hier, sables mouvants." *Le surréalisme au service de la révolution* 5 (May 15, 1933): 15, 44–45.

Giacometti 1946

Alberto Giacometti. "Le rêve, le Sphinx, et la mort de T." *Labyrinthe* 22–23 (December 15, 1946): 12–13.

Guggenheim Museum 1974

Alberto Giacometti: A Retrospective Exhibition. New York: Solomon R. Guggenheim Foundation, 1974. Exhibition catalog, with essay by R. Hohl. Traveled (1975) to Walker Art Center, Minneapolis; Cleveland Museum of Art; National Gallery of Canada, Ottawa; Des Moines Art Center.

Hall 1980

Douglas Hall. *Alberto Giacometti's "Woman with Her Throat Cut."* Edinburgh: Scottish National Gallery of Modern Art, 1980.

Hess 1958

Thomas B. Hess. "Giacometti: The Uses of Adversity." *Art News* 57, no. 3 (May 1958): 34–35, 67.

Hill 1982

Edward Hill. "The Inherent Phenomenology of Alberto Giacometti's Drawing." *Drawing* 3, no. 5 (January–February 1982): 97–102.

Hohl 1971a

Reinhold Hohl. *Alberto Giacometti.* New York: Abrams, 1971 (English); Stuttgart: Gerd Hatje (German); Lausanne: Guilde du Livre (French).

Hohl 1971b

Reinhold Hohl. "Alberto Giacometti: Atelier im Jahr 1932." *Du* 31, no. 363 (May 1971): 352–56.

Kirili 1979

Alain Kirili. "Giacometti's Plasters." *Art in America* 67, no. 1 (January–February 1979): 121–23.

Koepplin & Hohl 1981

Dieter Koepplin and Reinhold Hohl. *Alberto Giacometti: Zeichnungen und Druckgraphik.* Stuttgart: Gerd Hatje, 1981. Exhibition catalog. Traveled (1981–82) to Kunsthalle Tübingen; Kunstverein Hamburg; Kunstmuseum Basel; Kaiser Wilhelm Museum, Krefeld; Museum Commander van Sint Jan, Nijmegen, Netherlands.

Kramer 1963

Hilton Kramer. "Reappraisals: Giacometti." *Arts Magazine* 38, no. 2 (November 1963): 52–59.

Krauss 1984

Rosalind Krauss. "Giacometti." In *Primitivism in Twentieth-Century Art,* edited by William Rubin.

New York: Museum of Modern Art, 1984, vol. 2, 502–33; reprinted in Rosalind Krauss, *The Originality of the Avant-Garde and Other Modernist Myths.* Cambridge, Mass.: MIT Press, 1985, pp. 42–85.

Lamarche-Vadel 1984
Bernard Lamarche-Vadel. *Alberto Giacometti.* Paris: Nouvelles Editions Françaises, 1984.

Leiris 1929
Michel Leiris. "Alberto Giacometti." *Documents,* no. 4 (September 1929): 209–14.

Limbour 1948
Georges Limbour. "Giacometti." *Magazine of Art* 41, no. 7 (November 1948): 253–55.

Lord 1965
James Lord. *A Giacometti Portrait.* New York: Doubleday, 1965.

Lord 1971
James Lord. *Alberto Giacometti Drawings.* Greenwich, Conn.: New York Graphic Society, 1971.

Lord 1983
James Lord. "Giacometti and Picasso: Chronicle of a Friendship." *New Criterion* 1, no. 10 (June 1983): 16–24.

Lord 1985a
James Lord. *Giacometti.* New York: Farrar Straus Giroux, 1985.

Lord 1985b
James Lord. " 'Caresse' d'Alberto Giacometti." *Cahiers du musée national d'art moderne* 15 (1985): 22–25.

Lord 1985c
James Lord. "Sartre and Giacometti." *New Criterion* 10 (June 1985): 45–55.

Lust 1970
Herbert Lust. *Giacometti: The Complete Graphics and Fifteen Drawings.* New York: Tudor, 1970.

Matisse 1948
Alberto Giacometti: Sculptures, Paintings, Drawings. New York: Pierre Matisse Gallery, 1948. Exhibition catalog, with letter and checklist of early works written by artist in 1947 to Pierre Matisse and essay, "The Search for the Absolute," by Jean-Paul Sartre.

Matisse 1950
Giacometti. New York: Pierre Matisse Gallery, 1950. Exhibition catalog, with excerpts from letter by artist written to Pierre Matisse in 1950.

Matter & Matter 1987
Herbert Matter and Mercedes Matter. *Giacometti.* New York: Abrams, 1987.

Megged 1985
Matti Megged. *Dialogue in the Void: Beckett and Giacometti.* New York: Lumen, 1985.

Meyer 1968

Franz Meyer. *Alberto Giacometti: Eine Kunst existentieller Wirklichkeit*. Stuttgart: Huber, 1968.

Musée d'Art et d'Industrie 1981

Alberto Giacometti. Saint-Etienne, France: Musée d'Art et d'Industrie, 1981.

Musée Rath 1986

Alberto Giacometti: Retour à la figuration 1934–1947. Geneva: Musée Rath; and Paris: Musée National d'Art Moderne, 1986. Exhibition catalog, with essays by P. Bruguière, J. Starobinski, H. Teicher, C. Derouet, B. Giacometti, and others.

Museo Communale 1985

Alberto Giacometti. Ascona, Switzerland: Museo Communale, 1985. Exhibition catalog, with essay by R. Hohl.

Museum of Modern Art 1965

Alberto Giacometti. New York: Museum of Modern Art, 1965. Exhibition catalog.

Nationalgalerie Berlin 1987

Alberto Giacometti. Berlin: Nationalgalerie, 1987. Exhibition catalog, with essays by R. Hohl, D. Hönisch, K. von Maur, A. Schneider, and others. Traveled (1988) to Staatsgalerie Stuttgart.

Okun 1981

Henry Okun. "The Surrealist Object." Ph.D. diss., New York University, 1981; reproduced without illustrations, Ann Arbor: University Microfilms, 1981, pp. 233–338.

Poley 1977

Stefanie Poley. "Alberto Giacomettis Umsetzung archaischer Gestaltungsformen in seinem Werk zwischen 1925 und 1936." *Jahrbuch der Hamburger Kunstsammlungen* 22 (1977): 175–86.

Rotzler 1981

Willy Rotzler. *Die Geschichte der Alberto-Giacometti-Stiftung: Eine Dokumentation*. Bern: Benteli, 1982.

Sainsbury Centre for Visual Arts 1984

Alberto Giacometti: The Last Two Decades. Norwich, England: University of East Anglia, 1984. Exhibition catalog.

Sartre 1948

Jean-Paul Sartre. "La recherche de l'absolue." *Les temps modernes* 3, no. 28 (January 1948): 1153–63; translated by Lionel Abel, "The Search for the Absolute," in Matisse 1948, pp. 2–22.

Sartre 1954

Jean-Paul Sartre. "Les peintures de Giacometti." *Derrière le miroir* 65 (May 1954); translated by Lionel Abel, "Giacometti in Search of Space." *Art News* 54, no. 5 (September 1955): 26–29, 63–65.

Scheidegger 1958

Ernst Scheidegger, ed. *Alberto Giacometti: Schriften, Fotos, Zeichnungen*. Zurich: Arche, 1958.

Scheidegger 1986

Ernst Scheidegger. "Begegnungen mit Alberto Giacometti." *Du* 4 (1986): 96–106.

Silver 1974

Jonathan Silver. "Giacometti, Frontality and Cubism." *Art News* 73, no. 6 (Summer 1974): 40–42.

Soavi 1973

Giorgio Soavi. *Disegni di Giacometti.* Milan: Domus, 1973.

Von Meyenburg-Campbell & Hnikova 1971

Bettina Von Meyenburg-Campbell and Dagmar Hnikova. *Die Sammlung der Alberto Giacometti Stiftung.* Zurich: Kunsthaus Zurich, 1971.

Wescher 1953

Herta Wescher. "Giacometti: A Profile." *Art Digest* 28, no. 5 (December 1, 1953): 17, 28–29.

Wilhelm-Lehmbruck-Museum 1977

Alberto Giacometti. Duisburg, West Germany: Wilhelm-Lembruck-Museum, 1977; and Mannheim: Stadtische Kunsthalle Mannheim. Exhibition catalog, with essays by C. Ammann, M. Brenson, H. Fuchs, R. Hohl, J. Lord, and others.

Wolf 1974

Marion Wolf. "Giacometti as a Poet." *Arts Magazine* 48, no. 8 (May 1974): 38–41.

Yanaihara 1961

Isaku Yanaihara. "Pages de journal." *Derrière le miroir* 127 (May 1961): 18–26.